GW00535852

PICASSO'S REVENGE

PICASSO'S REVENGE

First published in 2019 by
MEDINA PUBLISHING LIMITED
Surbiton, Surrey.

medinapublishing.com

ISBN Hardback 978-1-911487-34-0

Designed by Arcadia Designs.
Printed and bound in Great Britain by
Clays Ltd, Elcograf S.p.A.

Set in Baskerville Old Face 12/16pt.

British Library Cataloguing-in Publication Data
A catalogue record of this book is available from the British Library.

Medina Publishing

Dedicated to the memory of

Walter Foulk

(1893 - 1956)

Ray Foulk & Caroline Foulk

PICASSO'S REVENGE

Medina Publishing

JACQUES

*At his birth Jacques Antoine Doucet found in his cradle
some of the greatest gifts the good fairies could bestow
upon a baby: beauty, riches, wilfulness and a taste for
perfection. The bad fairy – because one has need of one –
gave him a job: that of couturier – dressmaker to the rich
and famous. It was a meanness he would never forgive.
Couturiers did not count among the most important people
of the Republic.*

THE BOY DROPPED the shoelace he was playing with and began listening attentively, cupping his bare chin in his hands. His eyes, fully wide, considered the bullet shaped mark in his grandfather's chest. Jacques' gaze scanned the dumpy left thumb, partially hacked off by a sabre and the ugly ripple in his back, roughly stitched and warped by scarring from a lance's plunge. Were they the glorious marks of pride? He tried to see beauty in the body. His buttercup curls fell about his ears and he felt revulsion. He listened to Papy Antoine's tales of life as a juvenile of the *Marie-Louise* regiment with earnest concern about his own future.

Jacques drew the scars, painted the battleground repeatedly and retold the horrors to the pigs. Jacques and Papy Antoine tended the animals with the boy trailing in the mud after him regularly chasing the spotted boar hollering, 'Gee up, Napoleon, the Prussians are on your tail!'

On the farm the boy could breathe and be dazzled by everything, from the loveliness of the natural world in miniature to the broad shiny flanks of the brown cow, Clarabelle. Just a few miles away

was Paris, which in Jacques' eyes meant the "vast" rue de la Paix, linking the great squares of the place Vendôme and l'Opéra, where the classically entablatured business premises were also the home of his parents, and seemed a world away for the child.

Jacques heard tell stories of London's Great Exhibition of 1851, held a little before his birth and was especially fascinated by his father and grandfather's descriptions of the extraterrestrial glasswork of the Crystal Palace, and the treasures within. Antoine and Edouard, the boy's father, had represented France, carrying off a medal for their shirt making. In addition they earned a special commendation – the declaration that the French were *superior, exhibiting a finer quality of embroidery.*

At thirteen, Jacques' ambivalence to the diminishing aristocracy was cemented. Papy Antoine was visiting the family and beaming from ear to ear at every turn to see the *House of Doucet* flourishing at the heart of the Empire. He pledged to live to see his favourite grandson, heir to his legacy, take the reins.

It was a sultry summer afternoon when young Doucet, positioned at a window, painted a street scene from an upper storey. He spied the shuffling figure of Papy approaching. He watched him lose his footing. The old man fell into the gutter below. At the same time a heavy slung carriage blundered forwards and attempted a late turn. Jacques dashed to the scene. The collision had resulted in the grisly crushing of Papy's head under the wheel. The boy experienced the sound of the skull cracking strangely, as an auditory delusion – believing in his confusion that he heard spitting from a roaring fire. He watched the blood fan out – just as he had watched the crimson velvet cloth splay in the hands of the *coupeuse* in readiness for cutting that morning.

The imperious voice of complaint of the nobleman clipped the air. 'Why the devil can't these servants get out of the way!' Kneeling by his grandfather, the child watched the stately equipage trot away from the commotion and vanish around the corner.

Outwardly, Jacques remained the perfect young gentleman, appar-

ently happy to be the pet of others on the shop floor. He recoiled from painting from that moment onwards, but still had a need to assuage his love of art. Gradually he began buying small canvasses that could be purchased within his regular allowance. He determined to take on Papy's business and make it a success. In honour of his grandfather he would render the female body beautiful – that was to be his task.

PABLO

La Coruña, Spain. It was Christmas 1894. Seven-year-old Conchita lay dangerously ill. Her thirteen-year-old brother sat beside her as he had done for nearly two days. As a door slammed the boy quickly concealed a sketch book, lowered himself to his knees and lifted his great dark eyes towards God.

THE BOY COULD find no rest. He wondered if God might be open to a bargain and searched his juvenile soul for what he could offer to save his sister. Brought up as a devout Catholic, Pablo made haste to the Chapel of San Juan Bautista. He knelt at the altar and called upon The Almighty. 'Father in heaven ... I worship You. If you save her, I promise – I vow to You...' He threw everything into the bargain he could think of.

Returning to her sickbed, Pablo contemplated his sister's dormant form. His anxious stare rarely left the black locks of the little girl. Rosy cheeks meant life – Conchita was clinging on. Diphtheria had made dark circles under her shut fast eyes. The rasping was frightening, sometimes steady, sometimes stuttering. He held ice to her

lips. She had stopped sipping. Even the choking had ceased.

He was helpless and could do nothing. So he took up his pencil and edged around her shape, capturing her with astonishing accuracy. He lingered at the pretty hairs on the hairline, where the cheek fuzz was so short that it was barely perceivable. He captured the nap of the downy covering. The dewy youthfulness of her skin was there on the page. He arrived at the turn of the wrist, executing the hands with the ease of an old master who had already completed his classical tour.

He considered that the buff-coloured skin lacked its usual redolence. The bloom in her young cheek had become freakish – the complexion strange compared to its natural state.

Pablo thought of her as a baby and how she had been like a lovely and funny pet. She had shined – so shining as a baby and full of laughter. She was a bouncing joyous baby girl that loved the hubbub of company. He and Lola would command, 'Chica do your special smile!' The siblings would cry out, 'Look, look, Chica is doing her special smile!' The faces would turn and Conchita's grin would come sudden and generous and broad as if made with the effort of her whole body. She would light the room like a candle. The faces would spread with smiles and the ripple of joy would pass through the company as they put their hands together in happy applause.

The boy heard the voice of Doña María his mother calling. Some news had come. The family's doctor had read of a new treatment for diphtheria, and telegraphed to Paris for an urgent dispatch of the serum. Buoyed up with this glimmer of hope and awaiting the arrival of the medicine, Doña María accompanied siblings, Lola and Pablo, into the invalid's chamber. The slow asphyxiation had resumed. The brother and sister covered their ears as the girl's rasping became louder. Pablo leant forward staring at her discoloured, mottled skin. He could take no more and jumped to his feet shrieking, *'Ella es azul!'* – 'She is blue!' He fled from the room unable to hold back tears any longer.

Later in the afternoon of 10th January Conchita died.

The serum arrived from Paris the next morning. The distraught family felt cheated. Pablo took it especially badly and concluded, superstitiously, that his attempt to manipulate Almighty God could be responsible.

This was not Pablo's first brush with death. Indeed, he began his time in this world in Málaga on 25th October 1881, as a discarded stillborn. Only when an uncle, Dr Salvador puffed cigar smoke in his face did his limp form splutter into life, with first a grimace then a howl. His father José Ruiz Blasco, an art school teacher and painter of pigeons, though not sufficiently dedicated to make a career as an artist himself, had encouraged the baby's drawing abilities from the moment he could hold a pencil or a brush and even before he could speak.

Just before his eleventh birthday Pablo enrolled as a student in his father's class for ornamental drawing and, unusually among his peers, never tired of the repetitive grind of drawing plaster cast limbs by rote.

It was eight years later as a precocious teenager he made his first journey to Paris where one of his paintings was being exhibited in the 1900 Exposition Universelle. It was a fine, lifelike oil – *Last Moments,* and featured a young woman dying in her bed attended by a priest.

1

*Is there anyone to whom you entrust a greater number of
serious matters than your wife? And is there anyone with whom
you have fewer conversations? –* **Socrates**

'I AM TOLD they call Ruhlmann's style architectonic,' whiffles the old gentleman from under a heavy walrus moustache.

'His interiors have been visited more than those of any other pavilion here, Monsieur le President,' replies M. Doucet, a tall and elegant man in mouse grey. 'And I scarcely need to tell you of the prestige secured for *La République* because of it.'

Gendarmes clear a path, keeping the enthusiastic public at bay. The President and his entourage enter an angular fairyland, a courtyard graced with classically styled plinths leading to a full-bosomed stone and stucco clad building embodying the greatest domestic decoration that the country has to offer. The effect of gardens graced with Cubist palms and magical shadows mingling with perfect light is mesmerising. The exhibit, *An Ambassador's Residence,* is one of the most arresting pavilions in the whole of the Exposition Internationale.

'Now tell us, Monsieur Doucet,' asks the ruddy-cheeked President, 'would you call these sculptures *Cubism,* or even trees?'

The connoisseur pauses. He smooths his silky white beard, eyes skipping from kepis, sashes, to variously coiffed faces and concrete tree sculptures. 'We might ask the artist?'

'Do you mean Picasso?' queries the Arts Minister.

The connoisseur squirms at the mention of this name, given that his recent acquisition – a brothel painting by the artist of that name

is regarded as so hideous that it would cause for him immense embarrassment, if it were known about by this present company.

'No! No! They are by Robert Mallet-Stevens in fact – but come, this way, Monsieur le President. Gentlemen. Inside is the treasure I have in mind for the palace,' he informs the amiable President Doumergue.

The Prime Minister enthuses, 'We trust your impeccable discernment, Monsieur Doucet, to identify the singular piece to represent the artistry of the republic of 1925.'

The Arts Minister, looking as if he has been pinched, butts in, 'Yet remaining in sympathy with the splendours of the Élysée interior?'

'I am assured that Monsieur Doucet has taste enough to measure up to the task, good Minister,' retorts the President. 'Pray continue, my man.'

'My choice is strikingly modern,' says Doucet, 'but it would not have been out of place in Caesar's imperial villa ...' ushering the party inside the pavilion building.

They approach a majestic object with a glowing golden hue – a cabinet of immense size by Émile-Jacques Ruhlmann. Its presence is amplified by two dark classical sculptured heads mounted on plinths at either flank. 'It is the most exceptional item,' Doucet declares, praising the merits of the muscular breakfront cabinet. 'To save you the trouble of counting them, Monsieur le Président, there are more than 2,000 fine circles of ivory encrusted into the amboyna surface. A virtuoso performance in soap bubbles, Ha! ... Held within rigorous classical framing.' Doumergue pats his silk sash appreciatively.

'But word has it that *you* yourself do not collect Ruhlmann, monsieur?' cuts in the Arts Minister.

'I own a most pleasing armoire, in fact.'

'We must bow to Monsieur Doucet's better judgement for this task, my friend,' President Doumergue asserts roughly to his minister.

M. Doucet gads through the rest of the formal visit, buoyed up by

the privilege of conducting the President on such a tour. He strolls with ease to his motorcar awaiting him at the kerbside – his silk hat now in hand. The blowing wind has died away to a zephyr and plays lightly with his silvery locks. Privately he vows to present one of his own unique furniture commissions for the presidential collection at any future opportunity.

THE MAROON/BLACK Panhard-Levassor draws to a halt in the fashionable rue Saint-James, Neuilly-sur-Seine, close to the Bois. The silver fox, smiling and impossibly handsome at seventy-two, relishes his success at escorting the President of France on his official visit to the Exposition internationale. Chauffeur Chivet swiftly circles the car to open the rear passenger door for his master to alight. It is a master he is proud of. The assistant waits to brush the shoulders of the suit, woven of rare vicuna and qivuit wool, and free of any possible dust – as if there could be any? The figure stepping onto the flagstones from the limousine is as impeccable as if freshly decanted from a hatbox.

Arriving at Villa Doucet is the couturier to royalty, theatre actresses and nobility – Jacques Doucet. These days, in what might ordinarily be called his twilight years, he has become better known among the Parisian elite as patron to the arts and builder of great libraries. He returns from the sensational exhibition dominating the centre of Paris – the 1925 Exposition Internationale des Arts Décoratifs et Industriels Modernes – currently discharging the Art Deco style across the world. Still bolstered by advising the president and seeing his own fine furniture admired, his careful paces lead him to the door of his residence where a commotion is carrying on within.

Inside the villa, by rights the property of Mme Doucet, carpenters endeavour strenuously to remove the French windows to the rear gardens, while the proprietress flusters, in the hope that all will be done before the master returns. In fact Jacques enters to observe a hostile expression on the face of his wife.

In the case of Jeanne Doucet, evolution has produced in this sixty-year example, a swanlike dignity of stature, offset by a roundish face and features. She is pretty and sedate but adopts a fiery demeanour when fully roused, as here when her husband catches her orchestrating the banishment of his most coveted possession.

As Monsieur Jacques enters he is more than astonished to be confronted by the sight of the great treasure, a two-and-a-half metre square picture, looming at an ungainly angle across the erstwhile graceful drawing room. Time seems arrested as he surveys the outrage before him. His shock might be due to seeing his beloved Jeanne blatantly removing such a work for the purpose of disposing of it, but angry as he is, Jacques blushes internally at the glaring display of the five damsels of Avignon, staring everyone down lasciviously, in their flagrant pink nakedness. *How they accost the viewer! How vulgar!* he admits to himself. *How base! How ugly! – Large and strange, certainly wild in their overt sexuality, particularly the vile female on the lower right ushering in the bystander with her spread-eagled thighs. The blackened, necrotic heads of the right side are bestial with their twisted faces. What on earth was Picasso doing? How had it ever come to pass that it has found its way into the house at all? These ladies painted in disturbing angles over-reach what it means to be human on this Earth. And yet ... and yet, how arresting!*

So large is the canvas that removal of the French windows is the only means of extrication – a course of action Mme Doucet is decidedly set upon.

'Another jiff, and she'll be out, ma'am,' the carpenter reassures the anxious lady, as he struggles with a stubborn screw. 'Just this one hinge and that's ...'

All at once he is stopped in his tracks at the appearance of the imposing master of the house, replete with silk hat and cane in hand. The parlour maid's jaw drops. The two auction house porters glance nervously at one another. Jeanne starts to speak but is abruptly cut off by her glowering husband.

'What in heaven's name? Just what are you doing?'

'It's going. I've warned you,' she snaps back assertively. 'I thought you understood!'

Her husband turns instinctively on the workmen. 'And who the devil are you?' Before they can reply he persists, 'Right, *you,* young man, stop that. *Now!* ... And you?' looking towards the porters.

'We're from ...' Mme Doucet cuts in, 'from the Drouot sale-rooms.'

'What!?' he exclaims.

'You knew this would happen.'

'What the deuce?' raising his voice. 'Right. All of you, *OUT!* – *OUT NOW!!*'

The carpenters' faces pale in astonishment. 'Begging your pardon, monsieur, we were engaged by madame in good faith...'

Jacques manhandles the confused porter towards the door.

'Excuse me, monsieur,' pleads the hapless tradesman, 'the lady said she couldn't abide it,' gesturing towards the offending artefact. Jacques continues herding the men out. They attempt to confer. Jeanne is mute, white, bristling. Jacques turns on her.

'How could you?' he demands, as she angrily gathers up her papers at the escritoire. 'My art!'

'Naked women. Prostitution! I'll not have obscenity in my house! I am a Christian woman!'

Despite his shaky belief in the merits of the painting Jacques is ready to defend it with his all his might. 'You know better than this, Jeanne. Go to the Louvre. Regard Ingres or Rubens. Have they not employed nude women, endlessly?'

'Women!? Women you call them.' Moving towards the painting, Jeanne continues, as she nervously fingers a small silver crucifix pendant as though shielding herself. 'Tell me then, when *you* go to a brothel, is this how they present themselves? Here we are, take your pick. The choice is all yours.'

'For goodness sake, Jeanne!'

'No. Come on. I want to know. Here we have a fine choice.' She

points to figures in the painting. 'Do you prefer noble savage or menacing cannibal? Which culture do you choose? Which style? Or perhaps it's a case of which Africa? How very grotesque!'

'And isn't the African both beautiful *and* grotesque?'

'Don't draw me into one of your arguments on aesthetics, Jacques Doucet. I know too well what this is all about. *This* was your lover's obsession. Do you think I don't know? This is all to do with *her,* isn't it?'

Jacques momentarily reflects on this surprising accusation before recomposing himself and replying in a gentler tone. 'There is no need to pit yourself against a ghost, my dear.'

'Not at all!'

'My wish, as you know, is to only ever look forwards.' He adds quickly.

'Your Madame Roux was obsessed with it, and now it's here? A monstrous sin. And another thing ... how much was it? Come on, tell me.'

'A coup. Just twenty-five.'

'Twenty-five what? Francs? Don't take me for a fool.'

'Thousand of course.'

'What a terrible waste!' Jeanne furiously exclaims. 'You've gone through thirteen million. *Thirteen million!* The business is in ruins. When I think of those libraries you gave away. You've squandered your fortune.'

'Whose fortune?' Jacques snaps back, regretting the words as they leave his mouth.

'*Damn you. It's our*s*! Yours* and mine isn't it!' Jeanne lunges for a porcelain cherub and hurls it at the painting. It misses and smashes against the mantel.

Jacques physically restrains her before she grabs its pair.

The Scottish parlour maid, previously gravely quiet, runs from the room, crying loudly for assistance. 'Quick! Help! Help! Monsieur's going to have another heart attack.'

'Dora!' booms Jacques, 'I won't have this insufferable fuss!'

The front door is still widely ajar and a policeman is walking past on his beat on the other side of the street. He hears Dora's shouts for help.

Jacques holds Jeanne and stares at the broken china, fuming. 'Be still. You speak of money, yet which one of us is wasting it now? You are most handsomely provided for! ...'

His attention focuses momentarily upon her platinum necklace, held together with a jewelled clasp in the form of an Art Nouveau peacock. Jeanne pulls away and snaps, 'I mean every word, Jacques. It's going!'

'You cannot assume the authority,' he fulminates, 'to drag the painting from the study ... and behind my back. And what's more, send it to the Drouot ... without any regard ...'

'I would have set fire to it.'

'How ridiculous!'

'Ridiculous?' she shouts back. 'You call me ridiculous? The picture is ridiculous. Everyone's said so for years What is more, I heard the painter, that Spaniard, could never sell it – not until you came along, that is.'

'We agreed, if we were to marry, I would keep my independent interests,' asserts the collector.

'You bring pictures of prostitutes into my home,' gesturing back at the canvas, 'and now you slight our marriage!'

'Of course not.'

'I should never have agreed to this match. My home's turned into anarchy. The money's gone. You are quite mad.'

'It's one of the great paintings of the era.'

'No, not quite mad. *Completely* mad.'

'It's not even as though I'd hung it in here, in your drawing room,' says the husband, trying to reason.

'Why this obsession with the modern? A man of your age? To be a collector is one thing, but always ... always driving everyone to distraction... Such foibles. Supporting wild and unruly youths... Surrealists do you call them? And that Jacob fellow... Now Picasso

... I daren't even turn to the daily columns anymore,' she laments.

'If you do, you might read about my outing this morning to advise President Doumergue on a modernist work for the Élysée Palace, in fact,' he retorts quietly.

Jeanne's pursed lips denote a refusal to be moved.

A bewhiskered policeman is admitted to the room by Dora. 'Pardon me, there's a policeman,' advises the distressed maid. The gendarme takes a measured view of the disagreement. 'Monsieur, madame, I regret to inform you, a disturbance has been noticed at this residence.'

'I'll leave my wife to answer that.'

'I'm not staying another night,' she responds, 'until we've agreed two things. Firstly, you stop spending money that we no longer have ... and more importantly, this obscenity goes,' hitting out at the canvas as she strides out of the room. She shouts back, before slamming the door, 'When you've considered what on earth is driving you, *I'll* consider coming back.'

The gendarme observes the painting. 'What in God's name...?'

Jacques glances at the intruder coldly, raises an eyebrow and covers the picture with a drape. The drape falls off. 'This is scarcely a matter for the constabulary... Dora, show the officer out would you please.' Moments later Mme Doucet storms out of the front door carrying a small suitcase.

Jacques, perplexed, plucks a cigar from his day coat and breathes sparks into it with his Lalique lighter. He pours himself a brandy contemplating how to proceed and whom to turn to for counsel.

He recalls someone who indeed owes him a good turn – his former protégé, Paul Poiret. He takes comfort from the rich, sweet Havana smoke, while vividly recalling Paul's arrival as apprentice at Maison Doucet in 1898. This was a boy who grew up dressing his sister's dollies. At nineteen he had joined the fashion house. By studiously following his mentor's example as consummate aesthete, he has become the leading couturier today.

Jacques takes up the telephone receiver and dials a number. 'Get me Poiret,' he asks curtly, as he gazes thoughtfully at the painting

wondering how this impasse with Mme Doucet could possibly be resolved.

As he waits, he reflects on a time two decades earlier, in 1906, when he first knew Jeanne, long before their recent marriage.

2

The paradoxes of today are the prejudices of tomorrow,
since the most benighted and the most deplorable
prejudices have had their moment of novelty when fashion
lent them its fragile grace. – **Marcel Proust**

THE EXPANSIVE PARK was festooned with blooming, white gowned women adorning the arms of their upright, darkly clad gentlemen. The grandest couples were rejoicing in the Sunday jollifications where to parade in horse drawn traps and gigs was *très à la mode.* It was the living breathing canvas for the important couturiers of the day. Being one of them, and with my fiancée Mlle Jeanne Roger at my side I was obliged to parade among the smart set alongside the borders of rarer specimens of flora in the Bois de Boulogne. There we encountered, beside the lakes and islands and pepper vine foliage, an unusual looking man and woman – he just a little frayed in appearance and she bordering on the bohemian.

The couple were strolling – she followed at a cool distance behind him, as if drawn along by an invisible yarn attached to him with an unseen hook. I recognised the archaeologist Mme Roux and her husband. The mysterious Sonia Roux was known to me through her work in the archaeology commission run by the Louvre in the days when I sat on the museum committee there. Steady large eyes anointed with copper tones flashed at me – once in recognition and then away in modesty. I tried to place her as a painting's subject – from El Greco perhaps? Sonia's husband Serville was a rough spivvish-looking dark fellow with hair that clung in strands, moist to

his skin. Despite such an appearance he was also employed by the Louvre, as an undistinguished functionary.

After formal pleasantries the ethereal Mme Roux stepped into my path, saying, 'Monsieur, I wonder, would your committee consider relics brought back from the Congo?' But her husband cut her short. 'I really must apologise, Monsieur Doucet, my wife is taking her work far too seriously.'

'Not a bit of it,' was my sure response. As a connoisseur of ancient artefacts, I was naturally interested. I turned to the young woman. 'Madame Roux, I've heard of these marvellous finds. I'd be very pleased to see them. If you would be so kind as to arrange a time next week with Monsieur Vuafluart, my secretary? I'll come to the department ... or you might visit us in the rue de la Paix?'

Serville Roux pulled his wife quite roughly back into line. Jeanne was curious as she observed the incongruous couple. After further brief salutations of departure, the middle-aged husband, still within earshot, rebuked his wife. 'Really, Sonia! We must not trouble committee members with museum business on a Sunday. And Monsieur Doucet, too!'

As we turned, looking back at these acquaintances, Jeanne uttered from the side of her mouth, 'What a very queer woman she is!'

I marvelled at how the young archaeologist was able to work at all with that possessive husband bristling at her every move. Had she not been the only child of a renowned archaeologist, the late Professeur Henri Marquet, it is doubtful whether she could have ever followed her chosen career at all.

In my mind, I was *collectionneur*, first and foremost – deeming dressmaker a poor second, no matter how much I was lauded for it. So when Mme Roux arrived at *the House* for a private consultation, I naturally attended as art connoisseur – in fact I had begun my historical collection by decorating the walls of Maison Doucet.

She brought with her, a number of stunning examples of rare Congolese jewellery and a cache of ancient earthenware fragments, which she exhibited quite unselfconsciously.

Although I found her to be somewhere between intelligent and aloof, she was also animated and gay. I considered her beauty. It was more unusual than run of the mill. Attired in simple black with a sparse quantity of ethnic beading, she cut a clean curvaceous silhouette. A small hat only partially obscured hair that curled in a most free and easy manner.

She turned a rusty red pot in her hand delicately as if it were a baby animal. 'Absolutely the most complete of the period,' waxed Mme Roux. At this I could only respond that I was quite bewitched, before we were interrupted by a brusque knock upon the office door.

Crudely interrupting this good humoured meeting, the frightful Baroness de Faucheville barged into the salon office, demanding my immediate attendance. 'You do understand that it's almost time for my eleven o'clock? I trust that the evening gown modelled on the Goya is now ready!' she barked.

I was forced to apologise profusely to Madame Roux and leave the startled archaeologist to carefully wrap and box her relics while I was summarily dragged away.

I behaved well, gracious to a fault, as I reluctantly turned my attention to the ogress, taking her fur and placing it over my right arm, while offering her my left. 'Madame la Baronne, it has been but four days. We must give our seamstresses sufficient time to complete such an important task, no? However, the riding habit is nearly ready. So let us find a dressing area. Allow me...'

The Baroness threw me a disdainful look.

We caught sight of the strutting birdlike José 'Pepito' de La Peña as we made our way to a changing booth. He sashayed around a smiling Sarah Bernhardt, leading star of the Parisian theatre and one of our most illustrious clients. The proficient Spanish fitter commanded attention as did the cravat extravagantly tied at his throat. A tear-shaped pin bag swung from the girdle attached to the waist. In his dance and with a flourish, he yanked forth pins and silk samples, colourful like the flames of many elements. While

brandishing his powerful pair of scissors he judged the steadiness of a customer's nerves. Bold Sarah never flinched in his capable hands.

We also saw Mme Roux in the distance hurriedly departing and I was unable to bid her farewell.

We passed through the attractive waiting area, designed as a colonnaded gallery, and the Baroness wrinkled her nose at the sight of a framed portrait on the wall of Emile Zola. She peered scornfully at the image. 'Really, it's that Jew fancier! I'm surprised at you, Monsieur Doucet! Please don't tell me you're one of those!'

'It's this way, Madame la Baronne,' I continued, pointedly ignoring her remarks. En route to the changing bays I caught sight of a copy of *Le Monde* on a low table. The headline read, AFFAIRE DREYFUS FINALEMENT ANNULÉE – and I privately hoped my client had not noticed it, since Zola had been a notable champion for the persecuted Jewish officer.

'Now, Madame la baronne,' I said, attempting to divert her, 'have we received your confirmation for our Saturday Salon?'

'I'm sure I don't wish to squash you, monsieur, and this is a most delicate matter,' the titled lady replied in less than delicate terms. 'I can no more accept your invitations than have my valet on my arm as I make my calls around the Faubourg Saint Germain... Non! Non! Non! Why, once I stood here in this very room just as nature intended! ... For us to meet socially after that ... well really!'

Now repulsed, especially at the placement of my arm under hers, I escorted her to her changing bay and hung her chinchilla pelt on a coat stand. 'Baroness de Faucheville, ma'am,' I said, carefully lowering my tone, 'I've scarcely seen you in underskirts...' *Good God* ... I muttered. 'It is my staff, to whom you refer,' provoking a trout-like gape from the bloated bully.

My young lady, Jeanne, entered the secluded changing bay and exchanged greetings with the client, with whom she had always been on most cordial terms. The stiff-necked Baroness, now carried away, continued to barrack me with her barbed tongue as I was

trying to make my exit. 'Then I'll put it more plainly... You may keep your beard trimmed as neatly as a Van Dyke chin, but I'd scarcely let you loose on my coiffure! ... Allow me to proffer a little advice. Your establishment enjoys the patronage of the carriage trade, monsieur, but it doesn't do to assume a familiarity that could never be reciprocated.'

I had reached the end of my patience. I snapped to Jeanne, 'Fetch madame's things would you, Jeanne! And be quick about it! The Baroness de Faucheville is just leaving.'

The noble jaw dropped open.

My fiancée returned a few minutes later and railed at me. 'How could you be so reckless? All of this,' Jeanne cried, gesturing to the fine surroundings, 'relies upon your perfect demeanour. She'll not let it go. Every flap-mouthed maid in her entourage will spread it about.'

'What of it? I've had enough of servility – swallowing tripe from tiara'd bigots. Harrumph!' I bellowed, asserting my sudden resistance to the snobbery that I had been a victim of for too long.

'Do you want to be destitute?' Jeanne pressed me.

'Hardly likely, my dear, but I'd rather starve than bow to that!'

Jeanne shrugged hopelessly at my finality.

A little later, in my panelled private office, I gazed at my reflection in the glass above the Baroque fireplace. Jeanne entered the splendid room, warily. She saw me brooding and bade me sit down, which for her sake I did. She took the decanter and poured me a large brandy.

An impeccable lace-trimmed dress was draped over a side table. Thoroughly aggravated, I snatched up the garment, examined it and threw it back down snarling roughly, 'The workmanship is appalling!'

'But where? Where...? It's exquisite,' said Jeanne as she inspected it closely, really perplexed.

I jabbed the material. 'It's fit for the incinerator. Look! Look at it! This silk is not from the Lyons looms,' tossing it aside.

Jeanne carefully retrieved the dress and then began loosening my tie. I pushed her aside as she implored, 'You mustn't allow our

very particular clients to rile you so. It's their endorsement that affords you this wonderful life.'

'I'd like you to return this, Jeanne,' I growled, holding up a medal: *L'ordre national de la Légion d'honneur.*

'No, Jacques! No. You've worked so hard for it. It's your recognition as a great couturier.'

'A GREAT COUTURIER!' I shouted. 'My reputation as a dressmaker! *This* – simply serves to reinforce it!' as I tossed the medal across the desk.

Jeanne attempted to comfort me. 'But you are a designer, a true artist. Don't be provoked by difficult clients. Every business has them, and ...' she said soothingly, adding in resigned exasperation, 'you need their custom. Besides, what's wrong with dressmaking? After all, why do they come to you rather than Worth or Paquin?'

'No matter, Jeanne. The medal is to be returned.'

'No, no. Oh, Jacques I simply can't!'

'Well if you must ... give it to my private secretary. He works every bit as hard.'

'Oh, Jacques Doucet. You can be a stubborn mule!'

'I mean it. Vuafluart certainly deserves it more. I can see it, Albert Vuafluart, *Légion d'honneur.* Can't you?'

Jeanne felt she was perfectly justified in praising my reputation, but she failed to appreciate a permanent shift occurring in my creative aspirations. I was moving away from designing and purveying *haute couture* for European royalty and was frankly wearied by life as a Tradesman to the higher echelons of society – of which I felt I had earned the right to be accepted as a bona fide member. The rebuff to my Salon by the Baroness de Faucheville was just another of many similar poisonous remarks and insults inflicted by some of my aristocratic clientele.

Increasingly I found solace and creative satisfaction, in the art form of collecting, born from the glorious success of Maison Doucet. It funded such extremely costly diversions, and so I was able to adorn the fashion house and my residential rooms.

Jeanne's remonstrations were to be the last of such comments, but the extent to which I was particularly saddened by these circumstances, however, was studiously concealed. 'It is not as if you care, in any case, now that you are deserting us for Nice,' I said to Jeanne, the lady who was due to become my *former* fiancée.

Jeanne gasped. Her eyes were suddenly abrim with tears. 'Don't say it like that, Jacques. If it weren't for Papa's infirmity ... you know I'd never go, and besides, we have agreed. Things have not been well between us for some time now,' she responded painfully.

'Perhaps I should not have said *deserting*,' I added gruffly, 'Goodness, you know I didn't mean it like that... And here we are, out of tune again, falling out over a word,' I said, looking straight through her, failing to notice the tears.

Jeanne threw her arms around my shoulders but I stood stiffly. She appeared hurt and I caught the look and realised her sorrow. 'Oh I'm sorry, Little Cabbage Heart,' I softened, 'I am brutish and a bore. Here, I've something for you.' I reached round to the desk drawer and produced a large boxed item of jewellery. 'Let's call it a part of the settlement I am arranging for you.' I gently pecked her cheek, handing her the box. She opened the casket with a trembling hand. Her wide eyes mirrored the gleaming Art Nouveau peacock-eyed gem set in the platinum necklace she held. She was greatly touched by my generosity but not so appreciative of what she saw as an insistent lurch towards modern design, despite it bearing the *Cartier* crest. Reading her countenance, I grabbed my hat and coat from the stand and made a hasty withdrawal, leaving Jeanne no opportunity to thank me.

Before leaving Paris, Mlle Jeanne Roger sought to make peace with the Baroness, taking tea with the lady in her grand villa on the edge of the Bois. Seated at a satinwood table in a Rococo room of Louis XVI splendour, adorned with carved settees, commodes, cabinets, candelabra and engraved ivory-edged vases, Jeanne proffered her apologies, concluding with, 'I feel so awful about it!'

The Baroness patted Jeanne's gloved hand, 'I'm so glad you've seen

sense, my dear. You cannot afford to become involved with a man from the rag trade. Whatever will become of you if you do? I didn't like to say so before, but some of his opinions are of a very, er ... *peculiar* persuasion. Besides, I know your father will be so very relieved...'

Jeanne felt the pain of this sort of talk, especially as she had always been proud of me as a revered couturier and, I hope, the perfect gentlemen, and ironically it was me who had been so disdainful of my profession. Nonetheless, it was not as though she had much choice about leaving Paris.

Sighing wistfully, Jeanne was piqued by a tinge of discomfort on my behalf, and rather in awe of this society woman, but she was an important ally. Her father had always said so. And although she thought I was a generous and accomplished person, Jeanne wondered if perhaps her father was at least right about remaining on good terms with the de Fauchevilles of this world.

JACQUES SCRUTINIZES THE lie of his hair in the heavy mirror, wondering if he has overdone it with his styling pomade. He calls in the maid, requesting two portions of decorated oeufs en gelée for luncheon; the second for Monsieur Poiret, should he decide to stay. He dwells once more on the hateful scene with the Baroness as just one of numerous rejections.

Glancing at the brothel scene looming over him from the ungainly angle at which it has been deposited, he cringes at the notion of what snobs of her ilk would make of his present predicament. His line of vision flits between the picture and the coal fire roaring in the grate, from the flames of one to the warped fleshy wedges of the other. He ruminates – how the Baroness would certainly have picked over the entrails of this marital feud with her aristocratic *friend of the bosom,* Count Robert de Montesquiou. This notorious dandy, once dubbed 'the greatest wit alive,' was a man who revelled in his own poisonous spite. His greatest targets were those of inferior

status. How he would have delighted in hearing of the couturier's latest discomfort.

Pacing around the room impatiently, Jacques is attracted by the sound of a motor car. He peers through the sash window looking out for Paul. *He is always late,* Jacques recalls. *I suppose this is why they call it the Jazz Age? But then he is such a nice lad.*

He first took on Paul at the behest of the boy's father, whom Jacques had helped by finding a replacement puppy for their family greyhound, which had been killed in an accident. Paul had flourished magnificently in the Doucet workshops, almost too much so. By the time he had moved to a senior position at the House of Worth, it was clear that he would blossom on his own account.

Jacques recalls sending his dapper young apprentice out into the world, advising him to take a pretty wife who would cook and keep house for him and also serve as a model to show off his creations. This protégé's swift success was scarcely immediate competition to Maison Doucet, which was perfectly secure with a clientele that spanned Europe – including the aristocracy, stars of the stage, and royalty. Yet the truly flamboyant Paul Poiret is very much part of the younger set, a new generation of couturiers intent upon making a dramatic splash in the new century, which later on did eclipse the Doucet brand. The rising star has always looked upon his former master as something of a father figure, while the master is never averse to seeking advice from the younger generation – and not least of all now in this present predicament.

Jacques checks his pocket watch before glancing back towards the African masked faces drilling down on him from the painting. He twitches and mutters, 'Where is that young man?'

3

The chief enemy of creativity is 'good' sense.

Pablo Picasso

A S M A L L C R O W D was gathering in front of the inconspicuous and dusty façade of Galerie Vollard in the rue Laffitte, south of Montmartre, for the private viewing of a collection of modern paintings. The event coincided with the unexpected death in October 1906 of the gallery's most illustrious son, Paul Cézanne, whose recent work was represented in the show. There was also a generous selection of bluish canvases by the new discovery, Spanish artist, Pablo Picasso. Proprietor Vollard, bald, gruff and just turned forty, stationed himself at the door, replete with black arm band, to greet visitors.

Among the first to arrive was my exquisitely dapper one-time apprentice, now running his own much favoured Maison Poiret in the rue Pasquier. The enterprising couturier caught sight of me in the company of a young woman browsing canvases painted by the aforementioned Spaniard. He could not fail to notice my recent visitor, Mme Sonia Roux, the singular female with a high medieval forehead and thick black hair. Her attire was unusual and ethnic in appearance, of an Eastern cut, neither typical of Paris fashions, nor finely made enough to be considered *haute couture*. Poiret was curious. He beamed from his moonish face in recognition of me. I allowed him to address me unusually affectionately, for I was often prickly in manner. Likewise I did the same.

'Paul *Le Magnifique!* acknowledging the sobriquet given him by society's rapturous columns. 'How do you do?' How is Denise?'

Paul noded amiably. 'She fares very well indeed. She's making a good little wife and model,' he added with a knowing smirk. 'It's amazing how she's come on since our marriage.'

'Chap,' I said, frowning, as I put an arm on his shoulder, 'we have a modern woman in our presence,' seeing a flash of disapproval in Madame Roux's countenance.

Paul, refraining from asking about her garments, excused himself and begged an introduction to my lady companion. He was duly presented to the archaeologist, whereupon he promptly declared himself a good friend of the artist we were encountering on the gallery walls.

Mme Roux stepped to one side to examine a particularly small but heavily framed picture, labelled *La mort de Casagemas,* 1901. All three of us peered at the searing portrayal of a youthful cadaver of greenish hue, laid out and cast in a sickly yellow light, surrounded by shades of bloody entrails. There was no escape from this pervasive capsule of death. We were all aghast at the sight of the image, not least of all Paul who instantly recognised the subject. 'Good Lord!' he exclaimed. 'Carles!'

'Another Picasso. How extraordinary,' responded the archaeologist.

'You know of him?' asked Paul.

'Yes, Spanish – from the Bateau-Lavoir.' This meeting place and studios in Montmartre actually did resemble a laundry boat and was frequented by artists, actors, and men of letters. I was puzzled as she continued, 'Where the psychic, Max Jacob, has his shed... I attended his séance there just recently.'

I looked at Paul. 'Do you go to these séances, Poiret?'

'Let's say I'm aware of them.'

'Does this account for the ghostly apparition?' indicating the Casket Picture.

Ambroise Vollard joined us. 'Monsieur Doucet, welcome to my *Espagne en Paris,'* and with a small deferential bow to Madame Roux.

'Good evening,' I responded. 'Now come along, Vollard, I'd like

to know, does this stuff actually sell? This for instance ... not a little intriguing?' cupping my beard, pondering the image of Casagemas in his coffin.

'*La mort de Casagemas*. Do you think I'd buy it if it didn't?' said Vollard chuckling. 'As it happens, this is part of the show, but not presently for sale.'

'Tragic business ...' lamented Mme Roux, and quietly added, 'A man now dwelling *on the other side.*'

We each of us scrutinised the picture, even more closely. 'And now the great Cézanne, too.' Vollard shook his head in dismay, touching his black arm band.

'Leaving a considerable void... My deepest sympathies, Vollard,' I commiserated.

'Thank you, monsieur,' the gallery owner replied, solemnly. Mme Roux continued to appear mesmerised, staring at the boy in the casket. 'You're interested in such things, madame? *The other side?*' he asked.

The young woman nodded while continuing to gaze at the image.

'Tell me, Vollard, do you have any Cézannes to offer?' I enquired.

'I wish I did, monsieur. Believe me, I wish I did... The paintings are all sold. But I do have three interesting drawings,' gesturing to the adjacent wall.

I stepped across and peered at the small framed examples, one after another. 'How much are you asking?'

'Well now, that depends. Do you want one, two or all three?'

'Then let's say just one.'

'That will be two thousand francs.'

'And if I take two?'

'That will be five thousand.'

I was puzzled. 'I don't understand. What if I take all three?'

'In total? Let me see,' the dealer considers, 'Eight thousand five hundred francs.'

'You are having me on, Vollard!'

'It's perfectly simple,' the wily dealer explained. 'If I sell you one

of my Cézannes, I will have two left. If I sell you two, I have only one left. If I sell you all three, I will have none... Do you see?'

I smiled knowingly and said, 'I will consider it another day, and not just now at the passing of the great man.' Inwardly I suspected Vollard might double all his prices for particular buyers – a trick he was well-known for.

The dealer's attention was caught by another client. I returned to Mme Roux who was examining the next painting, *La Vie,* showing a group of cerulean figures, including the semi-naked Carles Casagemas in an even weirder composition. Ghostly Carles was embraced by a naked female and accosted by another holding a child – apparently a vision of an imagined wife and progeny he would never live to see. Two figures in a foetal embrace were locked together in the background, adding to the otherworldly atmosphere.

My companion was clearly fascinated. 'This is so very intriguing – and spiritual too, there is visceral power here. What on earth is Picasso doing? It is an extraordinary apparition,' she said, 'and surely we have Carles again?'

Suddenly in the midst of our company, also perusing the image was a young Spanish man with slicked back hair and handlebar moustache above a flat mouth. He leaned right forward, almost crouching to gaze at the brushwork. There were exposed rough edges on the seams of his jacket, in need of the attention of a needle and thread.

'He has a fixation upon this boy, no?' I suggested, addressing the sharp-looking gentleman absorbing the image.

'*Santa Madre de Dios!* I heard this was striking, but really?' the man whistled under his breath.

'One supposes that he and Pablo arrived in Paris together,' said Paul in a hushed tone. 'Casagemas, this boy here ...' gesturing to the cadaver on the canvas, '... also a painter. The two had been close friends in Barcelona, as I understand...'

'They certainly did arrive together. My, this is shocking,' interrupted the man with the moustache. 'Pardon me,' he said. 'It's Mañach ...

er, Pere Mañach. Excuse me butting in...' He straightened up and offered his hand. 'My trade is in young Spanish art.'

Paul and I shook his hand. He bowed to Mme Roux, as she was introduced in her professional capacity as an archaeologist associated with the Louvre and the Musée d'Ethnographie.

'It was *I* who put Vollard and Galerie Berthe Weill onto this painter, as his first buyers,' Mañach informed us. He then responded to entreaties to tell more of the young painter by diving into a curious tale, which he clearly relished in the telling.

'I'd heard all about their arrival, Pablo and Carles that is. They wasted no time in getting onto me. Of course the main reason for their trip was to see Pablo's painting at the Exposition Universelle – representing Spain, no less!

'They were a couple of young clowns, trudging along the smoke filled platform of gare d'Orsay, with a few other Spanish, all just in from Barcelona. They were covered in smuts, loaded with bags, canvases, paints and easels. Pablo was near on nineteen and Carles was about the same.

'Beyond the station, breathing the Paris air after the confinement of the journey, the boys swaggered along the quai Voltaire, full of optimism. They gazed across the dark waters of the Seine to the Louvre on the opposite bank. Pablo shouted, almost jumping for joy, *Hey Carles, over there,* pointing out posters by Toulouse-Lautrec and whole streets bedecked with many more. *See here Pablo!* cried the other, swivelling round, *there're Bonnards and Steinlens everywhere.* You can imagine it was a pretty scene for them – with the sandwich men and fashionable women bustling about on the embankment in their gay costumes and brightly coloured umbrellas and so on.

'Without much difficulty they found a studio in Montmartre, courtesy of their artist friend Isidre Nonell, who was returning to Spain directly. The opportune moment provided them instantly with food and drink, and there were girls hanging around, too ... that's where the problems began.

'They hauled their baggage and paraphernalia up to the rooftop

studio. It was a squalid attic room – small and you might say ... pretty unsavoury.

'Pablo wasted little time boiling up rabbit skin glue on the old stove. He set up his easel and at the same time began preparing canvases and stretchers. A rough canvas, with a little repair work, became the basis for a new painting. Carles soon found a canvas at the flea market, which he began repairing – in his case with some hesitancy.

'Am I running on a bit here?' Mañach turned to our three attentive faces and saw there was no need to ask the question – he was a born storyteller.

'Please continue,' urged Mme Roux, with a slight reddening to her cheeks.

'Using cheap red wine as a lubricant, if you will, Picasso and Carles quickly began planning paintings of their new models. The girls were long haired, giggling beauties, nineteen-year-olds Odette and Antoinette, and twenty-year-old Germaine – who was able to speak Spanish. It was not long before the painters paired off with them – at least Pablo made quick progress with French-speaking Odette, with raw sensuality acting as an amusing channel for communication, shall we say? As for Carles, his efforts with Germaine were in vain. He found himself unable to – er, how shall I put it? – *consummate* his love. It is not clear if it was drink that made him impotent, or impotency that made him drink. So while Pablo made love and painted with equal enthusiasm, Carles just quaffed away!

'I was a frequent visitor to their seedy attic. Their predicament was meat and drink to me. They probably saw me as Pere Mañach, the dealer's runner or chancer, *the sniggler* probably!' he grinned. 'But I saw promise in those bullfighting scenes and they needed me.

'I tell you, I felt quite the cultivated gent next to these bohemians, but they amused me. I arrived one evening and Germaine was posing. She had unlaced her body corset for Carles to draw her but

he was so distracted he could hardly haul himself across the room to get on with it.

'Pablo, at an easel, vigorously sketched the comely Odette, semi-naked, draped over a broken down settee. Another Spanish artist Juan drew Antoinette, fully clothed. By the window, Carles puffed at his pipe and swigged wine from the bottle. I tried to humour him but each time he pushed me away, so I gave up. There was Pablo industrious with painting and indulgent with pleasure, while Carles was increasingly morose.

'Later, things became quite raucous. For my part, a turn with the pipe had made me soporific, or I'd certainly have joined in. Anyway, all were tipsy, laughing and joking as they played a raunchy game, in which the men bet as to whether they could identify the women by touch alone. Pablo was blindfolded, seated on a box. Before him was Antoinette, naked to the waist, her breasts of pink and fawn flesh a sensual feast to behold. Germaine and Odette restrained her arms, laughing as Pablo's hands rose to the level of her navel. The subject suppressed a giggle. Juan and Carles crowded round. Pablo's fingertips brushed her bare skin and very gradually moved up her body. He lingered at the titties, tentatively feeling around them.'

Mañach similarly lingered on the description, quite carried away. 'I can hear his words now, *Angelic flesh, – It's too beautiful!* and then he had to decide. *Okay, Okay, that's... ODETTE!* There were peals and shrieks of laughter, of course.

'*Non! Non! Non!* protested bare-breasted Antoinette.

'Odette joined in with mock sadness, *Zut! Pablo, Non je suis ici. J'ai perdu ma vie!*

'*The connoisseur is delirious,* Juan joked. The faces of two young Spanish friends peered intently through the part-opened door. They were Ramón and Henrika.

'*Regardes, the baboons at play!* the older bearded man, Ramón Pichot, quipped to his companion.

'Pablo rubbed his hands, *Never mind. Next!* Juan motioned to

Germaine to remove her top. She stepped forward, loosening her blouse and undergarment.

'What fine caper is this? Pichot was chortling from behind the door.

'But Carles was shuffling awkwardly, griping, *Pablo, that's enough. You're a barbarian!*

'Pablo heard his panic and loosened the blindfold. *Carles. Carles. It's a game. Come on, your turn. Take the hot seat. Imagine you're in God's heaven.*

He pushed his friend onto the box saying, *Here, I'll put money in for you.* He dropped coins into a pot, swiftly placing the blindfold over Carles's eyes. He motioned to the others to assist. The group gestured to Odette to remove her blouse and stays. There she stood – topless before the boy.

'Christ help me! Carles pleaded.

'O barer of breasts, go to the ardent fingers, beseeched Juan.

'What would my mother say? Antoinette was laughing as she dressed.

'Okay, go Carles, go! prompted Pablo.

'Carles stretched out his hands nervously, touched bare skin and recoiled in shock. *This is ridiculous. A game...? Pollution by lust!* he yelled. Suddenly Ramón and Henrika burst into the attic. *Buenas noches mis amigos!* they cried and began shaking hands all round.

'Carles panicked and jumped to his feet, His face was ghastly white. He shot out of the door like a startled hare. His friend gazed after him with some concern. Odette covered her shoulders and took Pablo's arm.

'What's with Carles? enquired Pichot.

'Germaine was wailing, *he spoils all the fun!* She struggled to dress rapidly before charging out after him.

'It seems that this sort of revelry was anything but helpful to Carles's condition,' said Mañach, pausing in his narration and looking at the attentive faces. He had belatedly realised the un-suitability of his story. 'Oh madame ... my pardon... This is scarcely

suitable for a lady's ears.' The Spaniard nonetheless was enjoying his audience. He was amusing and knew it.

Mme Roux shivered and darted her eyes at the speaker, cutting in tersely, 'Must we women be forever treated as children? I am not offended in the least. Do not desist on my account...' She suddenly stopped speaking at the sight of an approaching figure. Poiret motioned with a fleshy finger to Mañach to change the subject but he did not quite understand.

'Well, the situation was not improved by liquor, or living in abject poverty ...' before a sudden interruption.

The archaeologist's husband, the tetchy Serville Roux, drew alongside. 'Who's this?' he barked, and then turned to Sonia, before an answer could be given. 'Madame, I've a cab waiting,' he carped at his wife, now subdued. He turned to the gentlemen, 'Good evening, messieurs.'

'Good evening,' Paul and I responded together.

'Don't let's loiter, the cab's waiting.' Serville snapped roughly. He rudely whisked her away, hustling her past other customers to the door.

We looked after them in astonishment. *How on earth does she stand for that?* I reflected.

We returned to Mañach's tale. 'So, what was it, señor...? Oh yes, poverty.'

'Yes, truly, from time to time – when funds could not be had from Spain. But such is the plight of young artists, and this is where I came in, I suppose,' continued the loquacious *sniggler*. 'I was outside their door on one occasion when I overheard them. I wasn't sure whether or not to go in. Pablo was arguing, *You're not working, just moping,* that kind of thing. Carles started on his usual tack.

'She makes me insane... She's all over me, and I can't do it.

'Pablo could only question such a possible predicament, *pouting and gorgeous – waxing affectionate and she's in Paris?*

'Carles was so despondent. *Screw Paris! Fucking city of love! It's shit. And I'm worthless.* It just carried on.

'I've seventeen pictures. You've one.

'I can't work. I'm in love. Germaine's upset. Why's it like this?

'You're not doing it for her. And tilting wine into your gullet doesn't help... It's enough to keep any man's maypole down.

'I knocked on the door which was already slightly ajar, making my presence known and Pablo appeared. *Amigo! Welcome back!* He greeted me enthusiastically as I strolled in. This time it was strictly for business, which had been inconceivable the other night, amid the horseplay. I had to show off my most nonchalant air as one does and casually shook his hand.

'You remember Carles Casagemas, don't you? Pablo said. I certainly did and I nodded to him.

'I straight away set out some terms as I leafed through Pablo's canvases. I was struck by the vibrancy of the palette. Spanish reds, yellows and umbers, cobalts and emeralds, all framed with a smudgy black. This was an impressionistic feast and the bristling talent could not be denied. I continued disguising my interest, of course. *The deal is standard in France. It's exclusive. We sign for one year and take all your work for one-fifty a month. And you make five good paintings each month. That's a minimum. Five.*

'And if there are more? he asked.

'Then they're mine, Pablo my friend.

'He turned to Carles and laughed. *What do you think? He gets the lot... Where's my incentive to work like a dog?*

'Easy, I told him, *the more you work the bigger your name – Picasso.*

'Then if you take these, how much advance?

'One month. One-fifty, I confirmed.

'Pablo spat out his response sharpish, saying, *Get lost. There are more than twenty paintings here.*

'I know. So we have a deal? I wanted to know.

'Pablo replied, *I'll be sleeping on it.*

'Till when?

'Till I've been to sleep, he said in his droll way.

'Then Carles chose the moment to ask me if I would represent him too. He brought me a small painting and I asked to see more. I was quite happy to take his work, as long as he produced the canvases.

'He said they were in storage and he would bring them round to me. I noticed Pablo looked sharply at him. So my words were, *Okay. Do that, my friend... Just get on and work harder my boys. You can seek me out when there's more to show!* And I went off chortling.

'As I was leaving I left the door ajar, as I'd found it. Walking away I couldn't help hearing their words. In fact a rumpus broke out.

'*Are you fucking crazy? Turning down cash? We've nothing. No chance of entertaining the señoritas. Nothing,* Carles yelled at Pablo.

'You can imagine the merry fury dancing in Picasso's penetrating eyes. *What was that horseshit with Mañach? Trying to cut a deal... In storage, my lady jane! And I'm not selling up for a hundred and fifty. He can go piss in the Seine.*

'They were, by then, becoming desperate for cash – and, of course, he made the deal with me later,' Mañach told his avid listeners.

'It seemed as though the lad rallied from this moment. Driven on by his lust for Germaine, and with funds sent from home, Carles set up an apartment – a love nest in which he had every intention of providing a home for her. He was not only besotted but also had a dangerous futile hope, twisting his grip on reality. The object of his desire, Germaine, scorned him for referring to her as his fiancée, firstly because she was already married (something she largely disregarded) but secondly because Carles was drinking heavily and still unable to consummate their love. Germaine mocked him when he threatened suicide.

'Pablo needed to act and do something for his ailing amigo. He was uneasy, but with the best intentions, he planned for Ramón Pichot to take the lovely Germaine off Carles's incapable hands.

'It didn't take long before Germaine became flirtatious, teasing and toying with Pichot's full black beard and enjoying quiet drinks with

him, which led to a passionate love affair. This suited Pablo. He made the arrangement to take his suffering comrade back to Barcelona. Pablo and Carles struggled back along Quai Voltaire to the railway station, just as they had done when they arrived three months earlier. I helped them carry their baggage and paraphernalia, and the row continued.

'*Why introduce her to Pichot?* Carles demanded to know.

'Pablo really felt he'd done a good deed. They bickered like old folks. *How would I know he'd goose her? Besides, Germaine's got into your brain,* he ventured to say.

'At this Carles really snapped. *What's this Doctor Freud Picasso shit? How the fuck do* you *know?* he shouted.

'*You've been a bastard since you met her. Why? Because she's just not doing it for you,* insisted Pablo as they reached the gare d'Orsay, struggling towards the steaming locomotive.'

Mañach paused for breath, allowing a couple of Vollard's customers to pass by. Their expressions appeared to harden at overhearing some of the Spaniard's words, but there was no stopping him now.

'And so after their first visit here, they headed home ...' he continued, 'with Pablo promising to get his friend some treatment in Barcelona. Carles trailed after him, resentful at having to give up the apartment ... his plan having been sabotaged.'

Paul and I listened intently, hardly aware of the paintings any longer, but the narrative was brought to an abrupt end by the return of Ambroise Vollard, who seemed to be focusing on prospective sales. 'Have you decided on anything yet, monsieur?' he asked.

'Let me look at those Cézanne drawings again,' I said, glancing across to the other wall.

HOW I WISH I had bought those Cézannes, Jacques muses to himself, waiting in the drawing room for Poiret.

Discarding his spent Havana, he reaches for another but doesn't actually light it, suddenly feeling queasy. Reflecting back to Mme

Roux's fixation on Mañach's every word he recalls how Vollard had drawn him away from the other two.

'Now, on Wednesday we are having a little wake, a dinner in remembrance of the great man,' the proprietor said quietly, gesturing to the Cézanne drawings. 'Would you care to join us, monsieur? And do bring your rather attractive archaeologist too, Madame Roux – that is, if she's not imprisoned by her antediluvian man.'

4

*The boundaries which divide Life from Death are at best
shadowy and vague. Who shall say where the one ends, and
where the other begins? –* **Edgar Allan Poe**

I N T H E E X C E S S I V E L Y moist, eerie cellars at *Galerie Vollard*, on Wednesday night, thirteen places were set for dinner. Inside the poorly lit, unadorned vaults the tablecloth, tableware and candles were of pitch black. Dark foliage dressed the table. A cylinder gramophone filled the sultry air with Mozart's *Requiem: Lacrimosa*.

As earnest guests, fully attired in black, we took our seats as mixed couples. The ladies removed their lace mantilla veils to reveal sombre faces. Mme Sonia Roux and I faced one another. The worsted-clad Henri Matisse and Mme de Bourbon sat to Mme Roux's left. To the archaeologist's right was an empty chair. I had the task of informing Mme Roux that it was for Monsieur Poiret, who unfortunately would be absent. She returned, 'A pity. He caught up with me in the Rue de Rivoli and kindly told me the rest of Mañach's tale – of how the young painters went back to Spain. Do you know...'

Ambroise Vollard took his place at the head of the table, sitting beneath Cézanne's *Nature morte au crâne (Still-life with Skull),* it being the only painting on the otherwise empty walls and the only concession to colour.

Black-attired servants swiftly brought forth tureens of dark turtle soup for the delectation of the assembled party, which was nimbly spooned into black-rimmed dishes. The appetizing aroma helped mask the faint mustiness of the cellars. I recognised a few individuals,

noting in a handsome mirror how washed out the faces of our party appeared within the confinement of the dark sodden walls. It was otherwise an enticing setting.

'Of course Cézanne would take his painting and place it next to God-made objects,' I remarked. 'Like trees or flowers, and if they clashed, he'd declare it *not* to be art.'

'Why would the God of Art need such props?' asked another.

'Curiously,' interjected Mme Roux, 'he often favoured raffia and paper flowers for his studies,' giving rise to murmurs of amusement, 'bringing them to life on the canvas.'

'But why?' thundered a voice from the dark.

'Well, because they wouldn't wilt of course.'

'Didn't you mount his first one-man show, Vollard,' I asked.

'In ninety-five. Not in this building, but here in the rue Laffitte,' confirmed the host. 'Credit where it's due. He made my reputation. I've made mistakes in my business, but not with Cézanne. I fetched a hundred and fifty canvasses from Provence. Best thing I ever did.'

'He wasn't well received then, of course.'

'Absolutely not,' Vollard replied. 'I heard a yell one day outside my window. A man was holding a woman by the wrists in front of a Cézanne painting. She was squealing, *Fancy forcing me to look at that horror... Me, that got a prize for drawing.* And the man, thinking this an excellent form of marital punishment, snapped back, *That'll teach you to be nicer to me another time!*'

The diners offered amused chortles at this but also remarks of disdain, such as, 'How ignorant,' 'Shocking,' and 'So rude,' which were mumbled all around the table.

The congenial host continued entertaining us. 'It is quite true this objector did not belong to the ranks of art critics. But you know it's interesting ... Cézanne himself was critical of his own approach. He admitted that his scanty knowledge thwarted him, declaring that he failed in the art of separating planes – of giving the illusion of distance.'

Movement heralded the arrival of a maid serving an exotic entrée of caviar in cuttlefish ink, with the blackest of rye toast.

'Ah, we've black food too!' exclaimed a delighted Mme Roux.

'You may find the creole curry will not be so black,' a man with a resplendent brown beard informed her. She recognised the gentleman behind the impressive chin brush as none other than Monsieur Matisse.

'Just wait and see,' said Vollard. Then quietly to Mme Roux, he added, 'I hope you're partial to venison, madame.'

'The young pretenders will struggle to fill the master's shoes,' I declared.

'There are many trying them on!' replied Vollard, gesturing towards the thirty-seven-year-old Henri Matisse, now one of the most sought after painters in Paris. The artist grinned amiably through his large round-rimmed glasses. He felt all eyes upon him. 'Not sure if I qualify as a young pretender, but we Fauves were once feared,' he said, swinging a plump black cherry to his lips.

'There's Henri Rousseau. Ha ha!' came a voice from the other end of the table.

'An accomplished spirit medium,' added Mme Roux.

But scarcely a new generation, thought I.

'Now, Monsieur Matisse, you are rather too modest, especially after your sensation at the Indépendants.' Vollard continued. 'How quickly the Steins snapped up *Le Bonheur de vivre.*'

'And buying works by your Spanish protégé,' I said to the host.

'I hear Picasso pulled a pistol on some critics besmirching Cézanne,' he replied with a note of approval.

'Young hooligan!' exclaimed Matisse.

'I gather the gun came from Alfred Jarry,' said Vollard, who was acquainted with the French Symbolist author of *Ubu Roi.* 'A noble figure in the world of letters; though very poor and quite mad. When cycling from Paris to his summer residence at Corbeil, he would fire his revolver to alert absent-minded pedestrians.'

'Couldn't he use a bell?' a shocked lady asked.

'Once he fired into a hedge and a woman jumped out shouting, *Sir! My child is playing here, and you might have killed him!* Jarry

replied gallantly, *Madame, I would have given you another!'*

'Disgusting,' exclaimed one of the ladies.

'Cézanne was rebellious too, you know,' continued Vollard. 'Manet had no time for him, saying he painted with a bricklayer's trowel and described his art as *the counterpart of the foul-mouthed man.* Well, Paul wasn't cowed. When asked by a colleague if he was preparing something for the Salon, he simply retorted – for the benefit of Manet, standing within earshot – *Yes, some nice dung!'*

Laughter and objection followed in equal measure.

'To rebel artists!' proclaimed Mme Roux, rising from her chair and holding up her glass. 'Let's toast the master, Cézanne!'

'To Paul Cézanne!' the cry went up, with a clinking of glasses. As the meal progressed the conversation loosened further.

'And when we stayed in his lodge, he just painted Sainte-Victoire again and again and again... My dear fellow, it was like watching paint dry,' chuckled Vollard.

'Beware, monsieur, he's watching you,' Mme Roux cut in, nodding to the skull painting on the wall behind him.

'Nonsense and fiddlesticks!' said Vollard, eyeing the image with a quick backward glance. He had very little patience with ideas of the supernatural. The guests continued with much chatter.

When the black gastronomic delights had been devoured and the unguent port expended, the serious minded Henri Matisse had a suggestion to make. 'How about we make a pilgrimage to a location important to Cézanne? He resided in various parts of the city.'

'Rather!' chimed in a number of voices. Vollard, too, was charmed by the idea. 'It would be fitting to make our way to the rue de Saules,' he suggested. 'It's rather a hill, but not far and the site of his single streetscape of the city.' At which point he took to his feet with a flourish and announced he would lead the half-dozen interested diners. 'Those who care to continue, please be my guests – while we make our little trip to Montmartre. In the meantime, the rest of you help yourselves, my dears.' Vollard thus withdrew, taking Matisse and a number of men folk with him.

Those of us who remained cast about for an after dinner diversion. It was rumoured that Mme Roux, if pressed, was able to oblige with a parlour game of the most extraordinary kind. We began forming a group around her. The maid was clearing the table, leaving only drinking glasses, ash trays and two large candelabra. A tentative request was made for a spiritual demonstration.

Mme Roux looked at me in order to gauge my opinion. I beamed with a smile that she interpreted as encouragement. The depleted group appeared captivated by her, as she busily moved aside the remaining items to clear space on the black tablecloth before her. Speaking in hushed tones, she said, 'If you have a token – a talisman – formerly associated with a relation, or friend now departed, then contact *on the other side* can be sought.'

'Do you mean a personal effect of some sort?' asked a young lady with hair waved in the modern style, clapping excitedly.

Mme Roux nodded in the affirmative.

'Could you? I've something,' offered the perfectly attired Mme de Bourbon, thrusting herself to the fore. She handed over a diamond encrusted gold bracelet for the demonstration.

Mme Roux placed it on the table and stretched her arms forward with upturned palms. 'Sisters. Brothers. I raise my palms to the eternal presence of the departed.' She spoke in hushed eerie tones. *'Mors enim est vitae essentia,'* meaning death is the essence of life.

The Medium closed her eyes, lowered her head over the bracelet, muttering under her breath for some moments. She was without doubt effective in her ability to create a spell. 'You are a lady of high connections.' The spirit guide looked to Mme de Bourbon. 'I'm hearing the call ... that of a woman ... from central Europe... I'm sensing Austria-Hungary. An aunt or ... mother. This person has dark hair, curled around her face. It would've been dark in life, but grey before her passing. She loves gardens ... lived her life out of doors... She is concerned for you.'

A woman alongside Jacques and opposite the strange performance broke the moment with a cry. She swooned and was revived

by a guest with smelling salts. Mme Roux's eyes widened and she breathed heavily.

'It's Isabella. My poor mother,' cried Mme de Bourbon, falteringly.

Mme Roux's expression showed intense concentration. 'She assures you that dying is not the end. The pain at her demise seemed ... atrocious, but it was really nothing. She wants to prepare you for passing over.'

'No. No,' whimpered Mme de Bourbon, gasping. Her neighbour began crying quietly.

'Do not fear! *Your* demise is not imminent, but she wants you to know ... you have earned a happy death,' she reassured her subject.

I was entranced by these proceedings. After a second consultation had begun, I left the cellar to fetch something from the gallery and reappeared some few minutes later with the small framed coffin painting, Picasso's *La mort de Casagemas*. I stood watching, spell-bound.

Mme Roux had broken her connection for simpering Mme Lepine and appeared to be having difficulty. 'I'm sorry, this artefact has not strong enough provenance with the subject,' she said to the downcast inquirer. 'You will have to try on another occasion with something else,' she concluded, handing back a handkerchief.

I put myself forward, showing her the painting. 'I'm curious to know more about this. What can you tell me, madame?' I probed, addressing the Medium as I placed the painting of Carles Casagemas in his casket on the table before her. She reddened, quite shocked at its appearance. 'A test, monsieur?' she asked.

'Not at all, madame.'

'I cannot. What of Monsieur Vollard? This was hardly what he meant when he said to help ourselves.'

'I will take responsibility for the reaction of our host.'

'But you are trying to throw me.'

'I am genuinely interested in what can be done.'

With a defiant glance Mme Roux swayed over the picture studiously. 'Come spirits. Speak with us... Come spirits...'

During a prolonged pause, glances danced from one expectant face around the table to another. Mme Roux with eyes closed, plunged her hands through her fine hair in an abandoned fashion causing it to stick out at odd angles. She was rapidly losing awareness of those around her. '... Yes, it's a young man ... Carles. He is an artist,' she said, looking at me. 'No, a poet!... Both I think,' closing her eyes again, grimacing. 'Two boys, Carles ... and his Spanish friend.'

She suddenly looked towards me again, but straight through rather than at me. The assembled company was feeling horribly damp. Beads of sweat were brimming from every pore. With the mounting tension, a prickling sensation was felt by each onlooker. I noted the glistening faces straining with concentration.

'There is a railway ... two young men trudge along the platform alongside a steam train. They struggle aboard with luggage... No. No... It's a bullring... Yes, a bullring!...

'There is a great spectacle. A crowded arena glows in the evening light. Banderillos and mounted picadors wait. The matador prances in, in splendid regalia. The bull is convulsive ... The bull rages towards him!

'In the terraces, the artists, Carles and Pablo ... and their friends, shout with the crowd. Pablo sketches furiously.

'Everyone is cheering. The bull is puncturing the matador's cape! ... Ahhhhh!' the Medium cried out, and flinched in her seat. She squirmed for a few moments lost in the connection, unable to communicate.'

With difficulty she resumed her strained dialogue. 'The matador is roaring. He is God-like to the crowd, displaying his bloody kill. The crowd is roaring too ... such a roar.'

As Mme Roux continued, the five around her became more deeply transfixed by the psychic connection.

'In amongst the audience Pablo starts packing up his pastels, boards and easel. Carles ignores his friends and watches the bloodied bull, bristling with knives. Now the horses are dragging it from the arena by its tail! One of the gang is taunting Carles.'

The strange woman started to take on another deeper, more manly voice – that of Carles. *'My friends taunted me... That hot-arse she-cat fucked off with Pichot...'* She imitated anguished Carles again. *'Bastards... They were cruel... I was driven to drink... My fury.'*

We were all transfigured with shock at the intensity of the young woman's strong language. Indeed, she was suddenly a weird phenomenon to behold. One side of her face was ash white and the other flushed crimson, her hair a bedraggled spectacle. She was in fervent full flow. The women present fanned themselves excitedly.

'Carles heads towards the exit, to the tavern above the gateway. The others follow. Pablo and his raucous friends enter the bar. Carles is drunk, holding a glass to his cheek. They mock him. *I lost my temper...* One of the friends makes an obscene gesture. They are laughing madly!

'Carles hurls a wooden chair across the room. It catches Pablo's heel. He is hopping in agony. The barman grabs Carles by the lapels and marches him through the door. In the skirmish the drunken one falls. He is cascading down the iron stair!

'I fell... They panicked,' Mme Roux shrieked in a weird low register. *'Pablo tried to revive me, as I rolled in the gutter quite done in,'* she continued, flipping again to Carles's agonised voice. *'No more painting,'* yelling, *'TELL HIM NO MORE.'* She threw her head onto *La mort de Casagemas* ... *'HE'S A MONSTER ... KILLING PAINTING!'*

Mme Roux was dizzy, almost fainting with exertion. She lay for a moment, then swayed with her head bent, just an inch from the table, her long hair swishing back and forth. Guests were shocked and moved back abruptly. I jumped to her aid.

'Come now, madame. This is too much. I should never...' I began to say as we were interrupted by loud banging on the doors upstairs. I grabbed the painting and handed it to one of the guests. 'Here. Quickly. Return it, will you? It hangs alongside the self-portrait on the left-hand side of the gallery.'

I spun around to attend to Mme Roux. Heavy banging at the entrance persisted and the strident voice of Serville Roux struck our ears. Guests withdrew from the circle muttering amongst themselves.

'Madame! Madame! ARE YOU IN THERE?' he shouted at the top of his voice.

'What the deuce?' I exclaimed. The erstwhile Medium leaped to her feet, shaken.

'Quick! Is there another way out?' she implored, panicking. I pointed to the adjoining cellar and swiftly escorted the alarmed woman into the darkness, while her husband's angry shouting and banging reverberated with ferocity from above.

Making our way through the musty cellars, we clambered over all manner of decrepit encumbrances in the dark, marking and snagging our attire, before reaching a service stairway to the outside. Serville Roux was trying to force entry at the front of the building, just as we emerged into the rear courtyard. The distinctive shrill voice of the angry husband cut the air. 'My wife is there!... Let go of me, man, before I set the police on the lot of you *MADAME ROUX!!!... MADAME ROUX!!!...*

I strode along angrily, throwing down my cigar. Sonia Roux hastily followed. I turned to her, enraged, 'What kind of witchcraft would you have us dabble in?'

'Well, I like that! You encouraged the demonstration!' she protested crossly, but still followed, as I increased my stride marching to the carriage. Coachman Chivet was startled from his snooze. I rapped on the door, before jumping in with little ceremony. Mme Roux struggled in behind, breathless and flushed. Highly agitated, I leaned out of the window and shouted to the coachman climbing up to the box. 'Crack the whip, Chivet. Rue de la Paix!'

The horses jerked forward and the carriage manoeuvred its way from the courtyard to the side street and gathered pace into the night. I paid careful attention at the window, for fear of being spied upon by a pursuer until it was clear we had got away, sitting back brooding with occasional quick glances at my silent companion.

As the carriage proceeded I addressed her. 'I want you to promise me something, madame... Do not recount the details of your divine inspiration. I was foolish. I had no business taking the painting from Vollard's exhibition. I fear we were all a little carried away.'

Mme Roux was unsure how to respond. She smouldered silently. I began reproaching myself for my startled overreaction. The silence was becoming burdensome. 'Madame. Please. Forgive me. Now that I can reflect upon what has happened tonight, I blame myself. It was I who fetched that painting...'

'It was *you* who entreated me to use it!'

'I know. I apologise. It was hardly a seemly way to carry on and now we may have a full-scale scandal on our hands,' I groaned.

As we approached the place de l'Opéra my unexpected accomplice voiced a concern. 'It'll not be prudent for me to arrive at the rue de la Paix – or to go home just now, Monsieur Doucet. Would you be so kind as to ask your coachman to drop me off at the museum? I'll take refuge in my workroom.'

I knocked with my cane. The carriage drew to a halt. 'Musée d'Ethnographie, the Trocadéro!' I to shouted up to Chivet from the window. We made our way to the embankment and crossed the Seine at the Pont Royal and past gare d'Orsay, silhouetted against the indigo sky with a glowing gibbous moon behind – the point of arrival and departure of the Spaniards we had been hearing so much about. I contemplated the tangled web in which I found myself. My former fiancée had left and gone to live in Nice – more than a day's journey-time away, even by the railway – and I was now consorting with a young married woman and by proxy an irate bullying husband.

We reached the Palais du Trocadéro and alighted. 'Where is this place?' I enquired, imagining an office in the vicinity.

'Here. We are exactly here.'

When I realised she meant actually inside the Trocadéro building itself, I was astonished... I firmly insisted upon accompanying the archaeologist to her sanctuary, wherever that might be. She was

grateful. The deserted palace was an ominous monument for shelter, a bizarre prospect, even for a lone woman fleeing danger in the dark of night. I thought, *either she is very desperate or her taste for adventure knows no bounds.* I instructed Chivet to go off and find rest for himself and the horses. As the weather was set fair, I could return to Maison Doucet alone and on foot, or pick up a night cab. The great fountains were stilled just as time seemed to be. For now Madame Roux and I were surely truly alone. We looked upwards. The structure before us loomed gigantesque in the moonlight.

I again reviewed my situation, reasoning that I was with a damsel mistreated, if not in distress. I paused briefly to observe the scale of this great monument. If we were going to walk from the gates it would be a considerable distance. 'You would never think this great *palace* was designed to be a temporary vision would you...?' The illusion is quite to the contrary,' I said as I considered its form – exotic and yet classically inspired.

'What period and place does it put you in mind of, monsieur?'

'Moorish or neo-Byzantine?' I responded dubiously. The fakery of the pastiche prayed on my critical eye. I sought an answer in Mme Roux's closed expression. *What kind of deception or illusion is she a party to?* I wondered.

The palace, containing a large concert hall with two wings, each topped by towers, had been the focal point for the great *Exposition Universelle* of 1878. It provided impressive exhibition space and had been made from a fibre-strengthened substance with the look of marble that could be moulded into shapes to become the great murky white elaborate façade before them.

I noted how even in the dead of night, and in a moment of matrimonial crisis, my companion chose to speak of architecture. Yet her animation was delightful. 'The builders mixed natural ingredients to create an innovative material – a sort of viscous concoction. I've watched them do it. Once it's dry, they nail and hew and saw it, so as to create such things as this vast wedding

cake,' she rattled on. *Is this her attempt to keep me at arm's length or invite me into her world?* I asked myself.

'I assume they used the same approach for innumerable other buildings in record time for the Exposition?'

A lock of hair had fallen across her forehead. I had an urge to stroke it back into position. She pointed out the central portion of the Palais du Trocadéro, identifiable by a circular dome. It was difficult to gauge the size. *Could it accommodate five thousand Clarabelles?* But I felt instantly foolish for the childish analogy. I had since boyhood counted space in *Clarabelles* or cows. Clarabelle was Papy Antoine's cow. *How unmanly!*

I reappraised the measurement of the building, five stories high – flanked by the two domed towers in the minaret style. I had attended concerts here in the Trocadéro's Salle des fêtes at the time of the great exhibitions. *Oh I would enjoy the company of this astute companion if she would attend such events with me.* And then I felt a little guilty at the thought.

The symmetrical crescent accommodating great galleries and balconies was so majestic it still impressed me. *But where in the name of Jove is the mysterious Sonia Roux taking me?*

She answered my unspoken question. 'The old quarries beneath us here house stock for the ethnographie. I have keys.'

As we made our way around the courtyard, the archaeologist explained that the Champs de Mars, a short distance away on the opposite bank of the Seine, provided additional exhibition space. The Trocadéro had a greater purpose in housing treasures acquired from France's ongoing colonial expansion. These were shipped and then transported across the landscape of *l'hexagone* to the capital in a never-ending stream. The resultant massive acquisition required much storage and sorting.

The bulk of these artefacts were held in the vaults of the Trocadéro where archiving and conservation was required. It was in this capacity that Mme Roux was employed, and provided with her own workroom. Her experience in archaeology and her quick

intelligence had equipped her for a senior role in handling the objects from all four corners of the Empire.

We finally reached a discreetly placed servants' entrance to the building. She turned the key and with unnecessary stealth we stepped within, switching on a low-level electric light. Both of us were now much calmer and she told me of her fears regarding the wrath of Serville. 'I'll not face him at night when he's like this.'

'And in the morning?'

'He has an important trip, which will take him away from Paris for three days – leaving early tomorrow – and no doubt deal with *me* upon his return,' she sighed. 'The good thing is he doesn't entirely mind my working, you know. It's consorting with so-called Undesirables that drives him to the brink,' she explained, fumbling a little as she sought a light in the first of the great reception rooms. We crossed immense cold floors of white Carrara marble. Each footstep clapped loudly announcing our presence. She lit an oil lamp and switched off the electric lighting. The lady had lost the black mantilla from the banquet long ago and her hair swung freely. The loose lock still played across her brow.

Nearly twenty years later I still recall the night vividly – that face shining out in the auric light like that of a heavenly being. She carried the lamp carefully, leading me through a series of dark corridors, across great walkways, taking me down a spiral staircase to the storage of artefacts in a series of brick-lined barrel-vaults below. I gripped the iron handrail with apprehension. *How is it that I'm transported to such a circumstance?* We entered a world of plunder, heralded by a pervading stench of muskiness emanating from innumerable animal sources – a mingling of ancient rush work, desiccated skeletons and skins – and an undertone of something completely unidentifiable.

Holdings of shelves were stacked from floor to ceiling with musty carved effigies, masks, dolls, costumes and sculptures, but they were only partially accessible. It was as if tunnels had been hewn through the great reserves of relics. Dust enshrouded the neglected treasure-trove of ancient and primitive artefacts. Ramshackle piles of relics

left little space to squeeze by. A wall of perfectly wrought Egyptian figures, inscribed with hieroglyphs emerged as my guide lit a second lamp. My searching eyes swept from item to item, from spear to mask, from carving to animal skin, utterly astonished. 'Good heavens, madame! What's this? *La grotte d'Ali Baba?*'

'There's a room this way,' indicated Mme Roux, leading the way. 'The force of magic down here ... is palpable.'

'Treasures with mysterious auras...' I declared, eyeing the piled up artefacts. She stumbled, disturbing an army of spears, which clattered all over the place. I caught her arm. 'Steady, my dear. Or we'll have the whole caboodle on top of us.'

'Ooh! Thank you, monsieur,' she exclaimed, regaining her footing.

I was absorbed by the cornucopia of strange and exotic treasures. She picked up a flute and joked, 'I am the Nile goddess of Buto,' pretending to play the instrument.

In my mind's eye, conditioned by the copious quantities of wine and port and the eerie environment now enveloping me, Mme Roux was transmuted into a black woman in silhouette, surrounded by snakes, one wreathed around her shoulders. She stood naked on the edge of a jungle river, against a clear sky and full moon. Only the whites of her eyes and pert nipples were prominent. One snake reared up in response to the pipe. Within seconds the apparition dissolved back into Mme Sonia Roux in the vault. She removed the flute from her mouth. I trembled. It was as though I had been transported into the great jungle canvas of a snake charmer by the old customs man, Henri Rousseau, which I had recently admired at the Salon. *Was this woman some kind of enchantress?*

'Whatever is it? Are you alright, monsieur?'

'I'll not leave you alone here. It would be unthinkable,' I reassured her, fearfully.

'It would be unthinkable for you to stay with me!' she returned. But there was something in her tone that suggested she was not really against me doing so.

'Does your husband visit this place?' I asked, in spite of myself.

'He knows of it, but he usually waits for me above ground.'

As we squeezed through the narrow and cluttered space an artefact crashed down behind us and Mme Roux lurched into me. It was a stuffed creature, a great thick-billed crow and largest of the corvid family with wings rigged at full span. I caught the lady. She trembled like a bird in my grasp, her breathing was rapid for a moment.

'What demon was that?'

'An ungainly fowl, tapping on my head!' she shook herself giggling.

'Ah, the ominous bird of yore ...' added I, recognising her citation from Poe's *Raven*.

'*Nevermore!* Giving me a fright like that!' She chided the fallen relic and then laughed again, embarrassed to have been held in a form of embrace.

'I must apologise for my foolishness, monsieur.'

'No, please don't concern yourself. It was I.' My pulse quickened. I would never compromise you, madame ... not intentionally.'

She straightened her ruffled black gown, in a sudden shy motion, and stepped backwards, picking the beast up, smoothing its black feathers gently, a few of which were dislodged and fluttered to the ground. I scooped them up and quickly concealed them in my coat pocket, not wanting to draw attention to the deplumation.

Feeling very drawn to her, I searched for words. 'I think he scarcely knows you – that oaf of a husband of yours,' I said, observing her for signs of any adverse response to the disparaging remark.

'Please, monsieur, I prefer not to speak of him.' But the glance had been neutral as if suggesting accord. It seemed she refrained from verbalising her true reaction.

'Do you suppose you can stay here?' I asked.

'Of course.'

'So whereabouts can you sleep, pray tell?' I queried, glancing about.

THE TINY WORKROOM with its raw brickwork and assorted tinctures and tools was graced with a workbench, a pair of high stools, a

number of oriental rugs, felts and cushions, and little else. Various knives of differing sizes were hung above with delicate instruments, glues, resins and formaldehyde.

Mme Roux looked for a moment as if unsure of how to proceed regarding sleeping arrangements. She crouched upon a rolled-up rug with her hair ruffled and blouse open at the neck where a button had been lost. Sometimes conscious of this she held her open collar closed for the sake of propriety. 'This will do for me,' she said after a pause, shaking a fringed eastern mat, woven in myriad colours, onto the floor.

I saw her hesitate as if not sure of my next move, and I thus interjected to save her blushes. 'It is not as if we both need to sleep at this very instant. I shall keep watch.'

'Thank you, kind sir. That is most gallant.'

I moved a morsel of old carpet to another less cluttered corner. I propped myself up, a little awkwardly, in a seated position and then added an arrangement of a roll of thick felting at my back. My usual immaculate attire was now dusty and dishevelled. I was by necessity an outrageous dandy and so fastidious about my appearance that I would, for instance, routinely send my shoes back to the makers in London for polishing. Now they were mud splattered, my spats soiled and necktie loosened and displaced. Here, a butler was not to hand. *My former fiancée would never have seen me like this – Jeanne would be quite appalled.*

We rested some distance apart, ranged around artefacts as if in front of a fire. In fact it was near freezing.

I wondered again, *how have I got myself into such a predicament?* I could hear the scuffling of rodents and the tossing and turning of my companion. After what seemed an interminable period I heard Farcot's conical pendulum clock, housed in the pavilion of the grand vestibule of Iéna, chime twice with lusty solemnity. *Is it quite in tune?*

Mme Roux suddenly sat bolt upright. 'It's no use. I cannot sleep.'

I relit the lamp saying. 'I see this is going to be a long night.'

The vapours of our breath could be seen in the eerie light. She held my silk-lined jacket around her shoulders. Even this felt chill against her skin. I had been glad to offer it, since I was untroubled by the falling temperature. Meanwhile, I noticed her teeth chattering.

'So tell me,' I asked, unable to restrain myself from dwelling on her explorations of *the beyond,* 'how much did you know? Your little show quite took me in... Do you have any recollection of what happened during the ... Channelling ... is that the term?'

She hesitated. 'You mean, when the subjects speak – through me?' She shook her head, perhaps a little unconvincingly.

'You might have been surprised if you could have seen yourself.' I thought about discussing her performance further. *It could be like waking a sleepwalker while in progress and perhaps dangerous,* I imagined, and so refrained from pressing her too strenuously. 'I have to confess, I was amazed at the extent to which you could take on the personality of another. Tell me more. Do ...'

She cut in, 'Pray, don't quiz me, I must make sense of it myself.'

'So that you may think up further tricks?' I scoffed, reverting to my previous testing stance.

'Of course it's all amusement to you. In fact it can be a real strain. Having made contact, the dead pester the living forever after – to give them new life you know,' she answered, blithely ignoring my scepticism.

'You, madame, are quite the artist,' I answered marvelling at her.

'Now my reputation is quite ruined you may as well call me Sonia!'

'Then perhaps we might dispense with formalities and you call me Jacques?' But by the turn of her lip and the sparkle of her eye I detected that she had been joking and so felt embarrassed. 'I mean of course only here,' I added quickly, 'since we are stuck in this place for the duration.'

The night wore on and we changed positions from time to time, gradually slumping with weariness. Little by little I grew to realise that the gnaw of cold had bitten into me. I intermittently reactivated the flickering oil lamp, for comfort and so that I could watch her

with greater ease – stretching, animal-like as she did. We might have succumbed to sleep but we gradually grew tired of trying. It was impossible. We exchanged anecdotes and recollections, of childhood days, early privations, summers past, visions of favourite pastimes and places. I talked of my early pleasures, of helping Papy Antoine with the pigs, and of the joy of painting, creating imaginary worlds of my own in watercolours. 'I had bold ambitions of being an artist,' I said, with a trace of regret. 'Forever searching for that evocative scene, wandering restlessly with my paints and easel – before, that is ... before I promised my grandfather ... I would take on the family business and make it flourish as a house of couture... What diversions filled your time ... Sonia?' I asked, thrilled with the naughtiness of saying her first name aloud. She surely dwelt upon the strangeness of it too.

'You'll laugh but I spent a life out of doors too – when I could. I adored clay. My cousin and I would locate gault clay in the most waterlogged areas of the heath and dig it up. I used to make model animals and fire them... The peak of my artistic career I confess.'

I was amused. 'A woman of the earth I see. But I never had you down as a sculptress.'

'Mon père was an archaeologist, of course, although he spent most of his time in Persia.'

'Did you go there with him?'

'Once or twice. He was steeped in ancient Buddhist studies, but I was too young to really appreciate his work *then.*'

'And now? You pursue Buddhism too?' I asked, and my interest quickened at her nod.

'I learned Greek. Later I became involved in Papa's work.'

I was intrigued by this erudite young woman with interests in things spiritual, Greek, Persian and Buddhist. *What else engrosses her?* I puzzled.

'With your fashion house, and art collecting and committee work with the Louvre ... there can be little time for recreation, monsieur ... Jacques?'

'Lately I have begun collecting first editions of great literature.'

'You mean novels, poetry – and such like?' She asked eagerly.

I nodded, appreciative of her attentive smile. 'And it seems you are familiar with the Baudelaire translations of Poe?'

'Indeed so ... *his words into my bosom bore,'* she cited, half jovial, half coy.

'Ha! I shall call you the Mystical Raven!' said I, focusing on her jet black locks.

The tension of playful flirtation sustained us through the long hours. '... So it was Grandmamma who told me I might have The Gift,' Sonia reflected, 'and counselled that I should use it sparingly.'

'You have *something,* it is true. But perhaps I am an ignoramus and you are gulling me.'

'What do you mean? Faking? It's not an easy craft, or a choice!'

'Perhaps you play with me as you like? I probably wouldn't know it.'

'Hmm. I see you doubt my art... So be it.'

'I do not know you ... yet...'

Time was running out. 'The light will be upon us when we depart this cavern,' whispered Sonia. We pondered what might be between us. I saw her shivering increase and then could bear it no longer.

I patted the blanket. 'Come ... we can use our own heat to help each other. What use is decorum for decorum's sake?'

She was shocked at this inference and then laughed with gusto. 'You are very amusing, monsieur.'

'Not really. It is a simple arrangement – just a practical exchange.'

But then she seriously considered the offer. It was a raw, acute, drawn-out moment. Sonia looked at me critically and held herself back, but I was incredulous to see her then crawl the few metres across the floor to my side. I hesitated almost imperceptibly and then drew her in, cradling her in my arms. 'We are like lovers now,' I whispered, unable to resist laughing with nerves.

'Forsooth! No, no. We are not!' she checked me. 'We are two cold beings clinging together for dear life, *only!'* But indeed she clung to me as if I were a raft at sea.

I thought of the hundreds or perhaps thousands of women I had seen, seemingly sculptural on pedestals, as dolls for dressing, in their various stages of undress. Yet here and now was one actually between my arms – warm and real and lovely. I was not interested in stuff and cloth, her pleats and frills, just the profound sensual pleasure. It was indeed a moment of heavenly blissful abandon to feel her warm body against mine. She was indeed lovely to me.

There was a moment in the midst of this *warming* when our lips actually did seem to brush momentarily against one another. It was undoubtedly a moment containing the thrill of adventure, but so very fleeting. We both would reflect on whether this touch had actually happened for a long time afterwards. I sensed the pull of danger and the change engulfing me. *Can the straightjacket of my milieu ever allow this?* I wondered nervously.

'Will you find a cab for me?' she asked.

Composing myself, I straightened my clothing and prepared to leave.

I saw that she still had on my finest dinner jacket and said nothing of it. 'So be it, oh Raven,' laughingly, I groaned. 'What a moment to fly away! You really want a cab?'

'For now, Jacques,' she nodded, with an enigmatic smile.

5

*Blinding ignorance does mislead us. O! Wretched mortals, open your eyes! – **Leonardo da Vinci***

HIS GREAT HEAD is graced by an embellishment of impressive swan-white curls creating a most perfect full beard, so well-coiffed that it flatters rather than ages the noble countenance. Yet Jacques awaits the arrival of Paul Poiret in torment over his predicament – his long legs are stretched out, his feet up upon a chaise longue, with the velvet upholstery protected by a coverlet. He savours the aroma from a brandy snifter as he takes a small sip of the poyent liquor and awaits its medicinal effects.

His thoughts turn to 1924, one year ago when he relieved the artist of his masterwork, the monumental whorehouse now towering over him in his wife's drawing room. He remembers what had then seemed an immense coup.

It was André Breton, he reflects, the *Young Tiger* who deftly engineered the conquest. Jacques feels awkward about the moniker, thinking of the group of advisors he employs, of whom Breton is chief. *Why do I call them Young Tigers* he chides himself, the rippling and prowling specimens – though they are? *Little wonder they ridicule me.*

That Jacques is consorting with the leading Surrealists may be the reason why the now elderly gentleman remains so youthful in spirit. These radical Tigers are not only maverick and mischievous, but also educated young men of letters with their fingers on the pulse of the avant-garde, and perfectly capable of presenting themselves respectably when necessary. Though Jacques, for the sake of

discerning fine taste, willingly sets himself up for derision in their midst, he invariably benefits from such company. Employing the Tigers, for years in some cases, has worked both ways. Ultimately the connoisseur gains brand new *artworks,* in the form of letters he constantly beseeches them to write to him, as well as insights into a rapidly changing cultural milieu. And as is frequently averred, 'Jacques Doucet and new art...? Well he finances Surrealism!'

THE INTENSE AND forthright André Breton, the so-called *Pope of Surrealism,* with his dreamy hooded eyes and substantial intellect acted as both my principal art advisor and librarian for my burgeoning Bibliothèque Littéraire. It was Breton who had thoroughly commended the giant *problem* painting and brokered the deal with its creator, Pablo Picasso. Although I had previously considered buying the work, *Les Demoiselles d'Avignon,* as it had been named, I remained to be convinced that it would be a sensible acquisition. I meant to make the purchase, if I could, but given its unseemly content I needed others to stiffen my backbone.

'Picassos will determine the nature of the collection,' exhorted Breton, with keen intensity. 'Whether it is exciting or not, rich or poor. It is an extremely critical choice. *Les Demoiselles* is the first work of Cubism,' said the poet, who was a principal theorist of the new Surrealist movement. 'Cubism is a pioneering voyage into the painted unconscious.'

'But will it endure?' I persisted.

'Forever, Monsieur Jacques,' asserted my advisor, 'and it should endure here in France. Picasso believes that if he sells to *you,* his magnum opus will one day reside in the Louvre, side by side with the Douanier Rousseau's serpent painting.'

'He knows of my bequest then?' I asked, caught by surprise.

'Of course! Half of Paris is agog.'

'And *Les Demoiselles* ranks as supreme in Picasso's oeuvre?' I challenged Breton further.

'It penetrates right into the core of his laboratory. It is the crux of the drama, the centre of all the conflicts Picasso has given rise to...'

On an overcast afternoon in the rue la Boétie, not far from the Champs-Élysées, I alighted from my chauffeur-driven Panhard-Levassor, followed by the twenty-nine-year-old Surrealist guru. We must have cut an unlikely image as master and hireling as we approached an apartment block.

For this important meeting, as ever, I took the trouble to present myself well. I naturally considered the leverage that fine attire can bring, and so I was typically fleckless in my apparel and snowy bearding. Breton, a modern dapper figure in a wide lapelled verdigris suit, walked with a confident swagger. We entered the hallway to Picasso's building with great anticipation.

Ascending the stairs to the third floor, after my heart attack of some years before, was as much of a climb as I should have been expected to endure. All the way to the artist's door I fervently sought Breton's assurances.

'Why is he going to let go of it for just twenty-five thousand?' I asked for the umpteenth time.

'Madame Picasso wants rid of it. She insists upon its removal from the apartment, and her husband wants it to go to you.'

'And you think this is due to my bequest of *La Charmeuse de serpents* to the Louvre?'

'Exactly. This is why he prefers to sell to *you,* rather than anyone else.'

'Well, who else could usher him into the museum...? And after all, it is not as if I am a young man. He will not have to wait forever.'

'Monsieur? The Surrealists depend on you. We need you alive and well!' my advisor humoured me.

We reached the apartment, and I caught my breath for a moment, before Breton pulled hard on the bell. A starched housemaid came to the door and bid us enter a fine, traditional drawing room. We were greeted by Pablo Picasso, attired in a comfortable looking three

piece suit and bow tie, but perceivably restless in demeanour. He was on his feet and ready to receive us. His luxuriant black hair had been carefully combed to the side and he was fuller in the face than I remembered.

'Ah, Monsieur Doucet. André. Welcome,' Pablo trilled as we shook hands. 'Do you know, monsieur,' looking to me, 'your name was echoing around these rooms just the other day?'

'Oh?'

'When your client Helena Rubinstein – a woman who paints more faces than I do, ha! – recommended that Olga should visit Maison Doucet for a charity ball outfit.'

'Quite so! Quite so!' I responded – amused at how bourgeois Picasso had become since we first met a decade earlier.

'Can we offer you coffee or a tisane? A glass of anise perhaps?' Picasso enquired with a sympathetic nod.

We both declined and so he bade us follow him into a still larger room serving as a studio. In passing through the hall, I caught a glimpse of Mme Picasso, the former ballerina, Olga Khokhlova. She was in the dining room beyond, fussing with the hair of their three-year-old son Paulo. I noticed a small portrait of the boy on an adjacent wall, dressed as a Harlequin in a suit with a diamond-patterned motif and ruff. *Ah! He's bringing up his son as a trickster too,* I thought to myself, recognising the theatrical character as the master trickster of old, *and the style is a world away from the ravages of Cubism.* I immediately caught the likeness of the child sitting at the dining table. The dark painted fringe was cut sharply, revealing beneath a piercing pair of Picasso eyes, as dark as his black hat. His father had reverted to a fairly conventional figurative style to capture the image of his son, in a traditional angelic pose, perhaps a concession to the rather prim wife and mother, Olga.

Once inside the studio I glanced around. This place of creativity was located in a well-appointed grand reception room, furbished with fine plaster cornicing and decorative mouldings over the ceiling. Yet in contrast to the orderly domestic rooms this was a jumble of

easels, artists' materials, bric-a-brac, sketches and furniture, including a rocking chair. There were paint smudges around the fireplace. All denoted the frenzied heart of the artist's Laboratory.

While Breton's attention flicked between random sculpted items and an incongruous assortment of objects placed ready for a still-life, I took a few moments to peruse a number of late-Cubist, canvases on display. The largest of these, at more than two metres wide, was the striking *Mandoline et guitare,* painted that summer on the Riviera. I reflected on the evolution of this man's art, from the Proto-cubist work we were there to buy, through dense analytical Cubism, collaged Cubism, departures into Neoclassicism and now this. *What a fiendish conjurer! Here he plays with the perspective to perplex the viewer,* I thought as I cogitated on the work, feeling mesmerised while its creator stood squarely, arms folded and watched me in silence. I considered, *Here we have two window panes that contradict reality: one foreshortening outwardly and the other inwardly. Then there are black railings both below the tabletop and before an open window with a Mediterranean sky above. Are we being fenced in or kept out?* I couldn't decide. The greatest trick, to my mind, was the *painted* wallpaper covering a number of different areas. In the Collage phase of Cubism, ten years previously, the artist would have glued actual wallpaper, news-paper and other materials onto the canvas to mimic painting. *Now here is* 'painted' *wallpaper, mimicking* 'real' *wallpaper, which had mimicked the painted wallpaper in the first place?* My mind boggled.

Picasso lit a cigarette.

Clad in my immaculate dark suit, I towered over the diminutive artist, a little troubled by the spumes of smoke drifting in my direction.

Breton was first to broach the subject of the large canvas I was there to discuss and then Picasso seemed suddenly alert and keen to get on with the business.

'What would you like, monsieur? Shall we unroll it here – or perhaps on the floor?' Picasso pulled the two-and-a-half metre long

roll of canvas from underneath the large central table. He knelt down and began to unfurl it. I remained poker faced and stared almost disinterestedly. The muddied, scarified face of the top-right figure was suddenly glaring up at me.

'No, no! It'll be quite unnecessary,' I insisted, curtly. 'I do know the picture, monsieur. I saw it at Salmon's show ... at Poiret's house during the War.' The avoidance of viewing the painting created a distinct tension in the air. Its preciousness was silently contemplated by the two of us. I was held in suspense, suddenly regretting the unusual decision not to view – *did that not just emphasise its power?*

'Very well,' said the artist, pausing with the procedure.

'Perhaps you will be putting it back on a stretcher?' I asked.

'Of course. My framer can see to it,' replied Picasso, returning to his feet.

'You do know, Pablo, Monsieur Doucet plans for his major items to go to the Louvre one day?' ventured Breton, oiling the wheels of the transaction.

Picasso turned to me, saying, 'I've heard of your success with the Douanier Rousseau's *Serpents.'*

Receiving this as a compliment I acknowledged the remark with a faint smile. 'Have no doubt, I am the only collector whose author-ity compels the Louvre to accept avant-garde work.'

Sensing that the artist was keen to do business, I then took a chance and went straight in for the kill. 'Well, then, it's agreed, Señor Picasso. You shall receive two thousand francs per month – beginning next month – until the sum of twenty-five thousand is reached.'

'This is already an unrealistic sum,' objected the artist, clearly displeased. 'And now you propose instalments?' He tucked his thumbs under his fingers to control his irritation.

'The thing is ... the subject is a little ... well ... peculiar,' I bluffed. 'And I cannot in all decency show it in Madame Doucet's drawing room.' I had not imagined for a moment the irony of those words.

Picasso was not at all pleased. He grimaced, but then surprisingly conceded. 'I'll not haggle, monsieur.'

We immediately shook hands. A few arrangements were made on payment dates and delivery. I wrote out my cheque for the first two thousand francs, dated one month hence.

As we took our leave we paused to examine a half metre high portrait on an easel: a head and shoulders view in traditional, figurative style, of a serious but kindly looking middle-aged woman. 'This is uncharacteristic,' I remarked. 'What do you say, Breton?'

Picasso watched us with steely eyes. 'Doña María, my dear mother.' He informed us curtly.

A KNOCKING AT the door of the Doucet abode signals the delayed arrival of Paul Poiret. The maid accompanies the portly figure – joyful and dandyish and impossibly fragrant. Jacques rises to his feet, appearing as a lofty figure beside his former protégé.

'Ah le Magnifique! Magnifique! Paul! At last!'

The two men kiss on both cheeks. Paul smiles to himself. Jacques embraces the bewhiskered Paul. 'Oh Chap, I'm in such a flutter... Pardon, my boy, I must congratulate *you*. I saw your splendid decorated barges, nestling on the Seine, right in the middle of the Exposition. You'll never guess who I showed them to today...'

But trade has been trailing off for the younger couturier's ground-breaking Maison Poiret and his Atelier Martine fashion school.

The younger man quips blackly, 'Actually we're having to work as hard as ever to keep afloat!'

'Ha! Very funny. Getting to the top of the pile is one thing, but staying there... I seem to be having the same problem.'

Paul's eyes are quickly diverted to the conspicuous obstacle at hand. 'Oh, but Monsieur Jacques?' He suddenly stops, plainly shocked at the sight of the giant brothel painting. 'Heaven forfend! What is happening?' he asks, regarding its position, strewn across the room between dark antique furniture and imposing busts. He considers its

marked incongruity with the traditional gilt ornamentation, lamps and candelabra. The room is comfortable enough but Paul knows full-well that the leaden French style is no longer at all to Jacques' taste. It is assuredly the province of Mme Doucet.

It was in the early days of the century, when the young Poiret had at twenty-one scrupulously modelled himself upon Jacques Doucet, by establishing his own fashion house, as well as in collecting and exhibiting works of art. After leaving his apprenticeship he had begun to surpass his former master in terms of innovation in haute couture. While Jacques had triumphed by dressing stars of the theatre, Poiret was inclined to host spectacularly decadent parties to promote his wares. Maison Doucet also had dressed the great ladies of France – and beyond – but Paul Poiret dressed their daughters and was soon hailed as "stylist for the new century". He had freed the female of tight corsetry, and above all, the punishing "S" shape, championing the relaxed silhouette, promoting instead the brassière to accompany his dresses and a waistline situated just under the bosom. By comparison with preceding modes of dress the whole arrangement was a marvel of comfort, as well as strikingly decorous, albeit that walking was somewhat impeded by much narrowed hemlines. With oriental influences and fabrics, Poiret had been inspired by the turban collections of the Victoria and Albert Museum in London and the arrival of Diaghilev's *Ballet Russes* in Paris. He had ignited the public imagination, with such exotic garments as the Hobble Skirt, Lampshade Tunics and Turban Headdresses. His Harem Pants had provoked the lusty condemnation of the Catholic Church, thereby securing a wealth of free publicity.

In another ingenious act of self-promotion, the younger couturier has trained himself to be a fine *perfumier* – master of aromatic compositions. He has widened society's perception of scent by incorporating ingredients from unexpected sources in nature, other than flowers, which he distils personally at his own *Les Parfums de Rosine.* It is no surprise that he is now daubed with his signature concoction – a blend of foliage, pine trees and salt marshes.

'They've been feeding you up well at those wild screaming parties of yours, I see!'

Paul laughs in his silly little high-pitched way.

'You're a game one, a game one! And as idiotically spruce as your old boss, as ever, aren't you, Chap?' Jacques booms. *'Excessively pernickety,* would you say?'

They both laugh heartily at this phrase, although Jacques is undoubtedly pensive and Paul can sense it.

In fact it has been a long while since Poiret has held an event such as the notorious *Thousand and Second Nights* party but he enjoys the old joke about the elaborate dressing requirements of an *haute couturier.* It is his trademark – no matter what the bank balance says. Just as Jacques Doucet had taught him – it is most imperative to go to extreme lengths in order to impress every client.

Jacques gets straight to the point. 'What consternation! And it's not only Jeanne.'

'Is this her doing?' Paul gestures to the painting placed haphazardly in the middle of the drawing room.

'I've been losing my way ever since I bought it.' Jacques runs his hand through his hair producing uncharacteristic stray locks. It is a gesture underlining his deep sense of unease.

'I do know what it is to house this beast. Two *Clarabelles* isn't it?' trying to lighten the mood. Paul sees Jacques' despondent expression. 'I'm sorry, I'm not really making fun, but I know the problem. Its reception at my *salon d'Antin,* brief as it was, caused quite a maelstrom!'

'I had forgotten that it was your pigeon.'

'No, not mine. In fact *l'Art moderne en France* was organised chiefly by "Longfingers", André ... Salmon.'

'Mid-War?'

'1916.'

'You know, when Longfingers first saw it in Picasso's studio in '07 ... how he balked at it and bemoaned, half-jokingly pulling at his own face with his great hands ... declaring, *it is the hideousness of*

the faces that freezes in horror the faces of the half-converted.'

'Yes well ... poets. They have their way with words. That's what I pay them for, ha!'

'By the time of our little exhibition during the War, Longfingers had actually come round. It was surprising and fortuitous,' Paul reflects. 'I cannot believe now that we were the first to reveal this picture in a public situation – just for those few weeks.'

'Well, it's not been seen by anyone since,' adds Jacques.

'I remember staying well-away during the viewings, for fear of having to explain it. But I could see people from a distance visibly shrinking from the picture. Men were even covering their ladies' eyes. It was so embarrassing. You came to see it yourself, Monsieur Jacques, did you not?'

'Indeed so, my boy. I saw it there. It was outrageous, but then in the end it is just a painting?' Jacques gesticulates helplessly towards it. 'Such a furore. I might have realised.'

'Longfingers was converted,' recalls Paul, 'but he was scarcely typical. To the rest of us it was either a prank or utterly scandalous.'

'You begin to sound like Jeanne – a private residence must not be defiled you mean. Is that it?' Jacques snaps a little hastily.

'I like to think I appreciate art, but I saw this as experimental, just a radical adventure ... yes... Seeing it here like this ... engendering such controversy. Still it takes the breath away. Can you blame your wife, Monsieur Jacques?'

'Hang what the world thinks!' huffs Jacques.

They both stand and contemplate the painting.

'You know she may *never* accept it,' warns Paul. 'We all struggle. How can you expect others who have never encountered the like of it to appreciate it?'

'My wish is only ever to look forwards.'

'Yet you cannot help looking back,' remarks Paul. 'Despite the harm this has done to painting, it is certainly a monumental landmark.'

'Harm, you say?'

'It is just an opinion. If only Picasso had kept his researches to

himself. Instead, Cubism has been propagated by all the avant-gardists in Christendom and has ravaged traditional painting.'

Jacques looks sharply at him, frowning. 'That may be, but it was his *Mona Lisa* – Picasso's you know. In fact Jeanne is hurt and insulted by it ... indeed I may as well tell you. She's left me.'

'I am very sorry, Monsieur Jacques ... but you mean, she has left you over this?'

'There is something else.' Jacques growls. 'It almost seems she is jealous of the love I had from another lifetime – Sonia – or even that I bought it for my memory of her!'

'She knew the painting and liked it?'

'She was more than unusual,' Jacques asserts firmly, 'and thought it tremendous.'

'But that was years ago?'

'Speaking of the *Mona Lisa*, it was the same day it vanished from the Louvre.'

'When it was stolen?'

'And at the same time, the destruction of our dear Sonia, my beloved muse ... which she was to me, you know...'

Paul listens intently, commenting sympathetically, 'We all felt for you, my dear friend.'

'It started in the Trocadéro. She came to her end there, too,' Jacques laments. 'She was ...' but he struggles to find the words, 'well, as an inspirator ... she unlocked *new* art for me ... in respect of my collecting.' Before he can continue he sees his man servant Henri Bonnet scoot into the room sheepishly. He appears ruddier than usual and nervously twiddles his waxed moustache. The master frowns, 'What is it, Bonnet?'

'I'm sorry to have to tell you, monsieur. There is a little matter with Cook.' He looks entreatingly at Jacques, as though requesting some privacy.

'What is it, man? Don't hold back. I'm sure Monsieur Poiret has domestic issues of his own to concern him.'

'She's leaving, monsieur. It's on account of the picture. She says

madame is right and ... and no respectable person can be expected to work alongside it.'

WHAT!? Fiddlesticks! As if she is expected to work alongside it!'

'I've told her it's none of our business but she is convinced it is evil. Of course, it's ridiculous...'

Jacques looks at his watch and snaps irritably, 'Tell Cook to come and see me at five. I cannot involve myself in this just now.'

'Then Mme Bonnet and I will take charge of the kitchen sir?'

Jacques dismisses the man with a nod, 'Very good Bonnet.'

'You see what nonsense this wretched thing provokes. Come on Poiret. Enough. Let's shift it, then we'll have lunch, if you'll join me?'

The two men move the canvas-clad stretcher back into his study. It is a precision task and care is taken with each manoeuvre. The great frame balks at the entrance doors and Jacques winces at every threat of a scratch or stumble.

'Of course, it fits very ill in this room but it is here that I am able to contemplate its fate and mine, and consider how to win its respectability!' declares Jacques as they reach the study. 'My own respectability being long departed – so my wife tells me.'

'It can't be so hopeless, Monsieur Jacques?'

'Picasso expects me to bequeath it to the Louvre ... in my will.'

'Well that might help, surely?'

'One would think so,' the collector considers.

Paul and Jacques bring the great canvas to rest, finally returning it to the end wall of the study, which it now entirely dominates. The spacious room is heavy with books and the décor decidedly modern in appearance, with unflashy elegance and cool sharp angles in the modern style, contrasting strongly with Jeanne's drawing room. A substantial Ruhlmann armoire faces the desk and Impressionist paintings bedeck the remaining walls. As a home for *Les Demoiselles* this is no permanent arrangement. Where exactly Jacques might finally site the dominating canvas, pending his bequest, has yet to be decided, and the present dispute has thrown the issue into further doubt.

'Once the Louvre formalises the arrangement, this work will forever enjoy the imprimatur of the greatest art institution in the world. *Les Demoiselles* will be unassailable, my boy. Unassailable!' declares Jacques, suddenly bullish.

Paul wonders at his bravado.

'You do know, Madame Delaunay sold me Rousseau's *Serpents,* purely because I could secure the Louvre as its final home, after my time?'

'Remarkable! The Douanier in the Louvre,' declares Poiret.

'Yes indeed. Our friend, the little customs man – imagine it, with his primitive hand and ferociously artistic soul. His is the first contemporary painting to be accepted.'

'Little by little you push the cognoscenti, Monsieur Magicien. You are steering them and how they must resist! I can never understand how the devil you do it.'

The older man regards his colleague from the fashion world. '*You* know all about *la mode,* my boy. We shall bring them into this century. Not that we want to poke them up, but I *have* donated the *Serpents* and made many bequests to the museum ... until now antiquated art, suited to their palette, but I feel I might tread just a step ahead and coax them gently, making no fast moves.'

'This is *not* a fast move?'

The master looks at his one-time pupil, raising an eyebrow. They both know Jacques is taking a risk.

You are a distinguished committee member. That must surely carry some sway. But I urge you not to be disappointed, Monsieur Jacques.'

'I am aware of how thoroughly reviled the picture was in your modern art show.'

'Picasso was furious when the major exhibit was discreetly baptized *Les Demoiselles d'Avignon.* Our long-fingered friend André Salmon again,' recalls Paul. 'He thought it made it sound respectable.'

'Yes and now it is hobbled with it.'

'Quite. Now it is mine I think of it as *Picasso's Brothel.'*

After lunch they search through files of cuttings and articles about

the painting, looking for a decent quality tinted reproduction. Jacques finally pounces on a photograph. 'I knew there was one. Now this is a rare thing,' he says, holding it up and at the same time pulling from his pocket a recent letter from André Breton. He offers it to Poiret with trembling hands. 'This, my boy, is from another poet, named *André*. It encapsulates everything... Have you seen Breton lately? He attracts attention – dresses all in green. Smokes a green pipe, he even smothers the parrot – just because of green!'

Poiret raises a curious eyebrow. 'Smothers the parrot?'

'Come, Chap, you know – partakes of the green fairy.'

'Of course,' Paul is amused by the odd idioms Jacques picks up from the youthful company he keeps, though he himself is no stranger to the popular craze for drinking the ravishing emerald absinthe.

Jacques hands him a letter. 'With this endorsement how will they fail to acknowledge its importance?'

Paul reads on with Jacques avidly awaiting his response.

12 December, 1924

Dear Monsieur,

You need not have the slightest doubt as to my opinion of Les Demoiselles d'Avignon – without which there is, to my mind, no way to represent today the state of our civilisation from this particular perspective; and this perspective is one that we can ill afford to ignore [...]

I cannot help but see in Les Demoiselles the most important event of the early twentieth-century [...] It seems to me impossible to speak of this except in a mystical manner. The question of beauty only arises much later, and even then it is only fitting that it be broached with prudence.

Les Demoiselles d'Avignon defies analysis, and the laws of its vast composition cannot in any way be formulated. For me it is a pure symbol, like the Chaldean bull, an intense projection of this modern ideal which we are only able to

grasp piecemeal. Still, mystically speaking, after Picasso,
goodbye to all the paintings of the past! [...] for me it is a
sacred image?

My fondest regards,
André Breton.

'Phew! So he doesn't like it at all then?' Paul retorts with amusement and then considers, 'Perhaps we might bring this missive to the Louvre to demonstrate support from the artist's peers.'

'By all means, and there is more,' says Jacques, handing Paul two further letters from Breton. 'They are the most engaging contemporary views I've been able to secure.'

'He *is* the leading Surrealist poet,' adds the younger man, as he slips the letters into his folder. 'If the mission can be accomplished, your wife should have some difficulty faulting you further on the matter,' he suggests.

'I trust so,' says Jacques with optimism. 'I believe she will feel bound to be more sympathetic. Indeed I hope she will stop this hostility altogether. Perhaps Cook will follow suit and this madness may cease!'

At this, Jacques picks up the telephone to schedule an appointment for next week with Dr Alphonse Crozier, head curator at the Louvre.

THE PANHARD CRUISES along the quai du Louvre, turns into the place du Carrousel and pulls up with a loud crackle outside the Pavillon Denon. The car tyres pierce iced pools in the courtyard, attracting the attention of passers-by. Darkly liveried vehicles form lines, heralding the news that the fortress welcomes many parties of sightseers today. But the smart set will not be alone. The museum's stony interior, cold as it is, shelters many pinched paupers on a chill winter's day such as this.

As the two men approach the vast classical façade and principal

public entrance, Jacques chatters on, concealing his apprehension. 'It is said they named the museum after the regular gatherings of wolf hunters, you know, *the Louverie, Lupera* and such like. Today, Paul, we shall be the wolf hunters, stalking the territorial beasts in their lair.'

'And taking them out by the throat do you think?'

'It is as well that it is so early in the day and not so busy. The crowds will be making their bid for warmth soon enough! ... *le calorifère national.* One would hope the poor *are* taking refuge here today. Where else can they go once the mercury has dropped off the scale?'

Jacques and Paul appear a sharply dressed duo, so note perfect in attire in fact that the broad hats of long-skirted women turn towards them, as they clip past, and through the Galerie Denon with its Grecian Sarcophagi and mutilated antiquities to the Pavillon Daru.

It is true that Poiret is becoming as orbicular as a barrel. He is a sight to behold in his jauntily styled ivory day jacket and gorgeously pressed flannels, just kissing pearl white spats on impeccable shoes – which mirror perfectly Jacques' own personal style. One could imagine they carried extra pairs of these foot coverings. It is as if they have spatterdashes over spatterdashes – there is never a mark of either gravel or manure on them. In Paul's case this is despite the many desperate house calls he is forced to undertake in these precarious days, encountering such a quantity of the grime from the city streets. But where would this burly dandy keep these accessories about his person? One would expect such matters to be in the care of his valet. Alas, *his* valet like so many others these days has deserted him for the factory.

The couturiers nonetheless are popularly celebrated figures and the viewers of *Prometheus Creating Man,* and sarcophagi of *Phædra and Hippolytus,* beam and stand swiftly aside for them. Paul replies with smiles at full stretch, waving his cane. Jacques nods, twisting his mouth uneasily, alert to his unwanted Prince of Paris moniker. Chivet paces behind, bearing a small cloth-wrapped package containing a framed oil painting. They ascend the grand staircase, passing

2

the *Winged Victory of Samothrace*, and proceed through the Picture Gallery to the curator's suite – the offices of Dr Crozier.

This Custodian of Art sports a preposterously long curly beard. In fact, so ragged is his facial coiffure it is as if his eyes and prominently aquiline nose are seated upon some shaggy and unkempt animal. It renders his countenance simultaneously comic and terribly serious. Doucet and Poiret are brought into a small side room, a cimmerian cavern laden with dreary furniture of the Louis XVI era. They chat with Crozier in this outer-office, staying well away from the topic of their fervent mission to offload Picasso's controversial picture, focusing initially upon a more modest donation.

Summoning his chauffeur to unwrap the package, Jacques offers Fragonard's *Le rêve Céleste (Heavenly Dream)* as a sweetener. Chivet places the picture on a stand, before nodding in deference to his master and departing to resume his post at the car. The tame image was for the eighteenth-century a celebration of sex without actually alluding to it – such is the good taste exercised in its execution. Jacques has chosen to donate the picture, with the subject matter of the lightest, rosiest erotica: a lounging semi-nude young woman, recumbent upon a bed and surrounded by cherubs. She is so utterly serene. The beholder might liken her delicious sensuality to that of an angel drifting in desire, as if upon a fluffy cloud. It also prefigures and contrasts profoundly with the second bequest Jacques rather shrinks from announcing. 'It is a riot of adolescent pleasure, no?'

'And so very tastefully done,' adds Poiret, privately queasy about the saccharin image.

Crozier takes the heavily gilded frame and offers it up to the light, blinking over half-moon spectacles. 'Monsieur Doucet, we are greatly honoured. Greatly honoured indeed! This is supremely generous and a striking addition to the Rococo collection.'

Jacques rebuffs the praise modestly, 'Not at all, monsieur. It is my pleasure.'

But Crozier will not be suppressed. 'How we have enjoyed your impeccable taste all these years – such marvellous acquisitions and

now to be gifted with this prize jewel. It is most affecting. It will be thoroughly enjoyed by all who have the pleasure to see it. Indeed, the entire nation will be eternally grateful for your unflinching good taste and generosity.'

Jacques nods, swallowing embarrassment about his next pitch.

'I hope you know from your work with the committee how very grateful we are, both for your donations and expertise,' Crozier waxes on, fully aware that Jacques Doucet is usually said to be one of France's greatest authorities on eighteenth-century French painting, whether inside or outside of this fortress.

Paul watches Jacques in admiration as he prattles on eruditely in response, offering tasty peccadilloes on the history of Fragonard, unknown even to this most senior curator. The connoisseur continues assuaging harmony. 'How dextrous is this master's hand?' he croons. His additional suggestions on how to place the work within the galleries are received with joyful sycophancy.

Yet Jacques nervously puts his silk hat on and takes it off again, smoothing the back of his shapely fingers. Then, taking in an imperceptible extra breath, he comes to the point. 'As you know, on my passing, my Rousseau is coming to the Louvre. But *now,* I've uncovered a most exciting proposition: *THE* first ever work of modern art. *Une pièce unique.* Needless to say the Picasso...'

Crozier is startled, 'Picasso! Pardon, monsieur. You say ... *Picasso?*'

Jacques opens a leather folder, perceiving Crozier's veiled disbelief at the sound of Picasso's very name. 'This is no ordinary Picasso, were there such a thing. I am speaking of his magnum opus, *Les Demoiselles d'Avignon* – here!' He passes the curator the hand-tinted photograph of the painting. 'The women are lifesize. It is of tidy dimensions; in fact, two-and-a-half metres square.'

'Oh dear me! Oh dear me! By the Lord Jehovah, what is it? Ah ha!' Crozier exclaims, politely concealing a chuckle. He examines the photograph for another few moments. 'How blessed we are by the benefit of your knowledge and taste. Your generosity has come to us more recently in equal proportion, but only today have I

come to understand you had such a sense of humour! Monsieur, this is so very droll! ... I see you must have your little joke!' He wags his finger reprovingly, but then stops as he discerns from the expression of these champions of Anarchist Art, that this is a most serious mission. He squirms and pauses.

Jacques' colour rises. He is inclined not to proceed – but Crozier assumes the lead.

'Come. Pray, follow me gentlemen.' He ushers them into an inner-office, clad in traditional walnut panelling. The cloistered effect is accented by the heavy scent of pipe tobacco and wood smoke. A curly footed antique desk is finished in the same sepia hue as the walls, which dominate the sanctum and is central to the ill-lit room, purposely made dark to avoid bleaching precious archives. Crozier stretches for the crystal decanter before him and pours a liberal quantity of brandy into tumblers. He offers them to his visitors, which they accept, but sip indifferently. He illuminates the desk with a bright electric green glass lamp, gesturing to two well-worn leather chairs and then scuffles inside a heavy oak filing cabinet, in search of a particular swatch of articles and reproductions depicting Cubism and its effects.

'You think we haven't considered these new ideas?' asks Crozier rhetorically, handing them a critical paper entitled, *Art in Emperor's Clothing: The Great Hoax.* 'Pardon me, *s'il vous plait.* It is not that I ... we ... would not wish to help ... far from it,' he stutters. 'An organisation such as the Louvre is a grand beast of a bureaucracy. Nothing is done without the most intricate scrutiny... But then you know this, messieurs... The party line is, Picasso has churned out dreary brown mess after dreary brown mess, each nearly identical to its predecessor – each hailed a masterpiece...' Jacques tries to get a word in but Crozier continues forcefully. 'Well, personally I don't know enough about it. Even Picasso himself has left this so-called style behind. Anything he touches is hailed Genius. But what I do know is this: it devastates painting!' splutters the curator. 'I can scarcely imagine *a museum* accommodating... Why, even the Luxembourg

– there for the very purpose of supporting living artists – would not consider this...'

'But, Doctor Crozier...'

'Monsieur Doucet, I am trying to shield you from public embarrassment. Besides, your own committee would never sanction it. And believe me, after your generous bestowal, I'd like to support you, if I could,' he says, handing back the photograph. 'I have to put it plainly; we are a museum after all, not a repository for anarchist leftovers.' Crozier delivers this retort with weary emphasis, unable to hide his fierce antipathy.

'Doctor Crozier, if I may interject here? I dislike Cubism and all its works as much as you clearly do.' Poiret adds with a bullish air. 'But here we are talking about an artefact, which, like it or loath it, wrought change to painting like never before. It assuredly belongs in a great museum.'

'Indeed so, this was painted two decades ago,' adds Jacques. 'A past age in a hectic century. A different era in art *because* of Picasso,' thrusting the photograph back into the curator's hands. 'It's historic.'

'It's hysterical,' counters the head curator and then remembers his manners. 'Forgive me I'm afraid you have been grossly misled...' Then he suddenly recalls, 'I wonder, are you aware of his association with thefts from the museum?'

'Thefts?'

'As good as. Take my word for it. Your friend Picasso has quite dishonoured his own reputation within these walls. Why, the artist is a hooligan.'

Jacques is tempted to question Crozier further on the matter, but there is a warning note in his tone. He refrains and bides his time.

'Come, come. Let us visit where the Fragonard will hang and speak no more of it,' the curator continues. He is quite immovable but Jacques will not let it rest entirely.

They leave the curator's office and enter the busy museum, pausing occasionally en route. They pass through the Picture Gallery taking in the wonders of a portion of the three thousand works of European

art. The couturiers are swept along, aware that this section has been chosen by the obdurate curator to underline the majesty of the Louvre's immaculate stock. He stops to point out key acquisitions. 'Here is the collection of Italian great masters of the sixteenth-century, none are more opulent this side of the Alps. You see the history we have here. This is the bastion of civilisation we uphold!'

They divert to the glorious Salon Carré where they stop to behold Leonardo da Vinci's *Virgin and Child with Saint Anne*. Just behind them smiling beatifically is the painting Jacques has avoided seeing ever since the death of Madame Roux – *La Joconde (Mona Lisa),* the world's most famous masterwork of a female subject.

The collector regards Crozier blinking implacably. 'Before your crucial decision ... in respect of the Picasso ... I pray, don't listen to me. Hear the words of today's men of letters.' He nudges Paul.

'If I may,' Paul taps a small book and clears his throat. 'Monsieur Breton has written a piece concerning the very painting.'

'Let Doctor Crozier hear it, Poiret. Read on.'

Paul offers a short section carefully selected for the purpose. '*A work which transcends painting – the theatre of everything that has happened in the last fifty years. The wall before which have passed Rimbaud, Lautréamont, Jarry, Apollinaire and all those we still love...*'

Crozier, pouting, explodes, 'Exactly!', 'Just as I say. Anarchists!'

Paul ignores this, continuing, '*If it were to disappear, it would take with it, abroad, the largest part of our secret.*'

Jacques gestures to paintings around him, 'Leonardo shifted the direction of art. But show me a single painting that really changed history.'

'Well ... monsieur ... I ... erm...'

'Why, even *La Joconde* changed nothing,' argues Jacques, gesturing to the half-length portrait of the tawny lady in finely worked oils in front of him. 'As a painting it is of little historic significance.'

'She has a tremendous history!'

'Oh, indeed so,' Jacques replies ironically, 'hanging in Napoleon's

bedroom. *He* might have changed the world but *she* scarcely did... Come, allow me.' Jacques strides through to the next gallery. Dr Crozier and Paul Poiret trail behind. They reach a small painting by Giotto, *Stigmate di san Francesco (Saint Francis Receiving the Stigmata).* Jacques waves his arms. 'Here, Giotto. A truly historic milestone. Of course, this is a minor example. Go to the *Cappella degli Scrovegni* at Padua with its magnificent frescoes and witness the convergent parallels – the birth of perspective!'

The curator is suddenly happier. 'Undoubtedly, monsieur. Truly magnificent!'

'So, which single painting wrought this revolution? *Ha.* Which one?' Jacques demands to know.

'Per ... perhaps no single picture,' splutters Dr Crozier.

'You make my case! ... Uniquely, we have *the* moment, when the next great milestone is reached ... and in a *single* work!' declares Jacques, waving the photograph of *Les Demoiselles.* 'Not a move-ment, not an *ism,* but a *single* canvas!' he argues, getting animated. 'After 600 years... A break with perspective... *New* art takes a strangled first breath: Cubism. Abstraction. Futurism. Expression-ism. Surrealism. Purism. Mewling orphans following, treading in its path. Who knows what will follow?'

'Even if you were to convince me – *and* your own committee ... I could never persuade my board. I cannot think what's got into you, Monsieur Doucet... You! You who once had the finest collection outside of the museum itself... It is for your sake that I say this.'

'The museum happily accepts my Fragonard – also controversial once. Tsh! Tsh! Shame! Perhaps I shall reconsider my bequests?'

Other visitors in the gallery turn their heads, gawping in astonish-ment at the fevered pitch of the row. Crozier's mouth opens and closes. '... Then ... then the Louvre will be the poorer.'

'And if you reject this ...' declares Jacques, waving the photograph, 'France will be the poorer!'

Crozier, incredulous, holds up his hands.

Doucet and Poiret leave the ruffled curator to ponder about the

would-be benefactor's conviction, and make their way back through the galleries. 'Crozier said something was stolen?' Jacques puzzles. They pause as they reach the Leonardos.

The two men contemplate the *Mona Lisa*.

'*She* was, of course,' ... 'the lady Lisa Gherardini. At least they say it is she,' says Poiret. 'But her disappearance had nothing to do with Picasso, surely?'

'No, of course not. But it was the dreadful day of *her* theft when it happened ...' murmurs Jacques. There is an oppressive pause until he launches forth. 'I was in my private office when I received a desperate telephone call from Madame Roux at the *Ethnographie*.' He buries his head in his hands. 'When I think of the piercing wail ... her cry. It was utterly chilling, like a barn owl's scream ... worse ... just terrible panic.'

Paul is stumped in the midst of the old man's anguish. 'Jacques ... Gosh ... I had no idea.'

'Her first words were, *He's gone mad,* or something like it. – *He's vicious and strange.* Then there was the scream and fighting. She fought back, like a cat. That I could hear. It was unbearable. *Who? What? Where are you?* I shouted, but I knew full-well where she was and that she was being attacked by Roux. Then of course she couldn't hear me. The telephone line droned its continuous tone. I fled to my carriage in the rue da la Paix yelling at Chivet to take me to the Trocadéro. After a few incidents amid chaotic traffic we encountered police roadblocks all around the Louvre, due to the theft of this,' continues Jacques, gesturing to the *Mona Lisa*. 'The carriage couldn't continue. The delay was fatal.'

Jacques and Paul remain facing the once stolen painting.

'Go on,' asks Paul.

'Let us not ...' Jacques frowns and is unable to complete the sentence. 'No, no. To the matter in hand.'

The younger man is concerned but nevertheless, glad to move on.

Still troubled, Jacques pulls out the photograph of *Les Demoiselles* and gestures to Paul. 'One cannot begin to comprehend a work

without first knowing, in full, the circumstances of its creation.'

'Well, what do we know so far, Monsieur Jacques?'

'Precisely nothing, dear boy. Nothing!' he replies ruefully, except, as in the case of *La Joconde,* the artist may have left it unfinished.'

'But we do know *Picasso's Brothel* began as a riposte to Henri Matisse and his *Le bonheur de vivre.*'

'That's not what I mean. There must be something else – something beneath the menacing psychology...? I don't know... But if I am to persuade Jeanne that it is more than a pornographic daub, then I have to find out. *Anyway,* I've more pressing matters for now.'

MADAME DOUCET READS a telegram as she stands in her room at the Hôtel Ritz:

```
MY DEAR JEANNE.  MUST MEET.  COULD
YOU COME TO LIT. LIBRARY THIS 3 PM?
CAN PUT ALL TO RIGHT.  JACQUES.

....TUE NOV 10TH 1925 ....
```

6

When you pay high for the priceless, you're getting it cheap.

Joseph Duveen

J EANNE FOLDS and refolds the message, idly contemplating her husband's brief but gracious communication. To some extent the literature library presupposes neutral ground, if not the most diplomatic of suggestions as a place for reconciliation. She needs, for the time being at least, to overlook Jacques' prodigious expenditure on the libraries, of which this is one of two such undertakings – both of which to her considerable unease have since been donated to the state. The first of these, the enormous Bibliothèque d'Art et d'Archéologie, now belongs to the Sorbonne. The library in which they are to meet is the Bibliothèque Littéraire Français, and is at this moment committed to the same destination. Should she be proud of his accomplishment? Perhaps – but she wrestles with a fury that curbs her appreciation of his success, and she wonders if it is simply her own lack of understanding of the complex man that causes her so much disquiet.

Jeanne rolls back the doors of her hotel wardrobe and peruses the few items of apparel hanging within.

An anxious half hour passes as she struggles with her extravagantly elongated pearl necklace, lacing it numerous times around her neck, intent on appearing statuesque as the true consort of this Prince of Paris. It had been a demonstration of his affection – buying her the famous pearl necklace, of a record seven-and-a-half metres in length, and at a cost of more than one million francs. She coveted it and was proud of it, but now she critically considers her appearance,

concluding that she resembles a strangled babe, or even a wild long-necked turtle. She muses as she awkwardly breaks free of the encumbrance – *there is a negative in appearing too fond by wearing such a gross tribute.*

IN THE LIBRARY where the estranged husband and wife are due to meet, work proceeds in cataloguing and sorting newly-arrived volumes. This worthy enterprise was established by Jacques Doucet with some influence from another of his writers forenamed *André:* that of André (The Peregrine) Suarès. According to this young man, The Peregrine, nicknamed for his peregrinations around Europe – as much as for his rather sinister appearance – this a more selective collection – 'unlike the art and archaeology library, which became so hideously sprawling and unmanageable.'

The new library is accommodated in a most exclusive suite of rooms and staffed by a small group of avant-garde poets and writers, who also lead the radical Surrealist movement. Carefully chosen first editions and manuscripts fill the shelves and include the many volumes clad in bespoke precious bindings created by the master's artisans.

André Breton, Paul Eluard, Louis Aragon and The Peregrine Suarès work around a library table researching inventories and indexing books. 'What's this ... Greek isn't it?' Eluard squints at Κύριος on the front of a volume and struggles to pronounce the word.

'Kyrios?' the scholarly Aragon translates.

Eluard rubs the bluff of his expansive forehead as if he knows the word but cannot snatch it from memory.

'I don't think we have much in the Greek section,' adds The Peregrine. With his lank locks he cultivates the dark look of a tragedian – like Corneille or perhaps Guy Fawkes. Mlle Rose Adler enters, a little self-consciously and ignores his lengthy stare, selecting a rare volume here and replacing one there. This attractive, thirty-something woman with a *Marcel-wave* hairstyle is now the Doucet

book-binder-in-chief, pushing the frontiers of primitivism-inspired Art Deco design for her patron. She is popular among the young Surrealists, especially with Louis Aragon for whom she created a stunning mosaic bookbinding for his first novel, *Anicet ou le panorama.*

Suarès – Doucet's arch-loyalist – is called away, whereupon the remaining young men relax and pass round a hip flask of strong liquor. Aragon begins aping Jacques' occasionally fey mannerisms, engendering gales of laughter from the others. 'Hey, I'm having an existential moment!' he jests.

'Get me one of those would you?' Breton guffaws...

Referring to Jacques and the spookily styled young poet Suarès, Aragon quips, 'Say, it's *quaint* the way they call one another The Magician and The Peregrine isn't it?'

'Well he is quaint, when you think about his name for us –Young Tigers,' interjects Eluard and adds with a filthy laugh, 'what does that make him?'

'Look, this is the old gaffer to a tee,' Aragon declares, showing the others an open book from his pile. It is a first edition of *À rebours (Against Nature)* by J-K Huysmans. 'The obscenely obsessive Duc des Esseintes, who goes off his trolley through collecting like a demented madman... What do you reckon?'

'That's a good one, Louis,' chimes Eluard. 'The Duke with the bejewelled tortoise, no?'

'And the rest!'

'Have you not noticed our man's fondness for writers rather than painters... What's he up to?'

'I'll tell you what he's up to ... he's on his way here with his wife and we are to make ourselves scarce,' warns Breton.

'He loves painting but is not so erudite when it comes to the written word. Is he trying to communicate in his own special way?'

'Very special!'

'He's never laid a finger on me,' adds Breton.

'Me neither, and he buys all these books and hardly ever reads

them,' claims Aragon, pointing to the stacked shelves around the library. 'But he needs us to sort them for him, that's to be sure.'

They continue amongst themselves to conjecture on Jacques and his motives.

'He has now asked me to write to him on the mysteries and virtues of De Chirico,' reports Breton.

'Exactly. Having to write letters to him all the time.'

'Do you think he's a dirty voyeur?'

'For sure. It's obvious. All aesthetes are that,' concludes Breton philosophically.

'As for the painters – well, he just *buys* their canvases.'

'You don't think he indulges in the sins of the flesh there?'

'No, but he needs enough advice from us on which to choose.'

'The old goat is seventy-something and hails from being a great eighteenth-century expert,' Aragon adds, 'and even an aficionado on Impressionism. But how the devil can he expect to cope with Dada and Surrealism?'

'Nevertheless, he could take advice from painters ... on what's what,' suggests Eluard.

'Nah. They are too unfriendly. Too stuck up their own easels and a clique of conceit. Besides, they'll be trying to sell him their daubs, won't they?'

'And they're a trifle too macho. Take a look at our Andalusian Cubist for one, with his women – and with a wife and kid, too. He's not going to consort with our Magician like The Peregrine does.'

'All painters are macho!'

'Rubbish!' retorts Breton.

'What, like Leonardo and Michelangelo?' adds Aragon, with irony.

'Hey, that reminds me.' Eluard takes a book from a nearby shelf, *The Autobiography of Benvenuto Cellini,* and sniggers loudly as he flicks through to a spicy passage of interest. 'Here's a good one,' he announces, giving a précis of a section.

'Michelangelo invited Cellini and friends to a supper, but with the

strict condition that they each bring a Crow ... their name for a young lady, you understand.' There is much laughter from the others, as they sip from the flask, passing it on in turn.

Rose Adler, who has re-entered the room briefly, catches the crude ribaldry. As a career woman, and highly accomplished artisan too, she does not appreciate their chauvinist manner. 'If women are crows then I wonder what that makes the males of our species?' she snaps as she leaves the room – showing her disdain with the sternest of expressions. 'Vultures perhaps?'

'Anyone failing to bring a Crow would pay for the entire supper,' continues Eluard, ignoring Mlle Adler's remark. 'Now Cellini didn't have a crow, so in desperation he urged a young scholar, Diego, to dress up as a woman and wreathed him in pearls and jewels... So divine was "Pomona", formerly Diego, that when presented to the company, Michelangelo was over-awed with *her* magnificence and so prostrated himself declaring, *Angel of grace and beauty, bless me and protect me,* and kissed Pomona's feet. At dinner Pomona was placed with the women, and their twittering was driving him mad. In exasperation he or rather *she* announced herself to be in pain, due to being pregnant by several months. In their concern, all the ladies plunged their hands down Pomona's skirts to feel the baby, followed by screams when they discovered something quite different!'

Hoots of laughter enliven the library.

'Cellini was terrified of the mighty Michelangelo's reaction to such a ruse,' the poet continues. 'The great man strode over, bellowing that he would mete out the necessary punishment to the perpetrator. He lifted the little man from his seat, and roared, *Long live Benvenuto Cellini! The only possible sentence for such a perfect trick.'*

'Would Picasso take such a joke?' wonders André Breton, highly amused.

'He'd be the one to play it,' insists Aragon. 'Or he would have done, before he went and got himself wed.'

'And the gaffer?'

'*Monsieur Protecteur.* Well he's married off too. But he can take a joke, surely?'

'We haven't established whether he is Musical or not.'

'Steady on,' whispers Breton. 'You'll have Rose overhearing this and then where shall we be?'

'Who cares? All I know is, he blew his top due to our antics at Picasso and Satie's *Mercury.*'

'Antics, you call it! Why would Surrealists *not* riot at a ballet, eh?'

'Why did it concern the old buffer, is the question?'

'Of course it did. If we get into disrepute as his ambassadors then he is bound to be mad about it.'

'We are likely for the boot anyway, I fear.'

Suddenly voices are heard. Rose Adler is greeting Mme Doucet as she arrives in the vestibule.

'Quickly!' exclaims Eluard. 'Evacuate! ... To the back room!'

Just as they have departed Jeanne steps in, pursed-lipped, wearing a high buttoned coat threaded with patinated silver, beneath which peeps a modest taupe gown in the finest of *crêpe de chine.* Her ashen coiffure is freshly set.

As she stands in attendance, her eyes fall upon the bespoke bindings of First and uniquely presented editions of his most treasured literary works – in bindings commissioned by Jacques, from his formidable designer-artisans – gracing the shelves of this most precious of libraries. Names cascading down the spines are reverently embossed. The books, in many cases actual bound manuscripts, are cloaked and preserved in jewel-like form. Jeanne recalls hearing his account of their production. Descriptions of his experiments were lost on her but now scrutinising them in the library for the first time she sees there was no exaggeration. It was as if he had been a faraway god commissioning strange and lush foliage for the landscaping of some alien planet. He had tried to tell her of handmade papers, silks and special velums, *galuchat. What was that, skin of shark?* She had asked herself. In the end he had gone on too long and she'd lost

interest. Yet here they are, the black, carmine red, blue, chrome yellow and ivory calf and goat skin bindings. Everything is tooled in exotic colours and gold or silver leaf. Perfectly stamped gilded letters adorn the supreme works of the many respected wordsmiths, exalting the impressive names – Rimbaud, Mallarmé, Huysmans, Verlaine, Hugo, Zola, Apollinaire, Reverdy, Bergson, Valéry, Mauriac and Gide. Scores more pack the shelves. She has even seen examples of course, but it is startling to see them entirely finished and stacked together in their library home. *How can I fail to be proud of all this, yet there is also a side to it that is utterly infuriating?*

Jeanne picks up Huysmans' *À rebours,* the book Aragon has left open on the table, and begins reading a page at random, squinting a little as she does so.

> *[the Duke] des Esseintes gave a nod of approval. There remained on the table only two slim booklets... He glanced through a number of sheets bound in onagar skin which had been glazed under a hydraulic press, dappled with water-coloured silver clouds, and supplied with endpapers of Chinese flowered silk, on which the slightly faded flower sprays possessed that etiolated charm which Mallarmé praised in such an enchanting poem...*

He is very like my peculiar husband! Jeanne inveighs within. She recalls the time when they were first engaged some twenty years ago, when at dinner Jacques had delivered an intensely passionate monologue on the art of collecting, and how such excesses had made her question his mental stability. She drifts into a reverie of how they finally married shortly after the Great War in 1919.

He had suffered a heart attack and I returned to Paris to help nurse him. Our parting more than a decade earlier, when I left Paris to help my father in Nice, had been more than amicable. We had kept in touch ever since. Dear Jacques, he was so generous. With some expectation that I might one day return to Paris, he

bestowed on me a fine villa in the rue Saint-James, Neuilly-sur-Seine, as a separation gift. To some extent our marriage that later followed was one of convenience, if not decorum – somewhat necessary if I was to continue caring for him. When we did finally marry, this villa, on the far side of the Bois de Boulogne, became our marital home.

A little after our earlier separation, in 1907, Jacques had begun building his own residence: a grand mansion in the rue Spontini, on this side of the Bois. Resplendent in the Greco-Roman style, the mansion was created under the auspices of the renowned architect M. Louis Parent. It was to be for himself and his new bride-to-be. This time not for me, it was intended for another ... for Mme Sonia Roux.

He had decorated the magnificent edifice most extravagantly. Each flatterer who came praised its exquisite nature – that it was not just a home for the preeminent couturier – it was also a glorious celebration of the past arts of France, and a suitable cradle for his famous antique collections. Some said how the abundance of art treasures and the double-height colonnaded grand salon made it on a par even with The Wallace Collection in London. Such private collections were rare indeed – outside of state museums.

The walls cascaded with paintings of every kind by Watteau, Fragonard, La Tour, and Boucher, and numerous others. Eighteenth-century French furniture, carpets, tapestries, sculpture, ceramics, silver and objets d'art drenched the rooms and galleries. The house and its contents became the flagship of Parisian luxury and excess. And although the collection was restrained – the pinnacle of good taste even – as well as being a residence worthy of Jacques' intended wife Sonia, it was somehow embarrassing – as it reignited the public moniker Prince of Paris, which he loathed – and of course, it drew criticism from the chattering elite as everything does.

The design and construction of the mansion, replete with its vast array of art, became his driving passion. And as auteur, Jacques simultaneously remained one of the capital's premier couturiers,

managing Maison Doucet. I cannot forget the occasion when I returned from Nice in 1911, when he was in full mourning following Sonia's death. I found him adrift in this glorious new villa, present in body but not fully in mind, quite petrified with grief. To my dismay, I was invisible to him. He glided through the interior spaces, as he had done for some months, unable to find peace, almost as if he expected her to come back to him. Rich as the rooms were, with their dazzling treasures, they offered little comfort.

JEANNE PLACES A hand on a large granite bird with giant eyes – the centrepiece of the library table. *Is it a raven?* she ponders, *Greek no?* She suspects it was something to do with Mme Roux, knowing as she did of Jacques' late lover's passion for all things Greek.

I had heard a little of the romance between him and the mysterious woman who seemed to have pushed the hourglass onto its side. My very fibres were taut with curiosity on this subject, but I never dared to tread too far into such treacherous territory.

We had delicately discussed it and he had been cautiously candid with me. I knew how Jacques' bond with Mme Sonia Roux had been terribly constrained, owing to the strictures of the archaeologist's marital bonds, so that their time together amounted to a few snatched moments, and a suffocating and secret double life.

Jacques had held soirées and dinner parties but rarely did Sonia attend; and then it was only ever in the company of that watchful guard – her obsessive husband. On such occasions Mme Roux's demeanour was extremely muted. For Jacques, the events were useful in enhancing his place in the Parisian social firmament – the world in which he was often disparagingly termed Dressmaker and Tradesman – but they also offered the opportunity of contact for the secret lovers. Of course, averting his glance from the intelligent yet beseeching eyes of the archaeologist was a great difficulty! On one occasion, to their acute embarrassment, both were quite frozen

to stone, when a noisy socialite trilled gaily, 'dear Madame Roux smells so very fragrant. Extraordinary ... exactly like, in fact, the designer Doucet!'

I later learned that when they had been intimate, it was in steamy cafés, greenhouses, parks and gardens. To my acute shame I had been unable to restrain myself from peeking at a portion of Jacques' private journal concerning this period and had actually read fragments therein. The contents had prayed upon my mind and I knew this to be God's punishment for my own foolish curiosity. There revealed, in Jacques' fine hand, was the torture of his ardent craving expressed for his 'Sonia'.

I felt much affected at meeting her again, but even after the exchange of that wanton night in the Ethnographie I could not ascertain the least awkwardness in her. I had hoped there might be 'something'. I could scarcely regard her as simply a friend any longer. That evening in H—'s summerhouse, we were quite alone. I nearly half by chance took her hand as it lay in nakedness on the chaise and pressed it. It was almost immediately withdrawn, but not at once. A minute afterwards she shuffled a little and changed position. After this I took her hand up again to my breast and was able to feel its warmth. It trembled like a baby creature in mine. And there it stayed for some prolonged seconds. She flicked those great eyes at me and away again and I had a fancy that they spoke to me and said, 'I am not indifferent to you.'

We were summoned for entertainments and I did not find any further prospect of expression with my fingers. But this evening after dinner at K—'s for the first time I had my opportunity and I was determined to be more decisive. As soon as it was prudent, I took up her hand and squeezed it a little. This time she returned the pressure and stroked mine in turn. We were interrupted again much to my annoyance. A charmless artefact found in the brook was brought to her for her professional opinion. I stooped a little

behind her chair so as to take a closer look and put my head as close to her raven black locks as I dared. Again I felt the warmth of her person on my face, while thus her head moved naturally nearer to my own. I was half mad with delight. Yet I am unsure that I shall ever be able to act on such profound sensation.

How painful even to remember those words. But the relationship, furtive as it had been, had prospered.

The Lovers had learned to live by promises – promises of freedom … of breaking free … of marital bliss. Naturally I was irked by this – though obviously sorry for his loss – but he was my former fiancé after all. I, for one, did not really believe in this Great Love. But her dying was a cruel blow, and so near to the time of requesting a divorce.

When I visited – a short time after the lady's tragic death – I was extremely shocked to see him in an appallingly ravaged condition. He was gaunt with his luxuriant hair stuck up like a blizzard-blown peruke. He was in the process of dismantling the entire contents of the intended marital home. The rue Spontini villa was being stripped, with everything catalogued and crated up by porters and clerks from the Galerie Georges Petit for an epic three-day auction at their salerooms.

Jacques had descended into a sleepless frenzy overseeing the minutiae of the sale catalogue, becoming irrationally furious about the quality of the scholarship. He accepted communications only from specialists in each field of concern. The servants kept their distance reporting only on how he was permanently growling and pacing up and down in his study. He called only for paper and pens. His secretary, Vuafluart, in particular became most concerned for his well-being, having been instructed to fend people off who might help. After withdrawing for days at a time Jacques had finally produced the artwork and contents for a lavishly illustrated three-volume tome, on handmade papers, for the disposals – constituting the auction catalogue.

When I was refused entry to the Villa, his spindly assistant told me that the distraction of the sale was, 'providing solace for M. Doucet in his bereavement.' Jacques later rescinded and received me. It was sometime before he would allow himself to be aided even by Vuafluart. Finally the work of art was completed. And I was astonished by it. It was by far the most academic venture he had ever undertaken.

As the sale approached, previews were allowed to collectors, art dealers and museums worldwide. Unlike the principal auction house in Paris, l'Hôtel Drouot – in which seventy firms operated in sixteen halls, processing art and antiques like a meat market, with paintings and objets d'art piled high for the masses – the Galerie Georges Petit was undoubtedly recherché.

The saleroom was immense, with scores of velvet armchairs and fully carpeted floors, all for the comfort of the buyers. Working together, Jacques, Vuafluart and Georges Petit presented the famous Doucet collection, as lots for inspection, in a tasteful and harmonious manner. Ornately framed eighteenth-century French paintings and pastels were spaced out on the walls. Sculptures, silver and porcelain were housed in bronze display cases. The magnificent antique furniture occupied the remaining floor space.

In advance of the sale the Doucet treasures were picked over by hordes of collectors and monocled noblemen accompanied by their fashionably adorned women. I noticed the philanthropist Baron Edmond de Rothschild there. So too was Jacques' decadent rival – he who had encouraged others of the nobility to exclude him, as a tradesman, from the finest salons. 'Eek! How beastly.' I heard Count Robert de Montesquiou say, in his waspish manner. Jacques of course steadfastly avoided him but unfortunately did hear that lacerating appraisal, 'Exclusive certainly, but for me it is a louse! – especially when you remember these are the fripperies of a dressmaker's sexy boudoir.' What a cruel and puny rake, especially in view of Jacques' grief. And how dare he say that to the Baron de Rothschild? I thought.

Jacques had felt the snub, but somehow retained noble composure. He had once bitterly envied the aspiring Symbolist poet's unfettered access to Society, with his lineage traceable to the Merovingian kings. Montesquiou's good fortune placed him quite naturally in the paradise Jacques had always eagerly sought – the choicest of salons and banquets, including Count Bezzerides' intellectual *Tuesdays* and the renowned Imbert de Mort's *Thursday dinners,* among others. Montesquiou had *entrée* to all. Jacques had forever struggled to ignore this *creature,* who spawned followers with the mere turn of his simpering hand. We were all revolted by the grossly affected mannerisms hiding the foul black teeth, but I have an inkling that for Jacques, he was in other respects rather too much like himself for comfort, most of all in his avid aspirations as a supreme collector. It was his crowning frustration that the infuriating Count seemed to have been blessed with some actual, if not inconsiderable, literary talent.

On Jacques' behalf, I too was wounded by Montesquiou's remarks. Oh that girlish titter behind the gloved hand...

I was doubly concerned to hear of other mutterings about Doucet losing his mind, after the tragedy of Madame R. And it was true, he did find it difficult to overcome his sorrow – the pain increasing with time rather than receding.

By the day of the sale, every minute detail had been attended to. Jacques, so meticulous as vendor, was contented that all was ready. He took himself far away from the auction. He chose instead to stay in a seaside palazzo on the Côte d'Azur and found himself a prisoner of the Mistral winds, unable to relax out of doors.

The sale became a sensation, dispersing the renowned collections to the four corners. For three days the auctioneer's gavel pounded relentlessly on the podium, in a gallery alive with eager buyers. The event's progress did not just occupy a whole special supplement of the *Gazette de l'Hôtel Drouot,* it also featured in the pages of *The Times* of London and the *New York Times,* as well as the American press generally – to where much of the spoils were destined.

'It's the sale of the epoch,' Rothschild proclaimed to Montesquiou as the auctioneer's hammer continued to fall. 'The haul is approaching thirteen million.'

'I can't imagine what he'll spend it on,' the Count replied with great curiosity, not having riches of his own on the scale of the Baron, nor being a freshly minted multi-millionaire for that matter. He piped up with unguent spite, 'Perhaps it will be gold-plated sewing machines!'

Many disappointed bidders went away empty-handed. The gossiping wife of American painter, Walter Gay, declared peevishly, 'Doucet razed and dismantled everything because the woman he loved had died before they could marry. It's the act of a spoilt child who, having been deprived of his favourite toy, breaks all the others.'

As though the destruction of the collections were not sufficient, immediately afterwards Jacques offloaded the mansion itself, to René Gimpel – international art dealer and brother-in-law of Joseph Duveen. My grand couturier's actions were seen as nothing less than sensational.

Oddly, I recall, he bought nothing that following year. Yet there was a weird Eastern inspired lacquered panel that he had become fixated upon, *The Magician in the Night*. It featured a flower, a lotus bloom perhaps, and the work of a modern designer, an Irish woman, I think. 'So compelling' he called it. The panel was also named from the actual words of a Buddhist chant, Om Mani ... something? He even took to practicing it for a while. How strange and ungodly, like his mind had turned. Was that the start of all this?

NOW WHERE IS JACQUES? Surely he would not leave me waiting? Jeanne stares at the library door and then consults her prettily decorated robe watch. *No. I'm a little early perhaps...* Having read something of the obsessions of the extreme aesthete Des Esseintes, she cannot help but let her mind run on again, on the subject of his infuriating fetish of *beauty-seeking*.

Recognising the familiar footsteps, Jeanne attempts to compose herself. Jacques enters the library – proudly impeccable – his frock coat lying smoothly against every contour of his form and with not a hair or whisker astray. She cannot resist admiring his handsome bearing. Her nostrils catch the drift of his familiar vanilla scent, perfumed with night blooming jasmine and beaver castoreum.

Each shy inwardly at the prospect of further conflict and politely address one another.

'Madame Doucet.' 'Monsieur Doucet.'

He bows. She nods. They hold steely expressions like generals on the battlefield.

Before Jacques can even offer his wife a seat or refreshments she begins to open her heart. 'In the War, when everything was so grim, I thought you needed someone. But now I don't know.' She picks up *À rebours* and approaches her husband with some trepidation, but with serious purpose. 'You know, Jacques, this character Des Esseintes is rather like you. Such similarities!'

'You are aware of what you are saying?' Jacques exclaims, quite taken aback. He visibly stiffens. 'Apart from that being a gross insult, you do realise, don't you, the character is modelled on Montesquiou?'

'But of course you *are* like him ... just a little.'

'How could you compare me to him, Jeanne?'

'It's here. I could read to you...'

'No, please don't,' he rears up. 'As if I would take aestheticism to those obscene levels?'

'There is a comparison, surely, no?' she queries insistently.

'One should not speak ill of the dead, but this is quite different. Montesquiou was perverted ... deranged! And there is a fine line between being an artist and an imbecile,' he snaps back.

'Well, I'm sorry, I'm sure. I suppose the Count could be very spiteful towards you.'

'You recall the unwarranted insults, even placing an announcement in *Le Figaro* saying that my Salon had been postponed, so that no one turned up.'

Jeanne nods in acknowledgement.

'It wasn't only me. Look how he mistreated Sarah Bernhardt too.'

'He did? A lovely creature like that. Fêted as she was.'

'I had an auction duel with him over her.'

'Oh?'

'Yes, yes. Despite his proclivities Montesquiou seduced Sarah, our most glorious customer. Dear witty Sarah, she who had made couture palatable to me. She, of all people, was defiled by him. Having spent the night within the rumple of her silken sheets, rather than take joy in such a privilege, this *beast* actually publicised his *revulsion of female flesh,* letting it be known he had vomited for twenty-four hours afterwards.

'I was enraged. On her behalf, I cursed the ratbag, regarding his deplorable conduct and demanded satisfaction!'

'Very gallant, I'm sure,' comments Jeanne, still with acidity.

'He called for pistols at dawn, but I refused his petticoat duel. I decreed that we would settle it where it counts - in the saleroom. The Hôtel Drouot was advertising a very special item, and I knew for certain he would be there!

'It was a rare opportunity for him to reunite his otherwise price-less eighteenth-century Riesener cabinet with its original precious doors. So I resolved to bid to the skies. I knew I could deprive him of his most yearned-for prize or make him pay a king's ransom...

'At auction I bid the price up to many times more than the worth of the doors. They were presented as a mere decorative panel - but he could scarcely refuse them. The malevolent ass was left reeling - his finances stretched considerably beyond his resources. Ha!'

At this Jeanne cannot resist a wry smile. 'Chivalrous to the end... Perhaps that's your trouble Jacques. Too chivalrous by half!' She reflects again on how amusing and frustrating the stubborn man can be.

'Yes, very well. But I've digressed.'

'Indeed. Have you something to tell me, Jacques...? Perhaps your gallantry might extend towards your wife more often.'

He smooths his beard apprehensively. 'Have I not shown you my love, Jeanne?'

She pauses before answering. 'It seems you need that wretched painting more.'

'Not a bit of it!' he insists. 'I never dreamt it would cause such trouble.'

'It's so utterly depraved... An obscenity. And that is besides the rumours.'

'Rumours?'

She rests her hand upon the head of the granite raven. 'Why, the Countess de Gaillon refuses to visit ... having heard that the fruit on the table represents... Well ... private parts ... castrated from a man's anatomy! Imagine!' Jeanne complains, taking out a handkerchief to dab a tear. 'Oh, those sluts, openly propositioning any man looking!'

Jacques is uncomfortable at her stance. 'My dear wife, this is what I want to tell you. I'm having the painting removed. Please, Jeanne, take a seat will you? Allow me to explain.'

They relocate to some plump armchairs, some distance apart before the library table. 'But isn't there more to it than this?' she persists.

'Don't, Jeanne.'

'When you lost your poor Sonia, I was deeply sympathetic. Not that it was a respectable conjugation ...'

'Careful, Jeanne.'

'You and I had separated after all... When we finally married, I believed you'd let go of her memory – entirely. And now ... well ... that painting meant so much to her.'

'She's been dead these fifteen years long.'

'Can you promise me, you'll banish all thoughts of her?' she asks solemnly.

'Jeanne, we cannot rule each other's thoughts.'

She jumps up and moves towards Jacques accusingly. He stands up to face her, but is careful not to come too close.

'So it's true, you *do* think of her!'

'You begrudge me a ghost but would allow a mistress, not that I...'

'How can I compete with a dead woman?' pleads Jeanne. 'I see I am right! You've never accepted your loss, even now. And as for Madame Roux – her especial admiration of the painting – well, it says more about her than you'd care to admit.'

Jacques struggles to maintain composure. He grips Jeanne's arm. 'Madame, you would do better to hold your tongue than to say such a thing!'

Jeanne pulls away. 'Take your hands off me!' she exclaims.

'You refuse to understand.'

'Oh I understand perfectly well.'

'My conduct scarcely amounts to any disloyalty to you, my dear... Knowing that Madame Roux's tragic end was, among other things, connected with her infatuation with matters *surrounding* this painting – matters which go beyond the painting itself, beyond art – I am forced to try and get to the root of it. One must forget one's own self in these matters,' he urges. 'Nonetheless, I want *you* beside me. You're my wife, Jeanne. This separation is unbearable... But don't speak ill of her. Let's not speak of her.'

'I won't disrespect the dead, but ... how you reacted when you lost her... Look how you destroyed those wonderful collections.'

Now, all these years later, in the midst of a legion of bespoke volumes that form Jacques' latest collection, Jeanne continues in her wrath. 'And for what...? To buy books... Books... All those books! Like a madman. Surrounded by mountains of books, filling five apartments – all without purpose.'

'Of course there was a purpose,' Jacques contradicts her. 'I confess I was drowning in books, but what became of them...? A monument to our name now stands at the University of Paris: The Doucet Library of Art and Archaeology, effectively the national art library of France. Does that mean nothing to you?'

'A noble gesture I'm sure, but it's of little consolation to *us* – now our resources are decimated, and our good name is in tatters!'

'How you exaggerate, Jeanne! We need not be fearful.'

'Again you are amassing books,' gesturing to the shelves around

her. 'And now also, the art of savages... And I'll not mention your anarchists again... You never ever stop... Yes, I must support you in sickness, if that arises. But in my opinion this is an unbending refusal to yield,' she pleads. 'My sensibilities are crushed. If I'm to return I must be reunited with the charming man of reason I once knew!'

'What more is there to say then?' Jacques takes his wife's hand with solemnity. 'I shall dispose of the Picasso. I'll not forfeit our happiness for mere pigment on canvas.'

7

Judge a man by his questions rather than his answers.

Voltaire

JACQUES DOUCET HAS returned home from the library. He is restless, pacing, and feeling idiotic for it. He paces some more, in front of the offending image, as if it will deliver the solution. *Such a hideous dilemma,'* he frets. *A debacle! What am I to do? I've promised to dispose of it. But to where? And how? For Sonia I must discover its secrets. How am I to rest otherwise?*

The picture remains as a monstrous intruder, not just dwarfing him in his study – where he gazes into the larger than life *Brothel* – but as a blight on his life. It is now nearly a year since visiting Picasso with Breton and the acquisition of the incendiary item. The Doucet marital home is a world away from bohemia and Jacques reconsiders his ludicrous predicament as the crudely painted fleshy gorgons tower above him. He always suspected the purchase would not be to his wife's liking, but never anticipated the kind of hostility now manifest.

Jacques, who is so calm, controlled and immaculate in all outward appearances, in manners and in taste – a man revered and held in the highest esteem by the cultured and literary circles of *la Belle Époque,* if not by the more snobbish circles of an aristocracy still lingering on in France, is supremely successful in business, an orchestrator of artistic innovation – is yet consumed by inner turmoil. As well as a great tragedy he carries in his life, he is now encumbered with the offensive inanimate object, so magnetic he cannot let go of it, even

with its propensity for creating havoc. But it is absurd to equate the two. *What is awry?*

He pauses a while, facing it, then peers closely to peruse the flat surface from every angle. Jacques, the spectator, the voyeur, gazes, then cocks his head, allowing himself to be welcomed – invited to participate: first, at the table of epicurean delights placed in the fore-ground – *surely the healthful fruits ARE suggestive of severed male genitals?* – And second, in the company of the naked females above him. Such thoughts cannot be un-thought. He feels a barrier, unable to breathe for the lack of pictorial space.

The women are being offered to the customer ... or is it the other way round? And who is the customer...? Surely it is I?

The alarming women invite him in, and yet they crowd forwards to occupy the whole of the picture plane. There is no depth of field. Now solicited, at the centre of attention, the challenge is for him to respond, but it provokes a wave of anxiety. *Is this the artist's stratagem: the spectator's response gives meaning to the work? Until now, painting has seemed to be merely the arrangement of form and colour, presented as a window on the world, judged for What it Looks Like. But here Picasso demands that the spectator confronts the unseen – that which is hidden. Is that it?*

Is Participation a part of the trick? But this would empower the viewer? Perhaps Jeanne's response is the correct one – conventional as it is? – does she understand it better than I...? No. No... I cannot think... It is preposterous.

It is now days since his firm promise to remove the painting and nothing yet is arranged. He needs help. Alas, his dearest confidante, The Peregrine Suarès, is away at Les Baux-de-Provence. Jacques takes a sheet of ivory-coloured vellum and pens a note:

My Dear Peregrine,

I need you here my friend. I have followed through on the strategy precisely as we determined and now I find myself

deeply embroiled in dilemmas. Mme D will not tolerate the big Picasso!

Meanwhile the Germans are in France en masse buying everything that can be bought. I have been much solicited, but I remain firm in my position. It would be silly to let anything go. On the contrary, there are two or three slightly scandalous things – too advanced for them. In two years I will prove to have been right with Les Demoiselles. At least this is my most fervent hope. For the interim though, there is a problem!

Let me know when you will return.

Most fondly … J.D.

He turns his thoughts to another poet to whom he has been a friend and patron and pens another letter:

My Dear Max...

THERE IS A ROGUE rumple in the couturier's silk-lined cloak as he approaches the mighty façade of the Abbaye de Saint-Benoît, some one hundred miles south of Paris. Greeting Jacques is a shorter, bald and robed man, who has retreated into monastic life. This forty-nine-year-old poet is eccentric in the extreme, with highly effeminate mannerisms.

Max Jacob, formerly one of Jacques' Young Tigers, addresses his patron, *Monsieur Protecteur!*

Jacques acknowledges the appellation with a wistful smile. His visit to Saint-Benoît-sur-Loire, however, is not for business purposes and signifies a reversal of their roles. He approaches this newly religious Redoubtable with care and a plan for gaining his assistance.

'Salut, my fine man. How do you do? You have new gravitas I think in your robes?' he beams at the compact fellow.

Max leads the older man around the ancient porch tower, saying little, allowing the Briare stone masonry to deliver its own grandiose

dispatch. Beyond the entrance, Jacques scans the breathtaking space, naturally staring upwards at the high arches of the nave. The pair follow the hallowed paths along the side aisles in turn. The visitor politely remarks on each canopied recess and niche, even entering the crypt to view the site of the holy relics of Saint Benedict.

They return to the shady path outside and study the sculpted stone-work detail on the north portal depicting the four horsemen of the apocalypse. Jacques is mindful that Sonia was a sometime associate of Max in occult and mystical practices. He turns to him and begins with questions relating to his own business at hand.

'Could you cast light on Sonia Roux's obsession with *Picasso's Brothel*, and the mysteries she perceived it held?' He observes reluctance behind the monk's eyes.

The question is met with a pregnant silence. Jacques soon jumps into it, to avoid further embarrassment. He pitches again, knowing that Max was a first-hand witness through the period preceding and during the execution of the great canvas.

'What do you know of its secrets, Max?'

'Impossible!' Max snaps back rather curtly. The outcome of the interview is not looking promising.

'Quite, quite,' Jacques blusters apologetically. This early foray into the subject is apparently blocked by an icy wall. He is left to brood. *It seems it is true that this acolyte is, and always has been, passionately loyal to Picasso and will never – under any circumstances whatsoever – disclose his maestro's confidences.* Then he appeals to the monk on another level. 'But dear Max, could I trouble you to *counsel* me in my current predicament?'

During a lengthy stroll around the serpentine cloisters, a little history begins tumbling forth from Max concerning his comrade and idol, Picasso, but only that which he feels is innocuous.

It was twenty-five years ago, on Picasso's second and third visits to Paris of 1901 and '02, when the painter and Max, then a poet, shared a squalid attic room during the leanest time in the artist's life. 'It must have been a struggle,' Jacques coaxes gingerly, but on

this less intrusive aspect, the monk recalls the period with glee.

'Such was our bankrupt situation – we jointly used a solitary bed. Not at the same time!' Max adds ruefully. 'Pablo slept during the day and I at night. The arrangement was workable since he often preferred to paint at night... And my goodness, those days of hunger I'll never forget. One day the cat brought something in. Pablo watched me drag a sausage from her jaws. He laughed very much when I told her to go and hunt for mice.

Holy Father that stinks, he cursed, retching at the slimy thing. *Fear not. It'll be fine once it's cooked,* I said, happy to have real meat. A little later I was prodding it in the tin on the old stove. Pablo asked, *How's it coming on?* It was sizzling very nicely. But then,

B A N G.

'It was really loud. The sausage exploded and the tin hit something, making me jump backwards in fright. Bits flew all around. Some landed on Pablo's painting. We both leaped back further. The cat, too.

'Wha...!! We shouted in unison.

'Stinking foul! Pablo grouched.

'It was completely putrid.

'We were to eat that?! he exclaimed and flicked a piece of rotten meat from his canvas, which landed on my coat. *Here. Your bit. Our only food.*

'Oy! My only coat! I shouted out. And brushed it off, quite horrified.

'Food, Max...? A mirage, he quipped, and took up his post again in front of his florid whirlwind of dancers at the easel... He could always keep painting despite the privations of little food.'

'My poor fellow, I'm sure it's as well you didn't consume that particular offering,' Jacques sympathises, feeling quite bilious.

'I was the first of Picasso's true comrades at this time and present

at the very germination of his success. With five years on him, I was simultaneously like his junior and yet opposite. Without a common language we began our communications by signing and miming. But it was I who nursed him to the French language, culture and literature.

'He was a titch, with a big head like me. In those days we shared a penchant for top hats – sometimes the same hat. I'd say we had the same sense of fun, infantile you'd call it...'

Jacques has heard of this, and that this humour was also satirical and ribald. He begins piecing together this new information he is gleaning with the old. He is already aware of the unfortunate mirroring: Max Jacob the generous giver and Picasso the ruthless taker, a sponge soaking up the other's erudition to exhaustion, before discarding him in favour of the next in line – a succession which includes some of the great minds of the epoch: Guillaume Apollinaire, Jean Cocteau and André Breton.

'As a couple of doubters, me Jewish and he Catholic,' Max continues, 'we were both 'church' dodgers. I didn't like being called an Inverti, but I was a little wild and could not hide my lust for certain hunks, the rougher and readier the better. This inclination, alas, was never shared by my macho Andalusian.'

Despite his initial coyness about Picasso the monk waxes on, occasionally clearing his throat and stopping as if considering the consequences of his discourse. 'Our religious roots became entwined later, when I converted to Christianity,' he explains. Curiously Pablo became my Godfather and at the sacrament he gave me one of his own baptismal names...'

'Excuse me, but how can this fit with dabbling in the black arts ... *Cyprien?*' asks Jacques, still a little at odds with the new name.

'That was then. You recall how interest in the occult flowered in our beautiful epoch? We gained Theosophists, Rosicrucians, Neocathars, Gnostics – all of whom called our great city, home. I played around with palmistry, astrology and tarot – such useful sidelines.'

'And communing with the dead, by all accounts?'

'Despite converting I have no remorse for introducing dark practices to Pablo. He surely made use of them.'

Jacques is beginning to wonder if the weirder aspect of Picasso's early work – that which had so intrigued Sonia – was born of Max's influence.

He considers again this former court jester to *la bande á Picasso*. It was Max who had dubbed the Montmartre studio-apartments *Le Bateau-lavoir* because of the resemblance to a laundry barge. He had proffered magic tricks. His ready forays into slapstick song and dance routines, with trousers rolled up and a knotted handkerchief straining over his oversized head, naturally made him popular, and he had revelled in satirising the bourgeois culture in a high falsetto voice.

That the poet should become a close associate of a member of the cultural elite, such as Jacques Doucet, is unexpected, yet the collector's patronage of the young Surrealists and avant-garde writers includes him. Max, now *Cyprien,* has been treated alongside Breton, Aragon, Eluard and others, to having his works glorified in precious bespoke editions in the Doucet manner. The unity of poet and patron reached an apex when the Bibliothèque Littéraire published his poetry – and it seems now the two are practically intimate.

Jacques reflects on the irony, *now the painting of the artist fed by the mind of the poet, fed by the patron, has comes back to haunt the patron!*

The connoisseur and the monk stroll through a leafy walkway and pause at a bench seat beyond the Romanesque basilica. The air is pleasant enough in the unseasonably warm afternoon. Jacques begins a lamentation of his predicament, describing the events surrounding the acquisition of *Les Demoiselles* and his subsequent rift with Jeanne. '... I have, in my possession perhaps the great *coup* of the modern age ... but it seems to be cursed.

Max bursts forth with a ditty from an English comic operetta: 'A nice dilemma, we have here, *A nice dil – e – e – e – m – m – m – a ...*'

'Yes, Max. – Look my friend, this is serious. Jeanne is one thing but it is as though a bizarre power has taken me into its grip. Is the

picture really sincere or some sort of hoax as everyone always says?'

'A sincere work is one endowed with enough strength to give reality to illusion.'

'I've been sanctioned by my wife. I must not hurt her, but I'm unable to bring myself to be rid of it yet.'

'No doubt she finds it indecent?'

'That's not all. She is aware that it conjures up for me the memory of Sonia Roux.'

'Ah, therein lays the blistering question. Am I right?'

'I confess I *am* driven by her memory. Just lately at any rate – since I bought the picture last year.'

'My dear old thing, if you could only closet yourself away as I did ... it was all I could do to keep my hands off those beefy boys in Montmartre.'

'That's all very well,' replies Jacques, half amused and shaking himself, 'but it is my seething mind I'm trying to escape from.'

'I had that trouble. For me it all changed when the Holy Virgin told me I was crummy. I said to her, *Not as crummy as all that, my dear Holy Virgin.* Now. I *cannot* sin quite so energetically...'

'Not for me Max, I'm afraid,' he cuts in with a perceptible growl. 'But really – oh to know what Sonia would have thought – I mean, of my actually acquiring the painting.'

'Perhaps we are among the few who appreciate it, Monsieur Protecteur?' suggests Max as they walk on.

'Sonia did. But *why,* in her case?' Jacques asks and then digresses. 'My only wish is to look forwards ... yet all I do is look back.' He instantly rewinds his thoughts to earlier days of his own conversion to modernity. His companion seems a strange and unlikely audience, a mixture of genius, reprobate and hermit, but he offers calm with his intelligence which is nurturing.

'It was after hours one evening in the salon of my fashion house. I remember snow falling heavily, transforming the rue de la Paix into fairyland...' he pauses to calculate. 'It must have been ... early '07. In a private meeting we had only the gas lamps from the street for

illumination. My lady and I enjoyed a snatched moment of tenderness and privacy. What I recall most was the light washing in eerily, impersonating moonlight. It played on her gleaming jet locks – creating a blue purple iridescence as she bent over reading my palm.

'On the wall above us hung Fragonard's *Le feu aux poudres,* depicting the image of a bare-breasted, sleeping girl, reposing on a silken, heavily pillowed couch, with a provocatively raised leg, embroiled with naked cherubs and putti, all gazing upon her in adulation and love. Such was how I felt about my perfect love.'

Max listens attentively, hearing the emotional lilt in his companion's voice.

'Sonia glanced up, engaging me with those beautiful dark eyes, gesturing to the heavy gilt frame above. She quite stirred my thoughts saying, *One day you'll leave boudoir art behind you, Jacques, and remember all this as a mausoleum.* I naturally resisted and demurred at this. I looked all about me in disbelief, at my majestic baroque antiques and paintings. *Jacques, this may be the greatest, most wonderful, eighteenth-century collection in France,* she went on, continuing to wound, *but in the end you'll see it all as bourgeois clutter!* At this I withdrew my palm. Sonia placed both hands upon a rounded cherub figurine. *Collecting, like the man on a Sunday afternoon in quest of tie pins,* she said cruelly.

'I bristled, *You don't know, do you? Only a collector could know – the exhilaration of the chase...* I evaded her sharp stare. *Like a compulsion! For what?* she needled me. *To covet...? No, no, no! – to assemble,* I defended myself passionately. *A real collection must be a masterpiece in itself, judged on its merits.* At this she struck her piercing blow: *Then collect for what art Means, rather than how it appears,* she said, gesturing towards the myriad artefacts all around us, *instead of all these – age-old likenesses and traditions...'*

In his patient stance Max leans in attentively as Jacques continues. '... I asserted that most of the works meant a great deal with many stories to tell, but Sonia was having none of it. *Ah, but in this machine-*

age – the world changes almost too fast for reflection. Today's painters wrestle with philosophy. Take Picasso, for instance, right now who struggles with a gigantic canvas. Such a work would be a worthwhile cause. Of course I was completely baffled.

'*But don't be fooled. New art will still be informed by the old – primitive even –* she said emphatically, searching a leather folder for an illustrated sheet. *Take the Lotus Sutra,* she continued, with sparkling animation, handing me a page with CAUSE & EFFECT written upon it, and an embossed image of a lotus flower. *The meaning of life can be found in this,* she added, extoling the virtues of Buddhism. *A true artist could use such an idea.*

'Struck by her enthusiasm, I nevertheless stopped her, wondering which way we were going with this discussion. *You have said before that Picasso conceals – conceals what exactly?*

'*Whatever it is, he is keeping it to himself,* she replied. *But I feel it goes back a very long way...*'

'And did she enlarge on that?' asks the monk.

'It is all I remember. But you see, Max, I cannot dispose of the painting just now. You *knew* her. How tremendous she was... And you were there when *Les Demoiselles* was painted. I have to know everything,' he pleads.

'It's true, I witnessed Pablo's frenzy, but you'll not expect me to make revelations about my dear boy-godfather... Well,' he corrects himself, 'hardly a boy these days! Ooh noo!'

'Oh, come, come, Max.'

'I never have and cannot now – not even for you, my own Monsieur Protecteur.'

Jacques is suddenly downcast, feeling certain that Max must be withholding something.

'Perhaps I could help out in other ways, Monsieur? I could probably find a fine cassock for you somewhere around here – nice and airy and loose...' Max lingers on *loose* and laughs. 'I think you'd like it...'

Jacques recoils and attempts to overcome the mischievous monk's derailment of the matter in hand. Nonetheless Max recounts with wit

and vigour details of his life with *la bande á Picasso,* the japes and tragedies, the stunts with Apollinaire, the Pichots, sculptor Manolo and the Catalan fraternity. 'I'll tell you how Pablo drew André "Longfingers" Salmon with an oversized chin and exaggerated hands ... I'll happily tell you of the women folk at the Bateau-Lavoir... Picasso's Fernande and so on, and even my delicious conquests with the *rough trade* of Montmartre's gutters,' he continues, fluttering eyelashes.

Jacques is alarmed by a burning sensation in his cheeks and wonders if the flush is visible to Max.

'But I'll not dabble with the stuff of his soul.'

'Who was he consorting with at that time? His influences? Can you tell me this much, Max?'

'Alright,' he pauses. 'The door of the studio Picasso at the Bateau-Lavoir carried the inscription, MEETING PLACE OF POETS. There were three French poets who formed the core of *la bande*: Kostro, that's Apollinaire, Longfingers Salmon and myself. We often delved into literature, the Symbolist poets, and sometimes philosophy and mathematics.'

'Oh indeed. When I first met the maestro Picasso, just before the War,' Jacques recalls, 'I was with the writer Henri-Pierre Roché ... we went to his studio on the rue Shoelcher. I noticed our friend spoke much more fluently than I had expected.'

'We *had* spent a lot of time on his French by then.'

'Well, we conversed for some time,' Jacques continues. Indeed, when I ineptly suggested that his Cubism was not sincere and that he might be fooling the public, he became quite persuasive and snarled back, *Was Michelangelo sincere when he painted the Sistine Chapel?'*

'You were not convinced by Cubism then?' asks Max.

'I was genuinely intrigued to see his work. I even bought a couple of small pictures. I had heard that here was even a genius – one who could draw like Michelangelo. He sketched my portrait that day, but it was no masterpiece. It took him all of ten minutes!'

'I know the one. More of a caricature, if I may say so, and not Cubist either.'

'I visited him again later,' Jacques continues, 'at a funny little house in Montrouge. Despite the poky rooms he seemed perfectly happy in his suburban hideaway, escaping from the hurly-burly and the unwanted attention of Montparnasse, but he didn't seem to be doing much painting – just drawing.'

'Yes. Perhaps there was a time when he partially discarded Cubism. To the great dismay of his followers, who, lacking his gifts, were not sure what to do.'

Jacques raises a carefully preened eyebrow with interest.

'But as a painter, his attraction was always to writers – men of the pen rather than the palette and brush – in a world in which painters might normally band together. There was I, and then along came the other poets – Longfingers and Kostro. Pablo and I had our own niches at the Bateau-Lavoir and Longfingers soon joined us.'

'The man with the spindly hands, eh?'

'Yes, the quiet one, always holding a wooden pipe. Like the rest of us he was an outsider but you would never have thought he was from a family of Communards – beginning his career as a bowler-hatted man of commerce and looking like a banker. Inevitably his muse took over and he had his early poetry and writings published. He championed New Painting and in time edited *Vers et Prose,* his magazine. For Pablo, our willowy youth with a protuberant chin was perfect fodder for caricature.'

'And Kostro?'

'He was similarly attired and did actually work in a bank. He boosted his income writing critiques and reviews as well as the bawdiest of pornographic novels. Just one year older than Pablo, he was a mountain of a man, with avuncular presence. What an erudite, witty dear creature with his overgrown pear-shaped head! And another victim for parody. Wilhelm Albert Włodzimierz Apolinary Kostrowicki,' Max pronounces with some aplomb. 'He called himself Guillaume Apollinaire, but for us he was always

"Kostro". He was the most influential poet of our time, as well as Pablo's champion. No one was more effective in promoting our painter. Kostro strove to identify the concept of New Art, even more so than Longfingers. He all but birthed the lexicon of modern art by calling our lot The Cubists, especially Pablo – declaring Cubism, *a new and very high manifestation of art. Not a system constraining the talents.* He named Surrealism too.'

'Did you poets influence the creation of *Les Demoiselles?*' Jacques probes.

'You must decide upon that. We were gods of course, ha! Pablo drank up Kostro's pontifications. But it was Baudelaire, a generation earlier, who led us all. Our Longfingers, Salmon – there at its creation – went from being scornful about the big picture at the beginning, to exhibiting it, as you know, for the first time ever at Poiret's during the War. He was a great apostle of Cubism, but like many others, *after* the event.

'The exhibition *L'art Moderne en France* took place in 1916. Wartime xenophobia rather infected the newspaper coverage, when a number of artist-soldiers had returned to Paris injured, many of them foreigners. That affected Pablo of course, himself a foreigner who had not enlisted.'

'I hurried back myself from my sojourn in Fontainebleau to see the exhibition,' says Jacques, recalling it vividly.

'Ah, you were there at Poiret's?'

'Of course. When I first encountered the picture, in real life – larger than life you could say. I was troubled. I had seen it previously in a photograph I had obtained for Sonia from Burgess.'

'Burgess?'

'The American from an architectural journal, Gelett Burgess...'

'Oh yes, I know.'

'So this is it? I pondered, standing before it in the gallery. *What on Earth had Sonia seen in this?* In all honesty I was repulsed, though I was not deterred from trying to buy it, if only to begin to understand her infatuation. I even instructed an agent put in a bid, but it was

not for sale.' He pauses. 'I am aware, Max, The Peregrine had a low opinion of André Salmon but would ... er ... Longfingers be someone I might talk to?' asks Jacques.

'You might find him unreliable. In his writings he describes the picture as showing *six* women!'

'If only Apollinaire was still with us...'

'It was curious that he had little to say about it, but you might look at his writings on Picasso.'

'Believe me, Max, I've been searching through his voluminous critiques and found nothing about *Les Demoiselles,'* the glowering Jacques says with a note of resignation in his voice. 'I fear I must dispose of it. Besides, I've promised Jeanne I will do so.'

'Dispose of it?'

'The museum has rejected it out of hand. Their endorsement might have validated it in Jeanne's eyes. But alas, no.'

'You might remove it from the house and store it somewhere until the rift subsides.'

'If I take it to some faraway place, its spirits will continue pursuing me, haunting me like a ghost.'

'You are really serious, aren't you, monsieur?' He steals a cautious look at the furrowed brow of his one-time patron.

'Perhaps so,' he flounders. 'Even if I sell the painting it will still exist and the haunting will carry on.' After a perceptible pause, 'Haunting? Am I going insane, Max?'

'Surely not!' the monk snaps back, but quietly harbours doubt.

'Sometimes I lie awake at night thinking I should cut my losses and just burn it. Perhaps that's what I should do, burn it!'

Max then looks askance at Jacques, checking for the vital signs of sanity, scarcely able to contemplate such a course of action as real. 'Monsieur. Never that! Promise me, never that. It would be quite reckless, a criminal act beyond all reason...'

'Maybe there is no other way, Max,' he replies despondently, suddenly quite exhausted.

'Let us repair to the refectory for refreshment,' the incumbent

suggests, concerned for his elderly guest's dispirited condition. As the two walk in that direction, Max has a fresh thought. 'There were, of course, times when Pablo himself turned the picture to the wall to avert its vacant, staring eyes.'

'Jeanne is scarcely going to accept that as a compromise.'

'I don't know?' questions Max.

'Besides, would not its actual presence allow it to persist with its allusive powers?'

'Could you not transfer the painting to a place of safety, beyond reach of any living person, including yourself, Monsieur Jacques.'

'And where do you suggest, pray tell?'

'Ah, that is the question. On the moon perhaps?'

'No... But wait a minute, Max...'

8

The memory of an absent person shines in the deepest
recesses of the heart, shining the more brightly the more
wholly its object has vanished: a light on the horizon of the
despairing, darkened spirit; a star gleaming in our inward
night. – **Victor Hugo**

JACQUES ADJUSTS the fastenings on white linen sheeting which cocoons the giant *Brothel* painting in preparation for its removal. Two delivery men stand by and take up the cloaked cargo from Villa Doucet through the gates to a large delivery vehicle stationed in the rue Saint-James. Chivet stands in attendance admiring the pine-green Berliet lorry, shining and well-liveried in lettering advertising Service with Security, Moving and Storage.

Jeanne remains in the drawing room overseeing the same carpenters employed earlier, reinstating the French windows following their temporary removal to extricate the painting. Jacques walks over to his own motor car where Max Jacob – now in an oversized suit – sits in the rear saloon, proudly upright and alert, in anticipation of the journey. Motoring is a novelty for the poet-cum-monk. It was a task persuading him to return to the dangerous environment of the City of Light – his own particular place of sin – but now here, he is excited and with a bounce like a child.

In fact it is impossible for Max to restrain his joy at the fairytale luxury of the limousine – although it seems sinful to notice such material matters. It is impossible to avoid the special features of the upholstered coachwork – even the car's ornate garlanded door

handles are exquisite. He realises that if he is to accompany Jacques, he has to endure the frills of his rarefied existence. It is a price he must pay for accepting the rôle of unofficial spiritual mentor to his admirable patron.

Staying as a guest in the Villa Doucet, for once in his life Max is indulging in the pleasures of exceptionally fine bed linen and running hot and cold water. Thus he has stipulated that his stay will be for two days only and insists that Chivet must return him to the Abbaye not one hour later than agreed.

Once Jacques has ensured the precious picture is properly strapped and safely secured within the covered lorry, they are ready to depart. He turns to the man in charge of the removal. 'I shall lead the way, Monsieur le conducteur. My chauffeur Chivet has the itinerary and is instructed to moderate his speed. We will be pulling over once or twice for provisions en route. Just follow us closely if you would, gentlemen, please.'

Jacques joins Max in the rear of the car. Chivet is at the wheel and the monk involuntarily conjures words in his mind to describe the line of the driver's cheek and nape from behind.

They lead the convoy slowly from Neuilly-sur-Seine, on their journey to La Chapelle, along the avenue de Neuilly, via the Arc de Triomphe, but divert south for the embankment towards place de la Concord, in order to collect the expedition's required funds from Maison Doucet.

As they travel along quai de la Conférence Jacques is distracted by sightings of dismantled pavilion buildings – the remnants of the Exposition Internationale des Arts Décoratifs, recently staged around the Grand Palais and near to the Pont Alexandre III and the Esplanade des Invalides. He feverishly contemplates the *palais*, built for the Exposition Universelle of 1900. *Why, it is a world trans-formed from the time of Picasso's international debut!*

'Which was Picasso's painting for the 1900 Max?'

'*Last Moments,* I believe.'

'Just so.'

Jacques is also reminded of his current post-*Exposition* duties, now neglected like everything else. The joy of his own illustrious assignment, advising President Doumergue on a prized item from the Exposition for the Élysée Palace is now clouded.

Alighting briefly at his Maison Doucet premises in the rue de la Paix, the proprietor meets his private secretary Albert Vuafluart who is waiting for him with the specified cash.

From there the party travels north on the rue de Clichy, pausing in a small side street, at a plumbing supplier brimful with trade merchandise. Jacques makes his costly purchases and the hauliers load the weighty material into the lorry, to join its precious cargo. While the men complete their task, Max remains in the back of the Panhard, his gaze flitting wantonly from his small prayer book to those exerting themselves.

After an hour the convoy resumes, turning into the boulevard de Clichy – an old stomping ground of *la bande á Picasso.* Max's eyes dart around as he recognises some favourite old haunts, which he has not seen for many years. They drive past two of Picasso's former studios and notice the Moulin Rouge, thought to have been lost forever after a fire during the War but now recently rebuilt. He drawls crudely, 'Ah the leg-flinging factory. Phwoah – smell that fanny!'

Jacques frowns. *How utterly un-monk-like,* but this errant brother is too important to him to admonish. Thus he reins himself in from remarking on such a comment, fervently contemplating the gravity of his mission and all that has brought him to this present moment. Max is distracted from further libidinous outbursts by the sight of tattered posters for the Exposition Internationale.

The boulevard de Clichy gives way to those of de Rochechouart and finally de la Chapelle. The convoy turns onto the old tin route, now called rue Philippe de Girard – the site of their destination, the large Stockage Girard.

On the forecourt outside the building four workmen are setting up winching equipment. Jacques greets them with handshakes and

heartily thanks them for undertaking the task. Set into the adjacent paving, a small access hatch, a pair of iron doors, provide entry to the vaults below.

'It will never fit in there,' observes Max winking mischievously.

'I've measured it,' retorts Jacques.

The doors are open and the workmen deftly erect a gantry hoist on the ground above it, in a smooth and well-practiced motion. Jacques stares down into the blackness of the chamber, faltering at the prospect of what he is going to do.

A warehouse concierge appears. The slight, elderly retainer in an old brown smock coat peers out from a face flanked by abundant sideburns. He shakes hands with Jacques. 'Good day, Monsieur Doucet,' he says, blinking.

'How pleasant to see you, Maurice, and let me say again how much I am obliged to you for your promptness in responding to our little emergency.' Despite the gracious greeting, the concierge notices a nervous tic marring an otherwise calm expression. Jacques is perfectly on edge.

'Let me say, monsieur, nothing can be too much trouble when it's for your good self, monsieur,' the concierge answers, rubbing his hands together. 'If you would like to follow me, monsieur, I can show you what has been arranged.' And he leads Jacques to the warehouse entrance. 'I'm sure monsieur would not wish to be winched down with the consignment?' he smirks, pleased at his own feeble joke.

Jacques looks puzzled.

'I have keys to the staircase, monsieur,' adds the concierge with a flourish of jangling metal.

Jacques calls back to Max, now fiddling with his rosary, while watching the brawny men. 'Perhaps you can stay with the lorry until the picture has been unloaded?'

Receiving a cheerful nod, he returns to Maurice. They enter the building and check through the arrangements. 'We shall of course be wanting electric light below, if at all possible, my good fellow.'

The swaddled painting is reverently carried, from the lorry to the open jaws of the cellar, *like a princess's bed,* the collector fancies. The process feels ridiculous. He imagines the unnecessarily long folds of fabric curled on top of the lid of a sarcophagus with a withered body lying in state.

There is a hold up as the hoist has to be shifted to one side. The physical dimensions of the package are just fractionally too great for mechanical assistance after all. Two men descend by ladder while the others prepare to lower the precious cargo by hand.

Max rushes round to the building's entrance and joins Jacques in the brick-vaulted basement below. They watch the slow descent of the consignment as it emerges from above. Jacques expresses better humour upon seeing the worrying encumbrance soon to be out of the way from his daily life. The four muscular workmen rejoin their comrades and assist in resetting the winch.

Together with two burly hauliers, they combine their strength to drag the plumbing materials from the lorry: two rolls of code-8 lead sheeting weighing nearly a quarter of a ton.

'This is the highest grade – designated 82 on the periodic table – the most dense and impenetrable of malleable metals. This will do the job,' the collector exudes excitedly in answer to Max's inquiring glance.

'It's impermeability to anything, including sound waves, is extraordinarily robust,' Jacques mutters, 'it surely will extend to barring spirits, whether benign or evil.'

Max's appreciation of the excursion is being quashed by doubts. 'Can we really place our faith in the power of a dense metal in this way?' Uncharacteristically, it is the poet-cum-monk who veers towards common sense, while the business-like gentleman is clinging so resolutely to faith; yet Max continues to humour the master, admiring him for his attempted resolution at least. *It might nudge him out of his dubious fixation, perhaps.*

Once the lead rolls are on the ground, the men inch them, with the help of chains, towards the cellar opening, whereupon they

hook them to the hoist. With much harrumphing each one is slowly lowered, followed by other equipment – oxygen cylinders, welding gases, lamps, hoses, paraffin, aprons and welding masks.

The task in hand is to create a leaden shroud which will encapsulate the two-and-a-half metre square artefact and weld the seams together to provide an airtight seal. Here it will reside out of reach of any human contact, physical or metaphysical. That is the theory. In such a way it will be entombed but not destroyed.

'Could you not simply remove the canvas from its stretcher and roll it up?' asks Max.

'What, and crack the paint and further fray the edges? No. Not while it's in my care, old thing.'

The hauliers take their leave and the four workmen join Jacques and Max in the basement. They firstly have to settle upon a final resting place since the completed dead weight will render the object physically immovable. The entombers have been allocated a small side-room, more properly described as a vault with a high security steel door and safe-locks. The men lug the lead rolls into the vault and unroll them as flat sheets. The bottom sheet is placed on the paved ground upon which the wrapped painting is duly laid. The top sheet is cut into smaller pieces in order to move the weighty material into place – and then welded back into a single sheet in this final location.

Two of the crew are consummate plumbers, normally plying their craft on the roofs and turrets of the Parisian skyline. Max issues instructions as they don their welding goggles. 'It must be a perfectly waterproof weld: Tight! Tight! Tight! In a harmonious conjugation!' he adds, gesticulating expansively above the monumental treasure and bringing his hands together suggestively.

With much tapping and hammering, by means of wooden lead-working implements, the sides of the bottom lead sheet are raised upwards and trimmed. The corners are folded in as though the article in question is an origami envelope. Finally, before the welding can begin, the top pieces of lead are located in position and

precisely trimmed. Jacques is highly concerned. He looks on as the plumbers spark up their blow torches. Max makes light of the situation with flippant remarks like, 'Do steer clear of the flat areas at all cost, my dears. We'll have no mishaps, with your blow torches...'

He and Jacques step out of earshot of the welders and toast the occasion with a Georgian brandy shared from Jacques' hip flask. 'You are quite lunatic. Haven't I told you before? And how, my dear Monsieur Jacques, will this ...' gesturing back towards the leadwork, 'contain the evil atmospheres of the canvas?'

'Hmm – The dubious process of laying Sonia's ghost to rest. And Casagemas's ghost too. Why *was* she so morbidly consumed by the boy's plight, Max?'

The monk shrugs and then – possibly due to the effects of the strong liquor after his abstemious sojourn in Saint-Benoît-sur-Loire – his tongue is loosened, 'Sonia came many times to the studio to view Picasso's paintings of the deceased – in death and as a spectre dwelling *on the other side* – perceiving with clarity what others were perhaps too close to Pablo to recognise: the *depths* of his intellect and his grief, displayed in paint.' Max describes an occasion when Sonia came to visit him for a tarot session, which was held in his own modest quarters at the Bateau-Lavoir – known affectionately as Max's Shed.

'Pablo was out and she ventured into the basement studio. Sonia was instantly attracted to the images of Carles. She was curious and a clever woman, I think. She absorbed the idea of the fourth dimension and how Pablo was trying to paint time, as well as height, length and depth in space. She bade me repeat the words of our maths guru, Maurice Princet. His recent visits were a point of focus for all of us then; but she declared herself *under Carles's spell.'*

'Was this before or after *The Brothel?'*

'During... The giant painting was almost realised. Sonia studied it most carefully but was also enthralled by other pictures. Not least of all an image of Carles's apparition and a bizarre portrayal of his

ascension into heaven on horseback, greeted by prostitutes.'

'Did she have particular interest in *Les Demoiselles?*' Jacques persists.

'Oh, certainly. She seemed sure of her sublime connection with Carles and related *The Brothel* picture to the tragic boy. She also spoke about the birth of a powerful new geometry.'

Jacques ruminates over this for a few moments, twitching his velvety beard. 'Whatever made the supremely gifted draughtsman suddenly produce a thing like this...?' he asks, gesturing to the great monument on the ground. 'Not using his divine talent for drawing and painting, but resorting to something so crude and scurrilous – as most people inevitably see it.'

'It is a futile line of enquiry, Monsieur Protecteur.'

Now once again evasive, Max returns to the welders down on the floor to inspect their progress. Jacques lights a cigar, reflecting on his friend's further reticence.

The erstwhile monk gradually reverts to his former mischievous tendencies and dallies with the bemused welders as they work their way along the seams, sealing up the huge artefact. He shouts in risqué tones across to Jacques, 'It's a slow job, monsieur. Let's unpack the *lunch basket* for these fine fellows.' Jacques is amused by the monk and his basket. 'Then do the honours, do, old Mum!'

Max enjoys playing mother to the men, especially now he is a little tipsy. His tongue loosens. Max lurches towards them. 'Fellers. Fellers. He's you know ...' swivelling his index finger at his temple, 'what's he think the whores are gonna do? Rape him!?' Then he barks, 'Woof Woof!' The men haven't the slightest idea what he is trying to say and assume he is the one that is unhinged, although they cheerfully fall upon a fine repast of bread, cheese and slices of roast beef, paired with beakers of Côte de Brouilly.

Jacques busies himself setting in place a psychrometer with wet and dry bulb thermometers for measuring the humidity. The fastidious connoisseur logs the readings in a notebook.

Just as the penultimate piece is welded in place with most of the

linen obscured, some molten lead drips onto the last quarter. The welder loses his footing in panic, drops the blowtorch. The linen ignites as the torch's flame sweeps across the fabric. Jacques rapidly darts across, attacking the blaze with his gloved hand. To check for damage he carefully draws back the linen to expose the top left corner of the painting. The heads and shoulders of the three least monstrous demoiselles are revealed and astonishingly remain un-damaged. The plumbers and Max pause to survey the situation. They are visibly shaken as they brush away the burnt fibres.

'Monsieur won't pay for cinders!' Max exclaims in a slurred voice.

'Many apologies, Monsieur Doucet. This is most uncommon, a most uncommon occurrence indeed. No harm done though, sir?' pleads the miscreant plumber.

'It seems I'm cursed with this great wonder of mine,' replies Jacques, his alarm superseded by a huge sigh of relief. He removes the blackened gloves, quite appalled at their condition.

'The ancients,' adds Max, as he gazes at the left-hand Egyptian face in the painting, 'would've had just such troubles while crafting *their* tombs!'

Jacques mops his brow with a handkerchief. He jokingly identifies the three heads now visible. 'Isis, Nephthys, – that's Neith, the great Goddess of the Dead.'

Max points to the central pair, jesting, 'Picasso and Fernande more like!'

'Fernande Olivier,' muses Jacques. 'Hmm!'

9

When man wanted to make a machine that would walk he
created the wheel, which does not resemble a leg.

Guillaume Apollinaire

R E T U R N I N G H O M E from the great entombment in the Stockage Girard, and with Max dispatched to his monastic retreat, Jacques feels exhausted. Jeanne is seated regally at her Louis XVI escritoire attending to correspondence, opening envelopes with a precious ivory-handled paperknife. Her husband sets up a thermometer attached to the window frame, peering through his pince-nez and recording the readings in a notebook. The terrier, alert to some movement outside, gets under his feet and whines to go out. 'Quiet Rodin!' he snaps loudly.

'Jacques, I have to tell you there are outstanding bills to attend to,' his wife remarks, rising from her seat to leave the room.

'Yes, yes, dear... Tell Bonnet to do something with this dog will you,' replies Jacques, not wanting to be concerned with money matters on this day of all days, having expended a veritable fortune on the unusual expedition – of which Jeanne knows nothing, beyond the removal of the offending item from her house.

He has returned home with one name on his mind. It would seem that the isolation of the painting has failed to erase the troubled man's obsession. The moment Jeanne closes the door behind her, he picks up the telephone and dials Turbigo 81-90.

'Get me Monsieur Poiret, please...'

'Ah, Chap ... yes, yes, it is I ...'

After the exchange of courtesies Jacques quizzes the younger

couturier. 'Now, Paul, Fernande Olivier? She works for you some-times, does she not?' Poiret answers in the affirmative, saying that she sometimes models in his life drawing classes at his Atelier Martine. This greatly improves the enquirer's demeanour. 'Then would you arrange for me to meet with her?'

Poiret cautions Jacques that he is likely to find her reticent to talk about Picasso and for that reason she will probably decline. He suggests that a better approach would be to drop into the fashion school unannounced rather than seek a prearranged interview.

Fernande Olivier was Picasso's first true lover, or at least the first he actually lived with, and for Jacques' purposes this was during the most critical time at the Bateau-Lavoir, when *Les Demoiselles* was conceived and executed. For six years she aided the emotionally awkward young Spanish artist to evolve from late adolescence to full manhood. Their love affair was sometimes marred by the artist's controlling ways. Although Pablo rarely expected wifely duties like cooking and cleaning, he could be insanely jealous, not allowing her to go outside without him, even depriving her of shoes to enforce his rule. He would rather do the shopping himself or even go hungry than have *la belle* Fernande venture out alone.

Paul recounts delicately, and with the proviso of discretion from Jacques, the private sorrows of Fernande's life story – both before and after Picasso. She was born Amélie Lang in Paris in 1881, just a few months before Pablo. Her unmarried father handed her over to his sister to bring up. At eighteen, after an unwelcome affair with a local youth, she was forced by the aunt to marry. The youth had beaten and raped her. A year later she had miscarried a child, rendering her unable to conceive again. She fled this unhappy situation, and was rescued by the sculptor Laurent Debienne, who introduced her to modelling. As a strikingly statuesque young woman, with an abundant mane of auburn hair, Fernande readily found work as an artist's model.

Another painter-model relationship that blossomed for her into something more, was with Joaquim Sunyer – a follower of Cézanne

and Catalan painter-cum-guitarist who, in 1904, was a resident at the Bateau-Lavoir. So while she was being entertained by Sunyer in the bohemian artists' colony, Fernande became Picasso's neighbour.

She had noticed the comings and goings of this lively character. His black eyes and hair gave him the air of a gypsy and she wondered who this stocky little Spaniard was – she thought he was perhaps an unemployed bullfighter. He never appeared to be working, but little could she know that he generally painted at night.

MOST OF THE dozen or so young girl students have left their life drawing class at the Atelier Martine as Jacques, already bashful from knowing Fernande's story, crosses the studio threshold. He is confronted by the generous curves of a forty-five-year-old naked model. He politely averts his gaze but has glimpsed enough to see a vulnerable form with skin a little rosy and mottled with cold. Fernande Olivier, pats her muzzy hair, alert to the intrusion of the elderly gentleman. She hops down from her perch and pulls on a robe. The group of students bustle round, collecting up their drawing boards and materials, as they make ready to leave. Poiret at his side introduces the earnest gentleman to Picasso's former lover.

Jacques wastes no time in pitching his rather unusual request. 'Would you consider enlightening me to the habits and lifestyle of the Spanish painter ... u'hem ... your gentleman friend, back in earlier times in Montmartre, madame? Forgive my impertinence, but I ask humbly, as an art connoisseur. I am in pursuit of information on a professional level and am willing to pay handsomely for it; especially in view of the fact that I hear you are a keen diarist?'

In accordance with Poiret's earlier predictions, Fernande listens warily and is hesitant about discussing her life with the young Picasso. However she is also disarmed by the great couturier's creamy charm. She agrees to an interview in a nearby bistro.

The two customers sip glasses of garnet wine in a tranquil corner of a room with chequerboard decorations. Scarlet red and white

squares extend across the tablecloths, along the floor and up to the rafters. Jacques' demeanour is jumpy. He picks at a single thread in his otherwise immaculate mouse-grey suit, noting the obvious signs of wear in his companion's long coat and her roughly arranged coiffeur.

He stares at her green, almond-shaped eyes distractedly, recovers and attempts to show interest in her present situation. She flashes an impatient glance and he sees that it is time to cut to his purpose. Jacques already knows from Sonia, of Fernande's hostility to *The Brothel* painting, from its unveiling to everyone in the Bateau-Lavoir. He passes her a photograph of the picture, saying, 'Madame Olivier, you will be familiar with this?'

'Of course, monsieur. I think I saw a rather too much of *that* aberration.'

'So not to your liking. But you must have seen it being painted?'

'Just a little. You see, it was in the basement studio, and I did not follow its daily progression or anything.'

'He spent a long time on it?'

'Some six months, I think I am right in saying – usually during the night.'

'Do you see your likeness? Did he put you in it?' Jacques quizzes her. 'It is imperative that I know.'

Fernande is flattered and insulted in equal measure. She indicates that while she had previously declined to gossip about her time with the inventor of Cubism – now widely acknowledged to be the most important living artist, and the richest – she is reconsidering matters since Pablo has shown scant regard for her own state of want. Moreover, the celebrity artist has even threatened legal action if she dares to try and publish material concerning him in her proposed memoirs.

She reflects on this bitterly while looking longingly at the 100 franc note shining brightly there on the table before her.

Jacques voices his wholehearted sympathy and begins ordering more wine. Fernande is suddenly on her guard and interrupts, 'I

hope you have a great thirst... I'm not saying much more, you do realise?'

He feels sullied by using demeaning methods but unfurls another note – enough though for Fernande to begin unfurling her tongue.

'I had become one of Pablo's neighbours at the Bateau-Lavoir, as we called the studios. It was 1905. A glorious August day brought me out of doors, until a torrential thunder storm appeared from nowhere in the early evening. I dashed across the rue Ravignan to the entrance of our dilapidated block and the small Spanish guy I had previously noticed around the place was standing in the door-way cradling a kitten. He barred my way as I was getting wet. *Quick, let me in!* I demanded. He looked at me with dark brooding eyes, deliberately preventing my entry.

'What is it you say? He pretended not to understand.

'You know I live here. Let me in!

'Who lives here? He persisted with his silly jape.

'Oh, don't, I'm getting soaked! He dodged one way, I the same, a couple of times and then we both laughed.

'I am sorry, mam'selle. Come. You're getting wet. I am a brute, and he relented.

'I thought I'd escape the deluge. I said, shaking the rain from my hair, and then I spotted the kitten, *Ah, what a sweet little thing.* At which he handed it to me.

'Manolo drowned the litter yesterday, but I rescued this one... Would you like it...? Here, have it ... a gift from me, for soaking you through.

'Thank you. She's gorgeous, I said. *But no, I can't,* and I passed the kitten back. *Aren't you from number thirteen?*

'Thus acquainted, Pablo wasted no time, inviting me to drop in the next day in order for me to see his etching.'

Jacques raises an eyebrow in disbelief.

'Yes, his etching – it would make a stuffed bird laugh, would it not, monsieur? I heard later of the turmoil that ensued on his return to his squalid studio apartment. He had rushed back and

thrust the kitten upon Kostro – Apollinaire, I mean – who handed it on to Max Jacob. The mucky stove, always buried by cinders, alongside used paint tubes, jars of turps, endless canvases, rubbish and buckets of filth – it all had to be dealt with.

'Max, Manolo and Kostro were instructed to tidy up. Pablo was a magnet for zealous poets and artists, and he dragooned his little *bande* into service, to whizz around and clean up – lest I should take flight on arrival – which I surely would have done, had I seen then what that unruly lot could be like.

'I soon heard the hilarious tale of how Max wafted a stinking bucket dangerously. Kostro was retching and cursing at the smell. It took hours – which I can believe. Max always wore a woman's hat, laa-laa-ing in a falsetto voice, when cleaning – which I have to say did not happen very often! The cleaning that is. Not the singing.

'Because of the wet canvases around, Pablo demanded *no dust* – but paint spatters and squashed-out tubes created a problem. Kostro decided, *quite brilliantly,* to damp down the dust and clean up the paint simultaneously. He and Max slopped paraffin about, and with a filthy mop smeared paint and grime around as they went, creating an even more ghastly mess. When Kostro then lit a cigar Pablo snatched it from his mouth and threw it into the bucket. He yelled at him for being crazy – raving about dreadful headlines like, *Mad poets burn down Bateau-Lavoir.*

'Kostro being Kostro made light of it. He hoisted the mop above his quince-shaped head, exclaiming, *Guillaume Apollinaire, High Priest of Fire and Brimstone!* There were complaints about the evil smell drifting down the corridors. So Kostro got busy with a large bottle of Cologne and newspaper scraps for rag.'

Jacques fiddles with his cravat, quite lost in Fernande's tale.

'While Max gagged into a handkerchief, Kostro splashed Cologne around liberally.

'The studio was somewhat tidier when I arrived the following day. Max had gone. Pablo, wearing a collar and tie, was wafting away the overpowering odours. Kostro opened the door for me. I stepped

in, immediately knocked back by the stench. You can just imagine my first impression.

'A black trunk was used as an artist's seat before an easel. Broken chairs were tucked away in one corner. Pablo's etching, *Le Repas frugal* was among many bluish artworks propped up and I recall a scrap of newspaper pinned to the wall which read, *Notre Dame is more likely to be stolen than Mona Lisa, brags Gallery director.*

'Pablo took command, ejecting Apollinaire and Manolo, and pulling me quite literally towards his etching. I was astonished and quite affected by it – apparently one of his first experiments with the technique. It depicted a stricken couple in the tradition of Degas' *L'Absinthe,* and probably reflected his own life of poverty in the rue Ravignan. But Pablo could make love very prettily. We immediately found things we had in common, not least a love of animals. I took to his dog, Fricka, and to my amusement he produced a white mouse from a drawer. How I giggled with delight on that first occasion!

'Of course it was not long before I was modelling for him, and I don't mind confessing I was flattered – as I was by his earlier images of me. Pablo was always keen to paint and draw those around him, but he could also paint portraits as a means of seduction... I wasn't the first of course.'

'I am familiar with *Fernande à la mantille noire,'* Jacques chimes in, 'a memorable image of you, and in a very traditional style – for Picasso at any rate.'

'Pablo courted me assiduously; introducing me to his friends in Frédé's café – that's the Lapin Agile, monsieur. I became a sort of honorary member of *la bande á Picasso.* But he never allowed me to go there without him. He showed me around the Louvre, where we sheltered in poor weather, admired the Giottos and saw the *Mona Lisa* too. At home we had nothing. Food was scarce and warmth scarcer, but we didn't mind. I would use my charms to get credit from the coal merchant.

'Soon after moving in I was astonished to find a little sacred shrine, hidden away in a niche at the back of the studio – like a tiny

spot of clean and tidy order amid the chaos. I realised, then, that Pablo had a surprising spiritual dimension that belied his outwardly crusty attitude to religion.'

Fernande hesitantly recounts an early memory to her elderly gentleman companion. 'In the spring we carved out a little boudoir space to live in, out of the normal level of squalor. So part of the room was a little tidier, cosy even. I can picture now, Pablo painting, naked but for a scarf around his middle. I stood on a stool, struggling to hook up a red curtain to hide our bed, with colourful cushions and candles in the alcove behind.

'Pablo, quick. Help me please. I called to him.

'What have we now? Very Parisian, he smirked, as he stood up and darted across to me in the alcove.

'This'll be our private quarters. Take the weight, will you? I asked. He began to help, but suddenly swathed the whole curtain around me, dragging me off the stool and onto the floor. We wrestled. My muffled screams would never have been heard from under the heavy drapes. *Pablo! What are you doing...? Let go! ... Argh, let me go!* I shrieked.

'Well, what did you have in mind you bad, beautiful girl? He squeezed me tightly as I laughingly screamed for mercy. I tugged myself partially free. We wrestled some more. I was breathless and flushed.

'Pablo! Look at you. I knew you'd be covered in paint. He held up his cobalt-stained hands in a gesture of surrender, then rolled to one side and lifted up his foot, which oozed paint. Then he was mockingly contrite. Such a devil!'

Fernande pauses, her face reddening as she recounts *to herself* what followed.

> *Be a slut. Lick me clean, he demanded...*
> *If you promise to lie still.*
> *I got up onto my knees from underneath him.*
> *I swear to you I'm going nowhere, he submitted.*
> *I moved onto him and began licking his abdomen.*

The blushing woman recalls this detail silently.

Recomposing herself, she resumes the telling of her story, faltering, to the disarming Jacques, who holds his gaze upon her hardly blinking, with rapt attention and eyes as blue as robin's eggs. 'We were coiled together on the crumpled curtain. We laughed at the cyan smudges all over my bare skin.'

Jacques' eyebrows arch variously as she continues.

'Once back to work Pablo was daubing a thick brush of *pink* paint onto a new canvas, outlining voluptuous legs and thighs.

'Pablo's poets soon returned with Max setting out tarot cards and Kostro reading with gusto from his manuscripts and such like.

'It wasn't long before we settled into a routine. Pablo held court – he always had the *bande* around him. Kostro would amuse us with vulgar pornography he was writing for a bit of extra cash, while Max, if not being court jester, would tutor us on poetry, or read the runes.

'Manolo, fresh from sculpting, was usually there hogging the only armchair. Other Spanish and Catalan friends dropped in and were always fun with their guitars and songs, while we sipped tea from tin mugs. All the while, Pablo never ceased to sketch or paint.

'Gradually he became acquainted with the Steins. They were fond of him and bought some of his pictures. He struggled endlessly with Gertrude's portrait. One day, after a visit to their apartment, as well as being full of talk about how the walls were stacked with Matisse paintings, he seemed bowled over by their new machine, a telephone, no less! Max promptly mocked the Americans, dancing on tiptoes, with trouser legs rolled up performing that music hall ditty and pouting crazily at Manolo – do you know it?'

Jacques shakes his head.

'Oh how does it go? ...Oh yes...'

> *I know who is unfaithful now / Who has horns upon their brow?*
> *Ooh, la la, Oh what joy / I've a telephone*
> *Oh what joy*
> *I've a telephone in my house.*

'Most droll, madame!' Jacques twitters, encouraging her laughter.

'Imagine, monsieur, while you were dressing Sarah Bernhardt in diaphanous silks at Maison Doucet, Max was imitating her in a falsetto comedy turn.'

'Are you saying,' asks Jacques, 'that this is when Picasso emerged from his sombre shades of blue?'

'No, not precisely at that moment, but his paintings of me became more pink and fleshy than blue. So yes, his palette changed when I appeared in his life, although I cannot vouch for the precise moment.

'Within a year Pablo had progressed so much everyone said he was vying with Henri Matisse as the leader of New Art in Paris. Strangely, Henri was young for his age, and no bohemian, while Pablo was old for his, very bohemian ... *and* twelve years younger. They have become friendly more recently, but back then they were fierce rivals. At first, Henri was the favourite of the Steins, but that was to change.'

'I think Picasso refused to show in the Salons, unlike Matisse?' suggests Jacques.

'Ha, Henri exhibited regularly. When he presented *Le bonheur de vivre* at the Indépendants' summer show of 1906, Leo Stein immediately snapped it up. Pablo saw it on their wall at the rue de Fleurus and was quite shaken. He felt defeated. But then his own first real success came when he sold almost everything to Ambroise Vollard.'

Jacques reflects upon seeing the melancholic pictures at the dealer's gallery on the occasion of the fateful black banquet. 'We may have passed like ships in the night at Vollard's exhibitions?' he ventures.

'It's true,' Fernande nods, 'Pablo had other buyers, including the Steins, but it was Vollard who had the biggest pockets.' She continues. 'In fact, I should say he had the biggest satchel. One day he arrived with it filled with gold coins. What a hoot that was. He bought all Pablo's available pictures – so many canvases he had to

sit up on top with the coachman to travel home. Suddenly, awash with cash, we all headed to the Lapin Agile to celebrate.

'Pablo decided on a triumphant trip home. Doña María always had faith in her boy, but naturally he relished having defied the gloomy expectations of his father.

'Moments before we were leaving he was torturing himself over Gertrude's portrait. He finally just painted out the face in white saying he would return to it when we got back.'

Jacques is enthralled. He stops her for a moment to summon éclairs from the waiter. Fernande's eyes light up with joy at the arrival of delicate buns laced with mocha. She adores sweet cakes and takes up one in her hands with glee. He sees this and quickly offers her a second, which is just as gratefully received and consumed.

After the brief interlude, Fernande reflects upon her most idyllic of days: how she entered Barcelona on Pablo's arm to be presented as his princess; how warmly she had been received by Doña María and his older sister Lola. The bold challenge of riding mules to the Pyrenean foothills for the summer in Gósol had intensified their romance. 'How joyous we were in the mountain village.'

The wine arrives and Fernande puts up her palm in refusal. She seems distracted for a moment as she peers through the castellated window decoration at a sporty Voisin Roadster in cabbage green occupied by a well-to-do couple. He waits a moment and then she takes up the carafe of wine and pours until her glass is half full.

Fernande resumes. 'After meeting Pablo's family in Barcelona and many of his old friends, we found a smuggler's village up in the mountains, where Pablo could draw and paint without distraction. He had only two principal models to work with: Josep, our aged innkeeper and me. (He was ninety-something, and we were both twenty-five). It was like a honeymoon in some bucolic universe of passion. For once I was free of our daily struggle – and free of his jealousies.

'I held my place upon his pedestal at Gósol and he painted me as

never before, or since. You ask me if I am one of the *Demoiselles.*
Well, at Gósol he painted *Le Harem.* I reigned as sole muse, and
to be in his harem was far from disagreeable. One day, when I
paused while modelling and popped behind him to view his progress,
I saw that he had done a strange thing. There was five of me. I
enquired, *All harlots – all me?'*

'*Yes,* he said, *but not in a bad way. It's an experiment.'*

At this, Jacques reverts awkwardly to his opening question: 'So
are you one of these?' pointing at the photograph on the table.

'You could equally well ask if Pablo himself is one.' Fernande
side-steps the question neatly. 'I see him in it. Have you really looked
at those eyes? Look!' she says, pointing at the central face.

Jacques contemplates the enigma.

'On our return home relations soured. As he began stretching the
huge canvas for that...' The avid listener quietly notes her frown at
the photo. 'And this,' says Fernande, tapping the image, 'this was
when the rot set in. As to your question, you'll have to decide for
yourself. Did he put me in it? It's one thing to be painted as all his
subjects in a harem. It's another to be as a whore in a brothel.'

'There is one other matter,' Jacques adds, handing Fernande a
photograph of Sonia Roux. 'Do you remember her?'

She squints at the tiny faded impression – pinching her careworn
face into a frown. 'Of course. Sonia. An enchanting thing. She had
second sight you know.'

Jacques feels the tension rise through his body.

'She rattled Pablo once. He'd had opium,' she reveals. At this
point Fernande gets up to leave, muttering as she straightens her
mole black skirts. 'I have to go, monsieur. I'd no idea it was so late.'

'Please, madame. Just a few more minutes.'

But Fernande is suddenly very edgy. 'No, I cannot say more... He
won't be happy to know I have talked about him. And, please,
please, monsieur, do not breathe a word of what I've said,' pleads
Fernande as she clutches the banknotes and takes her leave.

Jacques is puzzled. *Why?* he asks himself, *Why, after she had*

spoken so openly did Fernande suddenly become flustered at the mere mention of Sonia – or was it just a coincidence? He gazes after her frayed figure and through the bistro windows he notices a female bicyclist gliding past. His reverie draws him back to a sultry summer evening in the Bois de Boulogne in 1907.

I was alone with Sonia as she straddled a bicycle. She was quite new to this increasingly popular machine as indeed I was. I helped her to adjust her skirts and held the contraption as she pushed off. She rode round me in a wobbly figure of eight. Suddenly her skirt caught in the spokes. I saw it and lunged forward to catch her. The Hercules Popular fell over and we were both tangled with the metal frame, piled up in a heap together. Sonia laughed, 'Do you think I'll make it to Fernande Olivier's?'

I untangled her skirts, 'How intrepid you are!' I added reverently. 'Just as well it is you giving and not receiving the reading.' I gently brushed her bloodied palm before wrapping it with a handkerchief.

We swatted the dust off each other, only remembering afterwards we should avoid such intimate gestures in public. Although annoyed by the oil stains on her skirt, moments later she remounted the bicycle and rode forwards with renewed confidence. I planned, without further delay, to design a sporting outfit for the female bicyclist.

10

The camera will never compete with the brush and palette until such time as photography can be taken to Heaven or Hell. — **Edvard Munch**

AMID THE EXTRAVAGANT volumes shelved all around them in the Doucet literature library, patron and poet face one another across an expanse of high-gloss Macassar ebony with a small batch of bound volumes between them. The granite raven's eyes glisten from the side of the table. Jacques Doucet and Max Jacob meet again, this time for literary purposes. Only two months have passed since their rendezvous with the lead welders, but in Jacques' mind it feels much longer. He is not inhibited however from pursuing his enquiries.

'So Max, old son, I still had a couple of remaining matters I have been trying to clarify for myself.' His friend looks at him dubiously.

'I should tell you, I've had a useful chat with Fernande Olivier but I didn't properly get to understand how well Sonia knew Picasso.'

'Not so terribly well ... as best I can recall.' Max says thoughtfully. 'She was better acquainted with Fernande herself.'

Jacques considers this, just as they are interrupted. Rose Adler, the library's dynamic and pioneering book designer, joins the gentlemen. She succeeds Pierre Legrain as Jacques' specialist artist in this field. Her employer is pleased with his discovery of this versatile young woman and her talents. It was with the curious and receptive youth Legrain that Jacques had spotted Mlle Adler's work at a show at the Pavillon de Marsan a couple of years ago, where students were exhibiting their bookbinding creations.

Rose carries a manuscript bound in pale sea glass green of polished sharkskin, edged in amboyna and places it on the table. She opens the luxury volume to reveal the title page:

LE CORNET À DÉS
PAR MAX JACOB

Max is animated. 'Whoah!'

'Your poetry, Max, merited a special finish. Mam'selle Adler has achieved new heights of artistry here,' declares Jacques.

Max pores over the volume, and as he does so tears spring to his eyes. 'My little words. Thank you, mam'selle.' The artist smiles in acknowledgement.

'I've told you, we have a publisher going to press with your collected works as a limited edition of two hundred impressions,' Jacques informs the poet.

'More's the pity we cannot provide two hundred special bindings,' Rose adds warmly. She too is a writer and poetry-lover.

Once Mlle Adler has withdrawn, Jacques directs the conversation to the subject of Sonia – and Fernande's mention of opium.

Max recalls a wild occasion at 'Paulette's' one night. A one-time courtesan friend of Braque's, Paulette Philippi ran an opium den in the rue de Douai, behind the Moulin Rouge. 'A whole crowd of us were there, including Sonia and Fernande. There was a silly joke about Pablo thinking he was a minotaur. But the half-man half-bull had taken a bad turn this time and was far away in the clouds.'

Jacques looks quizzical. 'Minotaur?'

'Pablo ... you know ... but Fernande might remember being there with Sonia – both of them partaking in the poppy.'

'So what happened?'

'That's it, I can scarcely remember, but Fernande may tell you. Are you not seeing her again?'

JACQUES AND FERNANDE meet once more in the same little bistro with its red chequered interior. It has taken some persuasion. She remains ill at ease talking to the elderly gentleman, so charming though he is, if not a little obsequious; but she has intimated that she will continue to inform him about the old days, in the absence of any assistance from her wealthy but parsimonious former lover.

'You say he will not help you.'

'I won't ask again. But *he* knows of my hardship,' laments Fernande.

'If it's a matter of rent arrears, or something of that order, perhaps I can arrange some assistance.'

'No, no, monsieur. That would be too much, but ...'

'Nonsense, my dear,' he cuts in, 'you were a friend to poor Madame Roux.' He asks if she recalls the occasion of the visit to the opium den.

'Paulette was a petite blonde girl of around our age. She provided a smoking den for friends, and yes, one night Sonia went there with Max. Pablo and I only went a couple of times – and on that night he had a crazy turn – and so it was the last.'

'What happened? Who was there?'

'Oh, the usual gang, Manolo and some other down-at-heel Spaniards. Accompanying Kostro was a louche, brawny creature. What a peacock! He had a sweep of hair styled up into a great blonde crest. 'Kostro introduced Géry, as his secretary from Belgium, but he looked like a cowboy.

'The Den was dark and dingy with a fungus-filled adjoining back room. Everyone sat around on cushions, rugs and broken chairs. Smoking paraphernalia included a tall Moroccan water pipe.

This was handed back and forth, producing clouds of pungent white smoke. Max passed it to Pablo and then flirted with Géry. *You're just my type, an utter rogue – not wicked – but so greedy for the rare and difficult challenge!*

'Kostro turned to his secretary. *Speaking of which, I think it might be time for these. Pass that here will you, Géry.* The unlikely assistant handed over a heavy canvas bag.

'*Since you are in love with all things Spanish, señor,* Géry said to Pablo.

'*My remarkable aide has found these for you,* added Kostro, rummaging in the bag and producing two lumps of rugged carved stone. Géry basked in their awe before getting up and joining Paulette at the back of the smoke-filled room.

'*I must be seeing things. What is it with this stuff?* asked Pablo, gesturing with the opium pipe, quietly. *He's found these?* seeming to recognize them.

'*Apparently so.* Kostro replied sheepishly.

'*You two. Crazy!* exclaimed Pablo as he scrutinised the carvings. *They are Iberian surely to God...?*

'*Most ancient.*

'*What ... just found them?* jumped in Manolo. As a sculptor he recognised them as unusually ancient.

'In the vaporous background Kostro Apollinaire's so-called secretary was avoiding Pablo's quizzical demeanour and jested with Paulette.

'*Assuredly,* said Kostro. But Pablo was not hoodwinked for a moment. He roared with laughter. *Santa María, Madre de Cristo!*

'Géry had of course lifted these sculptures, which were ancient Iberian, from the Louvre, partly out of devilment, because the bigwigs had called it burglar-proof. It led to all kinds of trouble.'

'And you say Sonia was present?' Jacques asks.

'Oh yes. In fact she upset Pablo, about the boy, Carles, who had died tragically. *I've heard from Carles Casagemas, from the other side,* she suddenly told him. *He won't leave me alone, and you keep painting him.*

'At that Pablo had a turn. His face went ashen white. *No way!*

'*It's true! He hounds me, from the world beyond.* She said with a powerful conviction. *From the hereafter!*

'*Is there a message? How on...*' He suddenly stopped. *Are you sincere?*' he challenged her.

'At this, Sonia hesitated, and then she pressed him. *Perhaps you goad him? Are you consumed by his death?*

'*Well that's fine and dandy coming from you, Madame!* Pablo pounced on this with scorn.

'*Are there NO boundaries of decency?* Sonia needled him.

'*Or between one world and the next! That is a line that most would never cross. It seems we both step beyond the line,* he jibed again. *Anyhow ... was there any message?*

'She pursed her lips, side-stepping the question, and changed tack. *Why paint him so often? Are there not photographs – sketches of him – enough? Why paint him again and again?*

'Pablo did not appreciate this. *Photographs! The camera!* He was getting very agitated... *Always intruding, peeking, the stealing lens – enemy of painters.*

'Sonia struck back. *Is it the camera killing painting? – or are YOU, señor?*

'Pablo shouted, *Carles!!* He panicked, jumped to his feet with arms flailing, highly intoxicated from the opium. He knocked over the water pipe. The lads leapt forward and restrained him. He was having vivid hallucinations of being surrounded by cameras, as if ready to replace him. Pablo never touched opiates again. Not with me.'

Jacques Doucet and Fernande are engrossed in their conversation as the waiter approaches. Jacques waves him away. 'That is, unless you would you care for further refreshment, Madame Olivier – something to eat? Perhaps another of those coffee éclairs?'

She hesitates coyly, 'No, no thank you kindly, monsieur.' He then calls the waiter back and indicates to him to refill their glasses and bring éclairs as before. Fernande is quietly pleased.

'Such a strange business!' Jacques ponders. 'And Picasso was determined that painting should do what the camera cannot?'

'Absolutely. Plus, it made him rich.'

'I gather that Sonia visited you at the studios.'

'Oh yes, quite often.'

'I recall her bicycling up the streets of the Butte, past the hordes of playing children, to read your palm.'

'Yes, and certainly her journey back downhill would have been less arduous.' Fernande suggests, 'She was so flustered about being late, for fear of Monsieur Roux discovering her outing. He was a dreadful tyrant, that was clear enough. She seemed especially anxious that he might learn she was riding a bicycle!

'Sonia and I met in Max's shed, the tiniest of outhouse rooms. I offered her my upturned right palm. She apologised as her own hand was bound with a handkerchief. Her skirts were covered in oil. I helped her wash some of it out, I recall.'

Jacques nods with a sad, knowing smile.

'This informs me, the meeting must have been contemporaneous with the painting of the big picture... But do go on, my dear.'

'She examined my palm in her careful way. *You are caught in the palm of a grand master... Don't leave a piece of you behind when you go,* she warned me. I asked, *Will Pablo let me go? ... I, his one true love?* I sought reassurance but none was forthcoming.'

'Tell me, Fernande, do you think Sonia was there in the painting? Did he put her in it? I mean ... I understand she is not there now, as we can see, but *was* she ... and then perhaps painted over?'

'Not as far as I'm aware. But I would not necessarily have known.'

'And the palm reading incident? It sounds as if it was not long after the painting was started ... but sometime after your return from Gósol?'

'Oh yes, it would have been after the holiday.'

'This particular time was pivotal in the development of his art,' reasons Jacques, 'perhaps it was also a turning point ... if I may be impertinent to suggest, in your personal relations?'

'In Gósol, as I've said, I was his queen, his sole paramour. His jealousies lay dormant. It was like a honeymoon and despite the simplicity and privations, life was idyllic. We were blissfully happy. Pablo drew and painted with a clear, bright palette in reflection of the pure light of the Pyrenees. But it all came to an abrupt end. We made a bolt for it when a case of typhoid occurred in the village. Pablo was terrified of infectious diseases. That was when I

found out he had appalling hypochondria – because of Conchita, his little sister who died, I imagine. We returned to the Bateau-Lavoir and it was a rude awakening. So yes, perhaps the turning point began with our return and thence compounded with that accursed canvas.'

'It was unlike his painting of any other?' asks Jacques.

'Heavens! Where to begin?' Fernande exclaims. 'He was like a fireball. His preparations were laborious. Remember, monsieur, Pablo was fast. Often producing a painting every day – sometimes three a day! For this picture he produced eight hundred sketches! In fact he bound those sketchbooks in beautiful Moorish fabrics – the only time he ever did such a thing. He fussed and fretted about the precious stretcher with the finest canvas and lined it in the manner of historic masterpieces, as well as renting a special studio downstairs. Max meanwhile helped in his own way by dripping Baudelaire's poetry into his ears. It took six months to complete – though I remember him saying he thought it unfinishable.'

'Do you suppose he had been stung by Matisse?'

'I have no doubt. He couldn't abide the brouhaha created at the Salon with *Le bonheur de vivre.* There was no joy of life in it for Pablo. Mind you, he thought it pedestrian. *A pastoral idyll masquerading as la modernité!* It irked him to see it so lauded. He was then the laggard, and had to respond, but didn't know how to. What's more, the Steins encouraged the rivalry. Gertrude and Leo paid for Pablo's basement studio, while their brother Michael backed Henri, buying everything he could lay his hands on.'

Jacques fidgets impatiently in uneasy fascination, wanting to ask many questions but knowing better than to interrupt the informed witness's flow. He was intrigued by her mentioning Max tutoring on Baudelaire, remembering also that he held the writer's manuscripts in his literature library. *I will certainly be interrogating Max later,* he assures himself.

'So while Pablo was working on your painting, he was indifferent to me,' Fernande continues.

'But you were still living at the Bateau-Lavoir?'

'Oh I was there, but on my own, night after night, while Pablo locked himself away in the basement. One night, after he had promised to return to bed at a reasonable hour, I found he had girls in there with him. I ventured down to find the door locked and I could hear voices. Through a dislodged slat in the door, I caught glimpses of the nocturnal proceedings.

'This was one of the most perplexing nights of my time with Pablo, but I cannot say more.'

Jacques can scarcely contain himself. 'Now come, my dear. Don't stop now. I will guarantee you better paid work with Poiret. You will be able to settle your rent arrears. Come, come have a little more wine. There.' He pours generously – soothing and coaxing her into throwing caution to the wind and continuing. She looks into his blue eyes, considering them kindly and strangely desperate, rather than sly. She takes a large breath and resumes.

'It is not easy to tell,' she wavers a moment. 'Pablo was stripped to the waist, balancing on a stepladder. He was sweating profusely, applying brush-loads of paint to the canvas. Two naked models, some brazen hussies! I knew them alright. Zora and Choire, stood there pouting. Choire held both arms high behind her head. *Okay, señoritas,* Pablo shouted, *Hold it another moment. We're getting atmosphere now.*

'*Atmosphere? It's bloody cold!*

'*I'm freezing! Are there any more logs?* Zora yelled out, but Pablo made light of it.

'*Logs? Zut! You're freezing your titties and I'm frying. I'll take my skin off.* He was laughing as he climbed down and put two logs in the stove.

'*Good man,* said Choire. At this I had seen and heard quite enough and began hammering on the locked door, startling the life out of everyone. The girls grabbed their clothes to cover themselves.

'*Wa ho! Who's this?* screamed Zora.

'*Look out!* yelled Choire. Pablo rushed over to see.

'Who's this?' He shouted. He then heard my angry voice.

'Pablo, what's going on in there? When are you coming to bed?' I shouted.

'Fernande, I'm working!'

'Open the door will you?' I demanded.

'I'll be up there very soon. Go to bed.'

'Let me in, Pablo! – I know you are not alone!' I rapped louder on the door and I saw him put a finger to his lips, fixing the girls with his penetrating eyes.

'You mustn't disturb me while I'm working, you know that, Nan. Just another hour.'

He then blatantly ignored me and returned to the stepladder for his sketchpad and directed the girls into new poses. Not realising how much I could see, he assisted Choire as she crouched at his feet with her legs apart. It was disgusting! And he began sketching, while fixing his eyes fully on her. Zora sidled round, placing her hand on his naked shoulder.

'You have her perfectly now, Pablo,' Zora said with a giggle. He was now sketching rapidly as she began massaging his neck. This was all I could stand. I started banging on the door again, shouting ferociously, *Pablo, open this door will you! – Come on – open the door!* I took off a shoe and hammered with all my might. Pablo leapt up and returned to the door. The girls tried to cover themselves.

'Fernande, calm down, you'll awaken the dead.'

'Open the door. Listen a moment, then I'll go.'

'Pablo indicated to the models to keep still. He slid back the bolt, opening the door a crack. I rammed the door wide open, pushed past him, and confronted the naked women. They took flight, grabbing garments as they ran to heaven knows where. I shrieked, *I knew it. An orgy! I knew it!*

'Calm down, Fernande. I'm painting. They're modelling. Look,' pointing to the enormous canvas.

'Hell, Pablo! What's that?' I screamed at the image of jagged and lacerated human figures.

'*What d'ya think it is?* He retorted. *It's a bordello.*

'*I might have guessed!* I yelled. By now I was hysterical. *And what goes on in bordellos? Depravity! Now I know why you are not making love to me!* I wept and ran from the room. He charged after me and dragged me back in.

'We had a big fight, a real tussle, in the midst of which he held me fast and pinned me down until – arousing my passion as only he knew how – we were romping like animals, quite shockingly unclothed, there on the floor among the drapes. But the women worried me... *Isn't that what was going to happen to those tarts if I hadn't arrived?* I cried.

'*Fernande, I'm painting, see?* he said, gesturing to the painting of a brothel above us.

'*You're obsessed with whores... And just look at them,* I said. He smirked. *The beauty that comes from natural sin.*

'*What...? Ugly as sin, don't you mean?* I groaned.

'*Don't you know of Baudelaire's gruesome nymphs? – You know, whores through the ages have been painted as glamorous ... titillating,* Pablo protested.

'*So you make them ugly?*

'*Too simple, Nan.*

'*You know you are quite mad. Both ugly and beautiful?*

'At which point he took my chin in his hands, drawing over my face with his thumb and forefinger, firmly, sensuously, as if moulding clay. *There's truth in primeval art.*

'*So where is this brothel? I want to know. You've been to a few.*

'*They're not always nice places,* he said, pausing in rueful silence.

'*Poor Carles!* he then exclaimed. *It could have been anywhere.*

'*Carles? Why Carles?*

'*He was in love with Germaine, but impotent. – I thought I could help.* Fernande hesitates for a moment, playing with a gobbet of éclair.

'After their first visit to Paris in 1900 they returned home to Spain with the boy in a pitiful condition – lovesick and alcoholic. They

attended a bullfight and Carles got himself into an altercation with the barman, who threw him down a staircase. It was a spectacular fall. Pablo thought he was dead at first.'

At this, Jacques is carried along – rigid and in a shocked reverie. He recalls Sonia's narrative at the black banquet, ostensibly from *the other side*. 'You mean he didn't die from the fall?'

'No, apparently he stumbled to his feet, more drunk than injured. He wanted to get back to Paris, but Pablo insisted he first needed treatment – and not of a medical kind.

'Pablo began telling me of a horrendous brothel visit... intended to cure the boy of his impotence. The two youths loitered in the back streets. They reached a doorway alongside a window with a dim red light. Pablo put his head around the slightly open door.

'*Carmen! Katterina! Carmen! Katterina!* he called.

'*Hello,* replied the mistress from within.

'*Come on, Carles.* Pablo pushed him through the door and followed on behind, into a seedy room, decorated with lanterns. Incense was burning and old settees and piles of cushions were scattered around. Carmen, a buxom madame, was heavily made-up with a lighted cigarette drooping from the side of her mouth. She pointed to a settee as she greeted them.

'*Welcome back,* before turning and shouting in the direction of the back room, *Katterina!! Come on ladies!!*

'To say none of this was to Carles's pleasure would be like saying a fly was not delighted to find itself in a spider's web. He was humiliated beyond measure. *You're crazy, Pablo. Mañach's advance has nearly gone! We can't even afford this!* he moaned.

'Pablo told him not to worry and to just relax. *We're with friends. They owe me. You've gotta sort this out,* he insisted, turning to Mistress Carmen to request some liquor to settle Carles's nerves. He was extremely anxious.

'She took a glass and poured out a generous measure. *Here, settle yourself with this, m'boy.*

'Three tall young women entered through the drapes: Katterina,

and María were pale. Moroccan Dolores was dark. They were partially clad in satin wraps. Pablo whispered instructions to the madame, who muttered privately with her girls. He moved to the back of the room with Carmen and they concealed themselves behind a curtain. The girls consulted in a huddle. Katterina departed. María, silly and giggly, turned to Carles seated on the settee sipping a drink. Dolores slumped down on the cushions. Behind the curtain, Pablo and Carmen were in line of sight of Dolores. They could spy on Carles through a cracked mirror on the wall. Pablo peeled three notes off a small wad and handed them to the madame. María approached the quaking boy and pecked his cheek, *I'm María. You're Pablo's friend, no?*

'*Sí ... Carles, he said uneasily.*

'*Let's have a better look,* she whispered, again gently moving her face towards his and gazing into his eyes. He resisted and turned away. She took his hand and placed it on her thigh. He pulled it away. *You're a handsome boy, Carles,* she told him.

'*This ain't gonna work,* he muttered. María slowly started to undress him, unbuckling his belt and popping open the top trouser buttons. Meanwhile, Dolores sensuously caressed herself as she reclined on the cushions. María slipped her hand over his abdomen.'

Now Fernande is quite scarlet, remembering the story as told to her but tempers it for the old gentleman's ears, omitting some of the salacious detail.

'María asked the young man, in her most alluring tone, *What've you got for me, handsome boy...?* Carles recoiled.'

Fernande recounts to herself Pablo's words and cringes.

> ... *Suddenly María darted her hand down into his pants and seized him with great force. He tried to extricate himself. Owee! Aey! What the hell!* screamed Carles. *María gripped his shoulder with the other hand and tried to calm him, still holding him in a vice-like grip.*

'Behind the curtain Pablo was aghast. *Do something! It's terrible!*

he whispered. *This isn't what we paid for. The guy's a wreck.*

'*Another thirty! – Quick!* she demanded. He peeled off three more notes. Carmen signalled to Dolores to join María.

'*This'll do it,* whispered the madame. The second girl rose and moved towards Carles. *If I can't do it, Delores will,* said María. *She could rouse a dead man.* Delores thrust her bare breasts into Carles's startled face. *No. Don't! ... Let me go!* He yelled in distress.

'*But you've got us hot now, Carles. Mmmm, come on, my chicken.*

'*My wrap, Dolores,* said María, smoothly.

'*Carles baby, you're getting really aroused.* Dolores swiftly loosened her colleague's covering, releasing the latter's substantial bosom, as María kept her grip on Casagemas. Dolores kissed María sumptuously on the mouth, inches from the boy's face. Suddenly he managed to break free. He leapt up, roughly clothing himself and wrenched back his belt. María, scared, covered her breasts. Dolores jumped back.

'*What the hell?* he screamed.

'Madame Carmen pulled the curtain back revealing the disarray as an angry Carles stormed out through the door. Pablo looked on anxiously as she raised her hands as if to say, *Oh well.*'

Jacques breathes a sigh of relief, believing the unseemly odyssey has reached its conclusion. But Fernande has not yet finished.

'As Pablo and I huddled together among the drapes on that basement floor, his complexion was drained. He seemed haunted by the whole thing ... truly sickened by the failure of his inept actions.

'Sad and distraught, Carles headed straight for Paris, travelling uncomfortably in a packed railway carriage. Once there he endeavoured to find the girl Germaine, with whom he remained besotted. He discovered that she was now settled with Ramón Pichot, and while this made Carles utterly miserable, he quite surprisingly accepted an invitation to a dinner party at the Hippodrome café on de Clichy, which the couple would be attending.

'The restaurant was rowdy. A party of ten filled the central table headed by Carles, flanked by Manolo and Manuel Pallarès. Seated opposite lovestruck Carles at the other end of the table was his beloved with Pichot, and Pablo's former girlfriend Odette.

'When the meal was over Carles stood up to recite one of his poems. Appearing to be very nervous, he read hesitatingly from notes ... odd words ... something like: *A ghost I knew passed, fog-like, through the door. / This was the friend...* he paused and stuttered... *Materialised as a fluid through which I saw an infinity of dark variegated spots like brushstrokes, / These spread around and made him look repugnant ...*

'*Sit down amigo,* a young man heckled him. Laughter ensued. Carles darted his hand into his pocket and produced a revolver. He pointed the gun at Germaine and Pichot.

'Pablo was actually tearful as he relived these events. He was upset for hours after that conversation. I was quite worried about him. When I questioned him later he told me more – involving a previous great tragedy in his life.

'*It brought it all back – years before ... our little Conchita. She was only eight, lying in bed dying from diphtheria. I sat beside her, I tried to cool her down by putting ice to her lips. She sipped pitifully. I prayed for her fervently, begging God, over and over:*

> Father In Heaven –
> I worship You. If You spare her, I promise ... I promise You, I will
> even do this ...

'*Prayers were always like this!* Pablo growled. *Answer to them came there none and I watched Papá carry the tiny white coffin to the altar of the chapel of San Juan Bautista. I walked alongside Doña María and Lola. That changed me – then I became a devil!*

'It moved me too, looking into those great dark pools – hurt eyes. More poured forth about the terrible happenings.

'Returning to the plight of Pablo's friend at the Hippodrome ...

Carles pointed a gun at the lovers Germaine and Pichot seated opposite him at the end of the table... Everyone dived for cover.

'*For you, Germaine! ... Pichot!* he shouted, and then fired. BANG! Pichot ducked in time, with Germaine, too, escaping with just a graze on the neck. The flash from the gun injured Pallarès' eye. Manolo tried to restrain the crazy boy, but Carles was too quick. He jerked the gun to his own temple and fired again. There was blood everywhere and Pablo's fellow adventurer breathed his last.'

Jacques looks aghast at this turn in the story. His wrath has risen so that he almost shouts at Fernande. 'Oh lor! I have the painting ... with all of this vileness wrapped up in it! He is a monster!! ... And where does this leave Sonia's attachment to it? Aghh!'

Fernande is astonished.

Strongly affected, Jacques thrusts a bank note into the waiter's hand and storms out to the street. Fernande remains at the table, startled at her companion's alarming reaction.

11

... great art depends for its effects on concealment of all the cunning which lies behind it. — **Robert Harris** *attrib.* **Marcus Cicero.**

T H E P E A C E O F reflective silence is broken at the Saint-Benoît-sur-Loire monastery. Jacques bursts into the monk's cell. Appearing in a blueberry suit and overcoat, he contrasts sharply against the four flinty walls, but his immaculate attire does not disguise an anguished heart. The robed Brother drafts a letter at a low table a step or two from his sparse bed and glances up in alarm, with his own look of disquiet, but perfectly sober despite the rude intrusion.

Jacques rages, in distress. 'This is TERRIBLE!! TERRIBLE!!' he shouts, wildly gesticulating. 'ABOMINABLE!! ... I've a piece of pornography it seems, with a monstrous history. Look at it!' He attempts to flatten the screwed-up photograph, then throws it down and gestures angrily. 'Just look at it, Max! ... Cyprien?'

'I thought you liked it,' iterates his startled friend.

'LIKE? LIKE? What has *like* got to do with it? What's *liking* to do with what it *means*.'

'What ... I ... I ...' Max tries to speak.

'It's a hoax. It's Picasso's sick, most revolting joke! Who is he mocking? Is it Carles Casagemas? Is he mocking women ... and men? The art world? You? Me? Look at the black faces, animal faces, bodged physiques – That! That!' He prods the tatty image viciously. 'What's that? It doesn't even resemble an animal, still less a woman! It's an insult to all who view it. Most of all he mocks

me. He's laughing at me. Me, the fool. The one who was idiot enough to buy it! Is he thumbing his nose at me? Am I his dupe?'

'Woah, woah ... dampen your powder there, monsieur... Carles you say? What in the world has brought you to this pass?'

'Excuse me, friend, this is unforgivable. I am interrupting your solitude but tell me ... did Sonia really see *good* in all this?'

'It may depend upon your understanding of *good.*'

'Hang your sarcasm, eh Max! ... I mean I'm sorry. My pardon. Alright. Yes of course.' He steadies his thinking.

Max silently pulls his hand over his pate in a self-soothing gesture.

'Please. Forgive me, Max... Did you know of Carles Casagemas's "medicinal trip" to a brothel in Barcelona before he killed himself?'

'And you are linking this with the painting. Why?'

'Fernande has revealed the connection. She knows! She learned of it from the artist's own mouth.'

'Any connection is no more than oblique, surely?' suggests Max.

'No. Not so, apparently. Picasso takes his disturbed comrade to a brothel in a crazy attempt to cure him, and not only does it fail to do so, the fiasco disturbs him further – to the point of going to dinner at the Hippodrome and blowing his brains out.'

'You blame Picasso?'

'I don't know ... perhaps? He proceeds to paint all these pictures of the dead boy, in his coffin, as a ghost, ascending to heaven, and met by more prostitutes! ... This not being sufficient, he paints the brothel in question.' The strained pitch in Jacques' voice edges higher. 'Making capital out of the tragedy. This is what I have bought! Good God! Jeanne is right. It's an obscenity!'

'You can't say it's the same brothel. Nor is there a connection, as far as I can see, beyond the horror left behind after Carles's death.'

'I don't know what I've let myself in for. And yet more intolerably, it seems to be cursed. The picture is now entombed in lead, but it is still with me. It was a futile act. Better I should destroy it than have it destroy me.'

'There is something bigger than you or me, Jacques – it is to the

Creator that you might turn. We all need redemption... Yes, I should take you for a soupçon of the same.'

IN THE SPLENDID early evening light, Jacques Doucet and Max Jacob wearily climb the two hundred steps to the Basilique du Sacré-Cœur at the summit of the butte of Montmartre. They have made the three-hour journey from Saint-Benoît-sur-Loire in record time.

Golden fingers of late sunshine draw their regular lines upon the stone façade of the building. Long shadows of pin people flicker on smooth marble. Even the figures creating them seem to be in slow motion. Jacques takes Max's arm, as if leading the monk in his traditional brown cassock rather than the other way around. 'But why here? Any hallowed ground would serve your purpose.'

Back in Paris, I feel like an old sinner in stolen robes,' Max groans. 'By the waters of the Loire, I am pure. Here, my vices are roused,' he says, gesturing to the great city below. 'If I am not to sin disgracefully, I must keep myself in check.'

'You know this is no longer my religion, but I am willing to give it a try. And Paris is where I need to find peace,' Jacques frowns, muttering yet another apology.

Inside the crowded Romano-Byzantine-style basilica a pontifical mass is in progress. They tread lightly into the narthex and through to the bejewelled nave. Jacques and Max naturally tip their faces upwards to the hemispherical dome, and a depiction of Christ in gold and glass mosaic, attended by hosts of diminutive angels and saints. The arms are raised high suggesting crucifixion, but this Messiah exhibits peace and majesty. The grandiloquence exhibited by human beings in praise of God flies forth in rousing choral music. The choir's harmonies fill the basilica, as echoes bounce onto white travertine walls. Reddish-yellow metals accent the decorations with power as well as subtlety – the intricate gold work activating the human heart's pleasure sensors.

The two visitors remain with the congregation for the sermon.

Max closes his eyes and silently prays. Shafts of light bathe the internal panorama. Jacques is mesmerised. His eyes scan the ceiling and windows, and finally fix upon the bishop, attired in splendid ecclesiastical robes, opining from the pulpit. The troubled man's glance switches to the image of Christ with outstretched arms.

The bishop expounds with gusto. 'Are we customers? Customers of the church, customers of God...?'

In an effort to push away intrusive thoughts Jacques gazes into the apse, but is beset by wild visions. In his hallucinations the beatific Saviour stares down to him from the splendiferous ceiling transmuting into that of the central figure in *The Brothel* painting. The cherubic faces of Christ's attendants similarly blend into the other faces of the prostitutes. His focus switches back and forth from the faces to that of the sermonising bishop. Jacques invokes his own version of the episcopal dispatch – in an urgent address. *Customers entrapped by fallen women from different races ... continents apart... He was paranoid about syphilis. Women pose as the threat of castration... Woman the castrator is here, in the menacing still-life, the fruit in the foreground: the testicular grapes, to be rent by the severing blade of the melon slice ... smudged faces from different times. Unconnected! Disconnected!'* Each face in the apse stares out with piercing eyes, rendering the bewildered man part of the confused scene. *Nay, these women are not pretty. There is no escape from them!'*

Jacques' gaze returns to the outstretched arms of Christ and he visualises Picasso's central harlot, whose arms mirror the stance of crucifixion. A dark-haired figure with a glorious golden halo to the left of Jesus, at once strikes Jacques as a crooked effigy of Sonia. 'There is no escape,' the bishop concludes. Organ music swells over the words, heralding the crescendo of Jacques' confusion. He turns to take his leave of Max, who remains in his place. He nods in quick retreat, waving his cane as he scuttles away, making a hurried descent down the basilica's long flight of steps, back towards the city. Max stares after him in dismay.

Jacques sets off towards the boulevard de Rochechouart and slows up as he turns east into the boulevard de Clichy and through the place Pigalle, where a couple of pale, scabrous, boy prostitutes proposition him. *What can this immaculately attired gentleman be wanting in this area?* they not unnaturally speculate. Female whores similarly approach him, 'Can I be of service your eminence...? Such a handsome gentleman...'

Feeling nauseated, Jacques shakes them off and continues along the boulevard de Clichy, as far as the Moulin Rouge. Here he enquires as to the whereabouts of the Hippodrome café for which he searches, thinking in his confusion he might visit the fateful site of Casagemas's suicide. *Perhaps it could help me to face these terrible associations?* But a passer-by soon informs him that the Hippodrome was demolished long ago.

The exhausted man fortifies himself with some refreshment in the theatre bar of the Moulin Rouge. Steadying himself with brandy, he contemplates his surroundings. There is no entertainment in progress on the Sabbath, and he absorbs the historic atmosphere, imagining himself briefly as Toulouse-Lautrec, who had captured the dancers so vividly here – works that Jacques used to buy when he was avidly collecting Impressionism.

Soon he cannot help but allow his thoughts to drift back to his hallucinations in the Sacré-Cœur. The vision of his beloved Sonia has stirred his buried anguish. The worm within him begins to devour him once more.

He sits, stunned for some time, and as the brandy delivers its effects he is gradually calmed. Taking stock, he reviews in his mind recent events and the new information suddenly in his possession. He reminds himself of his own precipitous actions and tries to apply more intellectual rigour to his situation, but many questions plague him. *Was the escapade with the lead encasement a nonsense? To what extent were the hallucinations in the Sacré-Cœur actually self-inflicted? Am I, Jacques Doucet, of sound mind?*

He decides to return to the basilica and find Max, and his

chauffeur with whom he had arranged to rendezvous sometime earlier. Before reaching the steps, Chivet, who has come looking for his employer, spots him ambling through the place Pigalle. Max, already in the car, is highly relieved, and notes how odd it is to see the refined Jacques Doucet in this shameless district. He resolves that he is going to need much patience with this lost soul.

Jacques plants himself heavily onto the fawn coloured velvet upholstery with a great sigh, remembering his fervent promise to return the errant Brother Cyprien to his holy order. He instructs Chivet to begin the journey to the Abbey, in the course of which he hopes to gain some reassurance from his counsellor.

At first Jacques decides to refrain from interrogating the monk and allow him the peace of silent contemplation. But the pressure of his troubles requires him to resume the subject after travelling for just ten minutes. 'I cannot help but dwell upon Fernande's account. Was Picasso really exploiting his friend's tragedy?'

'I would not construe such things so readily. I'd suggest it was more a case of a depiction of modern life.'

'Modern life?' he echoes, still a little shaken.

'In the Baudelairean sense, that is.'

'She said you were tutoring him on Baudelaire.'

'Just so... I can tell you what was in my own mind and what *I* conveyed to my friend... From the outset I encouraged him to focus upon depicting modern life for his major work.'

'So how does a macabre poet-pioneer come into it?'

Max recites a quotation for Jacques, which had once impressed Picasso. *'The whore,* according to Baudelaire, *is a perfect image of savagery in the midst of civilisation. She has a kind of beauty which comes to her from her sin; always lacking spirituality, but at times tinged with fatigue masquerading as melancholy. Her eyes are cast towards the horizon, like a beast of prey... She is a gipsy dwelling on the fringes of regular society...'*

'Ho, you prompted him!' Jacques jeers. 'But Picasso confessed his anguish to Fernande. Didn't previous tragedies inform the painting?'

'I don't know what's behind the painting any better than you, but what I do know is, it's not my place to pry.'

'Come, come now, Max. It's not prying. I am trying to understand ... Fernande seems to think he never fully recovered from the death of his baby sister.'

'You could say, one man's quest for understanding is another's intrusion into personal grief,' replies Max, attempting to swerve the battery of questions.

The maroon over black Saloon speeds out of the city, along the avenue d'Italie, through the *banlieue*, towards Gentilly.

'There is more you cannot or will not divulge!' Jacques alleges with little restraint. Max frowns obdurately. Jacques uses all the strength of his eloquence to soften his companion's resolve, wondering, *might perhaps his promiscuous leanings and natural mischievousness have been flattened by the strictures of monastic life?* 'Why don't you help, Max? It would not be a betrayal, and after all I have done for you,' but he promptly reproaches himself for wheedling in this manner. Tension grows between them.

'I've always been clear, have I not? Unrequited as it is, my love for Pablo remains absolute. I fear I have said more than enough.' Besides as counsellor I offer you my ear, nothing else!'

Jacques scowls. 'Encasing it in lead has not helped. How could I have expected it would? If anything my burden has intensified.'

'As you know, I was never convinced.'

'Come along, Max, this is so infuriating. Can you not provide me with *something* more? 'What do we know of Sonia's connection with *The Brothel?*... Pardon me, I mean the painting of course?' He blushes. 'Did her connection with *Les Demoiselles,* the painting, contribute to her demise? Was she really psychic? In what way could the tragic death of Carles have been an influence?'

Max looks blank and squirms with a mild pain in his posterior. Night is closing in and electric lights begin to glitter in the myriad windows of the urban landscape. Few people are out on the streets this evening and all is quiet. Chivet is making good progress.

'You can speak on art. That's no betrayal...? Does the abandon-
ment of perspective contribute to its meaning? Need I go on...?'

Max considers carefully; the questioner cannot resist making his
relentless demands. 'Monsieur Jacques, so many questions.'

As the motorcar purrs on into deep countryside, the monk sees the
testing of his patience as a challenge that he must rise to, and
though strongly perturbed by this mission, he is also appreciative.
'Let me say again how terribly gracious it is of you to return me to
my quarters, and in such style and salubrity,' he says, readjusting his
upright position on the plush chaise.

'I hope you know how much I appreciate your support and
precious friendship throughout these difficulties,' Jacques replies,
deflecting the deflection. 'And forgive me for troubling you, but
may I just ask again, did Sonia Roux *really* have psychic powers?'

'Who knows? There are forces beyond us. Sonia was a proficient
spiritualist. You witnessed her séance?' Max wriggles.

'I was half-inclined to believe in it at the time. And contacting
Carles Casagemas, too. It was extraordinary. Even among her dying
words she referred to contacting him. It seems I am obsessed with
Sonia, she was obsessed with Picasso's paintings, and he in turn is
obsessed with Casagemas.'

'Quite a circle of interaction, twixt the living and the dead,' quips
Max, offering a warm smile.

'Excuse me dwelling on the subject once more, but did Picasso
attempt contact with Casagemas *on the other side?'*

'Not to my knowledge. But then you wouldn't expect me to say.
His way was to do everything in paint – or even with sculpture.'

'Oh, I wonder if his sculptures concern my quandary at all?' asks
Jacques, at last simmering down after his upset.

'That I doubt – but he once had in his possession some ancient
stone busts. So intrigued was Pablo that he chiselled into the bases,
trying to reach the ancients spirits within.'

'Dabbling with the occult then, after a fashion?'

'You might say... But then...'

'So with Sonia, her interest in Pablo's work just happened to be at the time of his obsession with Carles?' continues Jacques.

'From repeatedly painting apparitions of the boy, are you suggesting...? If so it continues to this day.' Max now ponders aloud.

Jacques straightens up in his seat, 'What's that, Max?'

'A little bird tells me, Pablo's *Dance of Death,* or is it *The Three Dancers* – or some such title – is underway, following the death of our old friend Ramón Pichot last year... In fact the work could even be called *Death of Pichot.'*

'You mean the same Pichot who stole young Germaine away from Carles?'

'Quite. And all three actors are portrayed in a triumvirate waltz.'

'So these are the three dancers ... Carles, with the Pichots, whom he shot at, before blowing his own brains out ... and Picasso is painting them in a dance, hum?'

'He's not letting go, it would appear,' concludes Max thoughtfully. 'It's twenty-five years since, and he is still exorcising the loss.'

'Seems he has never been free of Carles? What a tale of grief. Gruesome you might say!'

'Something that is widely known – so no breach of confidence here – was Pablo's initial apparent indifference – another side to him you could say... After Carles's suicide and before Germaine married Pichot, he had his own illicit affair with her.'

'Good heavens!' Jacques exclaims, appalled by another shocking revelation. He stays quiet in contemplation, for moment.

'Best leave it alone, in view of Pablo's lax morals?' Max suggests.

But Jacques quickly resumes, 'It is interesting that now Pichot is dead, Picasso rages once again in paint – this time including the girl – the only surviving character in the tragic drama... Is this about guilt, or doesn't he have any?'

'Oh he carries it alright, like a ball and chain.'

'Could this *Trois danseuses* compete with the *Demoiselles* for artistic significance in Picasso's oeuvre?' the collector asks, before quickly censuring himself, 'No, no, of course it couldn't.'

'It's like virginity,' the monk declares, 'you can only lose it once, alas.'

'Excuse me, Max?'

'His *Demoiselles* smashed through the centuries-old convention in painting. He can't do it a second time – once it is smashed, it's smashed.'

To Jacques, his mission seems even more serious at these words. 'But now the painting is entombed, and you are meant to be forgetting it – blocking it out of your consciousness. Remember the code-8 sheet lead?'

'Yes, and it plainly hasn't worked. I asked you just now if the abandonment of perspective contributes to the painting's *meaning*.'

Max studies his friend's enquiring expression. 'It's clearly integral to the *mise en scène* – so inseparable. Think of it this way. Why do *you* have the painting?'

'I was the one foolish enough to buy it. And perhaps because Picasso believed I was the only one who could secure its place in the Louvre.'

'If its greatness had been recognised, Pablo would never have parted with it, unless he had sent it direct to a museum himself... Or, it could have been bought by people with deeper pockets than even your own, Monsieur Jacques.'

'It remains a mystery – eighteen years on – in a post-Cubist world now with Surrealism to the fore... Why, even Apollinaire never recognised its power,' says Jacques, whose nerves seem overwhelmed by this same power.

'No one did.'

'I sometimes wonder, is it even art?'

'You know, my dear connoisseur, the avant-gardist exists on a very thin line. *Before* this line there is no originality – as in, *it has been done before,* or is mere repetition. Anything *beyond* the line, however, is too radical, and no longer recognisable as art.' Max speaks slowly. 'Your *Demoiselles* crosses the line. The break with perspective established a new concept for painting, separating it

from the function of the camera. Suddenly the purpose of art lies largely, if not exclusively, in what it *is* in itself, not what it represents *visually.*'

'You're good at this when you get going!' Jacques flatters him.

Max waves his arm in a flourishing gesture of finality. 'Just know this: the abandonment of perspective was a brutal, precondition of bringing art into our era – it had less to do with the actual painting itself, and more to do with what *painting* could be ... and what it might *do* to the viewer.' he adds. 'Ha! Your own state of mind is all the proof you need. You don't even look at it anymore, and it still pushes you to act. The rules had all at once been kicked away. *And,* at first, the person most influenced by the painting was Pablo himself – but then his critics and peers soon followed him – like the Pied Piper.'

'But this has nothing to do with its meaning, does it Max?'

'Picasso would insist that any meaning embodied in the picture is for the viewer to discern anyway. In your case, monsieur, I suggest you are already a good way into that voyage of discovery.'

'I'm on the tiger's back you mean.'

'My dear fellow, just listen to me, lecturing on art history, to he who built the national art library of France. *Invented* art history even!'

'Indeed. Show some respect!' Jacques jests, brightening for a minute.

A period of reflection prevails. Chivet has built up speed as the Panhard heads south. Max leans towards the driver's cabin to observe the illuminated instruments on the dashboard, noticing the needle flicker above 80.

Jacques drifts into deep thought, gazing from the side window into the darkness of the night, catching just an occasional glimpse of a rising moon through the spindly skeletons of distant trees. *How tiresome that my companion's new-found Christian devotion prevents him from advising on the subject of Spiritism, and a search for the truth – even if this could help, which is perhaps very doubtful.* He continues to fend off disturbing images of Sonia's face, the lead, the vaults and the linen shroud containing *the problematic whores.*

How foolish he had been to bury the offending object rather than confront it, he increasingly feels. Yet, he considers, *should I return with bricklayers and have it permanently blocked in?*

Hunger begins to intrude. 'Chivet, are we far from Orléans?' Jacques enquires. 'I'm sure we are all in need of repast by now.'

'Another hour, Monsieur Jacques.'

'May I suggest we make for the Hôtel la Renaissance for dinner?'

'How profoundly civil of you, Monsieur Jacques,' effuses Max.

The hotel in Orléans offers welcome refreshment for the nocturnal voyagers. The lounge bar, with rather dated Art Nouveau decor, fortuitously doubles as a provincial bistro since the hotel's main dining room is closed by the time of their arrival. Chivet joins the servants below-stairs for dinner, while in the lounge room the odd couple are served identical fare, an unglamorous dish of *côtelettes d'agneau* and *pommes de terre à l'anglaise*. Jacques struggles to concentrate on food while Max is delighted by it, and especially at the arrival of chocolate soufflés. 'I must sin. Forgive me, Holy Mother.' He raises his eyes and murmurs with pleasure, delving into the bitter sweet clouds of his dessert.

The group reconvenes sometime later beside the swirling curves of the limousine. Chivet opens the passenger door. 'Another forty minutes, messieurs, before we reach our destination.'

As the car pulls away, Jacques lights a cigar and sits back, sieving his thoughts. 'Too many unanswered questions,' he resumes.

'Ultimately, no secrets are *unanswerable* – on the day of Judgement at any rate.'

'No indeed, according to your God, Max!' returns Jacques, conscious of the moonlit hedgerows flashing past. 'But my concern is with the here and now, as we traverse a *temporal* universe.'

Max, satiated and feeling more helpful, returns to the earlier topic. 'Something I may repeat without breaching any great confidence...'

'Then don't hold back, Max.'

'For a period Pablo, Longfingers, Kostro and I dined regularly at Matisse's family home, at the quai Saint-Michel.'

'Really!?'

'Oh yes. Henri would expound his theories of colour, relationships between the painted surface, brightness of coloration and such like ... peering over his gold-framed glasses like a scholar as he did so... At one point he showed us a statuette in black wood – the first African wood sculpture Pablo had seen.'

'Are you certain of that?'

'That was what he said. Pablo latched onto it, and held it in his hand for the entire evening. The following morning his floor was strewn with paper. On every sheet was a large drawing, each nearly the same: a woman's face with a single eye, a nose too long and confused with the mouth, and a lock of hair on the shoulder. Perhaps Cubism was born then? This same woman reappeared in paintings. Instead of one woman, there were two or three, and then there was your own *Demoiselles,* as large as a wall!'

'Truly, Max. Would you say Cubism was born in *Les Demoiselles,* or at least in the right-hand side of the painting?'

Max shrugs. 'Apollinaire sang the praises of what *he* called Cubism. I wonder, have you read *Les Peintres Cubistes,* written just before the War? You must have a copy in your library?'

'Would it be of help?'

'If anyone could be...' says Max.

'I have heard Longfingers was an enemy of *Les Demoiselles?*'

'No one liked it, especially other painters. None of the illustrious Cubist retinue even knew Pablo in 1906. He was alone inventing that style of painting. Not even Braque...'

'And Salmon. Was he its enemy?' asks Jacques.

'Maybe at first, but he did exhibit the picture – at its one and only outing... Still, people come round in the end, as *you* will discover, I trust. I'd say, find the words of Apollinaire,' repeats Max.

'I shall but these are physical, formalistic, painterly issues. There is the deeper mystery to consider. And I am not abandoning my quest.'

Jacques has finished his cigar and tries closing his eyes. Minutes later they arrive at the monastery. 'Oh Max there is something else I

should probably have discussed with you,' he says slyly, not realising the strain he is putting upon his companion, 'about guilt ... and Jeanne.' Such a major matter would more rightly have been the subject for earlier discussion, but Jacques connives to have access again to the ear of the good Brother.

'How so?'

'Oh, I've tried my best you know...'

'Obviously,' Max snaps, quietly in pain with haemorrhoids.

Suddenly recognising the monk's fatigue, Jacques relents.' Perhaps we might do this another time? My quandary has many strands. Let us seek further answers after some repose.'

'Yes indeed, there is always another day,' the monk replies wearily, acknowledging the possibility of further questioning.

'Very well, my friend, another day.'

The two exchange a kiss on each cheek.

'Go carefully, Monsieur Jacques,' Max adds with affection, and takes plodding steps back to his cell for overdue prayer and rest.

The journey home provides the lone passenger with enforced time for reflection. He tries to sleep, but is too agitated. He rebuffs all thoughts of Jeanne, feeling the need to meditate instead on matters provoked by the good Brother: *Was Cubism born in the painting? – Perhaps in the right-hand side* of *it? Is it important?* He leans back, considering the connection to Henri Matisse's African statue.

Jacques pulls out a thread from his coat, to his annoyance. *In the light of Fernande and Max's recollections, the whole exercise of encasing the picture in lead may have been a pantomime!*

Instead of burying it, both physically and metaphysically, better to confront it and understand it, he feels forced to conclude, *not just by me but by the world at large. And that must ultimately include Jeanne – away at present visiting her cousin. There is time to act.*

12

The job of the artist is always to deepen the mystery.
Francis Bacon

Y ET AGAIN CARPENTERS remove the French windows of the drawing room to the gardens at Villa Doucet on the rue Saint-James. The painting, still swathed in the scorched linen, is being brought home, having been disentombed from the vaults. The lead casing has been returned to the plumbers' merchant as salvage.

Jacques commissions the services of a firm of piano movers and arranges for them to design and fabricate a petite piano *shoe,* of the kind that is strapped to a grand piano before it is turned onto its side and wheeled around. A light, modified version of this simple device is procured for the transportation of the painting.

Once inside the villa the canvas on its stretcher is seated upon the shoe and is effortlessly manoeuvred through to the study. Jacques removes the linen covering and considers its powerful presence, before sliding it behind the large Art Deco armoire, within which is housed a valuable collection of historic costumes. According to his plan, it fits perfectly in the space. With the addition of several artfully arranged lamps, which he has brought into the room, he is able to wheel out the painting and view it satisfactorily at any time. He is at once pleased and shamefaced at the deception.

While Jeanne extends her stay at her cousin's country residence Jacques is free to contemplate the picture with impunity. Seated at his noble bureau, he gazes across to the iconic work and studies its jagged form and colour.

Regarding his theory of Cubism being born on the right-hand side

of the canvas, he debates it over again and retraces the sequence of events preceding the execution of the work, in view of all he has gleaned from Fernande, Max and others. *Is anything less opaque than previously?* Above all he ponders Sonia's words – reflecting back to their rendezvous, at the opening of Cézanne's retrospective at the Salon d'Automne in 1907. *I clearly misunderstood her insight,* he concludes.

'They are still mourning the master of the Mont Sainte-Victoire at the studios,' Sonia had reported, as they gazed at *Les Grandes Baigneuses (the Bathers)* – Cézanne's substantial landscape work of ten naked female bathers luxuriating in a bucolic setting.

She muttered to herself. 'Did this in part prompt the giant nudes Pablo slaves over, I wonder?'

'You're speaking of the Spanish painter up on Montmartre again?' I asked.

'*His* women are not protecting their modesty like this, but appear full-frontal, brazen and straining to burst from the canvas, like pink, ice-packed sardines, staring one down,' She graphically depicted it.

'So not in this Impressionist style?' I gestured to the tranquil bathing party.

'No, not in the slightest. Pablo has overpainted some of the right-hand side to dramatic effect.'

'How so?' I asked.

'There are five giant, loping nudes. Originally they all had large blank, staring, almond eyes. Quite featureless faces. Only the central two now remain in such manner. The others have been painted over with Egyptian and African features – like tribal masks with animal snouts!' She was impassioned in her description. 'Extraordinarily, one of the figures seems to be visible from the front and the back all at the same time. I cannot imagine him ever being able to show it publically...'

As Jacques recalls these words of some twenty years ago, he sits back in his desk chair and focuses on the right-hand squatting figure with legs spread-eagled with the most bizarre of the masked faces.

He recalls questioning Sonia further, but rather indifferently.

'Why do you think the artist is doing this, my dear?'

I caught the flash of her bewitching eyes as she spoke. 'Cézanne made a great step forward with his geometric landscapes. And I suppose Pablo is making his own leap into the future.'

Now I can see, it is undoubtedly Cubist! How long it has taken me.

'With this work there is a spiritual dimension.' Sonia maintained. 'Pablo takes much ribbing, for he calls it his *Philosophical Brothel.'*

Jacques remembers how entirely distracted they were from viewing Cézanne's work at the exhibition, discussing an unfinished painting he had not even seen. *I certainly had no inkling of anything momentous at the time, despite her almost fanatical enthusiasm. I suppose I was more interested in the lady Sonia herself.*

'Pablo's artist friend and fellow countryman Ignacio Zuloaga, living nearby, owns a great El Greco altarpiece – *Saint John's Vision of the Apocalypse ... Sacred and Profane Love,'* she continued. 'Pablo is so enamoured by it that the others at the studios have started calling his new painting, *Picasso's Apocalyptic Whorehouse.'*

'Does that compliment or denigrate it?' I asked.

'I'm not sure, and nor I think is Pablo. But it may be both sacred *and* profane, as in the words in the title of the El Greco – two opposite kinds of love.'

'But quite an unlikely subject for the sacred, don't you think, my dear...?' I replied, gazing at Sonia – the word *love* ringing in my ears. *Why is she so obsessed with this? How I adore her intensity.*

Jacques rises from his bureau, rests his gaze upon his exhumed painting, then selects a volume of Spanish masters from a bookshelf. He recalls André Breton's unalloyed certainty of the *sacred* nature of *Picasso's Brothel,* as well as his own naïve responses to Sonia, and the surrealist too. Both had considered El Greco in relation to the Picasso. Jacques flips through the leaves until reaching a plate of the altarpiece of circa 1610. Confronting it now, he compares them. *Saint John's Vision of the Apocalypse* and *Les Demoiselles* are in a *blunted vertical* format. Each have elongated forms of naked figures,

draperies in the foreground and around the women in each, as well as likenesses in the treatment and palette. The upstretched arms and hands of two of the El Greco figures, holding up their cloth, are strikingly similar to the pose of Picasso's curtain-holding whore. But here the comparison seems to end. *Saint John's Vision* is not of a brothel, and while the figures are scantily clad, they appear to be in a sacred posture, gesturing to the angels, heaven and The Almighty.

'But wait a minute!' Jacques exclaims out loud, puzzling, *Is it similarity I'm looking for here, or is it the absolute opposite? This is a blessed altarpiece, created in deference to God. Picasso has converted it to an image of whores in a brothel. Is this a satirical riposte?* He wonders about Breton's assertion that *Les Demoiselles* is Sacred. *But then he must have used the word poetically, rather than with reference to religion?* He is suddenly pained. He conjures his phantasmal experience at the basilica and shudders.

Closely examining the *Avignonites* canvas again, he analyses the faces, snatching back through the tunnel of memory for Sonia's words, something like, *only the two pale central figures are made featureless by the artist.* Yes, the two on the right are masked. The paintwork of the woman on the left gives her a very much darker face in contrast to the pink-ochres of her body. She is almost in profile – an Egyptianised image – but not quite two-dimensional, since the slither of a second eye is just evident beyond the nose.

The El Greco is described in the full title as representing *Sacred and Profane Love.* This, Jacques concludes can scarcely be said of *Les Demoiselles. Sacred and profane? It cannot be both. If I could identify this, I might win Jeanne's acquiescence,* he persuades himself.

He replaces the book and covers the canvas with the scorched sheet and wheels it back behind the furniture. He turns his attention to other matters concerning his long-since neglected fashion business.

OPENING THE ARMOIRE doors, Jacques gazes upon a collection of rare garments, retained as prized exemplars from his life as couturier.

These fairytale creations in the finest lace, silk and satin are among the most exquisite he could have retained. The first, made for the actress Gabrielle Réjane, is a garment of satin and rose taffeta, very pale with Russian lace on the skirt and bodice. The next, a Sarah Bernhardt gown, is of powder blue. It has intricate embroidery accented with turquoise rhinestones – once Jacques' favourite colour combination. A flowing evening gown of lemon chrome has been overlaid with coral and orange charmeuse, sewn in silver and buttercup thread. A tunic in luxuriant cream mousseline has delicate ruffles, sequins and golden crystals.

One by one, he leafs through the collection and discovers a growing disdain for the shallow and facile nature of this extravagant raiment. *This is not real art,* he chastises himself. *Sickly and cloying like a viciously sweet syrup and above all mere surface decoration and clutter.* It belongs to a world long since passed, and valuable as the rare garments may be, they leave their creator stone-cold, if not disgusted by his own *superficiality,* and the effort he has made in reassembling these valuable examples of his work.

Finally, however, he removes a particularly dainty black peplum dress, beaded with jet and threaded with pure silver. He cradles it to his breast for a moment; a sensation strange to him catches his throat and tears pool in his eyes. This was different. This is the gown he had made for Sonia just before the fateful day. *No, they're not getting their hands on this,* he vows to himself. He lays it on the table, folding it expertly, and carefully wraps it in fine tissue paper before placing it in a drawer under lock and key, joining a number of mementoes relating to Sonia, including the raven's feathers he picked up from the floor of the Trocadéro, on that dramatic first night spent with her so long ago.

13

The rich client wants to own furniture which he can be sure
he will not find in the homes of those less rich than himself. –
Émile-Jacques Ruhlmann

THE WINDOWS of the fashion empire of Maison Doucet in the rue de la Paix are unadorned. The muted and sternly contritely reliable frontage appears much the same as if time has stood still, but a perceivable air of vitality has gone down since hemlines have gone up. The master and staff have known for some time that the era of Maison Doucet is past. The firm never fully recovered from the cataclysm of the War. The impact upon Paris fashion of Paul Poiret and couturiers of his generation has been relentless. Ladies in their airy flapper dresses and cloche hats are an extraordinary contrast to their stiffly cloaked and corseted mothers and aunts who once perambulated about the same expansive street, and are similarly unlike Jacques' diaphanous fairy goddesses. All had been different creatures entirely.

Falteringly, porters bring three large Impressionist paintings out through the front doors of the establishment and load them onto a truck bearing the livery, Galerie Georges Petit.

Within the building, bespectacled lawyer M. Louis Belbœuf with his busy *Guillaume II* moustaches faces his client across the desk and issues an ultimatum. 'How can I put this? You no longer have license to choose, Monsieur Doucet. It's sell-up or bust. Plain and simple.

'This only needs your signature!' The burly lawyer passes his client a document for perusal. 'Maison Doucet was indeed mighty

in its day. But as I understand it, you haven't crossed the threshold these past six months.'

Doucet stares blankly.

'Are you with us, monsieur? The world is adjusting to the new fact that ladies have legs! ... Have you, monsieur, eh?' M. Belbœuf roars a great belly laugh, tickled by his own drollery, 'Adjusted, that is?'

'It's true, I've let the business go,' replies Jacques, frowning heavily as he browses the documentation. 'I cannot begin to imagine the implications. You know how long it's been in my family.' After some hesitation he applies his signature. 'Quite dreadfully, I have proved to be the last stop on the line!'

'Not at all! Let's not be melodramatic, my friend,' M. Belbœuf wags his finger. 'We both know you have long been disillusioned with the business. Of course, the War was a setback for all luxury merchants. The House might have survived, as have your neighbours, the brothers Worth. But you are not them, Jacques. No indeed! I think we can safely say,' M. Belbœuf booms reassuringly, *Dressmaker Doucet* is dead. Long live *Doucet Patron to the Arts, n'est-ce pas!* ... Now, as to the effects; buyers may need to collect any stock from here. Can we arrange a date for taking the inventory?'

They discuss a schedule and confirm an appointment for the clerks to visit. Jacques makes it clear that all remaining original works of art on the premises are his personal property and must not be included.

Meanwhile, the Impressionist works sent to Galerie Georges Petit earlier that morning are being sold to shore up his current needs. As the lawyer makes ready to depart, he hands his client a daily newspaper. 'Old son, you might want to keep this out of Madame Doucet's way. The ladies do have a teeny tendency to lack finer judgment at a time like this!' Jacques grunts as he reads the headline above a small article:

DOUCET – WHAT MADNESS!

He tucks the copy under his arm, ushering M. Belbœuf to the

door. The ebullient lawman smacks his cheeks with hearty kisses and salutes farewell to his troubled client.

Not only has Jacques lost interest in the firm – a fashion house falling behind the times would be almost humorous if it were not so tragic – but also his feelings of repulsion for all it stood for continue to rankle. He prefers not to reflect on the fact that it has been in his family for more than a century. He evades thoughts of his beloved Papy's legacy, but this is what grieves him most. He fears that his grandfather might not have understood his present circumstances, alas. One thing is clear, he is not going to miss the elite and snobbish world that he is leaving behind.

Art collecting had been his fortress and through it he had earned respect and even a seat on an important committee at the Louvre. Perhaps it had even influenced his winning the *Légion d'honneur* – a considerable accomplishment, although he had felt it necessary to decline the award. All of this had failed to elevate him to social parity with his aristocratic clients, despite the advent of the Third Republic, now more than half a century ago.

Before the wretchedness of Sonia's death, before the War, and the liquidation of his famous antique art collections, everything had been different. His thoughts jump back to 1912 on the occasion of his great and celebrated sale which had astonished the art world and simultaneously elicited both respect and ridicule. Admiration and astonishment were expressed for achieving one of the highest grossing sales in auction history. *Ha! That vile Robert de Montesquiou, in perusing the daily newspapers over his breakfast eggs and kidneys, had apparently almost choked to the point of asphyxiation in amazement. How he must have suffered with grudging admiration. Still I was deemed a ridiculous fool for my wanton break-up of my collection ancienne.*

Newspaper headlines had alluded to Doucet as a maniacal vendor. *Prix Exotiques. Quelle Folie! The Fashion for Madness!* These and others were bigger headlines than the current splash.

After the sale I was drowning in money. In reality, I had disrupted

the French art market, switching everything on its head for some years afterwards. My own life, bleak and depleted as it had felt then, took another direction. The chasm of my existence was filled with a new sense of purpose. I was suddenly a hurricane in action, cleaving to my new cause. Plotting to spend such gargantuan wealth is not a simple matter. Ploughing millions of francs into books on art and archaeology was never as rapid as I would have liked. The scores of thousands of volumes sent for, from all parts of the globe, were offloaded into the five vestibules of my five consecutive buildings in the rue Spontini – each with five library crews endeavouring to sort and catalogue the material. The outcome was a great library, though considered once again by my irritated and high-handed neighbours to be a prolonged act of madness that had got wildly out of control. That in the end I was obliged to give away the library might have seemed bizarre self-sabotage, but it was a catharsis and forced me yet again to move forward.

It is one week after meeting his lawyer and signing the notice of sale. Three clerks with clipboards crawl all over the former fashion empire taking a full inventory of stock and effects. In a mammoth operation, large quantities of haberdashery of every description – from chalks and needles to silks, laces, embellished and encrusted materials, finely filigreed fabrics, threads, zippers and fasteners, costumes in every stage of completion, including historic pieces, velvets, furs and jacquards, along with equipment and many other mechanical aides, furniture and fittings – all come under the scrutiny of the administrators. 'Monsieur Belbœuf has noted you have stock at the rue Saint-James villa,' the senior clerk informs Jacques. The erstwhile dressmaker signifies his assent to this being added to the inventory.

'We've settled the legal transaction without impediment,' explains the same official, arriving at the Doucet residence a few days later. Jeanne stands in trepidation at the stone portico, intent on greeting the visitor and his associate herself. She sees them approaching – two men cossetted in grey flannel suits. The elder, also acting as the

spokesman, lifts his trilby. 'It is just a stock-take for now, madame,' he adds, addressing Mme Doucet. His breezy approach is hard for her to relate to at this very difficult moment.

Her face is blanched and pinched with concern. She shows them into the study where they are greeted by her husband, who steps out from behind his grand bureau.

Jacques is nervous, almost hostile. 'Right, let's get this over with quickly, if you please! You can make your inventory and be on your way.'

Jeanne frowns at this, wishing she could nudge him into making a modicum of small-talk. He unlocks the doors of the Macassar ebony armoire. The pen-pushing visitors inspect the contents and complete their task in brisk fashion. Jeanne remains in the room, stifling her distress as she resolutely witnesses the proceedings.

Copious notes are taken on clipboards as the officials examine the historic garments. Jacques reflects on how these valuable treasures will help settle, if only to a marginal degree, Maison Doucet's affairs, and he remains perfectly resigned. He hands over a detailed schedule with notes of provenance prepared for the purpose. Mme Doucet watches everything with beady eyes, appalled but also relieved that her husband is relinquishing his business.

At the finish, as the gleaming doors are closed, the clerks pause momentarily in admiration of the armoire itself. Jacques testily draws attention to its virtues. '... The handiwork of one Émile-Jacques Ruhlmann, of this parish – *ébéniste* to the Élysée Palace – and, I hasten to add, part of our own private collection.'

It grieves Jeanne to see that her husband appears to care more for the furniture than for the fabulous garments within. Jacques catches her look, realising that their differences still remain, he wonders, *Does she still cling to her idea of me as dressmaker?*

The senior clerk strokes the glossy exotic veneer, allowing his fingers to venture around the back edge. 'Oh what's this interesting looking object behind here?' he exclaims, and he gives a slight tug to the large painting. It rolls out effortlessly from its hiding place on

its wheeled shoe. The scorched white linen sheet falls away and audible gasps fill the air, as the head and shoulders of two whores are revealed.

'Ahh! *Quelle horreur!'* Jeanne screams in surprise and dashes from the room in fury, clutching at her throat.

Jacques ignores this extraordinary outburst for a moment and escorts the clerks to the front door. The three men likewise disregard the awkward occurrence and continue with their bureaucratic business, delaying Jacques by some minutes as they engage him with more tedious questions.

After a brief interval Mme Doucet, boiling over, returns with the servants. Red-faced, she confronts Henri and Marie Bonnet, as they stand by the great armoire and in front of the revealed painting. 'You both knew it was here. How could you?' shouts the irate woman. 'Dora, you too! – You're aware of how I felt about it! How could you betray me? I've a mind to dismiss the lot of you!' It is a moment of excruciating embarrassment. 'Bonnet, fetch the travel boxes and take them up to my room. Dora start preparing my things will you, and bring my boots too,' commands Mme Doucet.

Jacques enters, instantly assessing the situation and is horrified. The servants pause, somewhat confused. He intervenes with impressively clipped vowels. 'That will be all, Dora. You may go now, too. I'm sure you've been chastised sufficiently on my behalf,' he tells Mme Bonnet. Turning to his wife, 'Please, Jeanne, I've been trying to find a way to explain...' But he is interrupted by Dora, who returns with a pair of heavy leather boots and places them alongside the mistress of the house before making hurriedly for the door.

'So this is the stuff of your promises!' shouts Jeanne, launching into her husband. 'I'm not one of your Surrealist marionettes. You can't pull my strings!' She is particularly piqued to have read only that morning in *Le Figaro* of her husband being *the puppet master* holding the purse strings that enables the Surrealists' deranged onslaught – indeed, *Jacques Doucet is financing Surrealism!*

'I suppose you think you *are* a Surrealist?'

'Gah! I sometimes feel like one in this house.'

His wife angrily grabs the weighty boots, lifting each in turn and throws them at full tilt. Jacques catches them awkwardly.

'You'd better get my things to the car, seeing as how I've humiliated myself and the servants in such a degrading way!' she shouts.

'I've plans for it ...' replies Jacques, attempting to defend his position – and then falters, stumbling, dropping the boots and clutching the side of his face. He is suffering a sudden and excruciatingly pain to the head. He sweats, turns pale and falls to the floor. 'For pity's sake, Jeanne! ... Aagh! Aagh!'

Jacques is writhing in agony.

Jeanne shrieks to Bonnet as he leaves the room. 'Fetch the doctor! Quickly! Monsieur's having an attack! Quickly man, run!' Jeanne crouches down at the side of her struggling husband, cradling his head and doing all she can to comfort him.

What seems an eternity, before the physician arrives, is only a matter of fifteen minutes. The servants stand in silent readiness. A modestly dressed gentleman with a buff and shining bald head and kindly face is brought by Bonnet, straight to the ailing man, and is announced as Dr Capelle. Jeanne is fanning the fragile form of her husband, lying trembling on the floor. The doctor quickly snaps a capsule under his nose, injects a mercurial diuretic into his arm and administers laudanum by mouth. The prostrate patient is blanched and grimacing, showing little sign of recovery. His distressed wife looks on with foreboding – tearful in grief and self-recrimination.

'Summon an ambulance!' Dr Capelle barks at Bonnet. 'Go on man, HURRY!' Within the hour Jacques is transferred to the local Hertford British Hospital.

14

A painting that doesn't shock isn't worth painting.

Marcel Duchamp

J ACQUES LIES INERTLY in a private hospital room, in an extremely precarious condition. A nurse bustles around preparing medication. Jeanne, with lips taut, watches as the monocled doctor checks her husband's pulse. 'I should have allowed him his obsession,' she utters, dabbing tears from her eyes.

'Hush now... This isn't helping, is it, Madame Doucet?' murmurs the doctor, turning towards her supportively. 'He's a valiant lion.'

'That he is,' she sobs.

'You know, my dear, we all grow old,' the doctor philosophises, 'but Monsieur Jacques is that rarity. A man who grows young – in spirit, you know.'

A little later, Jeanne, who remains at her husband's bedside, mops his brow. He has drifted off into unconsciousness and there is still no sign of his awakening. A nurse replaces her from time to time and together they maintain a vigil through the evening and into the night.

During the lonely hours she recalls her time as Jacques' fiancée, before they separated twenty-one years ago... *So dashing and handsome, immaculately groomed and attired; so kind and generous to those he employed, and to her. How he so open-handedly gifted me the villa in the rue Saint-James upon our separation.*

She switches to the source of her husband's anguish. *Of course his intimacy with Mme Roux always provoked feelings of regret and jealousy, and even now, I confess, when I think of that vile*

painting. But then he had at the time been perfectly free to remake his own life as he chose, Jeanne reflects. *Had this Sonia been so passionately in love with Jacques, or was it a limerent infatuation, perhaps mutual, with my former fiancé acting as protector from the menacing Roux?*

Jacques had built the splendid villa in the rue Spontini from the foundations up, and orchestrated it all to his own specifications and exacting standards and taste. Housing his famous art collection, the villa was lauded by all as a magnificent lifetime accomplishment.

At a moment when all the strands of his ambitions and desires seemed to be converging, every bit to his joy and delight, this poor woman died! It was a mysterious death – just as she was due to ask her husband for a divorce. For Jacques it was a crushing reversal to his very purpose in life. I made efforts to comfort him during these dark times but there was nothing I nor anyone else could do to relieve his suffering.

Jeanne recalls wistfully his travels to Egypt, Africa and the East, excluding himself from every connection with his former existence, rethinking his future; if indeed he could see any kind of future at all.

After his return and the dismantling of Villa Spontini, the great sale and the disposal of the villa itself, there had been a period when she had seen or heard little of him. *I cannot even recall where he had been living – in an apartment attached to one of those five library buildings – which one....?* She cannot remember. *But I was an outsider then.*

Once he was through his incredible library-building obsession he gradually improved, as he began working with Paul Iribe to fashion a stylish new apartment for himself in the avenue du Bois. Little by little, this rekindled his purpose in life. The radical *modern style* of Iribe was a revelation to him. The furniture elements were bespoke – both in design and fabrication. Jacques was astonished by each exotic treasure conceived, as they stunningly reflected his own developing taste for the truly modern. Jacques grew confident in commissioning furniture and approached the glass artist René Lalique for a pair of

grand doors, which were duly produced. He marvelled at the deep crystal surface and would lightly dance his fingers over the glass sporting Olympic figures in motion, in glad fascination. It was also at this time that he began collecting modern paintings in earnest – an enlivening process – and he began to feel as if he were completely steeped in golden masterpieces.

The Great War intervened and I volunteered in the ambulance service established by Jacques. Just before the end of the War, and after launching into another library project, I had hastened to his hospital bedside after being informed he had suffered a heart attack. I pledged to take care of him and soon afterwards we were finally married... Here I am, Jeanne reflects, *at his bedside nursing the man, who is once again exhausted by a reckless schedule of work. He seems to have an absolute disregard for his age and general condition of health!*

The following morning, Jacques is propped up on pillows, conscious and pained. His wife sits alongside. He is tired and coughs intermittently. Jeanne appears drawn and attempts, unsuccessfully, to feed him bread and milk.

'Don't spoon-feed me, madame!' He slaps the bed in frustration.

'Well, I like that, when I've sat up with you all night!'

'Pardon me, Jeanne!' he says, in apology for his gruffness.

The new duty nurse orders the patient's wife to retire for some rest. Later in the day Jeanne is back, arranging fruit and flowers.

As the days pass Jacques shows strong signs of recovery and Jeanne finds it is all she can do to keep him calm and ration the time slots of his many visitors.

Max arrives, attired in his ill-fitting suit, bringing books, including Baudelaire's *Le Peintre de la vie moderne (The Painter of Modern Life)*. He finds his patron awake and apparently making a little progress, but sees that even so early in his recovery, he is most unwilling to accept 'the prison of his illness' as he terms it.

The Peregrine Suarès visits daily and the invalid requests readings from the writer's *Le Livre d'émeraude (The Emerald Book)*, an

exquisite world of words – of melancholy and sensation – with its use of a Buddhist vocabulary. The Peregrine watches him scan with his lens over pages of *Ukiyo-e* – Japanese pictures of the floating world. Jacques smiles and says, 'This is where I should like to be. Now that I can relate to the world of pain in which human life is so transitory and harrowing.' Jeanne raises her eyebrows, concerned to see he doesn't become overexcited.

The Peregrine is wary, although flattered. While Jacques seems to be mellowing in convalescence, Suarès detects an undertone – the knot of obsession, an unnatural energy, similar to how he was at the time of his frenetic amassing of art and archaeology books.

The visitor recalls how grandiose the book collecting became, so much so that the resultant art library had to be donated to the state. The Peregrine was and is grateful to have been employed in the creation of the later *literature* library, so very selective and sensitive in comparison to the previous endeavour; but hastens to remind his patron of the value of good health.

Among his many visitors Marcel Duchamp brings along two cases of equipment. One contains a Surrealist moving sculpture – a mechanical contraption he calls the *Rotary Demisphere,* which he demonstrates to Jacques in the hospital room. The other is a wind-up gramophone. Francis Picabia and Max Ernst also arrive. They sit around humouring their patron, 'Here take these, before the women-folk return,' chortles Picabia, handing Jacques a clutch of his favourite Havana cigars, and stuffing a bottle of brandy under his pillow. Duchamp hunts around for an electrical socket for his mechanical sculpture. He finds one by the bed supplying a medical device that appears not to be in use, and unplugs it to make room for the *Demisphere.* 'Well, I would call it medical anyway,' he jokes, as he inserts the plug. 'Just say it's an 'Optic-aid' to help the one-eyed person *right* their vision!'

'Splendid my boy. I've been waiting for this,' says the patron with a delayed guffaw. He moves across the bed for a closer look.

'One moment, monsieur.' Duchamp and Picabia bring over a low

table to the bedside, upon which they mount the equipment.

While this is being done Ernst hands Jacques a photograph of his new painting which has just caused a scandal at the Indépendants: *Sainte Vierge fessée l'enfant Jésus devant trois témoins (Holy Virgin Spanks the Infant Jesus in Front of Three Witnesses).*

'Phew! If I buy that it will be me that receives a good spanking from my own devout lady.' He sits back and peers closely at the image. 'She'd have a fit.'

Ernst grins as he helps Duchamp set up the mechanical sculpture. Standing about a metre high the apparatus consists of a large disk supported on a triangulated metal stand, containing a hemispherical convex glass. A pair of transparent discs, upon which single black spiral lines of differing gauges have been painted, are fixed within the domed glass. An electric motor spins the disks via a rubber belt on pulleys. As the *Demisphere* is set spinning, Duchamp gleefully winds up the gramophone and presently the rhythmic melody of guitar notes to complement the pulsating visual effect. The two spirals complete with one another and the effect upon the eyes and mind is mesmerising. The conflicting tensions of the swirls forcefully draw in the viewer.

All, including the patient, puff on cigars, clouding the room with smoke. 'At least you didn't bring me a urinal,' the patient chortles – at which Ernst suggests, glancing at Duchamp, 'Perhaps you can sign this for monsieur?' pulling out the bedpan from below his bed. Duchamp positions his pen to a burst of riotous laughter.

The exuberant companions contemplate the spinning disks.

'The creative act is not performed by the artist alone,' expounds Duchamp. 'The *spectator* brings art to the external world – adding his own contribution – deciphering and interpreting...'

Jacques questions, pointing at the pan, 'Would your *readymades* have been recognisable as art without Cubism preceding them?'

Before Duchamp can reply he is impeded by the arrival of an incredulous Mme Doucet. The patient's wife is horrified by the rumpus she finds in progress. The gaiety and bonhomie is

summarily terminated as she takes the bedpan from Ernst and demands peace and quiet for her husband's recuperation, 'not dangerous levity!' She removes Jacques' cigar from his lips and switches off the rotating apparatus and gramophone. 'Cigar smoking indeed! – with your condition!' Jeanne exclaims as she ushers the visitors from the room.

'The doctor said it was good to smoke as it helps keep me calm.'

'Maybe so, but you can scarcely breath in here.' Then she stops and purples at the sight of sight of Max Ernst's heretical photograph. 'What's this?' she exclaims.

'Oh that... Max Ernst brought it.'

'The German fellow who just left? Did he paint it?'

'Apparently so.'

'Shocking! Utterly shocking! I read about this outrage at the *Salon.* Tell me you are not buying it, Jacques Doucet?' she snaps.

'Of course not. Don't you think my crimes are quite sufficient without expecting you to tolerate *true* blasphemy,' he says, fearful that she might recognise the witnesses looking on at the large, haloed Holy Virgin administering a severe spanking to the bare bottom of the infant Jesus. Adding to the profanity, the child's halo has fallen to the ground.

'And who are the faces in the window meant to be?' Jeanne asks.

'I can't see from this,' replies Jacques, lying through his teeth, not daring to reveal that they are Max Ernst and Young Tigers, André Breton and Paul Eluard.

Walking to the door, Jeanne crosses herself repeatedly.

Once she has left, Jacques drags himself from his bed, reactivates the *Demisphere* and flops into an easy chair. He is lost in the whirling spirals, which propel his thoughts back through time.

Jacques envisions himself with Sonia, sitting on the floor, fanning out and sorting an array of photographs on modern painting. 'It's not the job of the painting to tell all,' she argues.

'And what did your friend's picture of savage ladies tell you?'

'It's not easy to say. I caught only glimpses of it being painted and

then just briefly at the unveiling,' she said. 'Though that was quite telling! A few of us assembled for it. Braque, Derain, and Maurice de Vlaminck, Leo Stein and his sister Gertrude sat together in readiness. Fernande and I held back, watching the others.

'The completed picture had been hoisted up from the basement. Picasso and Max held it upright between them. Picasso fussed with wedges and a small hammer. Only the reverse was visible. Leo, unable to contain himself, strode around to the front. *So, the infamous painting at last,* he said. He confronted the picture and then doubled up, emitting a whinnying horse-laugh. *Pablo, what are you doing?* Picasso's astonished face popped round from behind the canvas. Leo muttered to Gertrude, *What a horrible mess!*

'Each of us looked at it. I was so shocked by how utterly stunned they were and could not think what to say. Even the artists were confounded. Braque, Derain and Vlaminck stood before it with open mouths like fishes. Then Braque declared, *It is as though we are supposed to exchange our usual diet for one of tow and paraffin.* Manolo teased, *Hey Pablo, if you went to meet relatives at the railway station and they arrived with faces looking like this, you wouldn't be best pleased!* The others were virtually speechless.

'In the midst of this awkwardness came a knocking at the door. Picasso walked across to answer it, and caught various remarks of confusion. He welcomed Kostro and his mistress Marie Laurencin, the former looking too large for his suit as usual and she in an enormous floral hat. Upon seeing the painting, they too fell silent.

'Later in the day Leo returned with Gertrude and a German art dealer Daniel-Henry Kahnweiler to view what he termed *the frightful monument in oils.*

'Just out of earshot of Picasso, the dealer said to Gertrude, *Is this some kind of a prank? A joke? Steady on, Heini,* she replied, sotto voce, *everyone has off-days.* Later I heard that Derain had told Kahnweiler, *One day we shall find Pablo has hanged himself behind this great canvas.'*

Jacques' memory plays on as his eyes attempt to focus on the

gyrating spirals. He recalls Sonia's vivid description of Fernande's violent reaction to the new painting and how it developed into a blazing row.

'How much more humiliation do we need? she challenged Pablo.

'So they don't understand, he replied.

'Pablo, this is terrible. You must stop showing it to people.

'What?

'You paint all day and night for months. Six months. – To be a clown, she taunted him, *an idiot!*

'You're my girl. Not my judge, protested Pablo.

'You've painted a bordello in lunatic fashion and everyone hates it. – And people believe I'm in it!

'You try to interpret me! he complained.

'And why not? – I used to be your Aphrodite, now I'm ridiculed, gesturing to the picture. *There I am for everyone to mock.*

'You? Have I said they are you? He demanded to know.

'Wait till Matisse sees it. He'll have something to say. – And have a good laugh too. You'll see.

'Fernande chastised her man, *And you are exploiting images of women for your own artistic ends!'*

Sonia had thought this possible ... but went on to describe her own reaction as a woman. 'For eons the naked woman has been the playground upon which art practice has been played out – females glorified as objects of the male gaze and desires...

'Here is an artist doing the reverse. Like much of his previous work it depicts the downtrodden, subjugated and dispossessed. But here, the female is also a terrifying *threat* to the male.

'Then she revealed that all did not go well. Following his initial shock, Herr Kahnweiler, who now actually likes *The* picture, speaks of the terrible spiritual solitude Picasso suffers because of it, with no other painter giving him support – all baffled, disoriented and calling him a madman.'

As the motorised *Demisphere* rumbles on, with the illusion of a central ball pulsating towards him, Jacques contemplates how Matisse

might have responded to the painting on first viewing, but his thoughts are curtailed by Jeanne's return to the room.

She scolds, 'Now you've turned that contraption on again. You're out of bed, and you know what Doctor's orders are!'

He studies her cross demeanour, considering it lamentable that she forbids discussion of the root of his anxiety.

Max visits again and when Jeanne leaves them alone Jacques launches into more questions. 'Tell me, Max, I'd meant to ask, do you know how Matisse reacted when he first saw *Les Demoiselles?*'

'You are still on that one, *mon connaisseur?*'

Jacques nods and continues beseechingly. 'And also, how did it acquire that name?'

Max yields to appease the sick man.

'Matisse was never one of us. To Pablo, of course, he was chief rival, though the feeling was not yet mutual. We thought he was somewhat aloof with his beard and tweeds and briar pipe – not helped by him being a good deal older. When we dined with him each week he seemed to regard *la bande á Picasso* as a bunch of interesting *la bohème* renegades.

'Of course when he heard from the Steins that Picasso had created a *monstrous outrage* he was sufficiently curious to come and see it for himself. He stood stock still there in front of it, puffing on his pipe, smouldering every bit as much as the briar itself. To break the pregnant pause Pablo said, *I take it you'll be replying in paint, eh?* Henri remained speechless.

'He wasn't silent for long. Matisse was shouting angrily from the roof tops to anyone who would listen, condemning Picasso and accusing him of adding to the woes of struggling painters. He talked of *getting even with him* and making him *beg for mercy*. He saw him as ... *outrageous. Attempting to ridicule the whole modern movement.* Henri swore to *sink* Pablo and make him regret the *audacious hoax.*'

Jacques finds this surprising. 'Matisse himself caused a riot at the *Salon* as one of the *wild beasts,* the Fauves, no?'

'Remember, by this time Henri was a man keen to be a Worthy of the art establishment.

'And this was different ... here was an unrecognisable concept of modernity... Matisse had not realised it straight away – but he soon did! His rival had gone further than he himself had dared or been able to go.'

Jacques looks to him for more.

'He also thought Pablo was pirating and perverting his own ideas.'

'Surely not so?'

'Oh yes... Sometime after *Les Demoiselles* was finished, Sarah Stein bought Matisse's image of the bulging, globular *Blue Nude,* while Gertrude and Leo bought Pablo's sharply angular *Dance of the Veils* – each portraying a large, recumbent, naked woman. Henri had previously suggested to Pablo that the equilateral triangle was a symbol and manifestation of the absolute – saying, *If one was able to get that absolute quality into a painting it would be a work of art...* Well he was apoplectic with the Steins later – ranting, *Little madcap Picasso, keen as a whip, spirited as a devil, mad as a hatter, contrived this huge nude woman composed entirely of triangles and presents it in triumph. Agh!!!'*

'And the Steins I suppose were delighted, having bought both of them?'

'Oh yes, certainly. They loved the rivalry – even encouraged it. On display in their apartment were the two nudes, side by side. Matisse was incandescent.

'As to the name of *The Brothel* painting. That came later ... and could have been from a joke on me.'

'I can scarcely imagine Picasso taking *you* to brothels, Max.'

'My dear monsieur, I can think of one or two in Pigalle I might mention...' Max quips, with a joyous flourish. 'But seriously, no, it wasn't that. Longfingers and Kostro had this idiotic joke about my grandmother in Avignon running a brothel. When the painting first appeared the ludicrous tale circulated suggesting it was my grandmother's brothel. Of course I had no such grandmother. Or I

should say, I had a grandmother but she had no such brothel ... poor soul.'

Jacques absorbs the ridiculous detail with amusement. 'I might have known you were involved, Max!'

'They jested that one of the tarts was Grandmother, one was Fernande and another Marie Laurencin, all in a brothel in Avignon.'

Perhaps one was Sonia? wonders Jacques.

'When it appeared in Salmon' show at Poiret's gallery in 1916, Longfingers was obliged to provide a name to go in the catalogue. He decorously called it *Les Demoiselles d'Avignon.* That's how it was listed ... and it stuck. Pablo was furious! He went mad! *Would I be so pathetic to seek inspiration in reality - to a specific brothel - in this city or that street, eh?* And he has hated the title ever since.'

'So it's nothing to do with a brothel he may have known in la Carrer d'Avinyó, in Barcelona, as people have said?'

'Pablo bought his paints from a shop in Carrer d'Avinyó, and there was a brothel there too, but just by coincidence. My grandmother's Avignon, by the way, is the town on the Rhône.'

THE VISITORS HAVE all departed and Jacques lies uncomfortably brooding on the most vivid part of his life. His conscious thoughts slip back to sitting cross-legged on the salon floor with Sonia, scrutinising art photographs. A magazine article *Trésors du Louvre* was illustrated with images of ancient stone effigies. He held it up.

'Here, Madame Archaeologist.'

'Oh goodness, not *these* again,' she exclaimed... 'Jacques, I hardly dare tell you. I have done something terribly foolish. I mentioned at home that there are some ancient Iberian heads Picasso has acquired from a nefarious source. Serville has been *so* nasty about it. He was spitting unpleasantly, ordering me to *stay away from vagabonds.* He declares they must have been pinched from the Louvre. He is actually forbidding me from going near my artist friends, making his usual threat: the asylum.'

Jacques winces as he recalls the missed warning sign. Anguished by such thoughts he slams a fist into his palm, but his weakness means it is a pathetic gesture.

The following evening Max visits again. He straight away picks up the photo of Max Ernst's blasphemous painting and flinches. 'You are not buying this are you?' he asks apprehensively.

'Amusing as it is, why does everyone assume I'd even consider it?'

'Not so amusing to me, old fruit, and certainly not to your wife.'

'A bad joke by Ernst, no?'

'It's to punish his father ... a high Catholic who chastised his boy in just this fashion... And the strictest tyrant by all accounts. But this punishes the church too.'

Max playfully sketches Jacques as a cat. But the cat wants more answers – not about the Mary and Jesus painting but about the controversial masterpiece he already owns. 'The louche who stole from the Louvre and passed the goods to Picasso – remind me who he was, will you – the cowboy fellow? Fernande said Sonia once encountered him.'

'Come on now, Monsieur Jacques. It's time to let this alone.'

'Look, Max, I can't go on playing the invalid,' he growls. Feeling stronger he hauls himself out of bed and begins pulling on clothing.

Max is alarmed and steers him back to bed. 'Alright, you've had your sport. This has gone too far now. Your obsession is going to be the death of you... He's just some lowlife in Pigalle.'

'... And his name? The man? Who is the man?' he demands insistently, as he continues to struggle with his trousers.

'The doctors are going to be horrified if you continue with such recklessness. You must get back into bed.'

'Then tell me, Max, who stole those heads from the Louvre?'

His friend is becoming very concerned, feeling responsible for the invalid's worrying reaction. 'This persistent questioning is getting you down, Monsieur Jacques ... and me too, if you must know.'

The patient remains grim-faced and continues to dress.

'... Very well... Then will you return to the bed?'

'Only if you give me his name.'

'Right then, it's Géry Pierret. – Now perhaps you'll get back into bed. You can't go after *him*. – Not unless you fancy the delights of Madame de Pompadour's.'

'What?' Jacques exclaims, casting his clothes aside and sliding back into the hospital bed.

When Max leaves and closes the door behind him, Jacques climbs out of bed again and resumes the laborious task of dressing.

UNTIDY AND DRAWN, Jacques sits anxiously in the back of the car. Chivet is behind the wheel. The maroon and black Panhard Landaulette crawls through the Parisian red light district of the place de Clichy. He alights at Pigalle and proceeds on foot with the chauffeur shadowing at some distance. Chivet swallows his horror at seeing his ailing boss engage with various whores plying their trade on the street. He strains to hear as Jacques makes enquiries in his pursuit of a 'gentleman of the quarter,' fitting the description of Géry Pierret. He searches the brothels, public urinals and public baths. Each establishment he enters is draped with all manner of male prostitutes offering their services, wolf-whistling and eyeing Jacques with delight – such an obviously rich client being unusual pickings in these parts.

After a number of abortive calls at the seediest of establishments he stumbles into the flop house of Mistress Greta (a gentleman cross-dresser) with a near respectable demeanour. The décor attempts cosiness but fails abysmally. Mistress Greta smiles welcomingly, with *her* sharp eye for the middle-class client.

'Do I find myself in the company of Madame de Pompadour?'

'Indeed. It is I,' *she* gets up presenting a limp paw for him to kiss.

He ignores the offering.

'I am looking for someone in particular,' he says uncomfortably. 'I've heard that a certain Géry Pierret provides special services to the discerning gentleman. He's a masseur, a boxer.'

'Should I know this Pierret?' the mistress replies evasively, looking him up and down with suspicion.

'He favours the attire of the Wild West, you understand. Cowboy chaps and so on,' wincing as the words pass his refined lips.

The mistress smiles in recognition, taking ten francs and directing the forlorn caller to number seven on the third floor. He carefully begins climbing the dilapidated staircase, abhorring having to make contact with the balustrade, for fear of its structural safety and likely contamination. The effect of the filthy, worn-out stair carpet, with stickiness under foot, is overpowered by repellent odours lingering in the air. He nonetheless continues the ascent. It is true to say, Jacques has never been in such a squalid hole, even when passing through the porte de Clingnancourt.

Reaching the designated door he taps with his cane and withdraws a handkerchief from his top pocket, should he need to touch the handle. Before this is required the door is swept open. There before him is the predatory Géry Pierret – fortyish, trying to look twenty – wearing a sleeveless vest. His quiff is whipped up to a golden spiral. Pierret ripples his splendid muscles, adjusts his cowboy chaps suggestively, and approaches his client without fear.

Tactile and flirtatious, Pierret tries to remove his visitor's coat before he is even inside the small, seedy den, little more than a box room. Once ensconced, the refined Jacques Doucet encounters a sparse bed, a screen, weights, whips, heavy chains and a large chair laden with untidy costumes.

'Your desire, monsieur? We can offer much to those of taste and means.' He lewdly propositions his client in an affected lower class accent, as he tries on different hats, 'Swordsman, sailor ... perhaps tailor!' he says, knowingly and menacingly.

Jacques, plays along, takes out his wallet and flicks some notes for effect.

'Some of my friends prefer the services of thieves. Better still murderers,' Pierret offers, enigmatically.

'Tell of your exploits.' Jacques asks riskily. 'Come, come my boy,

sit with me. Tell me. What little nick-knacks have you picked up?'

'I've dildos an' prime rubber, and whips that'll make ya weep blood.'

'No. Let's talk.' Jacques tries taking charge.

'Right'ho you want talk ... what sort of thing, lover?' He pats the bed again, inviting the nervous Jacques to take his ease beside him.

'No, no, my son. I've a leaning towards crime.'

The hoodlum regales him with stories of a sleazy existence.

'What's the height of your career, bad'un?' asks Jacques, perching on the bed corner, unfolding a note. Pierret moves opposite to a theatrically antique chair. He is quizzical.

The charade continues for some time. Jacques remains seated. Pierret swaggers as he acts out a mock seduction, simpering. Finally, the conversation leads to an area of interest for Jacques.

'I'm a leetle, leetle pussy cat, monsieur, a picklock and a house-breaker. I cracked the beegest house of them all.'

'And where was that, my friend? Tell me,' Jacques asks, playing along with the bizarre character.

'Musée de Louvre! And it'll cost ya!'

Jacques flicks forth another note.

'It was easy! Child's play.'

'What did you wear?'

'The baldest, blue black leather you ever saw. Arse-tight.' Pierret strokes his client's thigh.

Jacques jumps, withdrawing. 'Tickles. – What did you pilfer?'

'Mona Lisa!'

'No really?'

'Well I might've. How slack it was. I could've done her, easy! More's the pity.'

'Is that absinthe I see over there?' asks Jacques.

'How very indecorous of me not to have offered it, monsieur,' Géry minces, as he pours a small glass of the green liquid and hands it to his client.

'Come, come, my fine fellow, you're not going to let me drink alone?'

He pours a second one. They clink the glasses. Jacques feigns a sip while Géry knocks his back with a single gulp.

'You were saying... So not the *Mona Lisa?*'

'As it was, I picked up some ugly heads, made of stone.' Géry Pierret springs up catlike, enjoying himself. 'I waited for the old curator to get the nods. I just slipped them under me greatcoat.' He mimes pocketing the heads. 'They were never missed. Not in four years! I passed them on to my associates. And grateful they were too – till they were indiscrete. Got nicked when *Mona Lisa* went missing in fact. Daft fools!' He pours himself another glass. 'Yes, daft fools... In court they blubbed like silly girls.'

Jacques plays along, flicking another bank note at Pierret.

'Yes, up before the beak, handcuffed, both weeping.' Pierret laughs heartily, knocking back more absinthe.

'And these were your fiendish associates?'

'The great Picasso and Apollinaire no less!'

Jacques is petrified but conceals his astonishment. 'These goods. The heads? What do you know of their origins? Were they perhaps from the painter's homeland? What were the faces like?'

'Oh, quite gruesome, to be sure.'

'Pray, tell me, then, what made them so special, my bad lad?' flicking another note.

'I can't say, but they left a real trail of destruction.'

'Is that so? You naughty burglar.'

'Some poor cow died,' Pierret brags.

Jacques quakes at the words but feigns a casual interest. 'You had a hand in her death? This is getting exciting.'

'Can't boast a murder, no. It was him. Her old man. He knew she'd spent time with them felons. Couldn't take her sullying his "oh so nice" reputation – being as she was there too when my booty was handed over. Oh yeah.'

'And? And...?' The cowboy slows down, sensing he can extract even more from this one.

Jacques urgently fingers another note.

'The old man only ended up jumping off a bridge. Got himself in a terrible state. Yeh. A real trail of destruction. Ha. Ha!'

'So what were they like, these people?' Desperation leeches into his voice. 'What was she like? What were their names?'

Pierret spins round alert to danger. 'Oh, you think you're going to trap me...? A person in my profession has many friends in high places. I know you, monsieur ... dressmaker. If anyone's blackmailing around here – it is I!'

Jacques rushes from the room in panic with words spinning. He mutters, *Some poor cow! ... Some poor cow died! ...* Leaving the building he jumps into his car, snapping at Chivet, his sleeping chauffeur. 'Just drive! ... Anywhere! ... Just drive!'

Chivet wakes himself and regards the clock on the dashboard with a flashlight. It reads a quarter past midnight. 'Very good, Monsieur Jacques.'

15

*You mustn't always believe what I say. Questions tempt
you to tell lies, particularly when there is no answer.*
Pablo Picasso

T HE PANHARD CRUISES through Paris, approaching
the city outskirts and on into deep countryside. Jacques brooks
no argument from his driver on the need to return either
home, or back to *l'infirmerie*. Chivet is instructed to 'keep driving,'
which he does, but not readily. The night passes with his employer,
in a trance-like, semi-somnolent condition, switching such conscious
thoughts as he can maintain, back and forth between his vile en-
counter with Pierret and the substantive matters involved. *Some poor
cow died!* he keeps repeating to himself... *Some poor cow died!*

The dawn light flecks the sky as they drive further north. Chivet
pauses at a lay-by for a period of respite. Jacques struggles to climb
a grassy mound with his cane. He stops at the top to catch glimpses
of the sunrise with the sky above half scarlet, half growling. A snap
of frost in the virgin air is reviving. Feeling somewhat recovered
from the shock of the night, he decides they should go back home.
Propped against the velvet upholstery of the motorcar he drifts into
a deep sleep, until they pass through the *banlieue* in driving rain.
He awakens disorientated.

They head back into Paris via the boulevard de Sébastopol. As
the Palais du Louvre emerges in view, blocking the lower skyline,
Jacques is caught by a frisson of emotion. They arrive at the exact
same spot of fifteen years ago, when once he had travelled in urgent
haste to Sonia at the embankment in his grand coach and pair.

HE REFLECTS RUEFULLY on the desperate telephone call that day. She was speaking from her archaeology workroom at the Musée d'Ethnographique in the Trocadéro, all the while panicking about the imminent arrival of her enraged husband.

'HE'S GONE MAD. – Serville's being vicious and strange,' she gasped. 'Jacques! Help! He's followed me down here. Do something!'

'What's that banging? I can't hear...'

'It's me ... the receiver. I'm shaking...'

In my Maison Doucet private office I pressed the telephone to my ear. 'What? Where are you, Sonia!?' But before she could answer Serville had entered the room carrying a medicine bottle. In a trice he physically bore down upon her. 'So this is how you fetch your coat? An excuse to make trouble!' he derided her menacingly.

I heard the rattle of the telephone being dropped. There was a most blood-freezing scream, scuffling, shouting, banging... I could not discern all the words of the frenzied exchange but could hear her husband Roux taunting her. 'I've told you, Sonia, I'll be driving you to the asylum.' I've seen the photograph. You're not right in the head. You're not right I tell you.' Then I heard the click of the receiver and silence.

I darted to the carriage, yelling to Chivet as I jumped inside, 'l'Ethnographique! Quickly man! The archaeology rooms!'

Setting off along the rue de la Paix, we found the road congested with carriages, cars and omnibuses, some distance before the place Vendôme. Chivet took a left turn into the rue des Petits Champs and south into the avenue de l'Opéra. We hurtled towards the Louvre and the embankment beyond. But something unusual, it seemed, was snarling up this part of the city.

'Hurry man! Hurry!' I shouted, 'and why the devil are we going this way?'

Beneath Chivet's whip, the two black horses trotted at a pace, weaving through the busy amalgam of horse-drawn and motorised traffic rapidly backing-up. I was twitchy and agitated, perched on

the edge of my seat and gripping the window frame. The carriage struck a street stall of fruit as it entered the place du Théâtre Français, sending the contents flying. Boxes of scarlet pomegranates <u>smashed onto the ground</u>. 'Keep going! – Don't stop!' I shouted frantically. Chivet gripped the reins in one hand, fiercely cracking his whip with the other. We encountered a police roadblock at the rue de Rivoli. The carriage was too cumbersome to turn around. Spectators thronged all the way to the main entrance of the Louvre. Police were steering and curbing their rapid ebb and flow in the road. Two officers made fierce angry gestures towards the intrepid coachman, insisting upon the impossibility of continuing through such a gathering.

A newspaper boy selling Le Monde *revealed the front page headline, above a photograph of the world's most famous painting:*

MONA LISA
STOLEN

Still the carriage struggled forward. More vehicles were backing-up behind. I was in despair. I argued angrily with a gendarme who refused to allow the carriage to pass. In a futile act I jumped down and attempted to draw the horses through.

Meanwhile, in Sonia's workroom, amid the wooden benches and stools with dusty specimens, tidily arranged in batches, a fearsome struggle was raging. Serville, in forceful mode, medicine bottle in hand, was intent on imposing it upon my love, no matter how much she resisted. 'You won't be told... Now look here, this is a wonderful cure-all. My doctor friend has kept many a good woman from lunacy with it...'

I abandoned the carriage and ran as fast as I was able, towards the place de la Concorde.

THE PANHARD arrives at that familiar spot, near the grand entrance to the Louvre on the rue de Rivoli. 'Stop the car!' orders Jacques. Chivet pulls the vehicle into the side of the road. 'I'll walk. Pick me

up at the Trocadéro.' He leaves the car and walks, cutting through to the quai des Tuileries embankment, retracing his steps of fifteen years ago – in deep contemplation.

SERVILLE WAS STORMING a t Sonia, 'Your trouble's come back, hasn't it? Even if you won't admit it, I knew it, the moment you mentioned those stone heads – and then that vile photograph! ...'

I sprinted beneath the trees, pausing occasionally, without success, to flag down any passing vehicle. Pedestrian heads turned in surprise, seeing me, a finely dressed man, darting on breathlessly.

'You won't be associating with thieves and ruffians again,' Serville persisted.

I ran on the road to avoid pedestrians, tripping at a pothole, badly damaging my ankle. Well-meaning passers-by rushed to help. I pushed them aside, grinding myself to my feet, and limped on with increased urgency.

I managed to stop a cab and soon I could see the Palais du Trocadéro ahead.

CONTINUING THE RE-ENACTMENT, Jacques walks the full distance knowing as he does, that the looming stucco façade is a stony nemesis, hard and cold and immovable, like the memory associated with it – eclipsing any thought of the earlier romantic encounter on that first night together in the same building. He cannot escape but picture the scene – of Serville assaulting poor Sonia in the work-room. The palace walls beckon – walls that were her prison and now his, those ancient walls, now so solid and impregnable.

THE HUSBAND BROUGHT a spoon from his pocket. 'Two of these, madame, thrice daily – or I'll be phoning the ward...' He poured the medicine, filling the large spoon. Glowering down at Sonia, he intimidated her into complying. Against her will she swallowed the concoction.

I arrived at the Trocadéro, exhausted, to find Sonia trembling

and in a state of panic, following the departure of Roux, moments earlier. She recalled in detail to me all that had just transpired. I comforted her, taking her into my arms. Although terribly shaken, her physical condition did not raise immediate concern. 'I cannot endure living with that brute any longer,' Sonia stammered tearfully. 'He thought I was contacting a child, but it was his friend ... pestering me as the Dead sometimes do.'

'Whose friend? Which child?' I asked. She was crying bitterly and not making any sense, except that she kept repeating: 'I must leave him. I cannot go on ... I cannot go on.'

'Let me have my doctor come and examine you,' I urged her, but she was emphatic. 'No, no. I cannot endure more interference.'

'At any rate, you should certainly not be requesting the divorce this evening, after all,' I cautioned.

'No. And never at that house anyway. I have to move away.' She began coughing, unable to stop for some time.

I discretely arranged for her to go and stay with the sister of my secretary Albert Vuafluart.

That evening Sonia began to prepare a suitcase of essential items of clothing and toilette, and as she did so her physical condition deteriorated. Her husband came home to find her collapsed. Quite rattled, he did at least have the presence of mind to summon an ambulance, before fleeing the scene.

Upon arrival at the hospital, and before losing consciousness completely, Sonia was able to ask the matron to inform me.

The following day she lay semiconscious. I sat helplessly cradling her little hands in mine. I monitored the slightest changes in her condition, willing there to be an improvement and wincing at every sign of deterioration. Her complexion had a dewy plumpness. I lost myself in contemplation of her ghostly white skin, unfurrowed by time. She kept straining to speak but was quite undecipherable by then. I caught a comprehendible phrase or two, as though she was trying to explain her husband's error. She was greatly troubled, muttering about a photograph he had discovered... 'The one you

got me from the American writer... He said I was possessed by a demon and if I didn't improve he would arrange an exorcism.'

'What do you mean, Sonia my dear?'

'Can you do something for me?'

'Anything, dearest.'

'There's a most beautiful place ... in Tibet. Light a candle for me, at the Temple of ...' But her voice trailed away and no sound was uttered. Her drowsiness curtailed anything further.

'Which temple is it, darling?'

I waited. My body and mind in twisted despair. I wasn't sure she was still breathing. 'NURSE! NURSE! Come quickly. NURSE!'

The starched figure rushed to her and held a small mirror to her mouth. The doctor attended, taking her pulse. Before the evening's end a priest was called. He was instructed to administer last rites. 'She has no such religious affiliation,' I told them, uneasy about the inappropriateness, and with little conviction or hope that Sonia could be saved, or could even hear the proceedings, I nevertheless prayed silently at her bedside, repeatedly crossing myself as I might have done before my affinity with Eastern religions.

Despite my loss, I received some threadbare solace as rough justice took its course. In my bereavement I had been ready to pursue the monstrous husband through every court in the land, but before the authorities had even time to investigate the poisoning and apprehend the culprit, he had taken matters into his own hands and thrown himself from the Pont de la Concorde, into the caliginous waters of the Seine.

JACQUES MAKES SLOW progress, tracing his fateful journey, towards the gateway of the Trocadéro and beyond. He finally enters the building, opening the door to memory, shuffling tremulously along one corridor and another to double doors. A dilapidated sign reads:

DÉPARTEMENT D'ARCHÉOLOGIE

Finding the doors locked, Jacques peers through a crack between

them. He catches sight of the former department, now tattered and empty. There is no choice but to turn back. At a reception desk, an attendant informs him that the section is no more, having been closed down during the War. He proceeds through a gallery and takes the small spiral staircase to the basement, mulling over some of the last words he had heard Sonia utter in life, *It was his friend not his sister.*

Chivet, meanwhile, has returned to the Villa Saint-James, in search of Mme Doucet. The ambrosial aroma of *papier d'Arménie* leads him to her drawing room which he enters abruptly. Perspiring in his anxiety, he tells his mistress, 'Monsieur is making his way on foot to the Palais du Trocadéro!' Jeanne jumps to her feet, and immediately seizes the telephone receiver to summon aid – from the only man she thinks may have some sway over her errant husband. Chivet assists her in putting on her coat and they hastily depart.

The limousine, now carrying Jeanne, draws up at a nearby villa. Paul Poiret hurries from the front door to join her in the back seat. 'Straight to the *palais,* Chivet,' she instructs the driver, and the car accelerates off.

'What am I meant to do, Paul?' Jeanne asks, clearly distressed.

'He has an instinct that understanding this painting will relieve him of the wretched torment he has suffered for some time now,' Paul attempts to reassure her.

'But has it not done the very opposite? The picture caused the upset in the first place.'

'He is so embroiled he feels he must unravel it,' he suggests gently, appreciating how Jeanne must feel about the emergence of her husband's memories of his tragic lover. He switches tack, 'You must realise he's taken a risk here. People are laughing at him. Imagine, the one-time doyen of academic art in Paris, now cast as the foolish old buzzard buying vulgar rubbish,' he tries to explain.

'Of course, but ...'

'You know,' he interrupts, 'Monsieur Doucet wagers this is the most important thing ever.'

'But you are a collector as well as a couturier and designer, Paul, and you have led fashion into the Twenties. Why, you also have received the *Légion d'honneur.* You don't go on like this, do you?'

'The most decisive influence on my life was your husband, who employed me when I was only nineteen. My ambition was to model myself as much as possible on the great Jacques Doucet and to follow in his footsteps. Don't misunderstand me, he is no saint, but he has the celestial touch, with a hidden intelligence for discerning what is fine.'

'He chose to employ you, I suppose.'

Paul consoles her with a cheery smile. 'As a couturier, he sent me to the best tailor in Paris; arranged for me to supplement my earnings by liaising with a rich American soprano...' He pauses and laughs hesitantly before continuing. 'From Monsieur Jacques, as we were all permitted to call him ... I learned the grand manner and the confidence that would later enable me to outface the arrogance of the Comtesse de Greffule or subdue a Rothschild.'

'You don't collect like a maniac though.'

'Well, I do collect, and I can go off the deep end just like anyone,' he laughs again. 'But I have always tried to make myself in his image.'

JACQUES DESCENDS into the dim and dusty basement of the Musée d'Ethnographie. The general impression of the ramshackle storage is of cavernous vaults, with various chaotic corners and some areas of abandoned scientific study. Among animal smells there is the note of something antiseptic hanging in the air.

The unexpected movement of another presence is quite audible and he hesitates, but edges forwards with his cane to the fore. In a dimly lit section he sees a male figure moving purposefully. He is clearly searching for something and blowing up small clouds of dust like pepper powder caught in the beam of his flashlight. The rummager is a regular visitor and moves items keenly, but carefully.

At once there is recognition. It is not a stranger, but the last person in the world he expected to encounter. The weary, elderly man blanches as if confronted by a phantom – it is Pablo Picasso, appearing well-to-do in a smart suit and bow tie.

Jacques freezes in shock. From the dusty old trunk of artefacts the painter picks up an Ecuadorian shrunken head, of the kind used for hunting purposes. He puts down the torch to cradle the *tsantsa* between his palms. Exhausted and dishevelled, Jacques approaches him.

Picasso greets his former patron with slow deliberation. 'So, the dressmaker who has been interrogating my friends. What brings you *here?*'

'Things. Memories,' is Jacques' hesitant reply. 'I should have guessed I might encounter an artist in this dungeon.' He looks at the shrunken head. 'Ah, the *tsantsa.*'

Picasso holds up the tiny head. 'A vicious and murderous business. Sometimes involving children.'

Jacques is held, mesmerised.

The younger man carefully hangs the tiny head back on its hook and points to the stretched facial impression of a Fang mask. 'But these are quite different.' He lifts up the wooden carving. 'Imbued with the spirit of their tribe... See the expression. Their passions bleed into my spirit. I take on their existence... They merge with the miasma of my soul and dash to the canvas... Do you see, monsieur?'

'Miasma?' Jacques puzzles for a moment. 'Maybe I'm here to resurrect spirits of my own,' bending to examine the mask.

'My first visit here, long before the War,' Picasso recalls, 'was so different. Really disgusting! The smell, the dust, everything reeking of death...' He suppresses emotion.

Jacques interjects, 'Death, always death ... always.'

He is ignored. Picasso continues, 'I was alone, I wanted to leave. I had to get away,' turning the primitive icon in his hands as he speaks, while Jacques listens intently. 'But I *couldn't* leave. Something was

happening to me. Something important,' he says, patting the African mask. 'These aren't like pieces of sculpture. They're magic things. *Intercessors.* Mediators. Against everything. Against unknown threatening spirits...'

Unseen, Mme Doucet and Paul Poiret quietly approach, pausing for a moment, behind some shelves.

'Come on, shouldn't we...?' whispers Poiret.

'One moment, monsieur,' she stops him, wanting to glean what was being said, as Picasso and her husband complete their exchange. She and Poiret stand and observe for a minute or two.

'Yes absolutely,' Picasso continues.

'I should tell you, señor, I've been, trying to persuade the museum to accept the painting, as a bequest, after my time... But alas, it's proving impossible...'

'Ha! The great Doucet ...' Picasso cuts in crossly, 'You're the one who's supposed to have the ear of these people – saying you would do this ... Now you're letting me down. I see that I've been deceived.'

'Now look here, Picasso!' Jacques snaps back, towering over the diminutive artist. 'You know I gave no guarantee ... I can scarcely force them to take it.'

'I believed if anyone could do it, it would be you.'

The two men measure up to one another – the imposing elderly collector against the stocky *taureau* who holds the card of youth.

'The picture is difficult.' Jacques hits back. 'You know it was never well-received ... then hidden away for many years, no...? Why, your young lady, Madame Olivier was wild with antagonism. Your friends reviled it. Even Apollinaire had nothing to say!'

Picasso reaches for a large, more menacing mask and holds it to his face. Jacques glances at him with suspicion. The artist puts on a strange drawling voice through the mask, 'Y o u k n o w t o o m u c h ...'

Cutting in, Jacques mutters falteringly, 'Yes. Yes. The grotesques.' He hands over the now twisted and damaged photographic reproduction of *Les Demoiselles* from his pocket.

Picasso puts aside the mask.

The questioner raises his voice, 'Did this concern Carles? Is he in it? Where? Where? It was you who introduced him to brothels, after all...? Now I learn you are painting him once more ... in your *Three Dancers*, showing a dance of death...'

'You really have some gall, Doucet!' Picasso interrupts abruptly. 'You wrench from me my greatest painting,' he rants, snatching the photo, 'the work that scorched my *soul* to deliver ... for only twenty-five thousand ... and in instalments too! And now ...' getting very angry, 'now you poke your way into the stuff of my ...'

Cutting him off, Jacques defends his position. 'Then I'm sorry, señor! I'm sorry... But I have pleaded with those bigots, on your behalf! Do you realise how subversive they find your Cubism?'

Picasso smoulders, silently.

'On a delicate matter...' Jacques hesitates. 'Those stone heads from Iberia you once had ... the havoc *they've* caused... Could it be that the Louvre holds it against you?'

'That was many years ago,' Picasso is taken by surprise and fires back. 'Besides, I was exonerated. As was Apollinaire.'

'But it fuels their antagonism? As far as Crozier's concerned, you are a marked man! It seems to me that the stone heads affair has prejudiced my campaign. Perhaps it explains their antipathy to Cubism.'

'Nonsense!' objects Picasso.

'And they've nothing to do with the picture?'

'Of course not,' he angrily insists.

'Then I'll take your word for it ...' concedes Jacques. He tries to collect his thoughts. '... I feel sure there is something else...'

At this, Picasso has had enough, 'There is nothing more to say,' he snaps.

Jacques ponders for a moment, 'Forgive me, señor...' and turns to leave.

As Picasso hands back the photograph, Jeanne and Paul step round from behind the shelves. 'Monsieur Jacques,' hails Poiret.

Then catching the eye of the painter, he nods, 'Pablo.' Picasso fires a black glance in return.

Paul turns back to Jacques, 'How glad we are to have found you, Monsieur Jacques.'

'Come along, you're exhausted,' asserts Jeanne. 'We've been so worried.'

'Yes, yes, my dear,' he mutters, somewhat shaken, 'but hear me. *Not* yet. I've some unfinished business.' He lifts his hand in a salute to Picasso, 'Good day, señor. Good day.'

Jeanne realises that she cannot force her husband to leave with her. She turns to Paul, 'Young man, look after Monsieur Doucet will you? I'll have Chivet fetch the doctor.' She turns briskly and ascends the spiral staircase.

Outside the Trocadéro she boards the Panhard, and directs Chivet to drive the Hertford Hospital at once to find help. As the car disappears, the two gentlemen emerge from the building. Jacques ushers Poiret into a taxi cab, and struggles in behind, catching his breath.

'You need to return to the Hertford, Monsieur Jacques.'

The absconded patient is in no mood for hospital. Paul's plea is promptly rebuffed as the driver is instructed to take them to the Louvre.

'You can accompany me, or I do this alone, Paul?'

Poiret stops and looks at the wan visage.

'I am tired. I would rather have your company,' says Jacques.

'Very well,' Paul concurs and puts aside his concerns.

'Did you discover anything new, or what it is you needed from him?'

'Yes. He is angry ... because I failed with the museum.'

'He's an enigma, I'll be bound. He wants his painting in the Louvre, yet he seems always to have despised everything the place stands for.'

'It is preposterous,' retorts Jacques in exasperation. 'What does the Louvre stand for if not for the beauty of art? He has dismantled the very nature of painting as we know it. Yet he wants his work to

be in there – among works that have for centuries beautified the physical world! What a task this is.'

Jacques and Paul reach the great bastion of art, inviolable and shadowy, backed by a wretched sky promising ill weather. Inside, they make steady progress despite the invalid's obvious frailty. He is recognised as Monsieur Doucet, distinguished committee member, and each guardian they encounter allows the men through with a nod. They make enquiries and an elderly caretaker shows them to an overfilled store room. The languid watchman, in a standard issue brown warehouse coat sits nearby, drawing on an unlit pipe. The two men rummage around and painstakingly examine an array of sculptures. One by one they focus on the features of ancient stone carvings of varying sizes.

'Are these sculptures really so important?' Paul asks.

Jacques ignores the comment and continues with breathy unease, lifting busts and statuettes from boxes, each time asking Paul for assistance.

Finally they stumble upon two limestone heads bearing labels tied around their necks. The small brown paper tags are examined by the investigators with fevered anticipation. The vacant visages, the eyes and the ears, are distinctive and immediately recognisable to Jacques. He suddenly exclaims, 'Wait a minute!' darting his hand into his pocket and withdrawing the crumpled photograph of *Picasso's Brothel*. He compares the ears and the eyes. The colour drains from his face as he realises that the images of these same stone faces now stare out of the picture.

Both men are sure of the likeness. Poiret's recognition makes the find conclusive.

'I cannot leave the matter here,' Jacques declares. 'We need to clear it up with the artist.'

'But, Monsieur Jacques ... what of Madame Doucet? I promised to get you back and we have been away two hours.'

'I'll be home soon enough. This shouldn't take long.'

JACQUES RAPS WITH his cane on an apartment door at 21 rue la Boétie bearing a sign:

I AM NOT A GENTLEMAN

Paul Poiret waits down below with the taxi. The door opens. Picasso appears, now in a dowdy sweater, puffing on a pipe.

'Forgive the intrusion, Señor Picasso, so soon after our encounter earlier,' says Jacques, quietly. 'I've been to the museum again, and I need more information. I'm told there are sketches. Could I...?'

Upon seeing the unexpected visitor, Picasso's guarded manner yields. Already he has regretted his impetuous words of a few hours ago. 'Monsieur Doucet...?' Picasso beckons him inside.

The collector climbs a step to gain entry into the vestibule. Once inside the spacious former apartment studio, he stands as tall as he is able, scanning widely, his greedy eyes roaming the space as if wishing to steal away every last morsel of sight to the back of his retina. Picasso is thrown by this one time Prince of Paris, who seems lost and whose majesty is fading.

'My demons seem to have become somehow melded with your own,' says Jacques.

'How so?'

'Well it's this... Frankly, the painting has been a curse on me.' His craving eyes flit about the disordered jumble, a muddle which describes a dynamic kleptomaniac at work. Random items presumably for subject matter are mingled messily with artists' paraphernalia, and dust. The rapacious glance flies from photographs to a bicycle saddle, brushes, masks, and stacked canvases – the most prominent being the towering, vivid, unfinished painting *The Three Dancers*. The ardent glance drifts up and around the contorted rendering. Jacques is gripped by what seems a horrid enchantment. Of course, it is what he had half expected, but he is weirdly captivated, feeling it so important that he is compelled to lose himself in it.

It depicts a tall French window, opening onto a balcony, before

which appear three deconstructed figures cavorting with raised legs and feet, clasping hands in a depraved dance. Windows dominate the scene bringing the subdued light of a cerulean blue sky. *Where is death? Is it tapping on the window?* A sparse right-hand shape, a mere suggestion of a human being, in brown and white, is attached to a lurking black silhouette which Max had identified as Ramón Pichot's face in profile. *But is Carles the shadow?* Jacques latches onto the notion that the left-hand figure in fleshy pink is Germaine – Casagemas's one-time lover, briefly mistress of Picasso and later Pichot's wife. It is a savagely deconstructed body in a state of wild contortion – her long neck and frenzied head lunge at right angles to her body. Her breasts fly high. Her tiny round head is agonisingly crazed, displaying a spikily vulva-like mouth. The jagged, sawtooth vertical line of her torso threatens another naked fleshy pink female in a state of wild abandon. This central figure dominates the trio with her accomplices on either side holding her arms high and widely stretched apart, completing the circular, hand-holding chain and creating the image of a crucifixion.

The painting is prominent among the many others visible, either completed or in progress, and is apparently a special project. *Is it some sort of exorcism in paint?* The connoisseur is suspicious, given Max's identification of the characters involved. He ponders the lack of any works in a similar vein, and questions, *could this indicate that* The Three Dancers *has completed some ethereal purpose, if indeed that is its purpose?*

Picasso duteously fetches a series of sketchbooks, bound in Moorish fabrics, which Jacques recognises from Fernande's description. He leafs breathlessly through the innumerable studies for *The Brothel.* Clearly in search of something specific, he finds a rough sketch of a medical student carrying a skull, and a sailor looking on. Pausing to fathom the meaning, he asks, 'There was a story here – *once upon a time* – a narrative. No?'

Picasso remains silent. Jacques pauses at sketches of women with large empty eyes. His own mouth and bloodshot eyes are gaping.

'The heads?'

Picasso shrugs.

'The Iberian stone heads! I see them. Now I really see them,' Jacques exclaims. 'I thought as much. – Cast in oils, their faces stare down at me from the canvas. *They* are the sculptures! Stolen, yes. Once, for all time?' raising his voice to a high pitch, 'So I was right. These are your tricks?' he exclaims.

'Monsieur?' mutters Picasso sheepishly.

'Captured and held for eternity in the painting. Little wonder they at the Louvre are so offended.'

'If they consider those statues from *my* homeland as theft... Who is the thief? This is the blood of my forefathers ... my family ... my mother ... my father ... my sister who died so young. My blood. My viscera goes into my work,' Picasso jeers. 'Here you have flesh and blood in the frame!'

'I'm sorry, señor?' Jacques pauses for a moment to reflect and refrains from probing. 'Perhaps we are both hypocrites...'

'Eh?'

'Seeking the approval of the Louvre – the last bastion of French tradition and regressive dictates... It's no longer *my* way. And you ... didn't you once pledge to burn the edifice down to the ground?'

'That was Apollinaire.'

'Now you crave their blessing.'

'No! *Painting* can be a weapon against the enemy!'

'The enemy?' Jacques asks, half reverently, half enjoying the vigour of his opponent's rage.

'Not the museum,' the wily artist sneers, 'But the bourgeois management. Their archaic judgments... *And* the bloodsucking scribblers and critics... Collectors and dealers – you, monsieur.'

'I should tell you, your name does now feature in the Louvre... The stone faces are labelled: *Temporarily in the possession of Pablo Picasso.*'

'Fame at last. Ha!'

Jacques turns to the towering painting, *The Three Dancers.* 'So,

the Dance of Death, if I am not mistaken? And is this Carles?' he questions out loud. Picasso seems frozen as the gentleman points this way and that. 'I've been hearing it features Germaine...' He indicates to the left-hand contorted figure with its vaginal mouth, 'and Ramón Pichot, may he rest in peace.' He nods to a crazy brown shape, crossing himself for the sake of his wary host. 'Now also departed from this vale of despair,' Jacques continues. 'Let me see ... unless of course ...' examining the crucified central figure. '*This* must be Carles, who fired at them both, before shooting himself?'

Picasso is increasingly riled by the audacious probing. 'I'm sorry, Monsieur Doucet,' he snaps. 'I'll not speak about my paintings. You *have* my masterwork. Is that not enough?'

'You ask for others to have faith in it.'

'Never!'

'Expecting the Louvre to take it. – But I too have a need to *create*. – I shall construct an ensemble. A secular temple, a shrine to the invention of modern painting. New art. Not public, not private. An equilibrium of primitive ... modern...' Jacques signs emphatically. 'Eastern... Western. The living and the dead. A work of art in its entirety. A mystery, *presided* over by your brazen whores, who detonated the revolution and the very look of our machine-age world,' waving the crumpled photograph in the air.

'A temple, monsieur? Hardly the Louvre!' he shrugs cruelly.

'No, and I'm not dead yet,' the older man states calmly. 'I've done it before and I shall do it again.'

'Ha! That's a good one, Monsieur Dressmaker!'

'Oh, you scoff! ... If you are the greatest painter alive, then I'm the greatest collector.'

'Is that so, Doucet? Simply because you broke a few records in the saleroom ...?'

'Remember my library, now at the Sorbonne?

'What of it?'

'Now deemed the National Art Library... And then there is my Bibliothèque Littéraire, also going to the Sorbonne...' The grand old

man glowers down on his insolent opponent. 'You think I can't do it, ha!? Have you any idea how much avant-garde art I've amassed, from all of you? I can rival any museum in this field. Just watch me!'

Picasso pushes out his lower lip in petulance. 'That's not our arrangement.'

'No, and you didn't tell me the painting flaunts your thefts of the Louvre's antiquities... Let's face it, my friend, you are *persona non grata* in those hallowed portals.

Picasso splutters, 'You just can't meet your...' But Jacques presses on imperiously.

'Don't you worry, old son. In my Temple your art will reign supreme...'

16

*I count him braver who overcomes his desires than him who
conquers his enemies; for the hardest victory is over self.*

Aristotle

J ACQUES SCRUTINISES the scaffolding erected around the porter's lodge at 33 rue Saint-James. Workmen in britches and flat caps move warily on frosted planks above this single-storey entrance to the Villa Doucet. The frail figure shouts up his orders. Jeanne observes uneasily from the dining room window, before venturing out herself to persuade him to come inside.

Several months have passed since her husband rashly discharged himself from the care of his hospital physicians. It is of great concern that his recovery is less than complete, especially given the manner in which he continues to conduct himself. He assures her that he is simply preparing for works to follow and that the architectural design work has not even been commissioned – although the husband and wife have decided that his Temple is to be built above the lodge. Snow begins to fall heavily and work is suspended. Jacques returns indoors.

'Why, if there is no design, in heaven's name, is there scaffolding?' Jeanne wants to know.

'I am simply making ready!' he answers impatiently, adding his regular plaintiff refrain, 'everything moves at a snail's pace, my dear.'

Jeanne peers into whiteness – out towards the lodge, and the rapidly vanishing courtyard entrance to her home – doomed to be a building site for some time. Although irked, she is glad to think that the painting will be finally removed from the house, even if it is installed

in the new extension. Nonetheless, she is determined to rein in the errant invalid following his near-fatal episode.

Later in the morning the snow has been whipped up into meringue peaks but has ceased falling. Jeanne, suddenly realises Jacques is outside again. She hastens to him. 'What are you doing out here now? The men aren't even working?'

'They are resuming in a moment, dear. I cannot leave them'.

When back indoors, she wonders which of his outer coats is the warmest. She takes up a plaid cheviot with snug wristlets and returns to him, sweeping the coat and a muffler over his shoulders, with maternal irritation. He watches her tip-toe back inside. Only when he is satisfied that the workmen are fully clear about their tasks can he leave them.

WHILE HIS RECUPERATION has progressed, Jacques has endured a touch of the Blue Devils. The big painting and the fate of Sonia continue to mischievously dog his thoughts. In want of funds to create a sanctuary for the picture, he concludes something has to be forfeited. Knowing that Amboise Vollard has coveted for many years some of his remaining valuable pictures from the last century, the collector is now willing to sell. He is devising a comprehensive plan of action, built upon his impromptu ideas advanced at the conclusion of his recent contretemps with Picasso.

He politely summons the art dealer to the entrance of the vacant porter's lodge. 'What the deuce have you brought me *here* for?' the imposing visitor barks, but he lifts a dusty fedora from his horse-shoe hairline in acknowledgement.

'Pardon me my friend, I don't like to stray too far from my new enterprise.'

'Indeed. Well I hope it will be worth the trouble.'

'Come this way, You'll not be disappointed.' He leads Vollard across the courtyard and through the stone porchway into the main villa. Once inside his study Jacques unveils three *ballerina* canvases

painted by the great Edgar Degas. Ambroise scratches his salt and pepper stubble, closely inspecting the gossamer images, each in turn. The two men are old hands at haggling but this notorious dealer will not easily get the better of artful old Doucet, and with Jacques' reputation as it is, there is no need for close scrutiny of the documentation verifying provenance.

'How much are you asking, old chum?'

'Well now, it depends. Do you want one, two or all three?'

'Then let's say just one.'

'That will be two hundred thousand francs.'

'For two?'

'Five hundred thousand.'

Vollard recognises his own ploy instantly and plays along. 'And all three?'

'Well let me see. That will have to be nine hundred thousand,' states Jacques emphatically.

Vollard yields to the ritual, staring into bold eyes of icy blue.

'It's perfectly simple – if I sell you one of my Degas, I will have two left. If I sell you two, I have only one left. If I sell you all three, I will have none... I think you see my purpose?' Afraid at the unspoken threat of withdrawal of the desired items, Vollard whoops amusedly at the intense face of his opposite, knowing that he has fallen into a hole of his own making.

'Voila! I fear you will win this time,' slapping his thigh.

After some intense bargaining, in which Jacques reduces his price for all three by just a margin, the dealer produces his large cheque book. Jacques' servant Bonnet carefully packages the pictures and carries them to the motor car, while Vollard writes out a cheque with many noughts.

Now better situated financially, Jacques can employ his architect, Paul Ruaud, a modest man and advocate of Aristotle, often quoting the philosopher. 'There was never a genius without a tincture of madness,' Ruard says, studying the artworks. He likewise retains placid composure, as the *maître* continuously commissions yet more works

of furniture and supplementary architectural features, from his avant-garde artists – in addition to a ten-year accumulation of art treasures and furniture – the finest of which, must be accommodated.

At a meeting with Ruaud, Jacques is shown initial drawings, which are not entirely to his liking. He becomes animated, sketching over them heavily in ink, forcefully reissuing instructions. Some days later the architect delivers a scale model of the proposed building, which the connoisseur calls a Gallery but also speaks of as The Temple of Arts. The model places the problematic canvas between two tall windows in the principal room. Jacques ushers Ruard away and so proceeds to contemplate the proposed Gallery at his leisure.

BEFORE THE NIGHT is spent, the silvery form of Doucet, often troubled in sleep, cries out and awakes in terror – in the midst of another harrowing nightmare. For a moment he lingers, terrified, in the twilight world between dream and consciousness. *Help me! What is happening?* Recognising it as the work of somnolent illusion, he clambers from his bed, shaking himself. He pulls on his quilted smoking robe and fumbles his way downstairs to the drawing room. He trips over Rodin, who scurries away with a yelp. Jacques lights a cigar and pours a generous nip of brandy, which he sips while leafing distractedly through drawings spread out on the grand piano.

Graced in her fitted banyan *robe de chambre* Jeanne enters, having been awoken by the noise of the dog. She is perturbed to find her husband up at this hour. 'It *was* you, Jacques,' she says, and with a worried intonation. 'Another dream?'

'Too many rogue thoughts ...' and he falters. His wife's sympathy encourages his explanation and he adds, almost incoherently, 'Forgive me ... it's a worry I have about the poisoning... T'was as if she had committed a crime. If only I knew for certain?'

Jeanne listens soberly as her troubled husband dips his head into his hands, uttering softly, 'I could have saved her.'

'All this ... Ugh! That Painting. Dragging up the past – offending

the present!' Jeanne exclaims, as she reaches for the rosary in her pocket, *like it's a weapon,* he feels. She clicks with the beads almost in time with the beat of the great hall clock. He watches the beaded circlet turn rhythmically – the delicate white hands in motion with silent moving lips, and suspects this pointed call to the Lord God is in regard of himself.

This will not do, he says to himself, edging his way to the hallway and towards the staircase. Jeanne flicks the electric lights off behind them. He grasps a familiar sensation, *the insidious worm again is ravaging me inside,* he fears, mounting the stairs dolefully. The moment of tension with Jeanne is left unresolved, and they part company as they make their way to their separate bedrooms.

The next day, he decides that despite his urgent desire to make progress, he has to see Max again. Chivet drives him back to Saint-Benoît-sur-Loire.

Orderly and pure in his monk's habit, Max carries the book of Psalms he has been reciting with the Brothers in the basilica. Through his curly lashes he gazes upon Jacques who strolls beside him.

The monk wonders if his former patron is being ineluctably drawn to a Christian life until Jacques begins his usual questioning.

'Tell me, Max, is it conceivable ... would a clairvoyant be better placed to make a psychic connection with a former clairvoyant, *in the beyond,* do you consider?'

'Oh, I don't know... Quite possibly so.'

'Then perhaps ... could not your own powers be commissioned for this purpose?' he requests pensively, expecting a negative.

Max turns sharply to his former mentor, who holds his breath in trepidation. 'Monsieur Jacques! No indeed not! That would be necromancy! I was visited by the Holy Virgin and found myself truly on the defensive. Can you imagine if I began dabbling again?'

'It would be deemed sinful then?' Jacques returns, again acquainted with the answer before even the question is asked.

Max's contorted expression portrays something close to horror. The religious convert is determined not to succumb to temptation.

'Sinful? ... An abomination! In the extreme, my dear fellow. I can scarcely imagine anything more so!'

'Then would you suggest I find another clairvoyant?'

'I suggest nothing of the sort. I'll have no part in any such adventure.'

'I'm not asking you to do so.'

'You are asking me to sanction an egregious activity, or condone it at the very least.'

'Very well,' concedes Jacques. 'Let us then go to another aspect of the conundrum... Do we have any clues as to how or why Sonia's connection with *Picasso's Brothel* might have contributed to her demise?'

'It may simply be temporal.'

'*Temporal?*' Jacques scratches his beautiful barbate chin.

'Yes Earthly. Nothing mystical. Simply the tragic actions of a jealous and brutal husband.'

'I know he was incensed about her having the photograph of the painting... The one I had obtained from Burgess, alas.'

'I cannot imagine,' ponders Max, 'how such a couple ever bonded at all – she, an archaeologist with great spiritual insight aligned with *la bohème*, and he, well ... a *petite-bourgeois* functionary from the corridors of bureaucracy. It was a blighted union.'

'Yet she clung to *me* – a paragon of so much that bohemians despise.'

'Come along you handsome brute – and what of your impeccable styling. Whoever could resist those mirror-like shoes?'

'Alright! Alright! But Max – Cyprian? Once only? A special *little* séance – *just* for me?'

'No! Monsieur Protecteur. Dabbling was part of my former life.'

'There is something about that canvas ... utterly defeating me... A dark secret? Tell me, Max, you who have found God, what was it? What made Picasso lose *his* faith?' Max smiles benignly. He simply presses a volume of *The Confessions of St. Augustine* into Jacques' hands.

'I'd prefer the confessions of Max Jacob!' the troubled man sighs.

In the face of Max's resistance, Jacques returns to the rue Saint-James, but with fresh determination to find resolution through his Gallery. *I'll bring Poiret back. His courage and flair are well proven and most importantly he is distinctly youthful.*

THE FOLLOWING DAY Jacques is locked in despondency peering over Ruaud's cardboard architectural model. His patience snaps and uncharacteristically, feeling the whole concept is wholly unresolved, he kicks the table in fury. He turns abruptly, snagging his silk-lined jacket on an oak plinth undergoing repair in the centre of the room. 'Where is that man?' he exclaims, cursing the absent carpenter who has disappeared to fetch a tool. He returns to the model, morosely peering one way, then the other, becoming frustrated yet again with trying to move items within the light card and canvas structure. But they are securely fixed in place. He dislodges a miniaturised cabinet, damaging its surroundings – and suddenly loses his temper. With a series of blows he thumps the whole thing flat with his fists.

The carpenter returns with surprise at the rowdy commotion. Jacques immediately ushers out the perplexed man.

At once there is a knock on the door and Dora shows in Paul Poiret, wearing flamboyant attire almost too trashy to be distinguished or fine. He is evidently going to seed, appearing not quite as youthful as Jacques remembers. The older man pours two large brandies while Paul cranks the squeaky handle of the gramophone. After a moment, Erik Satie's gentle *Gymnopédie no.1* floats from the horn.

'Take a cigar, Chap,' says Jacques, handing his guest the opened humidor. He chooses a large Havana.

Poiret peruses the crushed model. 'Goodness, Monsieur Jacques, my empire fares almost as well as this,' gesturing to the debris.

He sympathises by describing the sale of his own fashion house. After mutual commiserations and some reminiscing about better days, Jacques has a suggestion for his former pupil. 'Would you

care to join me in creating a new Gallery – a *temple de l'art*. How about it, Chap? With the dynamism of my collection and new commissions of every kind coming along, as well as the big painting of course, it is quite a prospect.'

'Alas, my problems leave me no opportunity for other diversions.'

'I was sure you would want to help me?"

Paul blushes, recalling two instances of how he had previously displeased his one-time master. It is an unwelcome reminder of a time when he had designed a black tulle garment for Rejane, and had it run up for his own fiancée by a dressmaker outside of the Doucet House. The unspeakable incident had led to his sacking.

Even worse, the success of Maison Poiret had impacted adversely on Jacques' own fashion business. With his introduction of vibrant colours leading the new age, Poiret had put the pastels of his former master in the shade. He could scarcely be blamed for this last occurrence, but both situations were unmentionable, especially in view of their mutual affection.

'I must apologise. It is really not that I don't wish to be support-ive, and alluring as your Gallery plans are, I've so little time... Do you know they speak of flogging off my gowns by the kilo, AS RAGS!!'

Jacques is shocked and sees he cannot press the matter.

Paul moves swiftly on. 'How about fetching Iribe back from Hollywood? – though it is *you* that has the celestial touch?'

When Jacques describes the breadth of his most ambitious project Poiret becomes bothered. 'Seriously, Monsieur Jacques, please, you escaped within a few heart beats last time. Jeanne is so very concerned. It'll be your ticket to heaven if you don't pull back.'

'I understand,' Jacques responds sharply. 'You must get on and save your business... As for Paul Iribe, I think nowadays he seems to regard Paris rather as a backwater. Besides, he is a designer and decorator. This is not merely to decorate my apartment as he did for me once before.'

'Isn't that a little disparaging, Monsieur Jacques?"

'I really don't mean to be. After all, he created some of my finest furniture. But now I need to resolve a philosophical enigma.'

He sees Poiret's baffled expression.

'Perhaps you don't understand, Chap. But you'll see.'

When Poiret leaves, Jacques rewinds the gramophone and flips the record over. He reaffirms his mantra to himself, *I WILL look forwards.* Since his friend has declined, Jacques starts to draw up a list of others from whom he might seek support.

He telephones his former art advisor, André Breton, inviting him to lunch the following day. Doucet's latest project seems an enticing source of funds to the poet. He breezes in, full of how much he has done already, declaring he can yet do more to make a difference to the outcome of the Gallery. Doucet has belief in these promises, since the infamous painting would not even be his if it were not for Breton – now full of fire concerning his latest Surrealist Manifesto. 'I really feel, Monsieur Jacques, that Surrealism is going to lead the revolution now that our aims are made clear,' he exudes.

Jacques is glad to hear it, since he has put such energy into supporting the ground-breaking Dadaists and embryonic Surrealist movement. Ever focused, he brings the conversation to his own personal revolution and the highly selective inventory of works proposed in support of *Les Demoiselles* in the new building.

'I shall fashion the Gallery as a *Shrine to Modernity*, now in honour of your success!' he beams at the Surrealist poet.

'Attaboy. Now you're on the trolley, monsieur.'

Breton swallows his impatience to return to his own work and listens respectfully to Monsieur Jacques' description of his difficulties with Picasso – the recent encounter and strands of information he has gleaned from the painter's friends and lover Fernande.

'Clearly Picasso suffered dark periods,' says Jacques, 'but he was by all accounts a jauntier fellow when he was dirt poor than he is now, as a serious businessman. Do you think he has changed?'

'He'll never go into liquidation, of that you can be assured,' the poet avers. 'Yet I suppose we must all grow up?'

'He is doubtless the greatest painter alive, André, now that Monet has gone, but should that turn him into an old curmudgeon?'

'I think losing Apollinaire really made a difference to him.'

'Poor chap. Survived the War though, did he not?'

'Hardly. He was badly injured. *I've* thought of him a lot of late. Kostro was never right after they trepanned him you know – he scarcely recovered – and then surrendered to the flu. To think they did that to such a great brain. He, who helped us develop Surrealism – his word even – and it carries real weight now, since the days of the *ballet Parade.* Of course I've distilled the cause in my own true vision, and we have some infighting it's true, but Kostro Apollinaire was our forefather.'

'I gather it was through him that you first met Picasso?'

'Certainly. At the time of his illness. One day I saw Pablo strolling down the rue Saint-Germain, looking like a "tidied-up" renegade. He assumed from my army medical gear that I was a doctor and asked after the patient. I could see he was heartsick about Kostro's decline, just as I was. So I took Pablo's card and he bade me pay him a visit.

'The Picassos were at their hotel when they received the dreadful telegram of the death. Pablo was adjusting his bow tie in front of a fancy mirror. He looked deeply into the glass, as if past his own face and then grabbed a sketch pad, returned to the mirror, and there and then started sketching feverishly. You could feel the sparks fly off the pencil tip.

'Pablo ranted, *Apollinaire was the inspiration of our time, supporting every modern move in art and writing and poetry. He was a great and loyal friend to us all. That was my youth. Now it has disappeared.* He recast his own image there and then on paper.'

Jacques listens intently. 'And this was at the end of the War?'

'Two days before the Armistice ... the day the Kaiser abdicated ... Pablo's drawing of himself revealed utter panic of the soul...'

Jacques is moved. 'Well, I am glad Apollinaire is immortalised in our library.'

'His funeral was bizarre. The Armistice celebrations were ablaze

on the streets and the *cortège* was mixed up with the crowds. I take it you didn't go?' asks Breton.

'I was convalescing in Fontainebleau at the time of the Armistice.'

'There were the flags of the allies everywhere – much carousing and raucousness as well as grief. The funeral procession could barely pass. Behind the horse-drawn casket walked Kostro's mother, La Kostrowicki, in her ostrich feathers, Kostro's new Russian wife, the beautiful Jacqueline ... as well as Serge Ferat, and Max – top hatted of course. Behind them were the artists and poets... Pablo was fiercely determined to smile for his friend; there was Olga, Satie, Salmon, Poiret, myself, the Derains, Gertrude Stein and Alice Tolkas with Fernande and Marie Laurencin.

'All who had survived the War were there. In the furore, hundreds of other mourners were yelling, *Down with Guillaume!* Madame de Kostrowicki was very confused, imploring, *Why are they shouting about Guillaume?* I told her, *No, it's the Kaiser, Wilhelm, they're shouting about* – *Guillaume in French.* Others were equally mystified.

'Pablo called it surreal, saying, *It's just the wake Kostro would want – and interment in Père Lachaise with the great Balzac and Molière.* But how can we recover now he's gone to the edge?

'There it was. The War over and nine million dead, including more than one great poet... Yes. Picasso grew up then.'

'Nature's sentence will be delivered,' Jacques murmurs quietly, 'despite our fury.'

'I guess he blamed God for another cruel blow – after losing Carles,' Breton adds. 'Pablo is from a devout Catholic family. He had his own arrangement with The Almighty, apparently.'

Jacques is watchful. 'Fernande said the same. A kind of pact?'

'I don't know,' Breton replies. 'As to your Gallery, Monsieur Jacques, you may count on my support.' He gets to his feet and puts a livelier Satie record on the gramophone.

'You are a tonic, André!' his host remarks, newly cheerful. 'Yes a tonic, I'll be bound!'

Finally, the poet bids adieu. Jacques is left to brood on Apollinaire as Satie's "furniture music" modulates his thoughts. He pictures his fourteen Apollinaire books, some original manuscripts, already exotically bound in the Art Deco mode by Pierre Legrain and Rose Adler, and suddenly recalls a title Max Jacob referred to. While it is not yet held at the Bibliothèque Littéraire, somewhere there should be a copy in his study.

He retreats to his voluminous archives and fervently seeks *Les Peintres Cubistes.* He roams the shelves, pulling out copious titles until finally stumbling upon the very work. After careful scanning, he arrives at a most interesting passage concerning Picasso. Twitching with excitement, Jacques discovers, what seems to be a most remarkable revelation, one which he takes to be Apollinaire's precise reference to the invention of Cubism.

> *There are poets to whom a muse dictates their works, there are artists whose hand is guided by an unknown being who uses them like an instrument. There is no such thing for them as fatigue for they do not work, although they can produce a great deal at any time, on any day, in any country, in all seasons; they are not men but poetic or artistic instruments... They do not have to struggle and their works show no trace of struggle...*
>
> *And then there are other poets, other artists who wrestle. They struggle towards nature but have no immediate closeness to nature; they have to draw everything out of themselves, and no demons, no muse inspires them. They are alone and nothing gets expressed except what they themselves have stammered, stammered so often that sometimes after much effort and many attempts they are able to formulate what they wanted to formulate...*
>
> *Picasso was an artist like the former. There has never been a spectacle so fantastic as the metamorphosis he underwent in becoming like the latter.*

'YES!!' Jacques exclaims, leaping from his seat. 'Apollinaire may not have had much to say about *Picasso's Brothel* ... but here he describes the energy, the very heart-seed of the moment... *The fantastic spectacle of the metamorphosis* in the creation of a single painting! Here, right here ... Apollinaire alludes to Cubism ... the essential transformation in Picasso's art, the beginning of which – where the effort and struggle occurred – was the creation of *Les Demoiselles:* the actual birth of Cubism!'

Jacques is now quite carried away, feeling himself suddenly there at the origins of it all. *I too, like Picasso, must shoulder the yoke of creativity, in order to metamorphose into an artist who struggles. I too with my rare Temple, shall command a most serious achievement – it is the very essence of pioneering!*

17

Architecture is a science arising out of many other sciences,
and adorned with much and varied learning; by the help of
which a judgment is formed of those works which are the
result of other arts. – **Vitruvius**

A T T H E P R E V I E W of a major auction of Eastern art at the
Hôtel Drouot, accompanied by his distinguished Eastern Art
advisor, Charles Vignier, Jacques Doucet stoops to scrutinise a
magnificent sixth-century statue. At half life-size, this Sui Dynasty
Buddha, is mounted on a plinth of sculptured lotus petals.

Acting as Jacques assistant, Mlle Rose Adler is also in attendance.
'Lotus petals,' he observes quietly, straightening himself. 'You will be
aware, of course, mam'selle, 'it is the lotus flower that thrives, most
productively, in the worst of the swamp?'

Turning to his advisor, 'Supposing *Picasso's Brothel* painting rep-
resents the *dirtiest part of the swamp* – a matter upon which you
may be one of the first to agree, Charles, the opportunity for purity
to emerge around it creates balance, do you follow?'

Vignier, the former symbolist poet, is now in his sixties. He slowly
shakes his head disapprovingly. With a passion for antiquities of the
East, the rather academic gentleman is not wholly sympathetic to
radical new art. He speaks with a mildly embarrassing tic at the end
of his phrases, regularly emitting a clipped high whimper, not as
guttural as the bleat of a lamb and lasting no longer than the squeak
of a marsupial. It is a pitchy *umm* with just the hint of a question in
its inflexion; this combines with myopia and his habit of advancing
his face uncomfortably close to a companion. 'The lotus blossom,

indeed, *umm?*' He raises his horned-rimmed spectacles to examine the petals. '... symbolising cause and effect,' adds Rose Adler.

Jacques nods appreciatively, keen to embrace Buddhism which had so absorbed Sonia, and incorporate it into his impending Gallery.

Vignier is a leading authority in Eastern art, of which Jacques has been a collector for more than three decades, including major Buddhist-inspired creations from the Irish architect Eileen Gray.

The expert is perturbed by his client's ambition to include such items *côte à côte* with Western modernity, and less than content with Jacques' obsession with a brothel painting. He puzzles, muttering, 'Juxtaposition – but with what, *umm?*' – making an oblique reference to the Picasso picture.

Jacques frowns.

'But then, if you're set on this, Jacques, *umm,'* referring to the Buddha in white marble with an ancient bronze patina, 'I can confirm its authenticity and would value it ... at between eight and ten thousand francs, *umm.'*

Once the sale commences, Vignier and his patron are prominent among the buyers, standing at the back. Bronze sculptures and ceramic pots are mounted upon a table at the front. Alongside the podium the *Sui Dynasty Buddha* has been placed on a plinth.

The auctioneer invites bids, beginning at twelve thousand. 'Well beyond my valuation,' whispers Vignier. 'You might let this one go, *umm?'*

'Twelve thousand... Twelve thousand. Do I have twelve thousand?' ventures the auctioneer. No one makes a bid.

'Twelve thousand... Twelve thousand. Do I have twelve thousand?' urges the auctioneer, raising his voice.

Jacques bids with a discrete nod. Vignier shakes his head, emphatically motioning that the price is too high.

'Twelve thousand two hundred... Five hundred... Seven hundred... Twelve thousand seven hundred... Do I have thirteen thousand...? Thirteen thousand... Two hundred ... Five hundred...' The bidding continues between Jacques and a flamboyant gentleman, almost

lost behind voluptuous wolf grey whiskers – and who flags his offers flamboyantly from the crowd. It quickly rises to fifteen thousand. 'It's fifteen thousand... Two hundred... Fifteen thousand two hundred ... standing at the back... Selling at fifteen thousand two hundred... Fair warning... ... Fifteen thousand two hundred francs!' The auctioneer slams down his hammer with a crack. 'Monsieur Doucet.'

'You are paying above the odds, my friend,' Vignier gimaces.

Jacques beams, enjoying the rush of victory and noting his dejected competitor. Turning to his companion, 'Always buy pieces that are really cheap or really good is my maxim. And this one is really good, so hang the price – just as long as it's authentic – and you assure me it is...'

'Then what of your *Brothel* picture? In which category did you place that when you bought it, *umm?*'

'Really good *and* really cheap. If you can achieve both, then so much the better, ha!'

Rose Adler looks on admiringly, but is concerned, too, knowing how her patron's finances are not what they once were. For Jacques, the purchase is a fillip. He is back in the arena, buying in the salerooms – a home from home, where he can excel. And a strategic plan is beginning to emerge in his fecund imagination.

He arranges to meet Mlle Adler later at the Doucet Library of Art and Archaeology, at the Sorbonne. Meanwhile he and Vignier break for luncheon to thrash out the details of the Eastern art requirement for the new project. Jacques has it in mind to continue designing and commissioning exceptional works of furniture and architectural features in a modern style but restricted to an Eastern or primitive vocabulary, while at the same time including the most refined selection of original non-European treasures.

At the Sorbonne, Jacques and Rose are met by the library director, septuagenarian André Joubin, who has held the post since long before the library was donated to the university. He embraces the library's patron, smiling through wild Dundreary whiskers.

'Monsieur Jacques.'

'Most pleased to see you mon ami,' he replies to the important custodian. After introducing Mlle Adler he turns to his require-ment, handing Joubin a note of the items of interest. 'We have come to inspect a particularly rare collection of botanical engravings.'

The visitors are soon leafing through portfolios depicting *Nelumbo nucifera,* the lotus plant, and Jacques identifies ideal examples for his purposes. Despite being the benefactor, it is not customary to remove items from the library. He could insist but this is not his way. Besides, Jacques is an artist himself, as too is Rose. They take their seats at a table, and make sketches of their selection.

'You know, my dear, the lotus flower is key to this,' he suggests. 'In the 1913 Salon des artistes décorateurs I encountered Miss Eileen Gray. I purchased a couple of items from her and was also enormously inspired by an over-mantel panel, showing a deep blue night sky with a black silhouetted magician holding a crisp white lotus bloom – *Le Magicien de la Nuit...* I wish now that I had bought it. I should tell you, Miss Gray is a follower of Buddhism and this lotus symbol is more intriguing to me than all the Madonnas in Rome.'

'Is this where Monsieur Suarès, *The Peregrine,* found his name for you – *Le Magicien?*'

'I don't know about that, Rose, but it was due to seeing that panel I commissioned my *Lotus table* which I may use in conjunction with the *Buddha* we just won at the auction. But it will first have to be returned to her workshop for repairs. The removal people care-lessly chipped the lacquer when bringing it to the rue Saint-James.'

Jacques' furnishing elements have been amassed during the past decade. Each and every item is a *pièce unique* commissioned from a host of talented, peerless artisans in their fields, from Eileen Gray's spectacular red lacquered four-panel screen called *Le Destin (Destiny),* to works by his coterie of interior-artists – Paul Iribe, Pierre Legrain, René Lalique, Joseph Csaky, Paul Louis Mergier, Marcel Coard, and Rose Adler herself.

Chief among them, the serious Pierre has excelled himself. Early in their partnership Monsieur Jacques had pleaded repeatedly with him

to create bookbindings that unhappily did not then exist for his precious manuscripts – many being in loose leaf form. The unassuming craftsman had declared his complete incompetence, but had flourished in the glow of the patron's belief in him, and turned his mind and hand to the task. Now, nearly four hundred examples of Legrain's precious bindings grace the shelves of the Doucet literature library.

Furthermore, princely bespoke furniture and carpets have been crafted by the artist, exclusively for Doucet. Legrain's latest exquisite *objet d'art* is a *grand bureau* in ebony, with a writing surface of inlaid *galuchat,* accompanied by a lacquered seat in the form of a stylised African throne.

Jacques summons his important protégé for appraisal. He reminds him of his beginnings, shortly before the War, with the remodelling of his apartment – as Paul Iribe's assistant. 'You probably influenced him in furniture design as much as the other way round, *n'est-ce pas!'* he begins, enjoying heaping praise upon the youth. 'How far you have travelled, dear boy. Astonishing!...

'And with a weak heart too! Such good fortune that you were liberated from the army in the first place. Thanks to you, Pierre, the JD manifestation of *arts décoratifs* is realised and so it is they call you *the Poet of form and materials!'*

Legrain shuffles with pride and pleasure.

Next, Jacques makes his way to Eileen Gray's Paris atelier. It is a tidy space, holding a plethora of modernist materials, wholly alien to furniture makers of previous ages, including lengths of gleaming chrome and modelling materials which can be shaped into tubes of all kinds as well as an advanced technical drawing board. Amongst the samples of her furniture is a prototype work that she calls her *Bibendum chair.*

Miss Gray reminisces about her contribution to the War effort when she had volunteered in the Doucet ambulance service. After closing her atelier in 1915, she had joined the future Mme Doucet to become a driver for the service.

In due course Chivet and Bonnet carefully bring in the Lotus table. The mood changes. While the fiery designer is clearly glad to see Jacques, her first significant patron, she is swift to react when she catches sight of the table.

'What on earth have you done to it, monsieur?' she exclaims in a shrill Irish brogue before repeating it in French.

'It's only a couple of scratches. You will be able to repair them, Miss Gray, surely so?'

'No, monsieur, I'm not referring to the scratches. What the deuce are the cords and baubles for?' she demands to know.

The table is in glossy green-black lacquer, standing on firm legs fashioned as lotus stems, the top of which splay out and up into ivory lacquered lotus blooms supporting the tabletop. Each corner is shaped to a simplified finial in the form of an extended loop. It is with this that the designer takes exception. Jacques has threaded green silk cords through the loopholes, terminated with large amber spherical beads and tassels.

'It is an Eastern-inspired work and this kind of Japanese finish is perfectly in keeping,' the patron contends in defence.

'It's *chinoiserie!* Much too fussy, Monsieur Doucet. I'm surprised at you.'

'You misunderstand me, I am afraid. This is to be my altar! Besides, you may recall, when you made this – what fourteen years ago? – we discussed the very idea, which offends you now but you applauded then. I fear it may be your taste, not my tassels, which has changed in the interim, Miss Gray?' The observation is astute. She now works almost exclusively in the modern functionalist style, with no frills or decorative effects, whatsoever. Her beetleish brows knit heavily as she struggles not to take offence.

Shaking her chestnut bob as if nothing is amiss, she sees that this man of action is not to be subdued. She agrees to attend to the repairs, but not before adding sharply, 'Pardon me, monsieur, but I would not want to see you swallowed into that strange little corner where reside the most peculiar of specimens ... of that singular

character *Des Esseintes* for instance!' At this she leaves the room hastily, before her surprised visitor can muster a response to such a forthright remark.

IN THE COURSE of the year approaching 1927, in which Jacques is devising and orchestrating the work around his Gallery project, it happens that J-K Huysmans' historically innovative novel *À rebours (Against Nature)* enters his library in the form of the original manuscript. Featuring the famously eccentric Duc des Esseintes, the work already has an uneasy resonance for Jacques. A first edition of 1884 is kept by his literature library which he had perused as a young man, but only scantily. He is reminded now of Jeanne's scornful reference to Des Esseintes, during their rapprochement at the library. More disturbingly, Jacques cannot cease considering the fact that the author was one of Sonia's favourites and that she too had more than once cautioned him against descending into a version of Huysmans' anti-hero – comments he had scorned at the time.

Now he has acquired the original manuscript of the seminal Symbolist work, Jacques opens it with fresh eyes, approaching it with trepidation, for here there may, after all, be something of a skewed mirror of his own self.

Turning the precious pages he considers his rival Count Robert de Montesquiou, who had been used by Huysmans as his model for Des Esseintes himself. In fact the Count had also been cruelly depicted as *antagonist* in a recent novel, the manuscript of which Jacques aspires to owning, Proust's voluminous *À la recherche du temps perdu (In Search of Lost Time)*. In this remarkable tome the supercilious Montesquiou is again portrayed in hideous glory – this time as the reprehensible Baron de Charlus.

Upon finding himself as literary model for a second time, the horrified and vengeful Montesquiou had quipped bitterly, 'Marcel Proust is a poor writer!' The Count and the author had once been seemingly the closest of friends and it had been a torrid fall from a

great height for him. It was widely held that the distress it caused contributed to Montesquiou's untimely death in 1921. Jacques might have been moved to feel a little sorry for him, if the man had not been quite so vile.

He absorbs *À rebours* with utter fascination, studying closely the travails of this Montesquiou-*esque* character – in Huysmans' version as the *protagonist* – a reclusive connoisseur, driven by unmitigated loathing of bourgeois society, and its intrusion into his aristocratic milieu.

There within is an essentially true reflection of the materially-led lives of passionate collectors *such as JD himself.* It is a hymn to the treasure-seekers who make *beauty* their quest, but to the extremes of gross obsession. In the fiction, the character retreats into an extraordinary artistic world of his own creation, having taken *collecting* to new heights of aestheticism (or depths of absurdity).

At first Jacques relishes the traits of a man surely many times more neurotic than himself. Here is one who consigns his domestics to live silently in quarters close to him, where they must wear shoes with heavy felt coverings, muffle their well-oiled doors and tread upon many heavy rugs so that he may never hear their footsteps. Utterly risible are his preparations for when the woman servant has occasion to walk past his study window to reach the woodshed. Just in order that her shadow should not offend him, she is charged with wearing a great hooded nun's habit, so that the Duke has the sensation of being in a cloister. Jacques' mind settles for a moment on his own rigorous demands regarding his tobacco calf brogues, and flits on with increasing perturbation. *How could it be,* he worries grievously, *that some have actually likened me to one so hideous as the fictional monster, or worse, that of the deceased aristocratic dandy upon whom he is modelled?*

As he absorbs the text, Jacques is struck by the great significance Huysmans afforded the symbolic lotus flower. Des Esseintes, in the author's portrayal, is obsessed with *the Royal Prostitute of Babylon ... the alluring vileness of debauchery,* Salomé*, painted by Gustave*

Moreau. In this large canvas, she brandishes the spear-like bloom whilst performing her lascivious dance, to awaken the slumbering senses of King Herod, before requesting the head of the Baptist be brought to her on a charger. *In this case the lotus is featured as a symbol of evil, attesting to the character's disdain for Buddhism and Eastern religions,* thinks Jacques. He finds this doubly disturbing as he wrestles with the complexities of such interpretation and his own understanding of the sacred virtues of this purest of blossoms, and his own Buddhist inclinations.

Alerted by the reactionary Catholic obsessions of Des Esseintes, Jacques feels passionately that his own high minded quest as a connoisseur must aspire to depth and meaning and not mere superficialities of lavish interior decorations. *There must be* More! *More than the visually beautiful,* he ruminates – bedevilled in a sense with the same struggle as that of the fictional Des Esseintes. *Of course there is* More! *But perhaps not?* he fears, grappling with emptiness. *There must be* Meaning!

Turning to his innumerable objets d'art, Jacques considers *they must dwell upon relationships: between cultures, peoples and ideas – primitive and modern, east and west, north and south, male and female, secular and sacred, dark and light, and so forth.* Between them they mine deep into the conflict and contradictions of modern life, style and taste. *Primitivist* imagery, form, motifs and ideas, juxtaposed with modernity. *If only they could be assembled correctly? Such tensions,* he contemplates, *are even embodied within the over-arching Brothel painting – that vicious cauldron of progress? This must form the foundation of my most profound undertaking,* he pledges, albeit a little dubiously.

Jacques is mindful of a paradox. He knows that while adhering to the language of Primitive Art in the works he commissions, his incomparable attention to refinement is extreme. While forms and motifs are borrowed directly from tribal art or other non-European cultures, the fabrication of the items is to be to the same exacting standards of excellence as he affords his shoes and spats, and the

cut of his beard. His aesthetic sensibilities demand that he handle the realisation of pseudo-tribal works, with the same concreteness and consummate manufacture, as his earlier gowns, a Ruhlmann *armoire à bijoux,* or a Rolls Royce.

As he continues to scrutinise the pages, Jacques garners insight regarding Max's tutoring of Picasso on the writings of Baudelaire.

Here at least, J-K Huysmans, through the mouthpiece of Duc des Esseintes, illuminates a great deal, and positively, to Jacques' guarded appreciation: *... until Baudelaire's advent in literature, writers had limited themselves to exploring the surfaces of the soul or to penetrating into the accessible and illuminated caverns, restoring here and there the layers of capital sins...*

Jacques reasons, *while it is a sweeping assertion, might the author be revealing a poignant clue to the corresponding progress of Painting, as exemplified by Picasso's* Demoiselles...? *Can it be that the primacy of Surface Beauty in the case of painting or Elegance of Writing in literature, as Huysmans suggests, were jettisoned in favour of a deeper meaning and understanding?*

Ultimately, Des Esseintes' quest was for refinement, taste and style; for the satisfaction of such sensibilities, albeit taken to the point of utter *dis*-taste. The fanatical search immersed the decadent Duke in the arts – who in the end *... did not know a single individual capable of appreciating the delicate shades of style, the subtle joints of a picture, the quintessence of a thought, one whose soul was so finely framed as to understand Mallarmé and love Verlaine.* How poignant it seems that not only do the works of these very same writers appear in Jacques' collection, his library contains their manuscripts too.

For Jacques, *À rebours* raises the prickly issue of the meaning of *home.* Des Esseintes uses his own home as a *canvas* of thought and aesthetic expression. While possessing the masterworks of Gustave Moreau and Odilon Redon, and literary works from the early Christians to Baudelaire, he does *not* create a museum. Jacques evaluates this eccentric quest for an enlarged experience.

The reclusive Duke admirably takes in the whole gamut of human sensations – reordering them in sense-deranging experiments – from the subtle to the simply absurd. He distils exotic perfumes and fabricates a masterpiece – a liquor dispensing rack for the mouth – a *taste organ,* which could perform a symphony upon the tongue. *Imagine!*

The Duke devises a floor decoration, cruelly introducing a live jewel-encrusted tortoise that creates shimmer by moving about the carpet – the latter being *too bright, too crude, too new looking.* Comparatively, the bejewelled reptile renders the perception of the carpet less bright! The creature eventually drops down dead from the weight of its baubles. Then just as tastelessly, he suspends from the ceiling in a small silver-wired cage, a captive cricket. Its singing reminds its captor of the ashes of the chimneys of the Château de Lourps – a souvenir of his childhood.

Am I really in danger of degenerating into this? Jacques frets disconsolately. *Oh tell me I'm not gazing into a mirror.*

Jacques, head-sore from reflection, has to put down the manuscript and take to his bed in a darkened room for recuperation, before continuing further – so disturbing does he find this parallel.

Later, he resumes reading cautiously. There it is described, the rooms of Des Esseintes' medieval cottage variously transformed: the dining room is a ship's cabin with mechanical fish moving clockwise past the porthole windows. Another room has its walls and ceiling bound like leather books in large grained, crushed morocco. Objects connote instances of memory. *Meaning* was packed into every crevice of the hermit's home.

So closely does some of this correspond to Jacques' own ideas and methods, he fears quite seriously for his sanity – gradually deducing that Des Esseintes thrived by distilling culture through the most diligent exercise of taste. *This is Me!* Jacques shudders. The Duke develops a substitute culture organised around himself, while rejecting his relations with the rest of society. The belief that art is the essence of culture, and private contemplation, the essential relationship to

art, allows this. Much of *À rebours* is consistent with the Doucet plan. He searches within, for his own differences from the fictional character. Des Esseintes' hermitage seems to have been created for the connoisseur to extricate himself from aristocratic life, due to bourgeois infiltration – *amongst whom I would need to be counted!* The former couturier assays, *I have long sought to avoid high society of which I have, at least partially, become a respected elder.*

It is far from Jacques' desire to emulate Huysmans' hermit, and even less De Montesquiou, but he has his own antipathy to society and a quest to escape. The piercing call of the highest form of collecting is alluring. Jacques would never wish to go to any of the superlatively absurd lengths described in the novel, but the notion that Collecting, as an Art, in the real sense of that word, and can be taken to such excess, provokes him.

According to his plan, the evolving Temple of Arts will showcase the extremities of human endeavour, and will be a worthy undertaking in itself. *Yet how am I to avoid pettifogging or even foul absurdities,* he fearfully squirms as he sends off the manuscript of *À rebours* to Rose Adler, to be cloaked in a luxurious binding of vellum, goatskin and pearl, in order that it may take its place on the hallowed shelves of his literature library.

18

*Just imagine, when I go out into the countryside and see
the sun and the green and everything flowering, I say to
myself, 'Yes indeed, all that belongs to me.'*
Henri (Douanier) Rousseau.

E V E N I F J A C Q U E S is troubled by his reading of *À rebours,*
his determination to adhere to intensively high standards of
production, as well as other profound issues, pray upon his
mind. Bubbling up from his subconscious is the notion that the
shrine he intends to create for the groundbreaking Picasso picture, will
also be in homage to his own lost Beloved. Her haunting presence
is irreducible – if anything, it drives and motivates him.

The fine Doucet conveyance draws up once again at Saint-Benoît-
sur-Loire monastery. Chivet alights to open the rear door, this time
for Max Jacob to climb aboard and join Jacques. After a short drive to
the riverside the chauffeur removes carefully packed equipment
from the luggage rack. Jacques changes his footwear and outer coat,
appreciating that Brother Cyprien has shed his robes for outdoor
attire in hunting green. Chivet carries the hamper and fishing tackle.

Now high summer is here, Jacques has invited Max to join him
for a spot of trout fishing, anticipating that the atmospheric change
will be conducive to fraternal discourse.

Around the broad river banks of La Loire a light early morning
breeze is refreshing, and catches the garments of the two men,
making play with the flaps of Jacques' sporting cloak and the folds
of Max's long overcoat. Jacques demonstrates the art of casting
the line, and Max is a quick learner. They settle down in folding

chairs on the bank awaiting a bite. Chivet deposits a food hamper alongside and returns to the car. Gradually the air stills and the temperature rises.

In due course Jacques directs the chauffeur to drive into the town to refuel the motorcar. He and Max are alone.

How much this recreational approach modifies Jacques' strained mental condition is unclear. The faces of both men remain a little tense. *Brother Cyprien indeed. He is always poet Max Jacob to me,* the silent contemplator broods inwardly. *How disturbing everything is. Having come all this way there suddenly seems little to say,* he muses, watching the river's gentle flow and waiting for a twitch on the fishing rod. Jacques has a request in mind but scarcely dares to even mention the subject. As in previous visits he appreciates the friendship and tacit support, but just wants more information – which it seems is never sufficiently forthcoming.

Max is patient about such diversion, considering himself to be on a humane mission, but anticipates what is to come, locking his fingers together in a sympathetic stance.

Jacques struggles to find an approach. 'I believed I had a workable solution when I informed Picasso that I was going to build a secular temple, a shrine to the invention of modern art – but now I simply foresee some sort of museum. What, you might ask, would be the point of that?'

'Ah yes, *Le Louvre de Doucet?'* sounds out the poet-monk.

'Don't be absurd, Max,' he snaps, 'Oh dear me. Very sorry. I am often sharp these days...'

'And it's *Cyprien* if you please,' suggests the Brother, not wanting to feel less holy so near to the monastery, especially while with an associate from the old days.

'It is more of a shrine to the elephantine painting, or I confess, also a shrine in homage to lost love. A *Museum* would be paltry and tedious! Besides, how could I compete with the Louvre?'

'A private shrine, then – is that what you mean?'

'I don't know, Cyprien ... innumerable drawings and models have

been produced for me – all to no avail! We have created the shell of the building but I find myself defeated. Now what? All eyes are upon me and I struggle to create. Moreover, there is something that irks me and I've not the faintest clue as to what it is. Have I lost my nerve, or my sanity? Underpinning it all, I need to know why Sonia was killed – or *was* she murdered? The coroner concluded accidental death, which I have never accepted.'

'You must not brood on all this, my friend,' the good Brother, replies, perturbed at such constant anguish.

The ranter persists, lamenting, 'Picasso paints an outrageous work, from nowhere. Is there, or is there not, a connection...? She swore to me that Roux did not even suspect our covert liaisons and therefore could not have been taking out vengeance upon *us* ... though we were after all in a sort of entanglement...' the words tumble forth. 'Indeed she and I were to be married. Do I lack the marrow to face the truth? Is that it? And then ... then Breton embroils me in a world of Surrealism, the dream state made real ... and for years I've tried to use this as my pathway. But alas, the mystery remains cloaked.'

'Have you talked this over with Jeanne?'

'Max! ... Cyprien! I have tried. But you know I cannot talk to Jeanne about Sonia. And even less of the painting that offends her so grievously.'

'I think we might cease talking about it, too, my friend?' adds Max quietly, dashing at him an uneasy glance.

Jacques dares not press him. Silence beats the air just as the sun beats down upon their heads. These rare fishermen are very soon perspiring and throw off their outer clothes.

'How long has Chivet been gone? I wonder.'

'Two hours and more. It will be the Divine Reading before long,' Max remarks.

'We are rather stuck here without him.'

The sun beats down harder, full and strong. It beats them into silence and onto Jacques' pain, until he cannot focus so surely on

it. The fishermen become absorbed in the verdant yet nullifying landscape.

Another half-hour of uneventful angling and Max picks up two fresh flies from the tackle box, passing one to his companion. They reconfigure their rods. 'Let's move under those plane trees, this sun is fearsome.'

Jacques and Max move through the long swishing grasses with nets, lines and tackle setting up once again under the leafy canopy.

'I suppose Chivet has had a puncture or some such trouble?' infers the flushed older man.

'I'm still far too hot, monsieur. It won't incommode you if I jump in will it? Indeed I suggest that you join me.'

Jacques hesitates.

'Not in the least. Go ahead, my boy. The fish are giving us a wide berth today in any case.'

Max peels off the rest of his clothing and takes a run, holding his nose in flight. He arises as a lily-white vision in water droplets and shakes himself with exhilaration.

'Come in! It's so refreshing!'

'Could I?'

'Absolutely you can. Come on, monsieur. I will protect you from drowning.'

Jacques is held fast by longing. He waits. Of course he considers the act would be practical and necessary in the circumstances.

Moments later he is astonished to find himself wading towards the centre of the river, enchanted with the natural world in all its glory. His hands held aloft resist the gelid water until finally he plunges his fingers downwards. *It's delicious,* he feels.

Just yards from Max, Jacques cannot help but observe that the monk's pale body is actually sinuous. He allows the silvery waters to slip through his fingers. 'How nature bedizens us with her charms!' he purrs. 'That slim physique of yours is undoubtedly a benefit of monastic restraint,' he trills, elated with the physical activity. Max returns the glance through prominent curly eyelashes. The elderly

couturier appears faintly ridiculous to him in the water, but makes no comment on the woollen long johns meeting the top of the waterline. Nevertheless, for the tender Brother Cyprien it is a relief to him to see Jacques apparently relax for once. He is a princely if portly figure while at play, he considers.

Once Jacques has met the unspoken challenge and has bobbed around for a few moments, he staggers dripping to the grassy bank, struggling for breath all the while. Returned to dry land, his mood is a little brighter. 'To think that I would do such a fine thing! Quite shocking ... something else I shall have to keep from Jeanne. But I *can* still swim. Whoever would have thought it! Another secret, but I shall not feel guilt for this one! And you of course are free of all that now, Max?'

'Of what?'

'Guilt of course. I mean now that you have your Holy Virgin to intercede on your behalf.'

Max pauses. 'Not so!' He throws himself down onto the grass, dripping and stretching out on the bank. He is suddenly pensive. While struggling to put his trousers back on, he wonders if he should assist Jacques, who hops pathetically and tussles with wet garments. He notices the increasingly creeping eyes in his direction – but he desists after all, suddenly resorting instead to a distraction tactic – the subject of his own past with Picasso.

'You know Pablo never forgave me for getting drunk at Eva's funeral. For this I have shame... What was I thinking of, cracking horrible jokes and making love to the hearse driver...? Phew, how could I? Life makes idiots of us at times, and death, and yes sinners too. Oh I have heaps of guilt.'

'Mam'selle Eva – Picasso's fiancée who died during the War?'

'His adorable Jolie, he called her, just 30. No age at all. You'll know *Ma Jolie* from the paintings?'

Jacques nods.

'Later I went to see the poor boy on Valentine's day with chocolates, roses, and cigars, but he wouldn't answer the door. I wrote to him

afterwards, *'Mon Cher, Pablo, the chocolates have been smoked, the roses eaten and the cigars have wilted?'* But he wouldn't reply.

'Well you know *my* sins all too well.' Jacques begins careful beard-smoothing, contemplating his own guilt. 'Poor Sonia. I endangered her – imperilled as she was by that jealous husband,' he says with a forlorn sigh. 'Oh love! Lust! All of us swept up by unrequited love of sorts.'

'Yes, if love of a dead soul counts.'

'Oh Max. Love forever unrequited! And there's my treatment of Jeanne.'

'How so?'

'I've done everything to be a faithful loving husband, but deep down, in the far reaches of my soul, I know I've not been entirely honest with her.'

'Is this over Sonia?'

'And the rest...' Max senses the tension ratcheting up as before. 'Monsieur Protecteur, please, I beg you, look to your health – driving yourself into your own early shrine. Think of your illness. You have every-thing: a fine wife, a stately villa, fabulous works of art and the greatest works of literature. You could be savouring the fruits of your successes in these years, not being driven to madness with ghosts and unfathomable notions. Let's not speak of this again,' he implores him. 'Please, old heart. It's only pouring acid on a festering wound.'

Jacques cannot let it lie. 'If only Rousseau was still with us.'

'The Douanier Rousseau?'

'I *need* a medium, my dear Cyprien. I've said it before ... a spiritualist. Oh please, Cyprien, take pity on me.' He begins falling to his knees, but Cyprien is aghast and, perceiving what is coming, pulls him up before he can complete the gesture.

The poet-monk can scarcely bear to see the piteous sight. 'Oh monsieur! Oh lor! We have been through all this before and I can no longer condone dark practices, or even discuss them. You must know this! ... Come along, monsieur, let us resume our fishing. All this will frighten our quarry away.'

The men stand once again at the riverside, rods in hand, and just as each of them cast off the roar of the Panhard engine fills their ears.

A YEAR OF PLANNING and preparation has been underway at the rue St James villa. Jacques is fully devoted to the Gallery which he has lately deemed his Exclave.

'As we have agreed, Jeanne, my dear, it will be my dominion, geographically separate from here, so will not further offend,' he avows to his wife, hoping that she is reassured enough by the painting's future location, properly segregated from their home.

'You know I've already accepted the arrangement,' Jeanne, rather buttoned-up replies with an irritated tut and declines to debate the point – more concerned for his health than about the banishment of the offending picture. There was hope that it would slake his need for further enterprise, but Jeanne is dismayed to see him now forging ahead, acquiring more works of art and commissioning so many opulent pieces of furniture.

'Are you going to slow down?' she demands to know. 'Think of your condition, I beg you.'

'Please don't fuss, my dear. I have more energy than men of half my years.'

'Jacques, you are so easily breathless! You do recall the doctor's words about overexertion?'

'Yes, of course. I am most mindful. Most mindful.'

In truth, the septuagenarian has been forced to decelerate. The production of bloodied sputum as he wakes and at his toilette in the mornings, and the shortness of breath privately concern him, but he is not one to brood on the failures of his inner workings. 'Your forebodings, surely, Jeanne, if well founded, oblige me to get on with things all the more urgently, if this task is to be completed.'

'What, in that you may not have long left? How bizarre.'

'If you insist,' he says dismissively, as he picks up the telephone to summon his staff.

Every moment has become precious, and Jacques has become adept at hiding quite how much he struggles bodily, believing his quest can be a great rejuvenator – if only he can overcome his emotional angst. *Still I am a ship adrift in a tempest, unable to find a navigable course – and, I fear I may find myself in conflict with my crew members, even as I anticipate our breakthrough.*

He has decided upon a new manoeuvre. He returns to the site of the lead-cladding escapade: the *Stockage Girard* where he has good relations with the concierge. Yet again, he surmises, *it can serve as a safe harbour.*

This time he will stake out a cavernous part of the ground floor as a rehearsal area for his proposed creation, housing the disreputable painting. In order to fully pilot his own work of art, for it will be that too – the ultimate interior of a triptych of rooms – his present purpose is to create not a *maquette,* but a full-size representation of these rooms. He is accompanied by his key lieutenant, André Breton – who, despite his initial optimism, is not entirely on course with his patron's precarious cerebral voyage.

'You know I support you here artistically, Monsieur Jacques, but all this forethought and precision is surely at odds with the psychic automatism of Surrealism?'

Jacques is wounded at what he considers to be a sideswipe, or at the very least unwarranted criticism. *Is the boy deliberately poking me up?* 'Why, you young Sap!' is the overly-scolding response. 'Sorry ... pardonnez-moi ... uhem!' The connoisseur checks himself, realising the peril of falling into bickering with his previously reliable ally. 'André, have I ever declared *myself* Surreal? Jacques Doucet is merely the facilitator of Surrealists!'

Breton likewise quietens, reining back his criticism. Despite his irritation, he recalls that it is *he,* after all, who had so fulsomely urged the elderly collector to buy the contentious Picasso picture.

Crucial decisions are still needed in respect of the building's shell now constructed above the porter's lodge at the rue Saint-James villa. There will reside the Exclave. More is to be decided upon, greater

than the mere placement of pictures, objects and furnishings within. Conceptualisation is fluid. Architect Paul Ruaud is in attendance but Jacques reflects uneasily upon his failed design and drawings. Ruaud, too, is undermined by thoughts of the smashed cardboard maquette that he had toiled over so fervently.

Floundering as he is, it is essential, the connoisseur discerns, to experience the spatial volumes and their impact at a human scale. His young colleagues simply must be made to comply.

The carpenters arrive, each bringing materials and tools, as if for the construction of a theatrical set. Outlines of the shell of the building are meticulously inscribed on the warehouse floor. The team of assistants align great wall pieces of portable hessian-clad screening, for the one-to-one scale representation of their Captain's vision – a rectangular space divided into sections forming three rooms: a domed vestibule (with entrance/stairway), a large central salon and a domed end room.

Under precise instructions, the men position themselves upon their knees to fashion panels for the representation of the principal paintings. Jacques closely observes them, while restless and fidgety, but tries hard not to stand over them too constantly, 'Ah this is marvellous! In a brace of shakes the concept will become real,' he exudes.

Charles Vignier brings his Eastern art expertise to the venture, urging his client to dedicate a chamber to his area of interest, insisting, 'The *Sui Dynasty Buddha* must enjoy due prominence.'

Within the model building, Jacques supervises the positioning of depictions of works of art. His gleaming eyes are never far from the men positioning the roughly hewn blocks personifying his own breathtakingly delicious furniture – the original pieces being far too precious to be used in a rehearsal.

The brilliant bookbinder, Rose Adler, clad in overalls like beach pyjamas, is among the crew. She is increasingly employed by her patron Jacques across a wider design field. Over a period of days she has been making approximations of furniture and is now sketching

onto a block, the last item, an African throne. Once she completes the task, there is some time to fill before the next stage is reached requiring her attention. Rose falls into conversation with Breton.

'How is the folio factory coming along, old fruit?' the poet asks.

'Unusually for a lady artisan, I am said to be making inroads. The latest reviews say we are taking modern bookbinding to its summit, and in the 1925 *arts décoratifs* style. My principles of geometric purity are lost on some – although not Monsieur Jacques – at least in our bindings.'

'He grasps what you are doing then?'

'Very much so. You know that under his patronage, with Monsieur Legrain, extraordinarily, we seem to have managed to reinvent *the book*. We now approach the cover holistically – as the front, the back and the spine – conceived *as a single design entity – a single work of art.* We are rather proud of that! Someone was saying to me just recently, *it is the first change of its kind since Gutenberg.*'

Breton is fond of Rose, and punches her arm encouragingly. He naturally sympathises greatly over the loss of her fiancé, killed in the War.

'I was asked to explain my ethos recently,' she adds. 'It's perfectly simple – transforming something previously used as a means of *protection,* into a thing of *beauty.*'

'Beauty will be convulsive or it will not be at all,' suggests André.

Rose puzzles over this.

He laughs, 'Don't show me a painting of a bowl of roses, but a bowl of sea lions.'

'Well if it moves me it is beautiful,' she counters. 'And that includes geometric purity.'

Breton steps across to the area designated as the vestibule and chats to Ruaud, who sketches an outline of *Les Demoiselles* on a giant calico board. Jacques wrinkles his brows at his handiwork and refrains from passing comment. Other panels, bearing black outlines of paintings of various sizes and shapes are propped up, awaiting hanging. *The Brothel* is the largest of the panels, sketched in red

and black lines, and is the only concession to bright colour.

Young Tigers, Eluard and Aragon smother their high spirits in deference to their patron, as they lurk, lost in time. In tedious moments they quietly practice childish impressions using monocles for props.

Occasionally Jacques' thin cry bleats out an instruction to them to move dummy art works or make sketches identifying features on the boards representing the great works in charcoal black. Their irreverence is compounded by the very long hours contemplating the master's procrastinations and mind changes. They quietly debate his extremely precise rehearsal for his Artwork, which for them, as for their leader Breton, is puzzling.

'This *Magician* of Surrealists is creating his masterwork in the most *un-surreal* manner wouldn't you say?' Eluard asks as he marks out sweeping curves for Rousseau's undulating snakes.

'The very opposite, my dear?' retorts Aragon, holding the board steady for him.

'It is sad to be so stuck in one way of thinking. If only we could help him...' considers Eluard. 'The dastardly ladies of Avignon are always praying on his brain. It's frustrating for all of us.'

'We should be able to do something, Louis. It's our job to unlock the unconscious after all...'

'And perhaps help him let them out?' retorts the other.

'I gather he is fixed on the idea of a clairvoyant too. Hmm, thinks it will help.'

With a smile, Aragon removes his meagre scarlet bow tie and pins it jauntily against a sparsely sketched board of Henri Matisse's *Poissons rouges et palette (Goldfish and Pallet)* – a rendering of an aquarium bowl before a window frame. 'Voila. A goldfish from beyond,' he declares.

Jacques uses a yard rule to plot sightlines. He squints, often look- ing for principal and secondary axes of oppositional forces within the construct. Although deliberate and purposeful, he is exhausting his physical reserves. He coughs into his monogrammed silk hand-

kerchief, averting his shocked glance at the blood stains, quickly thrusting it away into his pocket.

'Put that panel down and bring the Rousseau, will you? Perhaps it should face the Matisse?' he orders Rose. With the help of Breton she brings the roughly sketched *La Charmeuse de serpents* from Aragon and Eluard's stack of finished boards. They hang it in the centre of the salon area, as instructed. 'What do you say, Breton?'

The younger man's patience is wearing thin. His response is unusually snappish. 'Can we really make any proper judgements with these mocked-up artworks, Monsieur Jacques? It seems a little futile to me. I am still struggling to comprehend your vision?'

'And that might be because it is not your own,' retorts Jacques, a little wounded by the Surrealist's imperious tone.

Breton recants quickly enough, indicating his wish to be helpful, even if he currently lacks understanding. His patron points first to the sketched *Poissons rouges*, noticing but ignoring the jaunty bow tie goldfish, and then to the Rousseau *Serpents* panel.

'Matisse's icy *death tapping at the window* – opposes the piper in the verdant jungle. A serpent rears up. Another one, from high in a tree, lurches towards the flautist, to signify new life,' coughs Jacques.

Breton strains to meet his flight of fancy, but questions the idea, 'In the way that windows are deemed to be exit routes for the soul?'

'Yes. Yes of course. You are getting there, old son!'

The younger man's enthusiasm rises. 'Rousseau's most surrealistic painting *Le Rêve (The Dream)*, portrays his woman Yadwigha, naked, on a crimson sofa – in a jungle – also with a native snake charmer – just like this one, you know!'

Paul Poiret's arrival surprises Jacques – not least because he is accompanied by a care-worn auburn-haired woman. He weaves his way to them, through scattered panels, tools and wooden blocks. 'When you promised to call by I never expected the pleasure of you bringing this young lady too.' Jacques exclaims, and turning to greet her, 'How delightful it is to see you again, Madame Olivier.'

Fernande responds warmly. The awkwardness of their last parting

seems forgotten. She notices how wan and shrivelled he seems to have become, even since then.

'How d'you do, monsieur?' she says, offering her hand and making a discrete curtsey.

'I am quite recovered after my funny little turn thank you,' he answers smoothly, bowing a little and enquiring after her health.

'I had arranged a modelling assignment,' explains Poiret, 'and since it is in this arrondissement, I insisted that Fernande should see how you are going on. I hope you don't mind us dropping by.'

'Indeed not, Chap. Certainly not...' He appears perturbed for a moment. 'That is, so long as you are not here to spy on me for Madame Doucet? There's actually not much to see yet, but while you are here, you can consider our location for Henri Rousseau's *Serpents*,' indicating the area where André Breton and Rose Adler are standing. Jacques makes the introductions, before describing his plan for his Exclave. 'It will be a great *temple de l'art.*'

'Really I had no idea...' Fernande politely exclaims. 'I am glad to see the dear old Douanier will be represented so prominently. Such a gentle soul and too easily mocked.'

The conversation reverts to the late-blooming, naïve artist.

'Henri Rousseau was of course said to have The Gift.' Fernande says. 'He frequently talked of his late wife being with him, guiding his hand and telling him, *Henri, you will take this one through to a successful conclusion.* I remember well, *Le passé et le présent,* a portrait of the 1890s – of himself and his second wife. Above their heads, in circular clouds, hovered the ghostly faces of *his* former wife and *her* former husband... *I communicated with my first wife, and she with her old husband,* he would say. When asked if he really conversed with them, *on the other side,* he would reply, *Of course, and I still do.*'

'How very strange and charming,' says Jacques, reflecting on this communion with *the other side.*

'We – that is Pablo, Kostro and the whole Bateau-Lavoir gang – gave him a banquet.'

'I'll say! A banquet to remember,' interjects Paul.

'Pablo adored him, as did we all ... such a noble soul. The inventor of the portrait-landscape too – at least he liked to call himself that.'

Jacques' interest is heightened, so much so that he calls upon Eluard to take notes. He is alerted by Picasso's very name and amused at Rousseau's so-called portrait-landscape concept.

'They had only recently become acquainted,' continues Fernande. 'Pablo bought a large Rousseau canvas in Soulié's shop. A life-size, severe looking woman – for only five francs, and as something to paint over. When the artist Max Weber visited later, he saw the canvas and recommended that the two artists should meet. It was arranged, and Pablo called at Rousseau's studio. He finds the Douanier, with brush in hand, to his great surprise, capturing in oils, a chunky version of a familiar couple: Kostro and Marie Laurencin.

'When Henri visited, to catch sight of the rediscovered canvas: he was in raptures to see his very own, *Portrait de Yadwigha.*'

Fernande suddenly notices Eluard writing everything down and pauses, remembering Picasso's strict demand that she must not talk about their past together. She turns to Jacques. 'Look here. I've really talked too much already. I think I'd better stop there. I hope you don't mind.'

Jacques' sudden brightness fades but he refrains from pointing out the raw sketch of *Picasso's Brothel* looming at his side. He is disappointed but knows he cannot press her, and motions to Eluard to stop. 'It's all for this project you know ... in the cause of art...'

It is late evening. Everyone but Jacques has retired some two hours ago. In his hand he grips his list of artworks, sitting on a tea chest quite exhausted, rooted motionless with cold. His watchful eyes sting with fatigue. In the ray of a moonbeam, illuming the lumpen shapes before him, he sees movement. His skin rises into goose flesh. He hears the cry of an injured cat. *No, no it is a something quite different? What senile work is this?* he wonders.

There, just a few feet from him parades a stooped figure, a manikin with a felt hat and in the uniform of a customs official. With his

bearded face partially obscured, he shuffles around plucking a violin, with some eccentricity. The master is shocked to his core. *It is surely the distinctive figure of Rousseau himself? No?*

'Henri?' There is no reply. 'Henri? Please I must ask you...' One grizzled old man lurches towards the other. Then, the hatted figure waving his violin at him, suddenly seems to elongate, springing while, issuing a great guffaw. Jacques hears more suppressed hysterical laughter behind the hessian walls. He feels his anger rise. *It is the Tigers! Here to play a trick. Shame on them! Shame on me for allowing their chicanery!*

Work for the next day is cancelled. Jacques is quiet and morose. He has called for his former protégé. The two men face the life-size maquette. Some boards are hung upon the sack cloth walls, others stand aslant awaiting hanging. The older man, huddled up in his greatcoat turns to his companion, whose sincerity, as well as his rotund figure, seems to burst from his tweed suit.

'Why should they mock me? I, that has made them?' he laments. 'You dare to sup with radicals. They are the rule breakers, and so you need a long spoon, Monsieur Jacques,' Poiret consoles him, and then has an idea. 'You recall I am planning to reopen my atelier. I am considering that Madame Olivier might do very well there again – if I can find her the right assignment, as I did earlier at your request. Then she will perhaps be persuaded to talk to you further.'

Just a few hours later Fernande has been provided with the only usable chair in the building and the promise of a job. Seeing Jacques is still gloomy but seated again upon a box and with slightly renewed vigour, Poiret tactfully withdraws.

Fernande's enthusiasm for recalling the old days has returned and she chatters, her henna brown eyes candid and soothing to the old gentleman. She returns to the subject of Rousseau.

'I can picture him now at the Bateau-Lavoir, tears streaming down his cheeks at seeing his canvas. He cried out, *You have found my beautiful Yadwigha.*

'Pablo was sheepish, realising he might have painted over her. The

lady had been apparently Henri's mistress from his youth, but as to her beauty, you would need to decide. Nearby, and domineeringly visible, was the huge *Brothel* painting – which everyone had so far ridiculed. But the Douanier gazed at it at some length, completely mesmerised. He proclaimed gaily and to Pablo's surprise. *We are the two great painters of the age. You paint in the Egyptian style, I in the modern.*

'*Someone said you go to Mexico to paint?* Pablo probed.

'*No, the Botanical Gardens. But it seems that you go to Africa?* quipped the Douanier.

'*No, the Trocadéro.* How they laughed. And Pablo described its strangeness with plenty of colour. *When I went there the first time, the smell of dampness and rot stuck in my throat. It depressed me so much that I wanted to get out fast, but I stayed and studied. Men had made those masks and other objects for sacred purposes, a magic purpose, as a kind of mediation between themselves and the unknown hostile forces surrounding them, in order to overcome their fears and horror by giving it a form and an image. At that moment I realised this was what painting was about.*

'*Absolutely, monsieur! Absolutely!* Old man Henri concurred.'

As Fernande pours forth such sumptuous details to Jacques, his nerves are set alight. He contemplates Picasso painting African masks over the faces of former demoiselles.

'*Painting isn't an aesthetic operation,* Pablo insisted. *It's a form of magic designed to be a mediator between this strange, hostile world and us, a way of seizing the power by giving form to our terrors as well as our desires.* When he came to that realisation, he knew he had found his way.

'The Douanier was at one with Pablo. They agreed heartily and became the best of friends... Rousseau's triumph, one might say.

'It must have been, I think ... November '08, when we gave him a banquet,' continues Fernande. 'The whole *bande á Picasso* pitched in. We invited everyone vaguely connected. Even the Steins came. We decorated the ramshackle studio with African masks and strings

of Chinese lanterns. *Portrait de Yadwigha* was raised up and draped with a banner heralding *HONNEUR À ROUSSEAU* – hung above a makeshift throne consisting of a chair mounted on crates at the head of a rickety table.

'Another large Rousseau painting – that one by the look of it ...' she points to the *Serpents* sketch, 'was displayed above a sofa, upon which desserts were laid out. A large world map on another wall traced the routes of his *imaginary* voyages.'

'It's true he rarely travelled beyond the boundaries of Paris,' smiles Jacques, 'and for the *Serpents,* only to the leafy conservatory of Robert Delaunay's mother, who commissioned the painting.'

Fernande laughs, returning to her memory of the banquet. 'Some thirty guests, including Pichot and his wife Germaine, Cremnitz, Marie Laurencin, Metzinger, Gris, the Steins and Gertrude's lady friend Alice Toklas – all sat at long trestle tables down the centre of the room. The preparations were a fiasco. Pablo had ordered the food for the wrong day and so, with the help of all the scraps we could find, I cooked paella on the stove. The women helped serve the wine while guests were squeezing in extra chairs where they could. Max was excited that evening, even by his standards, flirting with the young Monsieur Poiret,' recalls Fernande, glancing round to see that her employer has not returned.

'Marie Laurencin, too, made quite a spectacle of herself, laughing incessantly and repeatedly demanding refills.'

'And so where was Henri Rousseau?' asks Jacques.

'The brouhaha reigned, until loud knocks on the door prompted silence. Pablo brought him in. There stood the Douanier with his funny hat, a stick in one hand and violin in the other. Our guest of honour received great cheers. The old man was visibly shaken. He fumbled his way to the *throne* we had created for him. The cheering continued and he waved most regally. Pablo fetched him wine. Holding the glass high, Henri was unable to speak. A tremor of emotion rippled through the room. Suddenly, all was quiet as he absorbed the scene, including *Yadwigha,* draped in garlands

behind. His sweet face broke out into a delightful smile. Seconds later, all was in full swing again. Such merriment. Georges Braque played an accordion. The Douanier raised his fiddle – little more than a toy – and played his own jolly piece, followed by his waltz, *Clémence*. Couples danced in the tiny space we had cleared.

'We had to send out for further supplies from a local café to add to my scanty fare. After a late and riotous supper Pablo nudged Kostro. It was time for *Homage to Rousseau*. The poet reached for the notes he'd been scribbling throughout the evening. Max signalled to Cremnitz to leave the room. The noise level faded. Kostro rose to his feet and flamboyantly chanted a poem, inspired by Henri's visions.

'I brought this for you, monsieur.' When I heard about your Rousseau I thought you might like this.' She pulls the old pages from her handbag and reads in a steady voice.

> Do you recall Rousseau, the land of the Aztecs,
> The forests where mango and pineapple grow?
> Where monkeys spill the red blood of the Pasticcios
> And the fair-haired emperor who was shot over there.
>
> Your painting captures what you saw in Mexico
> Red sun in green banana leaves
> Hereafter the brave soldier's uniform, Rousseau
> You changed for the Douanier's upright blue.
>
> We are gathered to celebrate your fame
> And since now is the time for drinking
> Let us drink this wine that Picasso pours in your honour
> Crying all together, "Long live Rousseau".

'Isn't that beautiful?'

Jacques nods seriously at her. 'Bravo! Thank you, my dear.'

'The Douanier wept with joy,' recalls Fernande. 'But things got rowdier when Cremnitz and another fellow reappeared from the

backroom with soap foam coming from their mouths as they feigned madness. They pretended to fight, arguing incoherently. Some of the guests tried to restrain them. Punches were thrown as things got ugly.

'Well, at that point Fredy from the Lapin Agile came into the crowded room with his donkey, Lola! Can you imagine? He stuck his arm up to prevent us from leaping lovingly at her all at once. Thankfully, the arrival of the pungent beast distracted everyone from the fight and so it was certainly timely. Marie Laurencin flung herself onto the sofa on top of the jellies and sweets, tossing her drink everywhere and laughing uproariously. The Douanier watched it all.'

Fernande becomes animated. 'Then from the raised dais he gazed across at his *Serpents,* above the horizontal Marie, by then comatose on the bright red sofa below, and made his great declaration, *The elements of this moment are most marvellously unreal!* I think he would have said *surreal* if the word had been invented.

'It was a delightfully special moment. We were none of us quite sure if we were all lampooning the old man, but it mattered not, since we loved him so. I am sure he didn't care.

'At the banquet, somehow Rousseau's sense of mystery returned with a vision. When Marie Laurencin fell onto the sofa he went away and painted his most ambitious picture – another great jungle scene with a native snake charmer playing a pipe, to become *Le Rêve,* adding a red sofa in the jungle, complete with a reclining naked woman ... and no, not Marie, but his own long-lost Yadwigha.'

Jacques is captivated and inspired by Fernande's narrative. 'I seem to be arriving at a clear insight about the inclusion of the Rousseau picture in my sequence. Yes, I feel I can make fresh progress.'

'But you'll have to live without Yadwigha!' quips Paul who has returned to hear this last remark.

ALTHOUGH LATE EVENING, Jacques cannot refrain from fetching folios from his private library to search for some fragments relating to this period.

The banquet – it seemed to others who recounted it – was a sensational moment marking the artistic revolution taking place at the ramshackle studios. At least *it was,* according to the long-fingered André Salmon:

> *Here the nights of the Blue Period passed … here the days of*
> *the Rose Period flowered … here Les Demoiselles d'Avignon*
> *halted in their dance to re-group themselves in accordance*
> *with the golden number and the secret of the fourth*
> *dimension … here fraternized the poets elevated by serious*
> *criticism into the School of the Bateau-Lavoir … here in*
> *these shadowy corridors lived the true worshippers of fire …*
> *here one evening in the year 1908 unrolled the pageantry of*
> *the first and last banquet offered by his admirers to the*
> *painter Henri Rousseau called Le Douanier.*

Jacques finds the words of Apollinaire's epitaph and is likewise moved. An inscription informs him that it was chiselled onto Henri Rousseau's tombstone by the sculptor Constantin Brâncuşi, sadly only but a short time after the great occasion that Fernande had so enthusiastically described:

> *Gentle Rousseau you hear us,*
> *We salute you,*
> *Delaunay his wife, Monsieur Queval and I,*
> *Let our baggage through free at heaven's gate,*
> *We shall bring you brushes and paints and canvas*
> *So that you can devote your sacred leisure in the light of truth*
> *To paint, the way you did my portrait,*
> *The face of the stars.*

Finally Jacques reviews his agreement with the Delaunays for the acquisition of the *Serpents.* His mind reverts to Sonia – as a naked black Eve amid writhing snakes, over which she has full command.

258

*I acknowledge the purchase from M. Robert Delaunay of his
painting by Rousseau, the Snake Charmer, for the sum of
50,000 francs, for which I will pay in five monthly instalments of
10,000 francs each, the first on June 15, 1922, and from month
to month, the last one on 15th October, 1922.*

*The painting will remain in possession of M. Delaunay until
full payment is made.*

*I hereby undertake to bequeath this painting to the Louvre
Museum, endeavouring during my lifetime to obtain their
assurance of the acceptance of the legacy.*

*Jacques Doucet
Paris, May 9, 1922*

*So the first twentieth-century painting to enter the Louvre will be
my La Charmeuse de serpents by Henri (Douanier) Rousseau –
notwithstanding their summary rejection of my Picasso,* concludes
Jacques, trying to content himself with this.

Some days later he orders the model of Marcel Coard's gondola
sofa to be brought from the other end of the mock-up and placed
below the *Serpents.* 'We will have this upholstered red and draped
with rugs and furs,' he elaborates, 'spilling out of the jungle!'

JACQUES IS JUBILANT. Seeing such progress brings renewed vigour
to the endeavour. The painting-sofa innovation is exactly the sort of
conceptual layering he is seeking to invest in his Gallery.

Following the Ghost of Rousseau stunt he takes Aragon and Eluard
off the project, a fitting sanction for their prank.

The entire space is in the process of flux and transition. Breton and
Ruaud are out running errands. Rose Adler works in a quiet corner
marking picture locations. Jacques takes a few steps up a ladder to
note the measurement between the top of a picture and the

improvised ceiling cornice. At this point Paul Poiret arrives. Jacques steps down hurriedly, slipping on the bottom rung, and crashes to the floor. Poiret rushes to help him stagger to his feet. 'Steady on there, Monsieur Jacques,' exclaims Paul, 'Let me help you... Are you hurt?'

'It's nothing.' he replies dismissively, dusting himself down, 'but I seem to have scuffed my brogues ... unfortunately,' staring down, more concerned for his footwear than his person.

'This is quite the sort of thing Jeanne is worried about. Didn't you say she expects you home by six?'

'I see. Conspiring again?'

'Come on, still you take risks... What has it been today, ten hours, *or more?*' After some argument Jacques yields and agrees to finish, but on the firm understanding that Paul returns tomorrow to give the benefit of his artistry on a number of issues.

Again, the following morning, the maestro is back in the model rooms orchestrating the ensemble. Poiret assists. Jacques points enthusiastically to the four corners. 'Man, woman – east, west.' He stops and contemplates for a moment, 'No, no... Two women, two men... East, west.'

Men in smart overalls carry in timber-framed panels, representing Lalique's moulded glass doors. Sketched horizontal bands represent the crystal work of the precious originals – depicting Grecian athletes. Another worker receives them and begins their installation between the vestibule and principal salon. Two other men, bring in wood blocks denoting furniture, and shift them into areas sectioned off with ropes. Although dubious of the position, Rose helps hoist the sketch outline of *Les Demoiselles* above the notional stairwell.

'Here, allow me to show you this, Paul,' Jacques says, taking him to the centre, and pointing to the rough of the *Serpents*. He picks up a glossy art exhibition programme he has brought with him and flicks to a colour plate of Rousseau's *Le Rêve*. 'Just exactly as Fernande described,' Jacques enthuses. 'And here we are recreating Rousseau's vision ... *Le Rêve* no less! Ha!' He recaps with a

description of his plan. 'And the Douanier wrote a poem to go with it.' Jacques reads with surprising vigour from the programme:

Yadwigha sleeping peacefully,
In a beautiful dream
Hears the sounds of a shepherds pipe
Played by a friendly musician.
While the moonlight is reflected
On the flowers and the verdant trees,
The red snakes lend an ear
To the instrument's cheerful melodies.

The younger man arches his brows – although fully mature – he feels the need to catch the coattails of his master once more.

They move to the centre of the end room, which is to be the Persian Chamber, advocated by Charles Vignier.

From here, they look back through the principal salon to the vestibule at the other end and the proposed location for *Picasso's Brothel* – a striking focal point in the distance.

'And a Persian Chamber, with pigskin walls? questions Poiret. A spiritual anathema to Eastern cultures, no? A muddle, surely?'

Jacques rebuffs this with an elliptical aside. 'Just here, will be lotus flowers in lacquer – the Buddhist altar rising from the filthy swamp, as it were. What is more, here on the principal axis, it will confront *Les Demoiselles,* as a polar opposite, in a *secular-sacred* firmament,' pointing to *The Brothel* panel in the distance.

Rose Adler scans her clipboard, attentively heeding the discussion. 'From here, through the doors, the picture is framed, precisely.'

'Back in 1906, Picasso felt ready to attempt a work of *salon* scale,' Poiret adds helpfully. 'A work far too large for the domestic setting.'

'Yet he didn't exhibit in the Salon.'

'No, but he must have had it in mind to do so. Just think of the careful preparation of the huge canvas, the cost of double lining it, hundreds of preparatory sketches, and so on? All consistent with a

major work for the Salon – but all that changed when it was so heavily condemned at the unveiling.'

Jacques follows keenly. 'So I am providing an Exclave for it.'

'It simply *must* go here,' interrupts Rose emphatically, pointing to the wall between the tall windows where Jacques has previously sited Matisse's *Poissons rouges*. 'At the centre of the drama?' She looks to Paul for support. 'Don't you think so, monsieur?'

Paul is surprised by Rose's intensity but her chief is not amused. Jacques shakes his head, scowling. 'Well, come on – say what you think, Chap? About *The Brothel,* inside or out?'

'Yes ... well you might have a strong Matisse at the entrance?'

'Matisse! Matisse! You'll be taking the teeth from a lion next,' Jacques scoffs indignantly. He indicates to Simon to fetch the panel down, but then becomes quite apoplectic.

'*No!* You actually *denigrate* the Picasso! Making it one of many!'

'Surely Matisse could herald the drama?' Rose continues.

'I can see you're ganging up on me again. I'll have another heart attack if you want!' Jacques responds, turning on them, crossly. 'Do you take me for an unruly tradesman?' He gets louder and agitated. '*Look,* the Matisse is important. Rousseau too, of course, but the entire ensemble is being created for this singular work,' gesturing to the red and black figures in the distance.

'So why not *within* the rooms? Wha...?' Rose is interrupted.

'Simon,' Jacques shouts across the elongated space, 'Sorry m'boy, let's try it. I know it's been up and down like legs in the can-can.'

'I'm not sure now,' Rose says sheepishly.

'One thing is clear – given its scale and abhorrent features – is its unsuitability for any place of reflection!' Jacques adds hotly.

Paul steers him to one side. 'Monsieur, you cannot go on like this,' he implores in a hushed but urgent voice. 'Like a man obsessed. Everything's suffering around you: your health, your wife, your finances, your standing – and for what? – A painting? What's happening here?' asks Paul, fearfully checking his pocket watch.

Jacques is fully absorbed in his task, however, as Simon and his

men bring him *The Brothel* panel. He directs them to locate it between the tall windows.

When they have done so, its domination of the space is patently overwhelming. 'There! Just as I imagined!' exclaims Jacques. 'The salon is *annihilated!* – Gorgons, bursting out on top of us. Demons all around us – and we've *no* escape...

Jacques notices the anxiety in Paul's face. 'Chap, I shall try to be more measured ...' he turns back, a little quieter, 'But look at this. See here,' Jacques says getting excited once again. 'The Painting is *not* here to serve the Studio!'

'Studio, do you say?'

'Yes. *The Studio* I am calling it,' he yaps, with verve and energy, 'Not just a gallery – it is a place of creativity. No longer the Gallery or the Exclave... As *the Studio*, it is here to serve the painting ... the painting *leads* the sequence. From the *start!* This must be the answer... At the entrance! *All* else trails in its wake... It is too powerful, and has to be restrained. The demonic masterpiece could not work *inside*. It cannot even be in the rooms at all!' He gestures to the space between the windows, shaking his head. All eyes turn to him as if he is raving mad.

Jacques shouts, pointing towards the entrance. 'Here, Simon, take that panel out, and let's have it back on the end wall.' They remove it, as instructed.

Jacques, agitated, falters in his strides back and forth, calling, 'You see, I am calm! Perfectly calm!'

Rose looks wonderingly towards the entrance from whence the large panel came and is now being returned, to preside over the atrium of the staircase. 'What's more, that balustrade will restrain the ogresses. And Lalique's doors cut them off – when so desired.'

'Containment! Precisely!' affirms the author of all he surveys.

PAUL POIRET HAS to leave, but he returns soon after with some startling news for his patron.

19

Great grief is a divine and terrible radiance which transfigures the wretched. – **Victor Hugo**

'MONSIEUR JACQUES,' exclaims Paul Poiret, finding the master's eyes glinting and gazing upwards. Paul's sight-line follows the rope Jacques has attached to a lighting fixture, which dangles across the room, like an ape in Rousseau's jungle. He is wrestling, as he often does, with sample equipment for the Studio. Poiret calls out to him but is not heard and he contemplates the stealth of madness seemingly creeping over the silvery old man, as if he marches asleep through his many tasks.

He hesitates for a moment before trying again in a stentorian manner, 'You are not going to believe who – or I might say *what* – I have just encountered.'

'I am considering natural lighting alone for overhead. What do you think, Chap?' Jacques looks down momentarily, otherwise he is fully focused above his head. Poiret grunts in annoyance.

'So surprise me, Paul.'

'A filthy wild-looking specimen, as foul a wretch as God put on the face of the earth ... goes by the name of Serville Roux!'

Jacques stops immediately. He almost fully lets go of the rope, which would have caused the suspended lamp to descend to the floor with a crash – but for a lightening reaction, he somehow lunges forwards and catches it.

Poiret breaks into a sweat. Already overdressed, he finds his leopard skin overcoat and flat cap suddenly overbearing. He pulls at his cravat. 'Phew, Monsieur Jacques, I'm sorry. I gave you a fright.'

Jacques eyes him carefully, fully incredulous. 'Roux!? He perished. Surely to God.'

'Apparently not so. I've just seen him, more real than nature...'

'Where?'

'By the pont de Clichy, near the dog cemetery.'

'No?' He looks again at Paul as if checking that he is serious.

'It was him alright. Fallen to beggary.'

'What? ... Are you certain?'

'I'm trying to tell you...'

'He threw himself off the parapet of the pont de la Concorde, did he not?'

'If so, he survived.'

'Are you sure? Did you speak to him?'

Jacques is so utterly shocked, he reaches for a block, to sit on for a moment.

Paul explains, he was approached by a man so dark and gaunt and unkempt, he appeared to have been spat from the bowels of hell. He continued with news of a lowlife wearing a frayed rope around his midriff, and prodding at the muddy waters at the Isle of Pests with a wand of willow, searching for something in that desolate spot.

'He broke off his scavenging at the sight of me and began bleating for spare change. I recoiled, failing to recognise him. He was ripe, I can tell you. I had to cover my nose. It was *he* that saw familiarity in my face.'

Jacques, again on his feet, shifts from foot to foot, struggling to grasp the details.

'He bellowed, *Friend, Monsieur Poiret, it is you?* It seemed he would lay his hands on me, and when I saw his sickly eyes, in that face, though cadaverous and drawn, it struck me who he was. He hacked out his story, interspersed with terrible coughing. I told him, I had heard that he was dead. He rambled on, sometimes incomprehensibly about being saved by the river police and taken to hospital, where a severe infection had detained him for nearly a year.'

Jacque's eyes widen in his blanched face.

'I asked what his business was there and he just laughed uproariously ... vacuously. His dignity was quite lost. He confessed freely, *Many of the husks washed up have coins in the pockets.* The dead can't refuse beggars. No matter how low they've sunk!'

'I cannot believe...' Doucet stutters bitterly. 'That cursed creature, robbing corpses.' He pulls on his greatcoat. 'Now where exactly was it? What are we waiting for?' He staggers towards the door, ushering Poiret along with him.

'But surely we're not...?'

Chivet, casts his newspaper aside and jumps up to open the doors of the Panhard. The two men take their seats among freshly arranged white fur cushions. Jacques directs the driver to make haste to the pont de Clichy.

As they travel, the ghosts of his past parade through his mind. On approaching the Île des Ravageurs he asks Chivet to slow down. They observe the steady flow of ragged men, in their sorry state amid detritus on the carriageway – passing the place where Paul had seen their quarry earlier – but he has now vanished. They stop and ask a peddler if he knows Roux. Paul gives a description: 'Fiftyish, medium height, pockmarked with long, straggling, greying hair and shoulders, very hunched for his age.'

'Plenty round here like that,' one fellow replies. 'D'ya ave any spare, sir?'

Paul offers a few centimes as bait.

'The gendarmes have not long since moved everyone on,' added the forlorn vagrant.

'You should try further on at the Île des Ravageurs.'

'Come, monsieur.' Paul helps Jacques back into the car.

'Even if we find him, what on earth will you say?' asks Paul. 'Just challenging him could be dangerous...' But before Jacques has a chance to reply Paul shrieks, 'IS THAT HIM?' In the distance, a man bobs around at the bridge, accosting anyone approaching.

The renewed excitement brings on such contortions of apoplectic

coughing in Jacques that his companions begin to be alarmed for him. Chivet turns from the wheel in concern. 'That coughing is worse, Monsieur Jacques. Shall we stop a while?' The sufferer can barely breathe, nor yet see properly. In this fleeting fit, he wonders himself whether he is really capable of interviewing this *incubus* of his mind. Will his nerves stand it? *I have the others at my side,* he steadies himself. *They haven't pestilent memories such as mine.*

'Pull up here,' Poiret shouts out. Chivet applies the brakes. They wait some moments to allow the master to recover his breath as words of hatred bristle within him. *Baboon, Bogeyman, Monster, Troll, Terrorist-of-old...*

After some moments he quietens, willing a return to composure. 'It's nothing.' He appeals to his aides not to fuss. Just a few car lengths ahead they see the wiry figure that is Serville Roux, squatting on the pavement clamouring to pedestrians for assistance. 'Paul, you and Chivet fetch him to the car. Use a few francs if you have to.'

Paul and Chivet succeed in drawing Roux to the Panhard, but he refuses to get inside. The group is stymied for an agonising moment before the vagrant barks, 'You want me to relieve you in some way, Doucet... I might be wretched, but I'm not dickylicking ... not with them here anyway! I have got standards.' He guffaws at his own drollery.

'Keep your filth to yourself, Roux.' Poiret puts a steadying grip on the man.

Jacques, quite stupefied, holds an impassive stance, swallowing his fury.

Serville fixes his gaze on Jacques' hip flask. He then seems to have a change of heart and suddenly swings into the car in a rapid motion, bringing leaves and mud into the saloon. An angry Paul draws to the side of the vehicle alongside Chivet who is exclaiming at the intrusion. Jacques changes his mind about the encounter too late. The unwanted guest sinks into the immaculate velvet upholstered motor car and peers at his equally immaculate host.

For want of knowing what to do, Jacques hands the broken man his hip flask of brandy, adding 'Now. You need to listen'

Roux takes it with shaking hands and hoists it to his lips, saying as if sharing a funny joke, 'Doucet, you rank old bedswerver, ha! ha! That's what you are. Still pouring treasures on other people's laps eh?'

Doucet blanches at these words, but enquires of the wretch boldly. 'Do you accuse me of being an adulterer?'

'Not really ... Not capable are you?'

The question lingers awkwardly in the air unanswered. Roux guffaws as he gulps the liquor and makes for the door. The chauffeur leaps to block his escape. Paul hovers, arms folded. 'Not so fast, *Friend,*' he growls, 'If you can contain your manners there's more.'

Serville's gape follows the movement of the flask.

'You needn't worry. You are not in trouble – yet.' Paul adds with a note of warning.

'What do you want of me?' the beggar asks.

'If you will listen I might be able to help you,' says Jacques, observing the man with suspicion. 'But I've a few questions first.'

'Oh really?' Roux stares in glassy eyed defiance.

Jacques passes the flask to Poiret, motioning for him to fill it. Three pairs of eyes watch the miscreant slake his thirst. 'First of all I want to know what exactly you have been doing these past few years,' Jacques demands to know.

With a little more golden liquor Roux loosens his tongue and it emerges that he spent several spells in prison, on account of a forgery charge and some alleged thefts – the authorities 'had something against him,' apparently. Jacques is beginning to see that *the pure and ever-so-morally erect* Serville, once he had become destitute, had suffered a rapid decline onto this low road.

Little by little the questioner comprehends that the creature who had defeated his brave woman was nothing but of the weakest character – a perfect study in pathos and confusion. For a moment he almost forgets to despise him.

'Let's get to the point shall we? If you can give us straight answers, I'll find you some kind of billet.'

'Oh really?' he sneers in disbelief.

Jacques falters, finding it hard to connect this lowlife specimen with Sonia, who shines so sunny and brightly for him in memory. He hesitates at drawing closer to the most painful moments of his unconquerable past.

'Hear me out, man – this isn't easy of course – your wife ... Madame Roux ... I need to know ... how ... why ... she upset you so grievously all that time ago?'

'It was she that brought me to this! She, that upset me then and upsets me now,' he snarls suspiciously. 'And I s'pose this fine hotel you oh so generously promise would be at the Commissariat, eh? With gendarmes for room service? Is that it?'

'Come now, Serville. I'm an old man at the end of life seeking peace of mind, about a tragedy of long ago, but which has plagued me ever since. Further recriminations are quite pointless, but I must comprehend the circumstances of her demise, and I'm willing to help you in return.'

Roux remains expressionless at this plea.

'Just tell me ... I know she was upsetting you, as you say. What was it she did, that you found so objectionable?' Jacques asks, not without some dread.

Serville seems to suffer inwardly and is momentarily dumb. Paul, crouching at the car door, administers more brandy.

'I was keeping her sane. She was embroiled with the occult, against all God's ordinance, losing her mind.' He reaches for the flask again and this time Jacques allows him a small sip. 'She needed treatment.'

'And did you know ... was there anything specific?'

'She had demonic pictures and then I followed her and caught her leading a séance. She was attempting to make contact with ... with a deceased child.'

He queries, 'A deceased child? Child or youth? Surely a youth?

Roux shrugs.

'Who?'

'I don't know.'

'And you found that so terrible,' Jacques laments.

'How could I tolerate being married to a witch?'

Jacques rounds on him fiercely, 'Now hold your tongue, Roux, before you say something you'll regret,' redirecting him. 'This ... deceased person?'

'I thought so *then*. I don't know now. I said I don't know what child ... I don't know...? What's it to you anyway..?' The wretched man's voice cracks, its tone seems to ring of something horrible and pained. Jacques pushes aside a spasm of panic.

'Come along. Don't let's get muddled. There's more?'

'I am wondering, there *was* something ... some of her effects and so on. You might fathom it...' Serville mutters, but then forgets this tack. 'What was your meaning about a billet?'

'I'll show you ... if you bear with me.'

Serville struggles to keep up with his interrogator. 'Let me think.'

Jacques asks Chivet to refill the hip flask again from a bottle kept in the glove box. Roux is watchful. At last Jacques returns the flask to him and turns again to his chauffeur. 'Drive back to the place de Clichy. There's the charity hostel on the corner of the rue Saint Petersburg. They receive my regular donations. This is a case for them.'

Paul and Chivet exchange glances. Jacques, now in the dizzying age of life, is becoming even stranger with his obsessions.

The party retake their seats in the vehicle travelling silently with the malodorous Roux, until arriving at an attractive auberge, striking for its hand painted sign "le Pèlerin" and veins of vine stitched into the façade. It has a pleasant cosmopolitan air thanks to the convivial chatter of the few wizened residents seated at the gateway holding long-stem pipes to their lips.

'So here we are,' announces Jacques, 'Do you know the place?'

Serville shakes his head. 'Before we go in we need a little more

progress ... on your recollections of Madame Sonia's disturbing activities.'

'It was when *Mona Lisa* disappeared. It made me see red ... and fury. To know she was tied up with those rough Spanish clowns. She could have brought us both down. She did in the end. You know I heard later on, Picasso and the poet were held by the police. I just gave her a spoon of medicine. That was all. I cannot...' He stops, seemingly muddled.

'What is it you were saying I might try and find?' asks Jacques. But Serville does not answer. '... We could probably fix you up with a year's sojourn here while you get yourself back on your feet... What do you think, Paul?'

'Monsieur Roux,' Poiret addresses the wretched creature. 'A little information could go a long way.' He gestures, 'Jacques, perhaps more libation may ease the situation,' indicating the hip flask he is keeping at bay.

Jacques shakes his head, mouthing, 'Not too much.'

'When she went ... the way of all flesh...' Roux hesitates, 'Her belongings at the Louvre were held by them, while an enquiry was underway ...' he growls. 'Of course once you have the information you want ... that'll be the last I see of you.'

'I think you will find Monsieur Doucet's word is his sacred bond,' asserts Paul protectively.

Roux screws his face into a scowl.

Jacques decides further persuasion is necessary. 'Chivet, do you have bread and cheese? Could we offer it to Monsieur Roux – he perhaps needs sustenance and sobriety for this?'

Chivet willingly fetches his luncheon.

'Thanks, my good man. We'll find replacement later,' he assures the driver as he passes the food to the prospective informant.

'You will need to behave with some decorum now, Roux, or this will not happen,' says Jacques, watching the man fall on the food like a hungry dog.

'Paul, you go in first,' offers Jacques. 'Make a booking would you

– in my name and register Monsieur Roux for three months. Any games, Serville, and I can cancel in a second. You behave with decorum and I'll extend it to one year. Do we have an agreement?'

The noncommittal nod is taken as an affirmative.

'Come along now, man.'

Roux begins again, 'Before I left the hospital, and after Sonia snuffed it, I got notice that her personal possessions were to be collected from the museum library. This was after my trip head long into the river, so I wasn't in a condition to care very much. But when I got out of hospital I took a peek.'

'Yes. Yes...?' Doucet is enervated. 'What did you discover?'

'Boxes of books and stuff.'

'What books? What stuff?'

'Text books, work books, notes ... her purse ... toilette. That's all.'

'How many boxes, and where are they now?'

'Two boxes ... perhaps to be had ... if you can track 'em down. Christ only knows where?'

'And the notes? Bank notes?'

Serville shakes his head. 'Not likely. Just rubbish.'

'What were they?' persists Jacques.

'I couldn't tell. Stuff and nonsense. You couldn't understand a word of it. I knew she was quite mad, unhinged.'

Jacques feels the chemistry of rage beginning to reign again, but he keeps it in check. Paul returns to the car to announce that he has arranged a bunk, as instructed.

'Now, Roux, Monsieur Poiret will escort you inside in a moment. I will send my man to Le Bon Marché for some new clothes and to return with them here this afternoon. If, and I say *if*, I find truth in what you have told me, my driver will return tomorrow to issue Le Pèlerin with funds to aid your recovery.'

'You assume much...' Roux says with a raised voice.

Jacques ignores the remark and his surly tone. Paul escorts the forlorn creature from the car into the hostel. Chivet attempts a temporary clean-up of the vehicle, the immaculate condition of which he

is extremely proud and privately he is astonished that such an unsavoury intrusion could ever come to pass.

Upon Paul's return the company make for the Louvre directly. 'I would never have been so generous,' Paul declares, 'After all the blaggard did!'

'Redemption is always an option,' replies Jacques quite airily. 'Remember, the purest good grows out of the dirtiest part of the swamp. According to Shakyamuni, caring for the dispossessed is the true course to enlightenment.'

ARRIVING AT THE bibliothèque du Louvre, Jacques is greeted by the chief librarian, with whom he is acquainted. M. Georges Meunier was not with the library in 1911, when the deceased archaeologist's effects were supposedly entrusted into its care. Jacques explains his purpose. Meunier turns aside and questions a longstanding member of staff who may have a recollection of those times.

The elderly Mme Barnard views Jacques over the curved brim line of brass lorgnettes. She knows of the sudden death of Mme Roux. Although not personally acquainted with her or others involved at that time, she is able to seek and find within a small bank of filing cabinets, a dossier, with evidence of the veracity of the husband's story. 'The archive was indeed once at the library but it has since been disposed of.' She informs Jacques.

'Where? You don't mean destroyed, do you?' he asks, suddenly alarmed.

'I cannot say,' Mme Barnard replies, adding, 'but not necessarily so ... although that would not be unusual.' After further searching she finds a note indicating that following a consolidation of the library after the War, the boxes of books were passed to the Sorbonne. As to whom they were sent, or what part of the university, there is no record.

Jacques reasons that the Department of Archaeology would be an obvious destination. He graciously thanks M. Meunier and Mme

Barnard and treads a solemn path to the Art and Archaeology Library at the Sorbonne. *How ironic it would be if a quantity of my dear Sonia's personal effects are housed in my former library?*

Buoyed up by the slim comfort of a reconnection with the past, he arrives with trepidation at the office of the director, his friend and ally, M. André Joubin, the honourable servant managing the great art library from even before Jacques donated it. The two greet each other, their white whiskers pressed swiftly together on each cheek. Behind the scenes Joubin works doggedly on the huge quantity of library material stacked up, yet to be catalogued. Despite his great task and uncertainty as to whether the boxes can be located, he promises he will make every possible effort to find them. Jacques remains hopeful that the hunt will yield results.

Retreating from the Sorbonne, Jacques concentrates instead on the matter in hand, in terms of support and therefore containment, of the pusillanimous Roux.

FOR THE NEXT few weeks Jacques visits Le Pèlerin hostel regularly, or sends Chivet in his stead. It is little more than a policing strategy, and produces only the most trivial dividends. But, among the fresh information retrieved, he is shocked to learn that Roux had been incarcerated for a long period at Pitié-Salpêtrière lunatic asylum.

The former beggar is attempting a kind of rehabilitation, occupying his time with whittling wood into clothes pegs and sometimes even wearing fresh clothes. He is lost however in bitter memories, strenuously asserting in a continuous monologue that his intentions had been honourable and for the best. His actions, plying his wife with medicine, he bleats defensively, had been intended for her benefit. Despite their agreement Jacques cannot get beyond the taciturn disposition, or broach the subject of Sonia without hostility. The patron tries another approach, and put it to him bluntly: 'Did you act as you did because your wife wanted a divorce?'

'Divorce! Divorce! I know nothing about any divorce. She never

mentioned divorce... I might say it could have suited me well. It truly might ... and I wouldn't be in this state now.'

Despite relief at being free of suspicion, and the disingenuous stance the former prim and proper husband may now be taking, Jacques is horrified to hear these words. *Oh, the futility of it all,* he grieves. *Can I accept, as the coroner indicated at the time, that Roux was a reckless bully rather than a murderer?*

20

I wouldn't mind turning into a vermilion goldfish. –
Henri Matisse

J ACQUES PULLS ASIDE the ornate lace curtain to see the electrician loading tools into his car. From this aspect, shafts of light bathe the sides of the stucco-clad elevation, lending it a pearly hue. It is now 1929 and more than two years have elapsed since the intensive design and planning of his treasured rectangular suite of rooms, located above the porter's lodge to the Doucet villa. The project is at last complete in its entirety.

Elegant lines below the parapet hint at a modernist interior, but the features of the façade contrast sympathetically with the Baroque swirls of the main residence. Jacques is bolstered to see this last workman doff his bowler to Jeanne. Her face shows relief as the boxy sedan motor car moves off, spluttering through the portico. It concerns him to see his wife cross herself so many times at this prosaic moment of departure. With the army of artists and artisans now discharged, the exquisite commissions, which have drained his coffers so low, are at long last safely installed.

Jacques slowly shuffles around in his increasingly faltering mode, unsettled, wondering strangely if he should visit his precious creation at all. Although the *temple de l'art,* or Studio as he now refers to it, is complete, he is seized by a pronounced fear of entering. He summons Mme Bonnet and begins prattling to her, earnestly repeating himself about careful cleaning within the temple walls. 'Have you checked and double checked that the workers have cleared their tools and rubbish away and that all is as it should be?'

'Yes sir,' she answers meekly, irritated at his fussiness but then softening to see his sickly and yearning expression.

He is alone again. A small door in his own bed chamber leads via a linking corridor to the upper vestibule, affording direct and discrete access to his magical domain, free of eyes and visitors, but now beckoning its creator. He covets its perfect isolation reminding himself. *No, wait the seven days as planned.* Only after closing the door on the Studio and reviewing it after that passage of time, may he fully appreciate it, with the relish only possible through fresh eyes.

The collector's suite is located above the front lodge to the Villa Saint-James as a *piano nobile* with the principal entrance at ground floor level. He glances across the flagstones to the side door, contented that he was able to find storage space beneath, for his private papers and documents. They remain unsorted, having been brought there in haste, following the disposal of Maison Doucet.

Although his self-imposed exile requires him to stay away, his mind broods on every detail. *Twenty-four metres in length with three rooms. Five metres wide and three-and-a-half metres high,* he reflects. *Enough to hold seventy Clarabelles!*

SEVEN DAYS OF lingering at the Studio door beckon for Jacques. Similarly, he is taut with apprehension regarding the possible location of Sonia's effects. In fear of such insupportable tension, he has a portmanteau prepared, for a rejuvenative stay on the Riviera. He has a sudden fancy that he might appear on the beach in a boater and swimsuit, and bask as many do in the healthful seawaters. Sadly he broods upon not knowing a single resort connected with Sonia, as he had never had opportunity of visiting the seaside with her.

Chivet conscientiously makes the necessary checks to the motor car. It is unseasonably hot and he puffs and blows, checking under the bonnet of the engine compartment.

'A good thing you are such a keen mechanic, old fellow,' his boss

remarks, upon boarding the vehicle. Jeanne fusses over his depar-
ture anxiously, privately relieved that he is taking this short sojourn.
She feels it her duty to accompany her husband, but he pleads with
her very sweetly that his purpose is for solitary meditation.

After three hours on the open road, with the windows rolled
down, it becomes uncomfortably hot, and the restless traveller eyes
his chauffeur warily. Now, he fears, is as good a time as any to
admit to his trusty companion, that this whole idea has been a
mistake. They must return to Paris and wait out the week. Chivet,
with barely a flicker of emotion dutifully turns the car around.

Following further vacillations, Jacques concludes that rather than
return to the house, he would admit himself to a health facility – a
place where he might improve his fitness, before a grand appraisal
of the Studio. With stops en route, and a series of telephone calls
to Paris, the ailing man signs into the sanatorium at Fontenay-le-
Fleury, near Versailles.

Quite shockingly, upon physical examination, the doctors are so
alarmed at his condition, they advise a stay of several months rather
than days. Jacques leaves immediately without signing out. The hasty
retreat brings him back to Paris and to his study at the rue Saint-
James where he squirrels himself away with folios and manuscripts,
summoning for bonbons and mint tea at intervals. Jeanne brings
unwanted meals and waits uneasily for this time to pass. On the
seventh day the master sends for Chivet. The chauffeur receives
instruction to drive out to the abbey and entreat Brother Cyprien to
leave his ecclesiastical allures, and bring him post-haste to Paris, for
a most particular assignment.

ON THE MORNING of the eighth day Jacques ceases procrastinating,
washes himself scrupulously and receives a visit from his barber
who meticulously trims his snowy beard. He dresses in what he
considers to be his most special raiment for the occasion. Max arrives
and is brought to the garden door where he is welcomed with relief.

'It's too kind of you to agree to come. I thank you most humbly, Cyprien.'

'Oh my! A full length white tunic, trimmed with gold? How fetching, Monsieur Jacques,' is his over-cheerful greeting, suggesting a little coyness, after the occasion of fishing together.

'It is part of my mental preparations, I hope. A robe reminiscent of Eastern monarchs and moguls?'

'Or indeed high priests or kings of past centuries, monsieur,' says Max, who wags his finger. 'And now we are both of us in dresses ...'

'We will have the Pope after us next!' They both laugh. 'You'll remember how Pius X castigated Poiret for introducing his harem pants? Trousers for ladies ... Ha. Ha.'

'Ah, but that was twenty years ago.'

'Seems like only yesterday... No matter, it's my honour to have you attend, Max, as my first visitor.'

'I'm sure the honour is all mine, Monsieur Protecteur. I'm so glad to see it now, as I will be unable to return to Paris very soon. My calling at the abbey is too strong...'

Jacques interrupts, 'Of course, of course. Bear with me please. You are about to experience *extreme-modern primitivism...*'

'And me needing to avoid extremes...' Max jests.

'Don't worry, my friend, it's not that sort of extreme.'

The two enter the ground floor vestibule with trepidation. Jacques gabbles with nerves as they go. 'We must resist being rushed along by the spirit of modernity. It would be all too easy to dash through the sequence and neglect the subtleties of the narrative.'

Their eyes dart blinkingly across the space, absorbing a general impression of the entrance. There is a sense of graceful perfection – as if the dull model Suite of Rooms of the Stockage Girard has been carried here and transfigured by magical beings. All is brought to life. The walls are finished in a soft green tint, with deep skirtings of beaten white metal. The sheet glass flags are partially covered by a lavish deep pile rug by Louis Marcoussis, in cream and black, accented with flashes of red.

The most dazzling feature is the staircase of bright gleaming steel, glass and enamel, adorned with etched glass panels, depicting animal and bird motifs. The structure shines ebulliently, catching the light from the elaborate electric *illuminators* in the ceiling above.

'Why, it's like that of a liner, a great ship,' exudes the monk.

'It is a functional soaring sculpture by Joseph Csaky, in fact.' The connoisseur leads on. 'Here is a rare *decorated* example from Eileen Gray,' pointing to a plum-red lacquered hall table, embellished with Greco-Roman-style silhouettes. He adjusts two ceramic pieces on top in his exacting manner and then returns them to their original position. Max absorbs the texture of this new world and falls into silent wonder.

Two items of sculpture are prominent in this foretaste of the main feast in the rooms above. One is an African head mounted on a massive hardwood plinth. Visible on the half landing, Brâncuşi's polished bronze portrait bust *Danaïde* shimmers. 'You know, Max, Constantin Brâncuşi walked all the way to Paris from his native Romania in order to sculpt such work.'

'A bald egghead woman,' he comments.

'That was what was said. It is modelled on Margit Pogany, a Hungarian student he met here in Paris. Of course it was scorned and thought incomprehensible, with incised almond eyes, but don't you think she is reminiscent of a *Demoiselle's* face?'

Max's eyebrows rise at mention of the much visited subject and he remains quiet.

'This is Pierre Legrain's.' There, looming in the vestibule is an impressive ebony black grandmother clock with proud Egyptian-esque features – a sort of upright mummy with an added elongated castellated headpiece. Alongside stands a tall modernist bird cage in steel and red and black lacquer, forcefully supporting the avian theme. 'Legrain came some distance under my patronage, c'est vrai?' the master considers. 'Do you feel you are pounced upon by a relative coldness, Max?' he asks anxiously, with an eye pointing to the clean lines of slick modern materials, which commence the sequence. 'I

had the head and cage positioned in *museum* mode, sharply isolated by virtue of them being the only such works in this entrance way. I am hoping they hint *art collection* without fully revealing too much.'

Max sways this way and that in appraisal, nodding sagely.

'The real drama begins above. The solemn moment is nigh!' Like an expectant father called to the maternal bedside, Jacques twitches, taking the first three tentative steps upwards. 'Come, my friend.'

They make slow and steady progress upon deep glass treads with their shallow risers, trimmed in polished steel. Max patiently keeps a pace behind. The master's hand, mottled with age, grips the newel post, which wraps around the turn of the stair, in the form of a curving, pseudo-Cubist peacock with a silvered-bronze plumage. Jacques reaches the half landing, pausing to allow Max to examine Brâncuşi's *Danaïde* at close quarters before making a full turn to the next flight. He is giddy for a moment and stumbles.

'Steady the buffs, monsieur.'

Scowling at this graceless manoeuvre, Jacques grips a smaller cold and curved newel, this time fashioned as a silvered-bronze parrot. He advances up to a further landing with a right-angled turn, to the four final steps to the *secular-sacred* space of the upper vestibule.

At the summit, adjacent to Picasso's *Les Demoiselles d'Avignon,* on the stairwell just behind them – before Max has chance to turn around to see it – the master stands at full height and pulls out a blindfold. With a surge of energy, despite the stair-climbing exercise, he launches forth. 'Now, Max. There was a time when you would have adored this. Would you not?' waving the fabric. 'I have a fancy for you seeing this in the proper order – to obtain the full impact of the large painting. For others I have tempered the moment. For you I would like to have you experience it at full power – impact-wise – if you like. So that you can tell me how it is working.'

Before the smaller man can say a word, Jacques has the eye cover in place and stops Max from lifting it with his fingers.

'It's alright I promise you. I need your careful critique. I want you to view this room last. Please Max. Trust me?'

'But then why put it first?'

'I have my reasons.'

Having acted swiftly enough to prevent his guest from swinging round, to see *Les Demoiselles* set in the wall behind him, Jacques turns falteringly, takes a breath and a bead of sweat breaks upon his brow. Behind his bewildered blind-folded aide, he eyes the perpetual encumbrance in wonder. After banishing the harlots from the suite of rooms, here they loom on the landing!

With this very particular placement, behind Csaky's balustrade, Jacques has purposefully introduced a means of moderation and control. The whores are housed and strictly contained, like rogue children, separated from their peers for fear of contamination – yet their presence pervades everywhere. He cannot help but feel that their influence seeps into the consciousness of any individual un-fortunate enough to be caught by them unawares. Like the eyes of Medusa, it seems they may poison and petrify the viewer.

'Something I must say, before we proceed.' Jacques confides in Max as he stands patiently beneath his eye covering, 'I have tried to resolve a great conflict within this collection. Remember, I have a wont to give everything away ultimately. The Buddhist way is not to covet material possessions. My purpose is for art and posterity. Yes, I have also addressed my own troubles within the work, but now *my* feelings must be set aside. I require honest appraisal.'

He proceeds, taking the poet-monk by the arm and averting his own eyes, as they process forwards like a pair in a three legged race – the taller, frailer partner rather more leaning upon his unsighted companion, than leading him.

The robed gentlemen approach the Lalique doors. Jacques fully opens both leaves back towards them as they leave the vestibule. Trembling with emotion, the host leads his companion over the threshold, into the principal salon of the Studio and falteringly towards the ebony bureau to the left. A cornucopia of treasures completes Jacques' field of vision, and he finally focuses on the open view to the Persian Chamber beyond, with its large angular

bronze bust by Ossip Zadkine, guarding the entrance arch. They shuffle forward in their awkward two-step.

The master is momentarily comforted by how well the expectation projected by the entrance sequence is fully realised. His excitement rises at the thought of his visitor's imminent enjoyment.

Inside the Persian Chamber, Jacques guides his guest ever closer to the back wall and fireplace, around the gleaming lacquered table with its Buddhist inspired lotus stem legs. He smiles at the swing of the jaunty tassels and ambers, disapproved of by the table's designer, Eileen Gray, but which he had so vehemently insisted upon. *I would have my Buddhist elements,* he recalls thankfully.

Max is brought to stillness, with head bowed at the far end of the Persian Chamber. He waits patiently. Jacques pauses and whips away the eye cover, eager to see the reactions of this most sensitive man.

Max's eyes open to see, first of all, Death there at his feet – in the grate, in the shape of a small brown bird. He stoops to look closer. He is perplexed. *Surely nothing to do with the cage? A prank?*

'What kind of auspice is this?' Jacques broods dejectedly. 'Indeed it has to be one.'

'Surely it has flown in from the garden and struck its head.'

'No, no! It has come down the chimney of course. Yes indeed, poor thing.' Jacques bends down and snatches it up in his effort to stay balanced. His pulse quickens, the drama of death both taunts and enlivens him and both men are suddenly alert to nature's creeping fingers, here inside this master's own steely fortress. He awkwardly wraps the little body in a handkerchief and carries it, clutching it between his fingers, obscuring its continued presence and still grieved at the macabre find.

Max lifts his head and he sees the reflection of Picasso's harlots in the over-mantel mirror. Unnerved, he says nothing, turning to find himself in the Persian Chamber, a room of exoticism.

Meanwhile the host's mind is suddenly taken over by a matter plaguing him more and more, so much so that even he ceases to closely study the finished Studio for some moments. 'I'm afraid

Mme Doucet is still not reconciled with the painting, and doubtless even less to this over here,' pointing to a shrine in a niche in the side wall. But while I'm in need of peace, more than ever I have an agonising difficulty. What shall be done with this Studio now that it is finished? I mean, after my time? Here is the residue of my life's work and wealth. Do I bequeath it to the state, the university or the public realm, or simply leave it to my wife?'

Max is shocked, not least because there amid the many wonderful oriental art treasures the niche appears to be a holy shrine. It seems to read as Buddhist but he cannot at first put a finger on why. *Is it a nod to his former life as a couturier?* he wonders. Then it suddenly dawns on him.

Before a beautiful midnight blue glowing lacquered panel, is a beetlish black beaded gown, on a dressmaker's dummy. The shimmering style is very much reminiscent of the late Mme Roux. There are little shelves behind, bearing candles with new wicks. Upon one shelf is a silver framed photo of the same Mme R. with black feathers arranged around it, and on another, a granite raven with giant eyes – the same sculpture once kept in the Doucet library.

Max gasps in recognition. 'It's Sonia ... No. No? What on earth ... Well my friend, it is truly difficult ...'

'But she...' Jacques interjects, not wanting to hear a negative.

'While you have reliquary like this? All chance of reconciliation ... and to bequeath this to your wife, you must definitely remove this eulogy to Madame Sonia. Indeed before you let Jeanne in here! I take it she hasn't seen it?'

'My wife doesn't come inside...'

'She will at some point. But tell me, what exactly is going on here?'

'The panel is sacred to me. The original Japanese lacquer with its inlayed mother-of-pearl lotus bloom is a nod to Eileen Gray's *Om Mani Padme Hum,* also called *The Magician of the Night.*'

'And the Tigers' name for you, if I'm not mistaken?'

'Hmm ... the Sanskrit word for lotus is *Padme.* The lotus is a fundamental symbol in Buddhism – the beautiful flower that grows

in the filth. It symbolises the notion that we can transcend our suffering. The jewel *Mani* is the enlightened mind.'

Max is astonished at how Eastern Jacques' thinking has become. 'But ... but ... you call it the Persian Chamber?'

'Persia was the origin of many of these vases. And, I might add, Sonia's father was an archaeologist specialising in Persian Buddhism – popular there prior to its suppression in the previous millennium. Besides, I could scarcely call it the *Salon de Madame Sonia,* could I now...? And, I confess, it is also a *hommage.*'

'So this room is a shrine to Sonia and to Buddhism? You cannot do this, Monsieur Jacques. Not only will you never reconcile with Mme Doucet – you may not do so with your Maker.'

The elderly man is crestfallen but unmoved in his conviction. He nods at the honest response, but wonders how this could possibly be fair judgement. While he has scant regard for notions of God he does worry about Jeanne. *Perhaps an adjustment is necessary?*

Max glances around at the untold riches before him. 'In any case, how does this accumulation of fabulous luxury correspond with your Buddhist ideals?'

'I have little to concern me there. As you know the vast bulk of my worldly wealth was expended on libraries, which I have since donated to the common cause. This installation could go the same way, if it can be guaranteed that it will not be dismantled ... just so long as I can be sure that Jeanne is properly provided for.'

'Do you mean, allow it remain as a museum? Or donate it to a museum?'

'It isn't so simple, Max. Don't you see? The Louvre will be taking Rousseau's *Snake Charmer* but will not touch the Picasso. While another museum *could* have *Les Demoiselles,* it could not have the *Snake Charmer?* It is an excruciating predicament. Of course Buddhism encourages me to feel I might give everything away, but Jeanne will have her needs. This collection is what now remains of my wealth and my mission. You see, its value for me resides in the collection *in its entirety* – its meaning, its completeness. It seems

that after my time, the major achievement of my life will be broken up and scattered forth.'

Max stands behind the Lotus table gazing back to *Picasso's Brothel* positioned on the end wall in the far distance. 'What would your wife do with the painting that offends her so grievously?'

'She'll probably send it to the salerooms as she once tried to do.'

'To whomsoever you bequeath it, a codicil could stipulate that the collection will never be dismantled.'

'But the Rousseau is pledged to the Louvre.'

Jacques steers Max into the next chamber – the central salon, or nave as he sometimes calls it – with *Les Demoiselles* now looming ever closer on the vestibule wall ahead. Glancing round, their eyes are greeted by myriad materials – sumptuous handmade rugs, furs, lacquer, ivory, tortoiseshell, crystal, *galuchat,* exotic woods, leathers, mohair, silk, parchment and many square metres of oil on canvas. Modernist paintings, furniture, glass, sculpture, ceramics, fabrics and *objets d'art* combine to engender a transcendent air, and one of increasing opulence but also engendering further explorations, elevating art to a higher plateau. The whole ensemble of modern and non-European art reflects Jacques' taste as guided by Breton and his fellow advisors, and developed over many years, displaying works created by almost all the leading young artists and artisans of the era.

The two men creep forward, ogling each treasure with veneration. Dominating this principal salon is the said imposing work by the Douanier Rousseau, *La Charmeuse de serpents* of 1907 – set in its own purpose-designed niche. 'You obviously know this verdant gem, my friend?'

Max nods, 'Of course. How firmly is this committed to the Louvre?'

'I doubt that it is enforceable in a court of law, but as a matter of honour, I could scarcely breach my promise to Mme Delaunay. It was a condition of purchase and to renege would be a betrayal.'

'Have you asked Robert and Sonia Delaunay?'

'No, and in all conscience, nor can I.'

'Therefore you really do need the Louvre to take the Picasso also?'

'Not a chance. If they would, they could have the lot.'

They both gaze into the Rousseau jungle. 'I have installed it just as originally conceived in my warehouse model, with the same red gondola sofa below it. See the exotically carved arms. I commissioned it from another *arts décoratifs* virtuoso, Marcel Coard. You must know him?' But Max is not sure. 'And the associated furs, how they spill into the room? That was a touch of mine.' His face lights with pleasure at his own artistry. 'My plan from the warehouse bore this fruit. We mimicked Rousseau's latest and largest work *Le Rêve.* Are you familiar with that one, Max?'

'Another female snake charmer in the jungle?'

'Exactly. And reclining upon a scarlet sofa is the Douanier's love, the naked Yadwigha!'

'And the *Dream* title alludes to Surrealism,' adds Max, knowingly.

'So I hope does this.' Jacques gestures to his precious arrangement. 'For Rousseau, dreams dictated this scene. His woman, his muse, falls asleep on a sofa. Her slumbering visions transport her into the heart of the forest upon hearing the charmer's pipe...'

'Unless it was based on the Douanier's own dream? You know, *Portrait de Yadwigha* was hanging in Pablo's studio on the evening of the Rousseau banquet...? I can still see the inebriated Marie Laurencin languished on the sofa, in front of the old boy, amid the jellies and desserts. Perhaps it triggered the whole thing?'

'Humm? I think it may have done.'

'But we can never really know.'

'I also had a dream a little like it,' Jacques mutters quietly.

'What was that?'

The host quietens, transported for a moment to the vaults of the Trocadéro – there, so long ago, seemingly yesterday, *she,* his own dear love and muse, had materialised before him, darkly naked, as an exotic snake charmer.

Max wanders around, one hand on his hip, the other tapping his bare head in a thoughtful gesture. 'I fully applaud that you have extended the drama outwards from the painting, with the furs and

the rugs as a major feature of the salon. It works magnificently. The jungle of the Rousseau merges with all of these exotic fabrics. Or at least you have brought the two worlds together.'

Jacques quakes with pleasure at such praise, but then adds with a tinge of sadness, 'I feel that this particular ensemble is one of the few aspects that Jeanne might find appealing as an inheritance, yet it is tied up with a bequest to the Louvre... Ho hum.' Jacques steeples his fingers in a pensive gesture, awkwardly retaining the tiny wrapped bird. 'Like the Picasso, this is quite indispensable to the Studio. Both are central to everything – perhaps of our whole era. Only time will tell of course,' he meditates.

Max remembers Breton's words about a viable cultural movement, rating these two artists above all others. 'Yet Pablo is an enigma to advocates of Surrealism – never signing manifestos or numbering himself among their ranks; but perhaps he opened up the domain, which they call their own? Rousseau too. Some say giving Surrealism its birth certificate!'

'Inadvertently, and in a different way perhaps?' says Jacques.

Max smiles.

'I have adopted three elements to temper the toxic resonance of *Picasso's Brothel.* In Buddhism the three poisons of fundamental darkness embody our own deluded impulses: Ignorance, Attachment and Aversion – or Fear, Greed and Anger – if you will. They are represented by the pig, the cock, and the snake. So you see, here is the charmer's *snake* of course, the Persian Chamber walls are of *pig-skin* and Sonia's raven emblemises the *cock*.'

The Christian monk shuffles, apparently discomforted. 'And how does that relate to the painting?'

'Now we are getting to the heart of it. Picasso is not averse to using objects for their spiritual resonance, yes? Harnessing their forces, as it were, and thereby gaining energy for compositions. He has done it with *The Brothel* too, of course, incorporating African masks – demons that ward off dangerous spirits, and so on. So you see, I am doing the same. I have found that some works of art can drive

demons away for me also. Even the pigskin walls have a role to play.'

Max struggles to hide his puzzlement and silently mouths, 'pigskin?'

'Come over here, Max. Don't let's neglect this little corner.' He ushers him to a robust desk in ebony with bold curves and angles, African inspired feet and garniture, and a writing surface inlayed with polished *galuchat.* 'It is primitivism recast.' The Pierre Legrain desk is placed before a group of paintings dominated by Giorgio de Chirico's large Surrealist oil, *Il Ritornante.* 'I believe this image is one that is central to Surrealism's very being.'

'Well, you of all people would know, monsieur.'

'I feel I drew close to the very essence of Surrealism, juggling layers of reality and illusion – the dream-state and consciousness. Indeed, I attempted to make Surrealist qualities central to every-thing – the reciprocity of space and solidity. I mean, the real space, the Ensemble here in the salon, and denial of space in the pictures – establishing the psychic tension.'

Max nods, attempting full understanding.

Jacques' face twists into a frown, recalling the post-War period when, following an initial resistance, he endured a sobering initiation. *How those Young Tigers teased and poked me up into a new way of being, making me alive to such radical new twists in modern art,* he twitters under his breath, momentarily oblivious to his staring guest.

'But have I done justice to all this fervid creativity? Have I resolved it? Is the future captured ...' and adds with almost a shriek, 'have I succeeded, Max?'

'Of course. Of course you have. De Chirico was pivotal to Breton's thinking, I understand...'

'Though I'm not sure now that *I* truly grasped it?' Jacques drifts into worried anticipation, cranking up to his oft visited subject once more. 'About the Picasso. We are on the threshold now,' he steps sideways suddenly. 'Over here ...'

'But, Monsieur, each artist in turn? Surely, yes?' Max steadies him, steering the patron back to their point of focus.

So Jacques quietens and concurs immediately, remembering other important works not yet seen. They study the de Chirico canvas once more, which features a balding Oriental man with a moustache and chin puff, closed eyes and defiantly crossed arms. He stands erect, in a flesh-toned garment that transmutes into a fluted column, mysteriously melting with the skin of his torso.

'What can one make of this articulated, armless puppet with architectural implements sprouting from where one might usually find a head?' Max mutters, patting and stroking again the back of his bald pate, drinking in the image as its impression makes impact.

'The standing figure is a blend of the artist's father and the Emperor Napoleon III – according to Breton,' Jacques pauses for breath. 'When I bought it in '25, at his urging, he told me that De Chirico is the Picasso of tomorrow! We shall see.... or perhaps I should say Jeanne or the museum will?' But he gabbles on in his own mind, *Jeanne or the museums? Which is it to be? Where will it all go?*

Max looks at him sharply, searching for words.

As the master's attention shifts upwards, Max follows his gaze to the extraordinary Aztec ceiling, lacquered in black and crimson by the Belgian stage and film set designer René Moulaert. Nor can Max help noticing walls panelled in a gold-tinted complexion of parchment marquetry, laid to a giant herringbone pattern; glancing around further he finds delight in the palette of luxurious furs, the light beige velvet pile carpet underfoot and a range of exotic surfaces – an ambience in striking contrast to the Persian Chamber and upper and lower vestibules.

Two full-height windows have been fitted with lacquered shutters, meticulously crafted by Jozef Hecht. An array of jaggedly patterned skylights provides natural and electric light using the most advanced science. The illumination is completed with banks of soffit downlights and recessed versions at the eaves.

'Moulaert's ceiling provokes our fascination with light, do you not think?' Jacques questions. Still clutching the dead bird in his hand, he laboriously draws a translucent silk curtain across the windows,

with his one free hand, eliminating the bright sunshine to transform the mood with a subtle warm, strawberry glow. 'This is my celestial cave, Max.'

'Quite delicious,' is the monk's encouraging reply.

All at once Jacques is overtired from all the exertion. He rasps. Alert to his discomfort, Max darts across the room to fetch a heavy curved stool for him. It is of highly polished and encrusted hardwood, based upon a Ghanaian tribal throne. 'Thanks once again to Legrain,' Jacques coughs, bashful of how catarrhal he has become, 'the original stools shaped in this way often had human skulls as bases. We couldn't ... of course.'

'Indeed not,' Max looks again with concern at his former patron, who struggles so greatly. 'But rest one moment, Monsieur Jacques.' Max insists, patting his shoulder.

'Ahem! Ahem! Ahem!' the coughing persists. The master grimaces, pained at spoiling Max's initial impressions with these splutterings. Gradually the attack subsides.

From their position, the robed viewers enjoy the benefit of an exceptional vista. The installation, precisely executed in every particular, delivers through the open crystal doors, the framing in clear sight of *Picasso's Brothel,* on the end wall of the vestibule beyond. Jacques gestures towards the painting. 'There! I have positioned it as a sort of *secular-sacred* version of a cathedral's great east window. The fractured shards resemble ... harrumph ... small fragments of stained glass. I shall be able to open and close the doors at will, when I wish to reflect upon it.'

'Just so my friend.'

'Imagine what Sonia would have thought of it?' She might have deemed it all vainglorious...' Jacques speculates, self-deprecatingly. 'Has it been worthwhile?'

'I hope it has, Monsieur Jacques.'

'If only Joubin could have found her archives...' He drags himself across to close the Lalique doors. 'Come, Max, sit. We'll see it properly in a moment.' He ushers him to the Coard sofa.

From this new position they shift their attention to the Matisse, *Poissons rouges et palette,* directly opposite.

'Well here is Henri's Artist with Goldfish. You may know it?'

'A bowl with discrete slithers of colour,' Max struggles to make out more, 'No, I don't, in fact.'

'It's a rigorous and icy abstraction, a geometric composition, don't you think? – with the tranquil beings providing a fine motif for movement through space.'

Max cocks his head, 'Painted when?'

'It's a post-Cubist masterpiece, painted eight years after Picasso's bombshell of 1907.'

'And with naïve simplicity.'

'Only the fish bowl, a dying plant, grapefruit and an artist's palette articulate a notion of *the Universal* as seen through a single moment. You see the three environments – the outside sky, inside the room, and within the bowl. Layers through which the basic facts progress,' explains Jacques, gesticulating enthusiastically. 'Like the colouring – the red of two fish, to the yellow of the fruit, a smidgen of green in the plant, the blue sky, back to the interior and a blue-black wall, before finally completing the cycle with the white fish bowl.'

Jacques' eloquence regarding his art rings in Max's head – such erudition not really apparent before now.

'And it is anything but a *still-life,*' Jacques continues, 'for the fish provide perpetual movement!'

'Yes. I was amused by that too.'

Isn't it extraordinary how far Matisse has travelled, since his bitter dislike of *Picasso's Brothel?*' Jacques notes, to which Max just smiles.

'While this is anything but *charming,* it generates a philosophical power. So the bowl is set on the simple table between two windows, which is why I have hung it between my own two windows.' The weary connoisseur pauses for breath, gripping his shaking knees and stifling coughs. 'See how it faces Rousseau's life-engendering jungle scene as an *oppositional.* Like 'death tapping on the window.' Jacques forgets that Max knows nothing of his secret nod to Picasso's

Three Dancers, also set against a painted window, and fails to notice the monk's expressive eyebrows – a picture of perplexity.

'Now you will definitely recognise this,' says Jacques, excitedly, ushering him to a small drawing from 1904, exotically framed by Rose Adler, bearing the artist's inscription, prominently across the top: PORTRAIT OF PICASSO FOR MAX JACOB. A great smile breaks over Max's face. It is a moment of rosy warmth, occurring just as the two men draw near the summit of Jacques' obsession.

Their bejewelled route has returned them to the upper vestibule and to René Lalique's glazed doors, which Jacques had previously closed for effect, concealing the major picture opposite. The frames of silvered-bronze house two columns of horizontal crystal panels, depicting foliage and high relief classically-styled naked male athletes in suggestive sporting poses. 'Goodness me, an aperture of sin. I thought I was past all this?' comments Max.

Jacques pushes each door back with his one free hand and they confront the looming *pièce de résistance.* Gazing ahead at the five prostitutes, now close enough to fill their field of vision, both men fall silent. Jacques feels suddenly alone. His eyes flit uneasily from face to face, around the canvas, the dark, lopsided eyes of the Picassoesque central figure eventually fix him with a gimlet stare. Eerily, the face resembles the painter staring back at him, defiant in his moment of creation. When he looks back to Max's face, he reads discomfort, but quips, 'I have restrained it, but not as severely as in our lead-cladding escapade, ha!' pointing to Csaky's balustrading which creates a cage-like effect around the painting.

Max's eyes are diverted to the adjacent Buddha, bought at the auction with Charles Vignier. The statue now guards the painting, as a sentry in an elaborate, top-lit niche beside the great work. The sacred Sui Dynasty figure is dressed in a tight canonical garment, forming subtle pleats that contrast with the stylised head. Mounted on lotus blossoms, it is raised upon a carved column. At thirteen hundred years of age it is not surprising the white marble has acquired a bronze-like patina.

'But my friend, you are meddling with dangerous forces. What on earth are you doing? Oh lor! For pity's sake get the big painting out of here! You've put a *Buddha* next to it...'

'There are many Buddhist elements here.'

'But pigskin walls in the Persian Chamber?'

'Intentionally, Max. As I have said.'

'Pigskin. No. You *cannot* do such a thing! This is a sacred object,' referring to the painting. 'Not religious, but irreligious in its own way. I cannot believe ... I'm sorry. I have held back, perhaps wrongly, but this is a step too far. What are you hoping for? Reincarnation? Isn't that what Buddhism promises?' Max's usual calm has left him and his objections have become a tirade.

In his dismay, Jacques does not feel qualified to answer. He looks down at the lifeless bunch of feathers in his hand. 'How sacred? In what way?' he quakes, referring to the painting.

'That is not for me to say, but I tell you it is a religious statement in its way! Too powerful. And surely you should be concerned with your own path. This is not the way forward if you are to receive absolution. How will you make amends? How will you explain to St Peter...? I advise you now before it is too late, and as your friend and religious counsel, if you will. You are a good man and I would wish that you could be received by God's holy angels when the time comes...'

Jacques attempts to interject but is cut off.

'I have said too much. I'm sorry, Monsieur Jacques. But now is the time to consider your future. There I have said it. I have always tried to serve you well.'

Max, clearly distressed, dashes down the silvery staircase, eyes continually glancing back to the painting above. He makes his rapid exit, robes flapping behind him as he vanishes through the garden door, leaving Jacques afraid that this first visit has been a fiasco.

He clambers pathetically, a short way down the stairs after him, promptly realising that he must not move too far, or too quickly. 'Max – Cyprien. My friend...' he cries.

Righting himself for breath for a few moments, he then returns with some effort to review the canvas. He has a ridiculous fancy that his painted ladies will escape and come and torture him at night. *How those women have bullied me. I was right about them not being fit to be in the main ensemble.* He turns and mounts the top steps heavily and then ruminates, eyes askance, stroking his snowy beard, gazing in confusion. *Here they are, basking in the glory of their power!*

Clutching the Buddha's plinth, in one hand, and the dead bird in the other, Jacques glances around trying to recompose himself. He is determined not to allow the upset with Max to spoil his task at hand. He vows to continue his appraisal, pushing the negative occurrence to the back of his mind. It seems it is time to take charge and consider the cool environment of the upper vestibule and focus on something else.

A pallid floor of plate-glass sheets, laid to a geometric pattern is surrounded by pastel-green walls. Three paintings hang opposite the solid Buddha. Flanking Francis Picabia's diaphanous *Transparency Dimension Quatrième (Fourth Dimension)* are two oils: *Pailles et cure-Dents (Straws and Toothpicks),* also by Picabia, with mixed media, and *Passage* by Joan Miró.

The airiness of the mystic vision, *Fourth Dimension,* is echoed in the large *air-hole* perforations of Legrain's wide aluminium frame. The composite vaporous image, in watery pastel shades, alludes to sexual ambiguity in a dream state; a mysterious male appears with his arms around a ram, his legs intertwined with those of a sexually provocative Spanish female. *What might the ace of spades signify, interposed between man and ram?* Jacques puzzles, not for the first time. Around the group a swirling vaporous fabric flows, to tie the group as it floats against a liquid sky. The greenish-blues of the vestibule are balmy, but not entirely soothing to him.

Below these pictures stands a precious side table, designed by Jean-Charles Moreux, in ebony, clad in *galuchat* and ivory, with crystal glass feet.

He notes with passing approval the splendour of the handmade woollen rug on the floor, relating to the red sky in Miró's *Passage* hanging on the wall above. It is a Jean Lurçat design – a strong and colourful abstract work, predominantly of an aqueous-lime green, accented with crimson.

'Balanced well enough,' he mutters, but remains distracted, still perfectly appalled by Max's hostility. Jacques is inevitably drawn back to the Picasso. He faces it once more. *Is this really it then? It has been an interminable odyssey to reach this juncture. I thought I had defeated it.*

The troublesome *chef-d'oeuvre* is set in Legrain's polished, steel frame, fitting precisely between the deep steel skirting boards and wide curved cornicing at the top – all designed for this very purpose. Its great size and stirring subject matter creates an inescapable impact upon his space, upon the room itself.

Jacques stares, focusing on the artist's manipulation of spatial depth. *... My expectations of traditional narrative art are reversed. Why, the effect is so striking. Even with the space around them and banishment to above the stairwell, these tyrant women still rudely burst forth at me. As one woman draws back the curtains with her foreshortened arm, she heralds the arrival of the others into my space. Simultaneously, I am barred from entering the picture's own space. There is no space! Even during the mock-up stage, they were quite misplaced as a centrepiece for the salon.* He mutters, feeling suddenly that he cannot breathe. *It is little wonder Jeanne railed against it altogether!*

Jacques observes that the women share neither a common space nor a common action. *The outward staring eyes communicate not with one another but directly with me, the spectator, just like the whores of Pigalle ... Picasso incites me!*

The whole composition is impaled upon the sharp point of the corner of the tilted table top, at the bottom of the picture, laden as it is with *genitalian* fruit and a blade-like melon slice. This table, like a see-saw on a fulcrum, serves to link the viewer's world with

that depicted on the canvas. *It is all wonky. I am made to feel wonky.*

He is glad that the dangerous women are corralled by the stairs and balustrade. Visually, they burst in from whence entry into the rooms is expected.

Yes! Yes! muses Jacques, calming himself, *I believe it works, architecturally at least. The drama is accentuated. But it is well I have restrained them with Csaky's exotic fencing, penning them in and holding them at bay... Now they surely cannot overwhelm the works to follow? What is more, despite Cyprien's qualms, further moderation is attained by the presence of the Buddha.*

While viewing the sacred figure Jacques ponders the power of icons over the human psyche. He stares at the statue – the guardian he has entrusted with a task of maintaining balance. As he pats the arm of the Shakyamuni effigy, he considers that idolatry was far indeed from the intention of the man it represented. He is moved to recall the two-thousand-year-ago story.

Shakyamuni Buddha was brought up as Prince Siddhartha Gautama and was completely shielded from worldly pains. Upon reaching adulthood, he was stricken to discover the unavoidable sufferings of the people – birth, old age, sickness and death. He renounced his great riches and title, devoting himself to finding a solution to suffering. He first followed a line of reasoning that all desire for transient experience and material objects led to misery and was hence futile. So the young man forsook all such desires and physical objects – but he found life without them solved nothing.

He resolved to live more moderately and pioneered new ideas and teachings, finally developing the Universal Law of the Lotus Sutra. In this he saw the Universe as being governed by the law of cause and effect. The Buddha averred that by proclaiming these mystic laws one could summon up Buddhahood *– a state of perfect enlightenment – in which life becomes as if lived in an internal palace, not a cure-all but a key by means of which to escape the cage door of suffering.*

Jacques ruminates, hardly wishing to acknowledge his despair. He

understands the story and feels the presence of the Buddha there in the statue, not as a physical shape but as a treasure box of mind and thought. He wrestles with his dilemmas.

For Christians, like Max and indeed, my own wife, we are all sinners. For a Buddhist Sympathiser, among whom I must be counted, I can scarcely see that I could ever achieve Shakyamuni's Buddhahood. All of this material wealth surely flies in the face of it?

Alongside the effigy a discrete door gives access, via the corridor to the master's bedroom and bathroom in the main villa, affording him a direct route from his personal quarters to this private jewel box and field of contemplation. In these days of anxiety it is along this special pathway he takes to scurrying, at any hour of day or night, much to Jeanne's consternation.

Once again, Jacques is drawn to *Les Demoiselles* and sighs. *They may be contained but ...* he torments himself, *what lies behind this painting of five jagged prostitutes? Did Sonia have a unique understanding, that has eluded all others? Despite my efforts here, as a riposte to Picasso himself, the Louvre, my own wife and all those doubting me, the undertaking has not resolved these issues. Despite all this great splendour, I am deprived of serenity in my twilight days.*

His sudden urge is to contact the artist himself. He ambles back through the sequence, closing the Lalique doors with his free hand in order that he may concentrate.

He returns to his desk, reaching to the adjacent drawers in a tiny *galuchat*-clad cabinet created by Legrain. He lays down the bundle of feathers, takes out a sheaf of paper and begins to write in his small, neat calligraphic hand, with elegantly, elongated, looped ascenders and descenders, not without the occasional flourish, revealing perhaps a latent flamboyancy.

He tears up his first attempt and pauses to contemplate a list of questions he would dearly like to raise with Picasso.

- *Why did you, who could paint like Raphael, produce this crude and wanton rendering?*

- *Was it Max's occult practices or the suicide of Carles that caused the Blue Period and so many morbid images of Carles?*
- *Was Sonia involved?*
- *How important was Baudelaire – and the prostitute … 'beauty which comes from natural sin'?*
- *Early sketches show a sailor inside the brothel, with a doctor carrying a skull. Why were they eliminated?*
- *Did you include likenesses of Fernande, Marie Laurencin, yourself or others?*
- *Were the faces of the Louvre's Iberian stone heads worked into the painting?*
- *Was The Brothel a response to El Greco's painting?*
- *What happened to make you blacken the curtain holder's face and give others grotesque masks?*
- *What happened at the Trocadéro?*
- *Was it an exorcism painting?*

Looking directly ahead, Jacques is drawn to his own compositional clusters either side of the Lalique doors. Two female portraits in oils balance one another: Marie Laurencin's *Jeune femme au chat et au chien (Girl with Cat and Dog)* on the right, and Amedeo Modigliani's *La Blouse rose (the Pink Blouse)* on the left. Each painting is the main feature in a group of pictures and sculpture, thereby serving the dual purpose of being the point around which a group is established, and forming a symmetrical arrangement adding force to the two end corners of the salon.

Returning to the letter, and with renewed focus, Jacques begins again with a fresh sheet.

My Dear Picasso …

He stalls, realising the futility of asking questions or even describing anything of the Studio, concluding it will be impossible to interest him with descriptions of the project, about which Picasso had been

so scathing at their meeting. He yearns to mention the *Shakyamuni Buddha* standing alongside *Les Demoiselles,* but is fearful of being misunderstood.

Suddenly, Jeanne's voice carries from the vestibule below. She calls up to her husband, 'Jacques, are you there...? Monsieur Joubin from the Sorbonne is on the telephone.'

'I won't be a moment ... better still, say I'll call back would you, my dear? I just need to quickly finish this.' He glances across to the paintings to his left, which include works by Picasso, Braque and de Chirico and then back to the blank sheet. He decides to truncate his message.

My Dear Picasso,

I am pretty much settled in Saint-James. There are a few of your children who would be happy to see you.
Choose your day and time. It has been quite a long time since we last saw each other. It's already a little in the past. But fondness is always faithful. It will be a pleasure for me to see you again.

— Jacques Doucet.

He folds the letter and seals it in an envelope. Noticing the prone sparrow half swaddled in the handkerchief, he picks up saying, 'Come little bird let's find you a final resting place.' Cradling the tiny corpse in one palm, he gets to his feet and begins retracing his steps back outside – but firstly, opening with one hand, each of the Lalique doors, revealing again *Les Demoiselles d'Avignon.*

21

*Life is really simple, but we insist on making it
complicated.* — **Confucius**

JACQUES LIFTS the receiver of his new cradle phone with
trepidation and dials the number for the Bibliothèque d'Art et
d'Archéologie. He requests connection to the director's office.

'André, how do you do? And the department ... all going nicely, I
hope?' he questions as cheerfully as he can muster.

'Oh, tickety-boo, as they say nowadays. And Jacques, I trust you
are well and fully recovered?'

'Indeed so ... indeed.'

'Not too overrun with visitors then? There's some curiosity about
this so-called Jewel Box of yours?' Joubin asks.

'I've just finished appraising the completed Studio in fact... You
will have to come... But I've been hoping that you might call with
some news for me André?'

'I'm pleased to tell you, we have located your archive.'

'Does it pertain to...' lowering his voice as Jeanne is on the other
side of the room, 'Madame R?'

'Exactly so.'

'And what's in it? Don't keep me in suspense, André. What's in it?'

'There are two boxes marked Mme S. Roux ... containing a few
books, some loose papers and bits and pieces.'

'The books and papers...? Have you examined them?' Jacques
urgently demands to know.

'No, I have thrown my eye over it, but not really. When can you
come and see it for yourself?'

'Let's say within the hour. Will that suit...?'

Jacques sends instructions for Chivet to ready the car, while he changes out of his robe, and throws on a wildly fashionable raccoon coat in the style of Rodolfo Valentino. He bridles at his own image in the cheval mirror. *Can I carry off this at my age? Would Sonia have liked it?* He sweeps out of the house, hands firmly planted in the deep lined pockets.

He arrives at the Sorbonne not long after the stated time. Bursting with anticipation, Jacques strides into the director's office of his own former art library.

'You see, André, you cannot keep me away.'

'It's grand to see you, Jacques. You *are* looking well,' he lies kindly, sensing a sorry condition rather masked by style. 'Over here, monsieur.' Joubin leads him to a side table. Jacques hesitates at the moment of revelation, barely checking his ardour. At last, he most carefully lifts the lid of the first box to espy its contents, and arranges them neatly on the table. Several text books, including a dictionary of archaeology, are embossed with the titles: *Application of the Mosaic system of Chronology in the Elucidation of Mysteries Pertaining to the Bible in Stone,* by E. B. Latch; *A Handbook of Egyptian Religion,* by A. Erman; *Explorations in the Valley of the Kings;* a workbook (mostly blank), with a few pages of almost illegible notes; a purse containing a small quantity of francs and centimes in coins; a lacquered ladies hairbrush and comb. The second box contains more archaeology books.

'We have all these editions in the library,' Joubin informs Jacques. 'So as far as we are concerned, they are unwanted.'

'In which case you will have no objection to my taking them?'

'Not in the least, they will otherwise be thrown out. I'll have a porter take them to your car.'

While this is being arranged, Jacques pours over the workbook squinting avidly at any readable notes. The whole experience sends a shriek of foreboding through his being, as he remembers the horror and nature of his loss. He is disappointed there is not more,

but the notebook looks to be fascinating, and the text books contain marginalia worthy of the closest examination.

Jacques replaces the items and turns to Joubin, 'I shall go over these forensically and hope for enlightenment.'

'Yes, now we have found them, you'll need to spend some time scrutinising the contents, I dare say.'

'Meantime, André, on an altogether separate matter, I have seen Gaston Sorbets, from *L'Illustration,* with a view to the magazine doing a special feature article on my Studio. I've received a number of approaches, but want to restrict coverage to just one publication.'

'Editor, isn't he?'

'Editor-in-chief, and André, I've suggested, he should commission you to write the article. What do you say, my friend?'

'*L'Illustration?* Is it the best organ for your purpose?'

'Who else covers the arts, home and international affairs with such fine photography?'

'Full colour will be crucial, I suppose.'

'It will be perfect for them, no?'

'I'll have to come and see, and familiarise myself with the whole thing,' says the librarian.

'Absolutely. I'll ask Sorbets to make the arrangements. And be sure to press for a respectable fee, André. It is not *just* as a favour to me.'

A porter arrives to collect the boxes. Determined not to let them leave his sight, Jacques escorts him to the car where his chauffeur is waiting. Chivet is frowning at the sight of a woebegone old woman at the foot of some railings, crouching with her palms outstretched. Reminded of Picasso's emaciated blue paupers, Jacques approaches the withered person, who trembles pathetically; he unfurls the warm coat from his shoulders and carefully circles it around hers.

'May the Lord be with you, monsieur,' she utters.

Chivet shrugs in disdain as he loads the boxes and returns to his station behind the wheel of the Panhard.

At home, thoughts of Sonia and the more recent dealings with

her husband consume Jacques' fevered brain. Roux's stay in the hostel had lasted just two months. He was void of further useful information and once his health had recovered sufficiently, he had chosen to move on. This suits Jacques, his squeamish sponsor, who wishes to expend no further emotional energy on the unfortunate creature. Being rid of him altogether is a relief and so with a little further expenditure, he has financed his emigration to Quebec – a destination that could not be too distant.

Having brought the boxes to his study, Jacques is finding the items recovered impossible to read – including text books annotated with extensive notes in Sonia's own spindly hand. There are folded sheets of *demi-raisin* marked with scribblings on obscure archaeological matters. One sheet has the penned outline of a person's hand placed on the page. Its upward palm is annotated with crease-lines and symbols. He handles the hallowed parchment very gingerly. *Here is a place once touched by my adored girl!*

Proceeding to decant the contents onto his desk he suddenly discovers some scraps of glossy paper caught in the lid of the box – the photograph he had been to such lengths to procure for Sonia from Gelett Burgess. The colour leaches from his face as he painfully recognises the significance of the torn-up image of *Picasso's Brothel – God's Blood Roux! You must have meant this. You said "Demonic Pictures". You are a deranged devil! You said this before poisoning her... WHY in God's name, did I stupidly arrange for her to have such a photograph?* He condemns himself, turning the torn pieces in his hands. So shocked and grieved is he, at finding this most direct connection between Sonia's fatal tragedy, the painting and himself, Jacques is forced to retire to another room, where he pours a stiff drink and sends for an elixir of laudanum.

Later in the evening, having been assured of solitude he returns to scrutinise the boxes further. He is riveted at the sight of Mme Roux's daybook, and flicks ceaselessly through the many notes of archaeological stock, appearing in list form. On a single extra leaf, he is stirred to find reference to himself, J.D. Patron of the Arts,

carefully pencilled in grand filigree capitals. He gasps, *She scribed me into her world. How I am honoured!*

Examining another sheet of doodlings he makes an extraordinary find. Written at the edge of a slim margin, in a featherweight hand, is: 'Ateliers B L.' *surely Bateau-Lavoir?* He peers. The shorthand is unintelligible, with letters and initials dotted all over it, like a work of Pointillism. M J, P, F, K, M L.

It is most probably meaningless but...? Jacques mutters, fancying the scrawl pertains to people. He begins matching names to initials: *Max Jacob for M J and Picasso for P, which would imply Fernande as F and Marie Laurencin as M L?* he puzzles. *There are also foreign phrases, perhaps in Greek? C C Αύξουσα στον παράδεισο. What the devil is that, my ingenious Madame R?*

On the next page is written *M L & K – likely references to Marie Laurencin again and Kostro. It is not so difficult. She has daubed an incomplete diagram* of the Zodiac with notes, M – Sc. K – V, *with Greek letters of the alphabet.*

<p style="text-align:center">Το Ρ τιμωρεί το Κ με τον ποταμό</p>

This last entry is marked with a star, seeming to denote particular significance. Jacques hurries to his shelves, in search of a Greek dictionary. He sits a long time – enough to be seized by stiffness, after endlessly scanning for patterns in the strange alphabet. Finally he finds something that is a near translation of τιμωρεί. The closest sense indicates *punir* (to punish) inferring the meaning of Sonia's note to be *P to punish K.* The last word translates to *bordel* (brothel). *What the deuce?* he asks himself. *How could this be? Picasso punishing Kostro? How does 'brothel' apply?* he puzzles. *So much the best of friends – loyal and inseparable? Perhaps it's because he refused to validate Les Demoiselles?*

The line 'C C Αύξουσα στον Παράδεισο' seems to read as, C C ascending to Paradise? Surely young Casagemas – and therefore consistent with a Picasso painting of that very narrative?

Jacques stops and collects his thoughts. *Who can translate these*

properly for me? He puts a call through to Charles Vignier directly.

Far from solving anything, these proceedings have rekindled his grief. With the Studio finished he had a firm resolve to close the door on the past. Now his balance is skewed.

Remarkably, Vignier confirms that his approximate translation of the Greek text is roughly correct. Be that as it may, endless hours with the boxes have failed to provide answers. Jacques is tormented, distant and guilty. He cannot tell Jeanne of the cause or extent of his sleepless nights and vile dreams.

The amusing and patient listener, Brother Cyprien, is far off at Saint-Benoît-sur-Loire. *Perhaps I should make the journey to see him? And I can make my peace after our fractious parting in the Studio. Meanwhile, Poiret might have a view of Sonia's own brand of hieroglyphics. And of course he must see the Studio.*

Paul warmly congratulates Monsieur Jacques on, 'the creation that outshines all that is precious – moonstones, garnets, emeralds and rubies all.' He shakes the master's hand vigorously at the end of his great tour, declaring the achievement, 'a new and vast summit to strive for.' He is then asked to study the pages of Sonia's note-books. In fact Paul can decipher little, and though he ruminates on "punishment" it is to no avail.

'Chap, do you think it is worth speaking to Mme Olivier again?' Jacques implores.

'I will be seeing her next week. I can ask.'

Paul does so, and Fernande gladly visits Jacques. The master glows when she fulsomely praises the Studio, but he rather quickly moves her on to see the archive. She confirms positively that the outline of the hand belongs to someone else. Alas, she has nothing new to add but recommends discussion with Apollinaire's former mistress, Marie Laurencin, since the letters *M L* would surely pertain to her, especially appearing as they do in one instance as *M L & K.*

Jacques refers to Poiret again, seeking further assistance from his fellow couturier, who is actually related to Marie Laurencin. Paul invites his cousin-by-marriage to visit the Doucet Studio –

ostensibly for her to see how her painting, of a girl with a cat and a dog, has been afforded due prominence in the dazzling ensemble.

He welcomes her in his grand manner, as royally as he can muster. 'I think it is a fine representation of your style, my dear, in your pastel colours,' gushes Jacques, ushering in the well-proportioned woman with high cheek bones and large upturned eyes – quite a contrast with the rather spiky-looking lady with piercing eyes in her painting. Poiret, attending closely, feels a slight unease at the praise of pastel colours, having jettisoned such a palette in favour of bright and vivid combinations – his chief stylistic departure from *Chez Doucet.*

'Though not my most experimental, and modest compared to some other works in here,' Marie Laurencin says as she glances around the upper vestibule. She stands stock-still in front of *Picasso's Brothel.*

'You are familiar with this, I'm sure?'

'You know I had my first solo show in the same year when Pablo finished putting pigment onto this great thing...' She peruses it for a long time. 'It looks handsome – the way you have installed it. I did attempt a response you know. We all did.'

'Indeed.'

'Mine was with *The Young Women* in 1910, which some people call Cubist, and even say there is something of Georges Braques' *Houses at Estaque* in it... For me, I know better than to run a commentary on my own work ... others do it better.'

'Marie was a drawing student with Braques at Académie Humbert, don't you know?' Paul informs Jacques.

She had taken up with *la bande á Picasso,* and as Apollinaire's lover had enjoyed his favourable promotion, when he named her Our Lady of Cubism. While helpful, she had already won her artistic credentials – having embraced Sapphic neoclassicism – even before meeting the illustrious group at the Bateau-Lavoir.

'But I went my own way. I thought, why should I paint dead onions, fish and beer glasses ... girls are much prettier?

'Of course being listed as a Cubist, alongside Pablo and Georges... Well it is difficult for people to consider me as a *real* Cubist!'

'And there's no shame in having your own brand,' says Poiret – who appreciates Picasso's research and experimentation into Cubism, but not its influence in the work of the many followers, who have tried to adopt it as the new style in painting.

They venture into the central salon, and Marie is heartened to see that her *Jeune femme au chat et au chien* has been given pride of place as the principal picture surrounded by a group of smaller canvases and sculpture. Glancing across the array of great works of art, she appreciates that her canvas represents a beacon for her gender, displayed here as it is, in regal fashion.

'You remember we met at the *Maison Cubiste* before the War,' Jacques recalls. 'Marvellous show! Marvellous!'

'Not according to the general public. We were under attack the whole time. The hoards were bristling. I had to stand guard at the entrance with Charlotte Mare and Gaby Duchamp-Villon, fending them off with our umbrellas.'

'Nevertheless, *Maison Cubiste* did a good deal to promote the popularity of Cubist art,' he cajoles her.

Poiret privately recoils at glowing tributes made to the art form he wishes had not gained such ubiquity – despite knowing himself to have been a modest promoter of it too.

Turning round, Marie is immediately drawn to Rousseau's *Snake Charmer*. They walk over and stand before the masterpiece. Jacques wonders whether to mention her alleged antics at the Banquet, but hesitates. 'Now, my dear, we have this delectable table made by your cousin, André,' he says, taking her arm and directing her back towards the left-hand corner.

'Your brother-in-law also, isn't he, Chap?' Jacques staggers a little.

'Steady, monsieur. André Groult, yes of course,' chimes Paul.

As the master falteringly leads her, Marie observes that his body has become burdensome to him. She follows slowly and respect-fully, arriving at a small precious round table.

'I adore André's anthropomorphic shapes,' she says admiringly, 'a great animal lover, though rather lavish with the *galuchat* and ivory!'

'I wanted to ask you, my dear, did you know the spiritualist, Madame Roux, Madame Sonia Roux?'

'Yes, for a clairvoyant she seemed so very ordinary and nice.' Marie reconsiders this appraisal. 'But she had a powerful personality too. I met her a couple of times at the studios in Montmartre. She read my palm and told me my horoscope.'

'Yes, yes that's right. And she would do the Tarot too sometimes ...' encourages Jacques. 'I have something of hers I'd like to show you.'

'She was either very spiritual, or else could gussy up a story and beckon you anywhere at her whim,' Marie speculates.

Jacques invites Marie to take a seat at his ebony bureau to look at Sonia's archive material. Glancing up she is struck by the majesty of *Les Demoiselles,* now seen from a greater distance, filling the aperture of the opened doors.

Paul steps aside to take another look at the Persian Chamber behind them. From the threshold he gazes within.

Jacques turns to the matter in hand. 'Does this mean anything to you?' He passes Marie the sheet with Zodiac signs, pointing to the evidence. 'Notice there seems to be a connection with the Bateau-Lavoir.'

She peers intently, pausing for some time, her effervescent charm now silenced. Then she suddenly bursts out. 'Ah! That's it ... the *M – Sc.* and *K – V.* They are our Zodiac signs! I'm Scorpio and Kostro was Virgo.'

She pauses to scrutinize the cursive swirls, as Jacques frowns at the probably trivial note. *At least it confirms that K is Kostro.*

'She was correct about us. Apparently Scorpio and Virgo have poor compatibility and of course we went our separate ways, didn't we? It wasn't always easy being part of that circle. I used to pray that my mother wouldn't hear of the wild partying. Do you know, I had to be home by ten o'clock every night?' she chuckles.

'Now Marie, another sheet. Here is a hand. Could this be yours?'
But he sees at once that it is not.

'Sonia's own petite hand I would say.'

'One last thing, if I may...' Jacques flicks through the notebook
again. He refers her to the Greek notation, written in Sonia's hand:

Το Ρ τιμωρεί το Κ με τον ποταμό

'I've had this translated and the line appears to say *P punishes
K with The Brothel,* and the last word could be referring to *Les
Demoiselles...* Now if the *P* is Picasso and the *K* Kostro, can you
imagine what it represents? What is this *punishment?*'

She shakes her head. *'P is punishing K...?'*

'Pablo punishing Kostro?' he repeats.

'Never. They were like brothers in arms,' Marie protests.

'I wondered, was Pablo in dispute with Guillaume over the issue
of the stolen Iberian heads?'

'Surely not? If anything it would have been the other way around,
and it was Kostro's so-called secretary, that Géry Pierret fellow,
who stole them.' At the mere mention of this name Jacques feels a
horrid shiver through his being. 'Besides,' she points out, 'it couldn't
have been so. Mme Roux died before the theft became an issue.'

'Of course!' he exclaims, embarrassed by his obvious error.

'If anyone needed punishing it was their idiotic chum, André
Salmon, after ineptly alerting the authorities. Imagine, offering
those heads to the *Paris Journal* by way of returning them!'

'Quite so... But then we cannot explain why Picasso might have
been at odds with Kostro?'

As they leave the salon they pause before *Les Demoiselles* again.
For Jacques it is pleasing that she is not cowed or offended.

'Pablo used me as a model. Can you see which?'

The owner of the painting is dubious, not least because she doesn't
appear to know herself. Nor is she aware if Fernande, or any other
specific model or person appeared in the final picture – or during its
lengthy gestation.

'The Louvre will rue the day,' Paul muses, turning to Marie. 'The head curator rejected it – the most historic artefact he might ever be offered.'

'Really?'

'We tried, Chap, didn't we?!' exclaims Jacques.

'I struggle with Cubism, as you know, Monsieur Jacques, and with some of its progeny, but I understand why it belongs in a museum!'

'Surely,' Marie nods.

Paul remarks on the splendour of the Persian Chamber at the far end of the sequence, saying how joyously it reminded him of his *Thousand and Second Nights* party held before the War. 'There is nothing more exotic than the Persian theme.'

After further conversation and offering them many thanks, the host escorts the artist and couturier to the Panhard for Chivet to drive them home.

Following their departure, Jacques replaces the contents of the black boxes from the library and stops to examine the hair brush. He notices a single strand of jet black hair among the bristles. With a sensation blent of nostalgic longing and sorrow, he extracts the strand and places it on a sheet of white paper. On the desk is a small silver framed photograph of Sonia. He speaks softly to her image, *Why do you have to be so damned mysterious?*

He opens the frame and places the glossy black filament around the image of her face behind the glass, and reseals it. The single hair is only discernible upon close scrutiny.

Once the archive is carefully packed away, he suspends the search, frustrated by a lingering sense of mystery. An unpleasant spiritual tingle persists in respect of the failed endeavour. Having delved into Sonia's affairs, he now dwells heavily upon his own mortality. At the prospect of posthumous scrutiny of his own life one day, by all and sundry – not least of all by Jeanne – he decides to take action.

With discretion in mind Jacques instructs Bonnet to transfer all of the personal letters and papers from his study, to join other records and papers stored in the former porter's lodge beneath the Studio.

22

It is conventional to call 'monster' any blending of dissonant
elements. I call 'monster' every original inexhaustible
beauty. – **Alfred Jarry**

P ICASSO STANDS AT his easel, upon which a vividly col-
oured, almost abstract canvas, *Buste de femme et autoportrait
(Bust of Woman and Self portrait)* is nearing completion. He
remains expressionless as he reads Doucet's letter and slips it into the
breast pocket of his overalls. He turns and loads his brush with red
paint. Before applying it to the canvas, he pauses thoughtfully.

Every day, for six weeks, Jacques checks his post box for Picasso's
response to his invitation to come and visit the Studio, before he
gives up hope.

By now, throughout the Parisian salon and artistic circuit, rumours
abound of the collector's stunning creation: *Dressmaker* Doucet's
mysterious *Jewel Box.* Such an appellation is whispered half in
admiration, half in anticipated envy, and sometimes with a catty
inflexion, through the garrets, ateliers, galleries and rat-infested work-
rooms of Paris. It is known to be accessible only by invitation and
at the master's whim. The whispers lift a tone to impart further
information: a precious, highly wrought *secular-sacred* chamber, in
three segments and adorned like the prized oratory of Padua's
unrivalled Scrovegni Chapel. It has been planned, commissioned,
lovingly created and now fully finished by *the dressmaker* otherwise
known as *the Prince of Paris!* Oh, to step inside. Tongues rise to
speculate on a universe of its own – a Gladstone-bag-shaped world
cocooned within its Parisian setting. It is said that nothing like this,

in the modern style, has been achieved to this level of perfection. And yet the owner and creator who conjured such a masterpiece is coy about receiving visitors.

One of the first to be admitted is Ambroise Vollard, whose coffers were prised open two years ago to help finance the enterprise in exchange for three prized paintings by Degas. The sixty-three-year-old dealer, like Jacques himself, has been an avid supporter and collector, not only of Impressionism, but also of the art movements since. Vollard has been good friends with most of the artists whose works now grace these parchment walls. He in his own way is king of his field – the great discoverer of artistic genius. For Jacques, the presence of this visitor is not unimportant but he disguises his nerves, while at the same time believing that Vollard cannot fail to appreciate his handiwork.

'So at last I am received into this holy of all hallowed domains!'

Jacques grunts at him to cease his teasing and concentrate.

Having ascended the glass staircase and upon entering the first chamber, Vollard fails at first to notice the large Picasso, looming behind him. He promptly recognises the Mirós and the Picabia on the vestibule wall, but when he turns back, facing *Les Demoiselles,* he is shocked and momentarily speechless. *Here it is then, the aberrant, explosive work of 1907,* about which he and Matisse had been so disparaging.

As Jacques awaits a verbal reaction, his private thoughts drift back to Sonia's notes and coded language. *How could Picasso punish Apollinaire over this?* he broods.

'Phew!' Vollard whistles low under his breath. 'So it is here then?' pausing to contemplate its power.

'You know, Jacques, I never fully appreciated Picasso's radical departure from using his extraordinary gifts. I sided with Matisse back then, but of course this *delicioso monstruo* has been rarely seen since.'

'Then you disapprove?' ventures his host, still distracted by his thoughts about Apollinaire.

'No. Not so. Just a little taken aback. But I have to say, Jacques, the manner in which you have presented it is quite astonishing. To think how everyone hated it at first – not least of all Braque, who embraced its ideas within just a year to become a Cubist!'

'Then have you shifted your view, Ambroise?'

'Show me the rest will you,' he replies coyly. They venture into the Studio's main salon and the visitor marvels at the synthesis of the dazzling interior with its cornucopia of great works.

Naturally, Vollard has kept abreast with the succession of *isms* of the unfolding century. From being a chief discoverer of Cézanne, the triumph bred even more success, when he had pulled off a most shrewd gamble with Picasso, at a time when the youth had struggled to keep body and soul intact. But Vollard was never a stickler for presentation – indeed at Cézanne's groundbreaking show, which had made both artist and dealer famous, there had been too little money even for proper framing of some pictures. Vollard, so successful on his own terms, reflects sheepishly on his comparative clutter of canvas stacked upon canvas. What is more, the dealer is aware that many items of his own are languishing without labels or even quite lost.

He considers his own approach in the light of the extraordinary ensemble before him. *Jacques Doucet is demonstrating something particularly refined.* If it were Vollard's job to alert the world to great genius, it is patron Doucet who is showcasing a new representation of artistic endeavour. *But oh, there is something freakish about him,* thinks Vollard. *He has the audacity to buy and present the Picasso Brothel and yet he is so secretive, denying entry to the many obvious celebrants of the world of aestheticism. For why?* He sees the masterpieces breathe fresh oxygen, the vigorous life force of new art. He concludes that this cannot be doubted – *here an array of delicious art can be truly appreciated and adored.*

This Creole man, a former islander of *La Réunion,* therefore an outsider in his own way, queries the meaning of the Studio. This particular manifestation of *Le Style 1925,* or Art Deco, pioneered

so exquisitely by the dandyish magician, and executed with his genii accomplices, has transported the veteran dealer into another world.

Vollard edges along following the master, involuntarily attempting a tiptoe through the inner chambers, as he absorbs the subtlety with which ancient and modern have been synthesised, both in the overall scheme and *within* each unique item.

Jacques sees Ambroise halt, and then stoop to look at something. To the right of the Matisse hangs a small oil on canvas in a neo-Impressionist style. It is Georges Seurat's *sketch* for *Le Circque (The Circus)*. His host's pulse quickens as he detects in his companion the trace of stirred emotion below the massive bald head and the wipe of the bulbous nose, suggesting a stray tear. He remarks, 'You have done something here, my friend.'

'It is just the sketch but it belongs – decidedly so.'

'How Seurat was rejected in his day by the Salon and obliged to show at the exposition of Indépendants. They said the angular components of the ballerina on the white horse were *rigid like an automaton.'* Vollard mimics the critics with a growl, 'Poppycock, just look at those curves. It is a wonder of movement – even the yellow tones evoke the energy of a summer's day!' The two men peer closely at Seurat's dotted surface.

'No one understood him then,' says Jacques. 'Breton insisted he should be represented here and, Ambroise, you will notice the virtual absence of any other works of the Impressionists. He singled out this leading *Pointillist* in the Surrealist manifesto – thanks to the influence of Apollinaire.'

'And how did you come by the treasure, if I may be impertinent?'

'In my usual rapacious way, I was present at the dispersal of the collection of our friend Félix Fénéon.'

'A great Seurat aficionado.'

'As Breton was emphatic that it belonged in my collection, I did not disregard him. And I should add, it has been promised to the Louvre on my passing, along with the Douanier's serpents,' he waves at the large canvas opposite.

Vollard turns and immerses himself in the Rousseau jungle. 'You know, Jacques, here is an artist devoid of time.'

'There is something else too,' Jacques rejoins. 'Degas recognised Rousseau – remember Degas' ballerinas, indirectly helping pay for all this!' He gesticulates merrily, provoking a smile from Vollard. 'In around 1890 he proclaimed Rousseau was *the painter of the future!*'

'Hm, quite amusing that here we have the Douanier facing Seurat, since Degas could not abide the sight of *Pointillism* and its scientific aspirations.'

They reach Picasso's analytical-Cubist *l'Homme à la guitare (Man with a Guitar)*. Vollard examines the dense, brown canvas intently. 'Now this is absolute *classic* Cubism, of course. You know he did a portrait of me in this mode.'

'Certainly. It went to Moscow, if I'm not mistaken?' Jacques says knowingly.

'That's right. Bought by Shchukin. No one could recognise me until the son of one of my friends, a boy of four, standing before the picture, put a finger on it. He cried out without hesitation, *That's Voyard.*'

'Interesting, Ambroise. Sixth sense, I suppose. Innocent children, you see... It shows the truth is buried somewhere within.'

As Vollard approaches the staircase to depart, he is confronted by *Picasso's Brothel* once again. He turns to Jacques, and gestures to the painting. 'I have to concede, monsieur, you have prompted an old dealer to consider, there *may be* something potent afoot.'

Jacques looks at him questioningly.

THE NEXT NOTABLE visitors to arrive come from the other side of the ocean. The sight of Americans swanning around Parisian galleries, antique shops and auction houses is as nectar to artists and dealers alike – if not to indigenous collectors who are obliged to compete with the purchasing power of their US dollar pocket

books. European art being shipped to the United States is a long established practice. It was Joseph Duveen, with galleries in the place Vendôme, Old Bond Street and Fifth Avenue, who made the astute observation that Europe had all the art and America all the money, and that something should be done to redress the balance.

Now, in 1929, Jacques' visitors include the convivial Anson Conger Goodyear – the new president of New York's embryonic Museum of Modern Art and the leading art dealer of that same city, Germain Seligmann. In the small Parisian world, this junior member of the family firm has showrooms specialising in modern paintings, four doors down from the Doucet former fashion house, at number 9, rue de la Paix.

Today they are ostensibly exploring the latest trends in modernist art in Europe, and in Paris in particular. A visit to the Doucet Studio is an essential stop on their tour. Jacques feels obliged to show them around while curiously shunning other keen viewers. The young visionary dealer Seligmann is too skilled to expect to buy anything, or indeed to even hint at such an idea. Goodyear, fully cognisant of the Doucet bequests to the Louvre, is likewise too astute to allude to possible future acquisitions or bequests. Nonetheless the gracious couple are, as if like a pair of vultures, smelling in the air dead meat, and can hardly help noting the likely meaning of Jacques' decrepitude and rasping. Besides such unmentionable matters as his diminishing future, the host is not minded to discuss sales. For Jacques' purposes it seems he is merely extending his usual courtesies to fellow connoisseurs, and selling or anything of that kind is far from his thoughts – although flying the Tricolor in the face of the American visitors is a matter of chauvinistic pride to the Frenchman.

'We are opening the New York museum in November with an exhibition of European modern art,' boasts Mr Goodyear, proudly, 'featuring Gauguin, Cézanne and Seurat,' to which Jacques secretly wonders if their concept of *modern art* is a little less modern than his own.

'Of course, Monsieur Doucet, there will be occasions, as with our first exhibition, when we will be seeking loans for future shows from private and public collections – to which we will naturally be happy to reciprocate.'

'I am sure that will be vital for specialist exhibitions,' Jacques concurs. 'Unless you intend to buy up half of Paris.'

'You shouldn't believe all you read about Americans, monsieur. But seriously, I know you have a reputation for great generosity when it comes to lending valuable art to museums,' the American adds.

Jacques remains noncommittal. For now he has no specific plans for any further development of the Studio.

The intrigued visitors stay for half the day as their host takes them through the iconographic sequence of the rooms. They even express enthusiasm for *Les Demoiselles d'Avignon.* 'The reputation of this picture precedes it, Monsieur Doucet,' remarks Goodyear. 'It is of truly historic magnitude.'

'Legendary,' adds Seligmann turning proudly to their host, 'I believe the very first printed reproduction of this was in an American publication, the *Architectural Record,* as far back as 1910?'

It is a ghastly reminder for Jacques, sending a bitter chill to the heart. He cannot help but recall that it was the photograph from that article, which had so provoked Sonia's deranged husband.

He takes a full breath and continues, otherwise feeling vindicated by their praise, observing the stark contrast between this American museum chief and Dr. Crozier of the Louvre. Again, he hides his suspicions behind his impeccable smile, appreciating their flattery, yet with an element of scepticism regarding their motives. He certainly refrains from informing them of the Louvre's refusal to accept the painting.

ANOTHER RENOWNED connoisseur to ascend the glass staircase, and in a pristine tuxedo, is the German dealer-collector Wilhelm

Uhde. He has an unexpected lady companion on his arm – none other than the eccentric artist Séraphine Louis de Senlis.

Uhde, along with Daniel-Henry Kahnweiler and others from his homeland, suffered sequestration of stock, including a large number of works by Picasso and Braque, in the French government's War Reparation Program. In his rehabilitation as a successful dealer, he still struggles, although as a collector he remains highly regarded.

Wilhelm is received into what he perceives to be Jacques Doucet's, *Beautiful Temple of Arts.* He considers the owner's demeanour, as that of a Grand Seigneur, like a head of state receiving a foreign ambassador.

The gracious host greets him, with a golden thread of charm, 'Wilhelm, you have been my role model as a collector, and I want to hear from the horse's mouth whether I am a worthy successor, and represent the fame of the artists to your approval.'

'These words put me to shame,' utters Uhde in eager deference – regarding Jacques Doucet's manner as one resembling that of a king bestowing a high honour!

Following the effusive welcome, he ushers in the dealer and his shy companion. Séraphine Louis is the notorious former cleaning woman and Uhde's artist protégé. Jacques recognises a distinctive odour of turpentine assailing his nostrils, obviously brought by the painter into the vestibule, which tells him this artist has not been long away from her easel.

An eccentric vision to behold in the revered space, Séraphine wears, albeit in an attempt at smartness, a shapeless dress adorned with a crucifix, the cuff spattered with perceptible dark paint spots. At sixty-six years of age she is tired, having led a life of drudgery, and forms a dreary image – bringing to Jacques' mind the wretched creatures living on the rougher side of the Butte de Montmartre. This French painter in the naïve style is self-taught, and with inspiration derived from her religious faith. She stares through half closed eyes and sings a tuneless song of devotion as she mounts the stairs. As they slowly progress, marvelling at the gleaming ascent,

Uhde appears oblivious to Séraphine's oddities – or at least he refuses to acknowledge them, never allowing as much as the twitch of a frown to cross his expansive forehead, for this is the woman who is making his reputation as a creator of Extraordinary Art.

On arriving at the top of the staircase, Séraphine veers backwards, aghast at the image facing her. It is impossible to ignore her clasped hands and intensifying cries to heaven, addressed directly to the Holy Mother and demanding some answers. She has seen the shattered image of prostitutes and is appalled beyond reason.

'What blasphemy? I cannot enter! ...'

After some moments of protestation and awkward exhortation, Uhde, betraying a little embarrassment, confesses, 'How sensitive the artistic spirit can be ... Séraphine, my dear,' he explains, 'You are truly spiritual. But this painting may be a rebuke to those who maltreat women. As a protest it would therefore be a wholesome statement, of course. We must not leap to premature judgement, as I confess I once did.'

'You know this picture, monsieur?' she demands, cowed from the image.

'Indeed so. I visited Picasso shortly after he unveiled it to his friends and colleagues. In fact I arrived just as Monsieur Vollard and Félix Fénéon were leaving – both without understanding a darn thing – and I must confess I left in exactly the same perplexed state as the other two...

'I needed the experience of more than one viewing, to imagine what had led Picasso down this track. Once I understood the new language, I faithfully accompanied the artist on his journey – as you can see Monsieur Jacques himself has admirably done,' he nods to his host, 'because he was fighting for great things – to give meaning and formal reality, on the human and artistic level, to a new sensibility and new aspirations – and because he was mocked and ridiculed by the very people who worship him today.'

'Quite so, Wilhelm,' Jacques concurs, before turning to Séraphine. 'Of course since the Renaissance, women have been abused in art,

almost always portrayed as an *ideal* for the male gaze – a gaze engaged in what you might call a process of imperial conquest – nothing less than the act of enslavement, one could say.'

'Fie! *This* is abuse! As much as ever I have seen!' blurts out the elderly woman. '... And have you not spent a lifetime encouraging the male gaze ... dressmaker, eh?'

Doucet splutters a little. '... Madame, you may be right.' He recomposes himself and tries again at communicating with the plain speaking woman. 'I have left that world behind. If you could see this differently...? This is an assault on the very exploitation practiced for centuries past... To begin with, Madame Louis, these women are scarcely susceptible to male ogling. Indeed, the figures are as unattractive to men as could be imagined. And the direction of gaze is actually *reversed,* and so the women – free of superficial beauty – have the power to stare down the spectator and frighten him away to take cover. As well as being an historic artistic break-through, is this not rebuffing the misuse of women too?'

Ignoring the question the pious woman suddenly catches sight of the adjacent statue, causing her to jump again.

'And this here is the sacred *Shakamuni Buddha,'* Jacques tries to continue. '... Providing a balance of a spiritual kind,' gesturing to the plinth with the Eastern figure.

'Such ridiculousness!' she cries out.

After this scornful outburst Séraphine is calmed somewhat. She blushes awkwardly, mumbling, *'Je m'excuse monsieur,'* if only for the benefit of her patron Wilhelm Uhde.

Jacques smooths the way and resists rising to further challenge. 'We do understand, you know. The large canvas has been so very problematical. This is why it is banished from the principal salon. It is safely behind the steel bars of this balustrade. Do you see?'

'Indeed, Jacques, and the canvas looks very well,' asserts Uhde genuinely. 'I'm so glad to see it,' making an attempt to steer the mood of the party. Jacques gestures towards the Lalique doorway with its crystal panels folded back and with gentle persuasion the

two men entice the former charwoman inside. Her eyes dart this way and that and she stares in wonder at the great feast ahead, her hands clapped to her mouth.

'Wha! it is a proper sanctuary! And so strange. Such luxury as I never saw...' She scans the salon in awe, her eyes drawn to the furniture, objets d'art and paintings, not knowing where to fix upon first. She puts a hand out to feel a delectable fur. Uhde is simply astonished.

'But over there, is a painting surely by the old customs man?' Séraphine gravitates to that which is most familiar to her.

'A fine masterpiece,' Uhde dares to say, at which she turns sharply, not liking the nudity.

'What is this? A house or a museum, *eh?* Have you brought me here to clean?'

'No, no, my dear. It is for enjoyment and reverie,' replies Uhde.

'These are representations. Some of the greatest creators of our age are placed most assiduously with primitive and spiritual aspects brought together,' Jacques adds, while doubting the likelihood of comprehension by the intensely staring woman.

She steps back, retreating in order to stay firmly near the double-doors, her brows knit in trepidation. 'But they are ungodly. You have many icons here ... calamitous and not at all what the Holy Mother would wish,' shaking her head.

Séraphine turns as if to leave and as she moves she touches a panel on one of Lalique's doors, a favourite Doucet commission. It swings back to reveal the glassy reliefs of sexually suggestive naked young men, in the classical style of athletes in physical motion. She springs back newly horrified. 'Sodom and Gomorrah! Here is evil!'

In the lengthy and excruciating pause that follows, both Uhde and Jacques fail to respond.

She rants, 'I am a poor woman who understands little, but who understands too much, messieurs!' she declares lustily, 'You want truly modern paintings? They are those of I, Séraphine de Senlis – godly images sent direct from the Holy Mother!'

The eccentric woman falls to her knees, launching into a fervent series of Hail Marys. She stays prostrate for some time before Uhde sees that she is immovable. He is unable to proceed with the tour and mutters a bashful apology. After which he aids his protégé to her feet and escorts her from the building with promise of the opportunity for prayer in due course. 'Farewell, monsieur,' he cries out, as he disappears from view with Séraphine. Jacques is speechless.

Of course, the German visitor had scarcely had an opportunity to discover the master's iconographic strategy and looks forward to visiting again but with a more appropriate companion. He pens a letter to his friend and client Gertrude Stein who is visiting her brother in Florence.

> My Dear Gertrude,
>
> I have just enjoyed the privilege of visiting Monsieur Doucet's 'Jewel Box'. Remarkable! It is all I can say. You simply must see for yourself. This old man, suddenly and with youthful enthusiasm, has amassed Cubist pictures of Picasso, Braque, as well as works of Rousseau and of the young school.
>
> I demurely intimated how happy it made me to see, so perfectly preserved, the pictures I loved, such as the Avignonites by Picasso and the Snake Charmer by Rousseau which brought back beautiful memories of the past and is to be willed to the Louvre.
>
> What does this tell us about what Doucet is really like? Very revealing, just a heart that has remained young, a sensuality that has survived over the years .
>
> I hope I can arrange a visit for you (and another for me) when you return.
>
> Yours affectionately, and with fondest regards to Leo.
>
> Wilhelm

23

*There are photographers who maintain that their medium
has no relation to painting. There are painters who despise
photography.* – **Man Ray**

ALTHOUGH JOURNALISTS and publishers are clamouring to visit the new construction, the master remains determined to restrict press coverage and grant access to only the prestigious French weekly magazine *L'Illustration*. The grapevine has churned out stories: that of a new creation – *the Jewel Box* as a new kind of space – not a museum or a private house, but somewhere beyond either. Interest remains high.

From the disparaging reports around the sale of his antique collections, to the acquisition of radical modern art, Jacques has been mistreated by the press too often in the past. Now, as curator and connoisseur, he is able to dictate terms to control press coverage and prevent over-exposure. Moreover, he is sensitive to the eccentric notion, that allowing too many eyes to be laid upon his works of art, can removes a layer of their illusory power.

In 1891 *L'Illustration* was the first French magazine to publish a photograph, and in 1907 the first to publish in colour. Jacques' agreement has been settled with Gaston Sorbets, the editor-in-chief. Acquainted with Jacques Doucet from three decades ago in the collector's days as the doyen of antique art, Sorbets seizes this opportunity to cover the new creation. He assigns his most senior arts editor M. Alphonse Zèle to handle the delicate arrangements. Meanwhile, Jacques' recommendation of the author is accepted. The feature article will be written by André Joubin, his own

associate and director of the Bibliothèque d'Art et d'Archéologie.

M. Joubin and the magazine's chief photographer are duly invited. Jacques also arranges for his Eastern art advisor, Charles Vignier, to attend. Three days have been assigned for the shoot.

In the lower vestibule Joubin, trim as ever, with friendly mutton chop whiskers and round-rimmed spectacles, bustles around. He conducts introductions with his secretarial assistant Berthe, a girl hiding fashionably under a cloche hat – one whose appearance belies her keen intelligence. She waits, observing the seriousness of the photographer M. Georges Fay, struck by his slim physique, *like a trouser press,* and by the fact that he is accompanied by not one but two lighting technicians.

'Monsieur Jacques,' Joubin takes him to one side, 'this is a happy day. Tell me, did you gain any reward from the recovered boxes?' the librarian quizzes his former employer. 'I am intrigued to know.'

'I am studying them, as it were,' replies Jacques, with a fey gesture. 'There maybe something pertaining to an old mystery? Perhaps concerning the poet Apollinaire, but it could be just a red herring.'

Joubin has organised a deputy at the great art library, in order to absent himself for the necessary time to prepare a fitting article for the prestigious journal. Whilst a staunch ally, he is also keenly interested in the fine art on display, seeking answers to innumerable questions, as Jacques and Vignier escort him through the sequence.

Arriving at the same time is the magazine's arts editor M. Zèle, who is to supervise matters personally. Each is welcomed by Jacques in his impeccable manner.

'We shall endeavour to cover everything,' declares Zèle, 'in spite of there being so much, although I must say my own penchant is for the antique rather than modern.'

'I'm sure there will be enough to suit your tastes as we progress,' replies the host, barely perturbed by the inferred lack of interest, if not discourtesy. Loyal Charles Vignier looks on with concern, wondering if Jacques will achieve the rapport he is seeking with such a person.

Zèle, a wiry, bespectacled little man in his fifties with unsmiling features and a bureaucratic manner, produces a specification from the magazine. 'Four full pages have been allocated, which will include the only colour photography in the edition.'

'Very good, monsieur. Just as I agreed with Monsieur Sorbets,' acknowledges Jacques, feeling a little more assured.

'Perhaps you will be good enough to apply your monogram to this release document for the images to appear *exclusively* in *L'Illustration,'* requests the editor.

Reaching the upper vestibule Jacques takes the document to his desk in the adjoining salon and signs, as requested, while Zèle and Vignier, Joubin and Berthe, contemplate the effect of the principal painting, fortified by the seventh-century Buddha statue.

'They said that Monsieur Doucet was a man of great taste and discernment, advising the President, no less... So what do we have here?' asks Zèle with an edge of sarcasm and casting a disdainful eye towards *Picasso's Brothel.*

'All will be revealed, I trust, by the time we finish, *umm?'* Vignier responds positively – with the intonation of a question rather than an answer.

Jacques returns with the signed release form. Zèle slips it into his attaché case, glancing back at the Picasso with an ill-concealed grimace.

André Joubin, aware of Jacques' particular mania, cringes on his behalf, especially upon seeing Jacques' eye twitch with irritation in a slow burning glance.

'Great effort has been made to accommodate this very singular work I believe. Let us come back to it later shall we, Monsieur Doucet, *umm?'* intervenes Vignier.

Entering the main salon, Joubin's attention is drawn to an exquisitely elegant miniature writing desk to his left – upon which is placed a rock crystal, silver and enamel winged obelisk by Gustave Miklos – standing before the first of the tall windows.

'This desk is a *pièce unique* designed and made by Rose Adler,'

Jacques informs his visitors with relish. 'We have a number of items here created by women artists – you'll remember the red lacquered hall table by Eileen Gray downstairs in the vestibule, and this is by Marie Laurencin,' pointing up to the large *Jeune fille au chat et au chien* canvas to his left. He refers back to the writing desk. 'See how the polished ebony is sharply contrasted with the geometry of the white *galuchat* writing surface.' The sharkskin is set in a stylized cityscape of stairs, arches and streetscape in forced perspective. A silvered bronze drawer pull and similar sabots on the feet also contrast sharply with the ebony.'

Jacques invites Joubin to raise the side flaps, set on upwardly angled winged compartments. 'Nicely executed, I have to concede, despite the unusual design,' he adds. Joubin, while a faithful friend, and well-apprised of his art, represses a discrete preference for antiques. The editor seems even less impressed and remains mute.

To the left, a carved African head is mounted on a high plinth, centred below the Laurencin painting. In front is an extravagant cubic armchair by Legrain, in glorious, glossy red leather. As they make their way through the Studio, Jacques continues to identify works of art. Meanwhile, in the lower vestibule, photographer Fay and his technicians are busily setting up their equipment for their first exposure. The editor returns below to monitor their progress.

As Jacques and his guests approach the third room, the Persian Chamber, Joubin expresses surprise and delight at the sight of the ancient Eastern collection. 'Like the Buddha at the opposite end, this makes for a striking counterpoint to the modern.'

'And it is central to the concept,' replies Jacques. 'But just one moment please,' he says, halting their progress. He opens a side cabinet and produces a number of pairs of soft felt shoe coverings and issues them to his guests. 'Would you be so kind as to wear these over your shoes before stepping onto the polished parquet?'

The visitors comply. Upon entering this chamber their eyes immediately fall upon an object covered with a calico cloth placed upon a small low table. They ignore it at first and marvel at the

plethora of fine and precious china, statuettes, pictures and art objects surrounding them.

'What is this?' asks Joubin, pointing to the cloaked mystery item.

For a moment Jacques coyly hesitates before answering. 'It is a piece of sancai-glazed pottery from the Tang Dynasty, a caparisoned Ferghana horse in fact.'

'Oh, a Tang horse? Can we see then?' asks the writer.

'I'm sorry, gentlemen ... er, madame,' Jacques states emphatically. 'It is a new acquisition... Each time a pair of eyes regard a rare and precious artefact, they take a layer off it. I cannot possibly show this just yet,' he adds hastily. 'Another time, perhaps.'

Joubin casts a look of complete confusion, while Vignier appears to comprehend. Only he recognises this eccentricity as arising from the Eastern idea of preserving mystique.

Eileen Gray's gleaming Lotus table is the centrepiece of the Persian chamber. The fury of the designer is forgotten and there suspended are the silk cords, amber spheres and tassels she had fiercely threatened to go at with a pair of scissors. The table now stands proud, repaired and repolished, finished in the darkest, shiniest, yew-green lacquer. The precious furniture dramatically incorporates replica lotus blossoms in splays of ivory lacquer. The connoisseur is particularly conscious of its presence, more than that of any other item of furniture. He expostulates most earnestly, now quite in his element, pointing back to the vestibule to *Picasso's Brothel* above the stair-well. 'You see, André, it is effectively my Buddhist altar, set here at this part of the sequence ... confronting the picture at the far end ... and establishing a powerful primary axis through the entire plan!'

Joubin spreads his hands, 'I can see how these subtleties might have been lost on your previous visitor, Jacques.'

'Did you run through this with Uhde, *umm?*' asks Vignier.

'I didn't exactly have the opportunity. As I said, it was such a chaotic visit.'

The Chamber – strictly speaking, beyond Persia – contains, as

well as an array of Islamic works from Persia and Syria, ceremonial items from Africa, China and Japan. The dimensions of the room mirror those of the vestibule at the opposite end. Both are lit by René Marlaert's large circular glass cupolas, incorporating combined electric and natural light – edged in lapis lazuli. The pigskin walls, studded with gold nails, are perfectly accented. An exotic parquet floor designed by Legrain, in Macassar ebony, is interlaced with black marble and gold mosaic, surrounded by deep lapis lazuli skirting boards. Faint but discernible scuffing to the highly polished floor, due to the footwear of previous visitors, perturbs the master – hence his introduction of shoe coverings.

Ostensibly, this part of the complex is devoted largely to the display of art objects. Eight bronze vitrines house Persian, Japanese and Chinese porcelain and ceramics. A colourful, two metre high, *crocodile* mask in ethnic wood from Guinea is fixed high in the left-hand corner. Also to the left, in the centre of the wall, a substantial Pahouin wood sculpture from Gabon is mounted on a tall plinth. 'This masked and helmeted head,' Jacques informs his visitors, 'gazes, in what is effectively a powerline, across the chamber, over the Lotus table, to the Lotus shrine, establishing a resonant secondary axis.' Eyebrows are slightly raised in surprise at this last comment, but Jacques ignores the doubters, adding, 'Apollinaire described the Gabonese piece as comparable with the best of Roman sculpture!' Joubin and Vignier are quite prepared to share Jacques' fascination and purposefully follow his sightline, observing the effect.

Questions are raised about the significance of Jacques' shrine to Mme Sonia Roux, but he declines to discuss it, describing it as personal and not to be included. This too involves the iridescent panel featuring the bewitching blossom of lotus.

Beneath the table stands an impressive Syrian earthenware jar, known as a *Rakka,* originating from the Syrian city of that name. Further earthenware vases surmount the vitrines.

Vignier puffs himself up in readiness for eulogising the ethnic

collection, quite forgetting that Joubin has expertise on Matters Doucet, especially concerning his eastern art. 'You may observe, these are more sober utility examples which have been sought, meticulously, exhibiting truth to materials and restrained decorative effects, *umm.*' He looms towards his listener to check his response. 'What is more, we see the arts of Islam alongside Far Eastern and African art, although it is only the last of these that has become common-place among the avant-garde, *umm.*'

Secretary Berthe struggles to note it all down, word for word, not being *au fait* with the concepts. The nineteen-year-old is occasionally at sea with all the art, the names and technical terms.

'Of course I disposed of much of my ethnic collections in 1912,' Jacques adds, 'none of which, I hasten to mention, exhibited the excesses of Oriental decoration, so popular in Western collections, and I retained this selection – each for its individual purpose.'

The end wall features a fireplace and hearth made by the sculptor Jacques Lipchitz. The carved pink limestone fire-surround depicts abstract animal figures, guarded by geometrically stylised golden fire dogs, while electronic flames illuminate the grate. Various antique objects appear along the mantelpiece. It is the massive over-mantel mirror which provides the reflected view of *Les Demoiselles,* some ten *Clarabelles* away on the opposing end wall. Either side of the mirror hang portraits of Zen Buddhist monks, facing towards the salon. Several exotic rugs and a number of impressively large ceramic vessels appear around the room.

To an Eastern art aficionado of the calibre of Charles Vignier, this windowless chamber is unalloyed nirvana. Any doubts of his are superseded by respect for the Doucet strategy. If Picasso's *Les Demoiselles* is the cornerstone of the enterprise, he sees the Persian Chamber as the centrepiece, placing as it does, Oriental, Native American Islamic, and African culture, cheek to cheek with the avant-garde and modernist designs of Western Europe.

'European value is not necessarily the only value in art and life, as you will observe, monsieur,' Vignier continues, brimming with

enthusiasm, directing his remarks to the knowledgeable writer of the article, 'the *antique,* the *primitive* and the *exotic* also represent the *modern* in Monsieur Jacques' idiosyncratic realm, *umm?* We can observe *non-European* imagery as an integrally woven thread through the fabric of the entire undertaking, whether in these historic authentic pieces, *umm,'* gesticulating to the wide array of art and antiquities around him, 'or in the *modern, umm?'* indicating the salon through which they have just passed. 'The *modern* borrows forms and elements from ethnic originals in a stylised, luxuriant manner and in the most opulent and sensuous of materials, *umm?'*

Jacques twirls his beard roughly with his fingertips against the line of the nap – gravely appreciating the depth of Vignier's critique. He is rooted to the spot in suspense.

'Manifestly, Monsieur Doucet has not simply juxtaposed antique originals with *modern* counterparts. The *modern,* in each and every instance, embodies exotic or ethnic language in its conception, *umm.* Every chair, cabinet, desk, and so on, the picture frames, staircase, the doors, the ceilings, yes all these, *umm,'* he gesticulates widely, 'contribute to the tapestry of the exotic constellation, *umm.* But the presence of original antique pieces is indispensable to the *mise en scène.* These antique examples have not only become compatible with *modernism,* but in this setting also represent modernity itself. Indeed it is marvellous, *umm?'*

André Joubin, although irked by Vignier's verbosity, follows the excitable description, noting the content. He privately determines to recall it for his editorial and trusts that Berthe is getting it all down. He searches instinctively in the silvery mirror for the giant chopped bodies of *Les Demoiselles,* framed in a reflected vista, and says, 'Just as with the large modern work in there,' pointing to the Picasso, with its African masks, 'combining primitivism and the exceptionally modern.'

'Exactly so,' confirms Vignier. 'And you might further observe that even the most modern items we see here today, owe little to the stripped-down functionalism sweeping architecture and design,

as propagated by Le Corbusier in France, Dutch *De Stijl,* or the *Bauhaus* in Germany and the rest, *umm?'*

'Miss Gray as well now, so it seems,' adds Jacques, 'with her tubular steel furniture, and avowed intent to exclude any and all ornament derived from history or nature. But do you consider that Cubism might be the seed kernel of everything? I confess I do.'

'I had not given that enough thought, monsieur, *umm...* But here the sequence of rooms is established along *iconographical* lines,' Vignier continues, just as the editor returns from the photographic shoot below. 'When dealing with Eastern art in Western collections, there are complexities which make specific interpretation extremely hazardous, *umm?* But in the present case the connoisseur here is an authority on both.'

Zèle steps over the threshold from the plushly carpeted central salon into the Persian Chamber. 'Pardon, monsieur!' Jacques exclaims. 'Allow me to find you some shoe coverings for the sake of the parquet.' The man appears nonplussed, scowling as though insulted, and before Jacques can hand him the felt galoshes, 'No, monsieur,' he replies, 'It will not be necessary for now... The first photographic plate is ready for exposure below. You might wish to come and see for yourself before they proceed.'

Jacques returns to the lower vestibule with the editor. As a former couturier and major collector of the arts and of innovative images for his libraries, including portraits of himself and others taken by Man Ray, he is a seasoned aficionado of the medium.

The single-lens reflex bellows camera mounted on a substantial tripod is surrounded by lights and deflection umbrellas, drenching the scene with a pure white arc light. The editor stoops under the viewing hood in order to peer at the composition. He nods to Fay, the photographer, indicating approval. Despite the spatial restrictions the camera lens captures, in a landscape view, the lower part of the Csaky staircase with Eileen Gray's hall table and Marcoussis' rug in the foreground.

Jacques asks to see for himself. He follows the procedure, dipping

his head under the black hood. Popping back up he exclaims, 'This crops off a most important element! ...'

'Pardon, monsieur?' questions the bemused editor.

'The staircase is a major work of art. To eliminate all of the second flight would be quite unthinkable. What is more, the Brâncuşi on the landing is lost... I suggest we consider a portrait orientation for this one? Any loss at the sides will scarcely be missed. That corner of the room is not especially helpful in the shot after all.'

Fay looks to Zèle for instructions. His editor is confounded and addresses the connoisseur, 'I do say, monsieur, I am having some difficulty in recognising this modern staircase as a work of art!'

'An ascending sculpture by Joseph Csaky? – If you cannot see it that way I cannot explain... All will be well, you may rest assured,' replies Jacques, straining to maintain his composure. 'You will see with the proofs.'

Reluctantly, the unemotional Zèle concedes, 'If it is not going to take up a great deal more time to reset the camera for a retake, Fay, you may proceed. But first make an exposure as it is, as a reserve in the event of the alternative being unsatisfactory,' he sighs.

After the adjustments to the camera and lighting, and the elapse of a further forty-five minutes, the new orientation is ready. This time Jacques is the first to venture under the hood and he affirms his satisfaction. The view now encompasses the floor, ceiling and entire staircase. 'Bravo, monsieur,' he praises Fay. Zèle checks the viewfinder and authorises the exposure.

The crew carefully manoeuvre the equipment upstairs and through to the principal salon, where they begin setting up for the next plate. Various angles are considered, each encompassing a corner of the room. To capture the most advantageous view-points, there is a good deal of positioning and repositioning of equipment. During these proceedings a technician attempts to move an item of furniture to relocate a lighting stand. 'Stop!' shouts Jacques. 'Please don't touch! You may not handle the works of art. My staff are trained in moving all precious items.' There is a further delay while Bonnet

and Chivet are summoned. The photographic crew are increasingly frustrated, as Jacques mutters more than once and almost audibly, *Why? Why did I ever permit such a rude intrusion?* An awkward stalemate ensues. The photographer baulks at the interference, 'I need freedom for my art!' To which Jacques retorts, 'Not at the expense of mine!'

A lengthy pause follows, during which Fay partakes of his pipe outside in the rue Saint-James and Jacques too rallies himself and decides cooperation, at all costs, means careful joint care of the objects. The master and his own men proceed to handle furniture and objets d'art as if they are angel's wings, and he is better pleased.

At last the next view is established, a wide angle shot, looking towards the alluring corner that includes *La Charmeuse de serpents* with the sofa below, Picasso's large Cubist *L'Homme à la guitar*, Modigliani's *La Blouse rose* and the left-hand leaf of the Lalique doors to the right. While the lights and camera are being positioned for the next exposure, Zèle announces he has to return to his office on a matter of some urgency and promises to be back later.

Jacques reappears in the Persian Chamber to find Vignier minutely detailing the provenance of a Tang Dynasty bronze statuette. The host interrupts, having noticed the time on his pocket watch. 'Come gentlemen, mam'selle. We should repair to Mme Doucet's *salle à manger* where luncheon has been prepared.'

They make their way to the main villa and take their seats around the dining table adjacent to a sideboard laden with a splendid buffet. The hostess graciously joins them.

'Before we begin, Dora, my dear,' Jacques instructs the maid servant, 'will you take a selection of refreshments back to the photographic crew. We must make amends for our little contretemps earlier... And perhaps you will remain with them to ensure there are no crumbs.'

'Very good, sir.'

'Oh, and Dora,' he adds, as she turns to the silver platters, 'we shall need a final dusting when all is set up.'

Between the hors d'oeuvres and Soles meunière, Vignier takes the opportunity to correct an earlier *faux pas*. 'Of course Monsieur Joubin, I was overlooking your familiarity with Monsieur Jacques' expertise in the arts of Japan and China which is no doubt greater than my own, *umm?*'

'Being custodian of his great array of more than one hundred illustrated albums is quite some task. Curating them has become my life's work, in fact,' effuses Joubin.

Jacques appreciates this topic of conversation, but for the benefit of his wife he steers them to the pre-War milieu of haute couture, antiques and traditional fine art, which is clearly of greater interest to her than Eastern art and modernism.

'You remember, Jeanne, don't you, how you urged me to adopt the Japanese no-frills approach to my gown designs long ago? You were often more modern than I, when it came to fashion.'

'But how it tormented our chief fitter, La Peña – always ready to elaborate the otherwise simpler creations,' she adds enthusiastically. 'Dear old José ... Pepito they called him.'

'There was no stopping him. Poiret said he was a Don Quixote. He would spin his ladies around like a toreador, coming at those great beasts with his enchanted hands, and wafting his large scissors, quite deliberately undeterred by their tantrums!'

'But always ready to add more in frills than the original design called for – much to your chagrin, my dear – wasn't it so?'

Her husband smiles, remembering his right-hand man of the salon with deep affection. In spite of it, he is certainly glad to have no part in clothing the nobility these days and turns his attentions back to the present task.

After their good-humoured repast, Jacques and his guests return to the salon which is looking increasingly like a photographer's studio or a Hollywood film set. After intricate checking and refinement, the afternoon is drawing to a close. A telephone call from M. Zèle confirms that he is detained and will not be returning today, but leaves the authorisation of the exposure to Monsieur Fay, in

whom he has the utmost confidence. The photographs are taken, but not without Jacques' prior approval.

Jacques then abruptly calls a halt to the day, as he is expecting an important visitor – one whom, he is intrigued to hear, spends much of her considerable income in Paul Poiret's fashion house.

The crew pack up their equipment and depart.

THEY ARE ALONE. Josephine Baker, the celebrated dancer with an oil-slick Eton crop, leans forward over the balustrade. The star of the Talking Pictures has been received to great acclaim at the *Folies Bergère* and has called upon M. Doucet at his request. She wears a snowy fur stole. Her plunging neckline showcases rippling dark skin glowing with health. Jacques' eyes, as if over stimulated, are drawn elsewhere: upon his sometime Folly.

'Do you really think it is any good?' he asks.

'But is this the right question?' Miss Baker wonders. 'Why are the black faces so ugly? It might be a kind of cultural bullying – is the abduction and repackaging of the images of my race supposed to be progress? I am confused. I love it, in a sense, and you say you are in love with Africa, but I don't know what is happening here.'

He leads her inside and directly to an object he feels is of interest. 'Do you see the traditional African inspired stool here? This work is by Pierre Legrain – modelled on the Throne of King Ghezo, of the West African kingdom of Dahomey. The design is taken from an original, supported on four human skulls as its feet.'

'And what does that mean?'

'I beg your pardon?'

'Just what are you hoping to create?'

'I am aspiring to the perfect assimilation of East and West ... although perfection of course is unrealistic. I would very much like your views on it, Miss Baker. I would be prepared to pay... Also, how would you like to sit for photographs in here?'

'Let me bring in Chiquita then. She is most excellently behaved

for a big cat,' delivering the remark in an expressionless manner, as if the most normal suggestion in the world.

Jacques has heard of this famous pet and ponders the prospect nervously. Seized with an idea he reflects, 'Perhaps we should discuss this over a little brandy... The strict rule is no refreshments in here, but on this occasion we might make an exception.'

A little later, Jacques slouches, legs akimbo and a brandy glass leaning dangerously over the red velvet upholstery of the Marcel Coard sofa. He is making merry with the dancer who out-drinks him with gusto and is stretching across him for a top up.

'But you are negroid and female...!'

'And you are an old, old fairy!'

They roar with laughter, now getting on quite famously. 'I can see you now, the banana girdle at your waist and the marvellous cheetah stretched out. Perhaps you'll be lounging against her? The camera will just love this.'

Jeanne has arrived at the top of the staircase, venturing no further. She studiously keeps her back to *The Brothel*, in time to hear this plan and is appalled. She immediately takes control in the most forceful way. 'Young woman,' she calls through, 'I appreciate you are being commissioned for some modelling, but my husband is a sick man. We cannot have such commotion. I would beg you to collect your things. He has had a very long day and must rest.'

The mettle in Madame Doucet's fearsome tone is death to the party atmosphere and the lively, shapely young woman acquiesces and makes ready to leave. Bonnet appears with her things.

THE CREW RETURNS the following day, sans Messrs Joubin and Zèle, both of whom are due to arrive later. The second view to be captured in the salon will be the opposite corner, to include Marie Laurencin's painting and Rose Adler's pretty writing desk, in front of the large, floor-to-ceiling window. By the time all is set up, the editor, librarian-writer and secretary have returned.

'Perhaps we might close the shutters for the backdrop, and see Hecht's artistry,' suggests Jacques.

'Oh, very useful, yes,' Georges Fay concurs – especially since it makes his task easier, not shooting into the light. The building is east-facing and at this hour is receiving the last of the morning's sun, slanting through the tall windows at an oblique angle, brilliantly illuminating the centre of the salon.

After more readings of light meters, corresponding adjustment to the equipment is made. The shot is now ready for approval. The editor has little to say and both he and Jacques commend the view for the third plate.

At this point Charles Vignier reappears and returns to the Persian Chamber. The others join him. Jacques is anxious to ensure the writer understands everything, 'Rely on Charles, André, he is one of the foremost Eastern art authorities in France...'

'Some might be audacious enough to say such things, *umm,'* his advisor responds with feigned modesty.

'I have Berthe to assist with the brief. All will be well,' Joubin assures the collector, fending off further fussiness.

Vignier continues his description of the significance of the non-European elements within the overall scheme.

Jacques listens to him with some emotion, feeling he should speak up himself. He recalls the words of his confidante and regular correspondent André The Peregrine Suarès, and wonders how his ideas will measure up, against the views of other authorities. The Peregrine has been one of the first to appreciate his "Magician's" work and the crucial aspects of his "Jewel Box":

> *The fragments are in accord; the pieces join up. The objects are no longer disparate; and the whole goes together... This harmonious ensemble is thus your finest discovery... I will give you two reasons why: for you, it is the art of the Far East that bestows the "antagonistic" elements. That is rather odd. Today, the style of Asia is the root cause that draws together*

all our Western arts... Opposing also means confronting, and
dissonance can be abolished by a more sophisticated
harmony. It is there that style may be born... But your
Byzantine style is not immobile, nor is it second-hand fancy or
the work of an archaeologist. It is all action and movement.
That is why Modigliani and the white and black and gold
interior of your Persian room already have a mildly classical
air. The classical is a measure in movement and in life.

Jacques begins gabbling a little, hardly containing his enthusiasm. 'Within these walls, opposing also means confronting. Throughout, I have pursued a theme of Oppositionals. The paintings in the corners are prime examples, with their symmetry.' He points to the portraits of the Zen monks on the back wall. They face the two female portraits in the corners of the salon. 'So we have two *Eastern men* countering two *Western women.* Otherwise the room is almost exclusively populated with Eastern art and antiquities. Here stands the lotus *altar,* created by the modern architect Eileen Gray – while at the opposite end of the sequence is the seventh-century marble Buddha statue, alongside an array of modernist art, including Picasso's twentieth-century work, itself a supreme example of integrating primitive imagery within a Western creation, just as you have noted, André.' He gestures, directing their attention back to the vestibule, as he steps out of the Persian Chamber.

'In the centre of the salon here, two great pictures confront one another: the ascetic abstraction of Matisse's *Poissons rouges* and the exotic and luxuriant primitivism of Rousseau's *Serpents.* And overall, the vestibule and the Persian Chamber oppose each other as the two ends of a dumbbell: East versus West, modern versus ancient, public versus private, cold versus warm, and more.'

Berthe is scribbling furiously. André Joubin holds his flocculent chin brush. Jacques pauses for a few moments, acknowledging the return of the editor. Frowning, and with a quizzical expression, Zèle asks abruptly, 'In what sense do you say this is an altar, monsieur?'

'The Lotus table. It is more than a motif...' Jacques hesitates, 'Help me here, Charles, you say it better than I...'

Vignier picks up the idea and continues. 'It is one of the most significant of ingredients. The lotus flower is a sacred Buddhist symbol, signifying a major strand of doctrine. Shakyamuni, the first historically recorded Buddha, in 500 BC, taught only the *Lotus Sutra* during the last years of his life – stating it was his final and ultimate teaching, *umm.'* The orator peers intently at his audience. 'This influential Buddhist teaching used the lotus as a metaphor for life. Our Buddha in the vestibule stands upon lotus blossom, *umm?* Central to Buddhism is the notion of oppositional elements and forces in the universe. As with *Yin* and *Yang*, positive and negative, every cause has an effect, and so on. The lotus flower metaphor signifies enlightenment. The plant thrives in the filthiest part of the swamp.' Becoming more intense, Vignier, in his eccentric manner, brings his face closer to the group and continues.

'It does not sustain itself in clean waters. Nevertheless, its flower is beautiful and the purest of white, *umm?'* This provides the first metaphor for life: the purity of spirit is only obtainable through confronting the problems of life, its grimness and its pain, *umm*. Secondly, the lotus flower is unique in the way in which it both seeds and flowers simultaneously – a duality analogous to *cause and effect, umm?'* The pairs of eyes follow Vignier as he preaches his sacred lesson.

M. Zèle is less than convinced and before he can interrupt, the scholar's erudition brims over. 'Thirdly, it is a metaphor for belief in the eternity of life: birth and rebirth, *umm?*

'In sum, the Buddhist notion, that by facing up to the problems of life, poisons can be turned into medicine, derives from the lotus flower, *umm?* And so you see, this table with its lotus flower motifs serves as an emblem of purity standing in this Persian Chamber, that contains certain resonant impure objects, both secular and sacred.'

Charles Vignier again peers at Jacques as orchestrator. 'Of course, monsieur, you have not built a Buddhist shrine? Indeed, had you

done so you would scarcely have covered its walls in pigskin, *umm?*'

'No, indeed,' Jacques interjects. 'Nevertheless, having acquired a Lotus Table from Miss Gray – herself an enthusiast for Buddhism – we are fully cognisant of the spiritual dimension, a force even.'

The party utters polite noises which seem to assure genuine interest and step back towards the centre of the salon where the host explains the iconography of the Rousseau tableau facing the Matisse and its function, as a secondary axis within this part of the plan. He also points to an adjacent, low, circular, lacquered table by Eileen Gray with African-inspired motifs in its supporting columns.

Editor Zèle, squinting for a moment at the Rousseau, suddenly asks, 'Aren't those serpents a trifle childlike?'

Vignier and Joubin look aghast. Jacques is approaching the end of his tether with the man. *How can Gaston Sorbets employ such a complete oaf as this, as his arts editor?* he asks himself. 'I believe it was Picasso who said, it takes years to paint like Raphael but a lifetime to paint like a child,' he adds with acidity, 'but then perhaps you may not appreciate anything concerning Picasso!'

'Each to his own, monsieur,' the editor replies. 'One man's genius is another man's vulgarity.'

Now well into the second day, Berthe continues her copious notes, but chooses to ignore Zèle's insinuation.

The setup procedure by the photographers is repeated into the late afternoon, for the final view of the salon. This looks back the other way focusing on the large ebony bureau in the corner.

The sightline then reaches *Poissons rouges* on one side, above a splendid object – the Louis Mergier manuscripts cabinet in green-leather-clad-oak and *coquille d'oeuf*. The same sightline provides a glimpse into the Persian Chamber on the other side – including Zadkine's naked bronze at the threshold. This time the red silk curtain is drawn across, to defuse the natural light from the other large window, the direct sunshine having moved round to the back of the building. As a portrait shot a portion of the Aztec ceiling is also captured.

A third day is required to complete the shoot. Once again, the photographic crew is accompanied by Zèle. The Persian Chamber is photographed next. Jacques is anxious to enforce his No Foot-wear edict and the technicians work without entering the polished floor area. A wide-angle lens captures most of the chamber and its contents, but the very personal Buddhist-Sonia shrine remains concealed – conforming to the host's prohibition. There is a clear view of the Marie Laurencin *Jeune Femme,* diagonally opposite, as seen through the large over-mantel mirror, forming a triangulation of the two Buddhist monk portraits at the sides, and the Western women between them in the lower centre. Jacques and the editor approve the composition.

Upon checking his watch, Jacques announces he has a special visitor arriving shortly, who will take part in the final photograph. Zèle is quizzical but Jacques keeps his counsel, assuming it will be a most welcome surprise for the editor.

The final part of the sequence to be photographed is the upper vestibule. The equipment is all set up for the first view: looking towards the rear corner, with a portrait image to frame the Joan Miro *Paysage,* Picabia's dreamy *Dimension Quatrième,* Lurçat's woollen rug in the foreground, Moreux's ebony, sharkskin-clad table and Legrain's recessed wall cabinet, to the right of the frame.

Just as the two adversaries have agreed the shot, and the exposure is made, Jacques hears from below that his visitor has arrived and he laboriously descends the stairs to greet her.

Josephine Baker, the former American, has entered the lower vestibule, this time in the company of her pet cheetah, restrained by a diamond studded collar and lead. Chiquita, the size of a very large dog, appears well-tamed but Jacques prudently keeps his distance and avoids stroking her vividly spotted fur. He brings them up to the vestibule, to the astonishment of M. Zèle. The strikingly beautiful black dancer in her skimpy outfit with an equally striking exotic animal in tow, present a larger than life image, somewhat eclipsing the array of surrounding art.

'Now we have a special addition for the final view of our shoot,' announces Jacques as he introduces the star. 'Of course this is most unusual but Miss Baker, from *the movies,* has agreed to appear for us.' The eyes of the assembled company widen in unison.

Josephine brandishes a happy smile as she listens to each name in turn. 'Gee, I'm real sorry if I don't remember all your names.' She is reassured this won't be a problem and continues, 'This is Chiquita by the way. She is quite tame. I'm just going to give her some kitty food and settle her down.' She brings a bone from her handbag and places it on a silk scarf, also from the same bag.

She ushers the cheetah to the floor and sits cross legged beside her. The company present are more than astonished, confirmed by a wave of nervous titters. Josephine's face radiates delight as she notices above her head an image of a stylised big cat – ready to pounce – etched in glass on the Csaky balustrade, alongside her own feline companion. She points it out with enthusiasm.

'You don't think this might be a little dangerous do you?' Berthe is heard to whisper to M. Joubin, who raises a finger to his lips.

The cheetah happily plays with the bone. 'You're such a darl! Aw yes you are...' Josephine croons at the cheetah, while flashing a smile and flap of her hand in reassurance to Berthe.

Once Fay and his crew have absorbed the surprising arrivals, they continue setting up the camera and lights, facing the Buddha.

'We have only this to go, Monsieur Doucet,' declares Zèle, 'and I'm sure we don't need any models with your *sacred* Buddha.'

Jacques is by now becoming physically exhausted, after three days of toil and the endurance of the unfriendly attitude of the arts editor. He is suddenly perturbed. 'Wait a minute, monsieur!' he exclaims loudly. 'What of the main event?' gesturing to *The Brothel.* 'It is with this, our guest here is to feature.'

Zèle shakes his head with disdain and instructs the photographer emphatically. 'Carry on as you are, Fay.'

Josephine appears baffled. Even Chiquita seems to give a snarl at

the raised voices. Zèle takes a step back. 'We are a family magazine, monsieur,' he proclaims to Jacques.

'Please don't be obstructive. *L'Illustration* magazine features African and foreign subjects quite regularly... What the devil is the issue, man?'

'With due respect, it is nothing to do with Miss Baker. It is this offensive image!' Zèle flounces at *Les Demoiselles.*

'You have heard Monsieur Vignier's account of the iconography, from bow-to-stern.' Jacques argues back, becoming heated.

'But I mean really,' responds the editor. 'Can you imagine – one's wife or daughter encountering such a thing, in the doctor's waiting room?'

'I entreat you, monsieur.' He points to the controversial *Brothel* painting. 'This is the linchpin – the indispensable anchor securing this entire constellation to the twentieth-century.' Jacques veers energetically towards the balustrade to confront the Picasso.

'But scandalous, nonetheless...' declaims Zèle.

'No, no, no! ... Not in this *secular-sacred* context,' Jacques rails, coughing and spluttering. '... I would have thought ... from all our conversations ... these three days you would understand at least...'

The young dancer is startled at the appearance of Jacques suddenly clutching the centre of his chest. She in turn grips Chiquita's lead in response to her raised hackles.

'Are you feeling well, Monsieur Doucet?' she exclaims.

He is unable to respond. Yet Zèle continues to force his words upon the host.

'But a man's wife or daughter ... or servants ... are scarcely going to comprehend such subtleties, Monsieur Doucet, surely you must understand? Besides, I cannot imagine my editor-in-chief will allow such an image to appear in *L'Illustration.* You must see the problem.'

Jacques is now fuming and beginning to lose his temper completely, when another powerful sensation inexorably consumes him. The room is shrinking down to his own body. He loses all colour and a grey pallor sweeps across his face. He sweats profusely and lurches

for the balustrade. He is losing awareness of where he is, or what he is clutching. He stops, as though the region behind his sternum is suddenly assailed by a hammer blow. There is a sharp, fearsome stab, and another – more pounding, punching into his chest. A harsh ringing in his ears renders the words reaching his eardrums incomprehensible. His lungs seem to be closing up. The brain is starving for oxygen. It is such an effort to breathe or stay upright. He lets go of the balustrade, and clutches his chest again in agony before falling down, so quickly and inevitably that the alarmed man in front of him, is unable to break his fall.

24

*There are two different types of people in the world, those
who want to know, and those who want to believe.*

Friedrich Nietzsche

RED EYES AND a bloated complexion from the ravages
of many tears signify Mme Doucet's distress. The doctor has
warned her that the end may be close at hand, and she has
requested a visit from her local priest. Solemnly attired in his long
black vestment, the elderly Father Bérnard carries a prayer book
and displays a large silver crucifix pendant. His arched back makes
his stature appear even shorter than it is – which usefully brings
him closer to bed-ridden parishioners, such as the man he has
come to attend.

'I believe, madame,' he suggests gently, 'it would be more
appropriate, if you seek your husband's invitation for me to go to
him – assuming he is sufficiently conscious to be consulted.'

Jeanne proceeds to her husband's room where he is tucked up in
bed, propped on a cradle of voluminous silk pillows. Here is a
forlorn but stately sight. The spacious bedroom is more *fin de siècle*
than *Le Style 1925,* in keeping with the period villa itself. Jacques
appears diminutive in the large, wide, antique sleigh-bed. From his
pained countenance, one can imagine the radical forward-thinker
feels quite out of place with wood carvings on the head and foot –
imagery a world away from his showcase Studio, just a few footsteps
away via the discrete corridor. It is in essence a gentleman's room.

Jacques appears drawn and is as pale as his snowy beard, sweating
profusely and breathing erratically. Jeanne is not certain if he is

conscious. 'Jacques, my dear, are you awake?' She asks softly. 'How are you feeling now?'

He opens his eyes and peers up to her blurred face. 'Much the same, I suspect,' he grimaces as though still in pain.

'Is there anything you need?' she asks, just as a nurse comes in and mops his brow with a cool sponge, checks his pulse, and leaves again.

'My spectacles, if you please.'

She places them on the bridge of his nose tenderly.

'When will the doctor be here again, Jeanne? What I need most is to be liberated from this interminable *chambre,'* he declares, still with a mind to resist convalescence.

'Later today, dear,' she assures him. 'But meanwhile we have a visitor. Father Bérnard has kindly called and wonders if you would like to see him.'

'I'll not receive him...'

'But he...'

'Not now. Do not presume as to who I'll see regarding such matters!' he snaps, and then softens, seeing his wife flinch. 'No, no. Take no notice of my bad manners. I am sorry, Jeanne my dear. If I'm to see anyone of that persuasion, then it must be Brother Cyprien – Max Jacob.'

'But he is not a priest, Jacques?'

'Ha!' he perks up, 'it's last rites you are after, is it?'

'No, no, Jacques. A priest is very comforting at a time such as this.'

He tries to stay pleasant but fights for control. 'At the deathbed, you mean? Has it not struck you, Jeanne, I have a greater affinity with Eastern religion? How must a man feel to have a religion forced upon him? You would have me receive extreme unction... No! It would probably finish me off.'

'Don't take on so, Jacques. You are certainly showing signs of recovery.' It is true that this is the first time he has been disagreeable since his collapse three days ago.

'But let me have Max Jacob visit. Chivet can go to Saint-Benoît and fetch him.'

'Very well, I'll see what can be done.'

Jacques calls her back as she is leaves the room. 'And Jeanne, *please* would you have Bonnet bring my *Le Destin* screen in here from the study? – That is if you wish to comfort me. I must have *something* inspiring to look at.'

Jeanne leaves the room to dismiss the amiable Father Bérnard. 'I'm very sorry, Father, he will not receive you. At least not at present,' she laments, 'but thank you so much for coming. Your kindness is truly appreciated.'

'You know where I am to be found if you can persuade your husband to allow me to take his confession,' Father Bérnard proffers softly with a subtle smile and making strong eye contact with his parishioner. 'It always makes the sufferer feel more at ease on his journey, you know.'

This reference to 'the sufferer' and 'his journey' brings on sobs from Jeanne as she helps the priest with his hat and coat and leads him to the front door.

Prostrate and uneasy on his sick bed, Jacques is assailed by thoughts of what has been his life, what it might have been, and what might be to come. His imagination oscillates randomly through his professional and personal life and eventually settles on the bundles of personal letters and archives stored in the ground floor rooms below the Studio. Realising that he may not recover from this latest heart attack, he finds himself anxiously picturing his dear wife, and others for that matter, sifting through his papers and everything he is leaving behind.

A little later Bonnet and Chivet discreetly transport the tall, four-leaf screen, *Le Destin* – known as the *Day and Night* screen – into the bedroom where they set up the vivid red object some little distance before the bed, occupying almost entirely the master's field of vision. It leans precariously for a moment and Jacques strains to lift a leg from the bed, in an attempt to jump up to help his men.

Chivet reacts quickly, 'No, no! Monsieur Jacques. Please. We can manage. It's quite safe.'

Jacques reclines against the pillows breathing heavily. His men look to him for approval of the screen's position. He nods when satisfied. Its origins come to him in his moments of contemplation. It is a major work by Eileen Gray, and the most significant *arts décoratifs* commission he had placed with anyone. It was also one of her first works in lacquer, and poignantly provided her big break into this field. After some minor adjustments, he is able to appreciate it, without straining to glean the mysterious shapes on each panel.

'I'm much obliged, gentlemen... Tell me, Chivet, has Madame said anything about fetching Brother Cyprien from Saint-Benoît?'

'Yes, Monsieur Jacques. I shall be there at first light.'

'And Bonnet, do you know what became of the photographers the other day, when I was taken ill...? and Miss Baker?'

'She left straight away. I stayed with the cameramen, Monsieur Jacques, while they completed their last photo. They then packed up their tackle and went.'

'Did they photograph the large Picasso above the stairs?'

'No, Monsieur Jacques. Just the Buddha.'

Jacques suffers a barrage of coughs. The nurse returns and orders the chauffeur and manservant to leave monsieur to rest. Bonnet waits outside in accordance with his master's request. Nurse checks the invalid's pulse again, applies cold cloths to his forehead, offers him water and fastidiously straightens the bedding, leaving the forlorn man looking as though he is wrapped in a mortuary shroud.

When she has finished Jacques calls Bonnet back in. 'I have a very important task for you, Henri,' he croaks, '... and I need to depend upon your absolute loyalty and discretion.'

'Certainly, Monsieur Jacques... Anything at all... What can I do for you?'

'This is a time for last requests, and please be assured, Henri, you have not been overlooked in my will.'

The faithful attendant turns his back on his master momentarily to spill a few tears.

With speech faltering, Jacques struggles through instructions to this

servant of eighteen years, requesting that he go to the old porter's lodge, and retrieve three tea chests of papers stored beneath the workbench. He is to discretely remove them to the basement where the boiler for the heating system is located. This afternoon, when stoking it with coals, he is to carefully feed into the furnace all the papers, diaries, letters and notebooks and incinerate the lot. 'Every last shred. On no account are you to alert Madame or anyone else to the matter. Do you understand?' he pleads. Bonnet nervously accepts the instruction, pledging complete loyalty.

Jacques remains in an extremely delicate condition. The next day the doctor returns and carries out an examination, commencing with checks of his vital signs. He places a thermometer in the patient's mouth. He listens to his heart and lungs with his stethoscope, checks his blood pressure with a pneumatic tourniquet device and looks into his eyes and throat with a flashlight. In all, he deduces that monsieur is no worse but will not hear of him leaving his bed. The physician also discerns his patient is in more pain than he is willing to admit to and administers a hefty injection of morphine.

Once alone, Jacques lies comfortably, but is deeply ruminative. He gazes at *Le Destin* screen, drifting in and out of consciousness, interspersed with moments of delirium. The striking allegorical work, originally inspired by a drawing of a *madman* incarcerated in *Pitié-Salpêtrière* lunatic asylum, features three figures set against a fiery crimson and orange background: a ghostly white, heavily clothed classical character, supported by a smaller, black naked man, and another black naked man with an outstretched arm in close pursuit. Even in his severely weakened state he feels the arousal of his spirit and body. In his increasing confusion he is reminded of Picasso's invocation of African exotic imagery in *Les Demoiselles,* and the jumbled relics of the Trocadéro. Amid blurred thoughts he recalls Picasso's words at his meeting with him among the artefacts of tribal peoples. *'Intercessors. Mediators. They're against everything. Against unknown, threatening spirits... When I first saw them, I understood – I too am against everything. I also believe everything is unknown,*

that everything is an enemy! Everything! I understand what the Africans use their sculptures for.'

Jacques drifts into a hallucinatory projection. His mind clutches at pictures of dusty old shields and spears in that basement, hearing Picasso's words: *I too believe everything is unknown, everything is the enemy! Everything! Not the details! Women, children, babies, tobacco, playing ... but the whole of it! I understand what Africans used their sculpture for... They were weapons. To keep people from being ruled by spirits; to help them become independent and free. They're tools. If we give form to the spirits we become free. Spirits, the unconscious, emotion, they're all the same thing. I understand why I am a painter. All alone in this awful museum, with masks, dolls made by natives, dusty mannequins... Les Demoiselles must have come to me that very day, but not because of the forms; because it was my first exorcism painting, yes!*

He imagines Picasso turning the shrunken head in his hands as he speaks – glancing up to the African masks '... *Those aren't like pieces of sculpture. They're magic things.'*

Jacques' thoughts fly into a vivid dreamscape. Suddenly he is a golden boy of perhaps ten years old. He is running at full tilt. He draws deeply for breath. Across the park he races, and then with swift foot and hands he propels himself up, using aged bark for footholds, he swings himself skyward. Healthy limbs synchronise in a flow of movement. Arise. Arise. Arise. Ever higher. He clings to the lofty branches of the great oak. He must be as close as possible ... the call is 'go higher'. Just a little further. His stretch is immense. So too is his laughter. His prayers will reach the Master Creator. His Will must make it so. Ah *mon dieu,* the effort of physical extension ... the pressed hands point to heaven – a temple of palms making reverence. The vista shakes. He trembles. Every-thing trembles. His grip fails him. All is trembling. *God, make me a painter. Please God, let me paint,* is the cry, smothered as soon as it is uttered. But his hands have been loose too long and the boy falls in a great and fearsome swoop. Blank... The heart pounds in rapid thumps and

the dreamer asks the inevitable questions... ... *Am I dreaming? Is this real? Am I alive? Am I dead?*

One scenario supersedes another. The visions transport Jacques to a theatre of tragedy – rushing him to the Café l'Hippodrome – the old world of long skirts and starched collars. Casagemas stands taut, addressing the dinner party with something like poetry. Eyes fix upon the intense poet. Customers occupy smaller tables nearby, among whom is Jacques' own Sonia, who sits quietly watching...

Carles shouts ... muddled, macabre words ... shoots at the lovers ... hits a glass. Like a burst of music, it explodes. The troubled young man dashes the gun to his own temple and pulls the trigger. BANG. There are screams. Frantic figures descend into a chaos of movement. One is Sonia. She rushes to Carles's side as he makes a gory mess of death. She places her shawl under his head, muttering comfortingly and blood gushes out, flooding the floor.

Jacques tosses and turns, highly disturbed, talking in his sleep. *You ... Sonia? ... You were there? Picasso took him to brothels... Did he paint Carles's brothel?* Sonia's face becomes twisted, distorted and fragmented, part-metamorphosing into the central figure from *Les Demoiselles.*

There is blood everywhere, Sonia rasps. *Red paint. Ruby red! Deeper and darker than the red of Le Destin! What are you doing with the picture, Jacques?*

'But how? How did it come about?' he cries in frustration, 'Why did he paint it?' His questions come one after another. 'What is its place?' Jacques pulls himself up in the bed with his arms in a sudden start from the nightmare, as if trying to escape. Max Jacob is sitting at the bedside. After some moments of considering dream and reality, the dreamer readjusts to full consciousness.

He hears the kindly words, 'Monsieur Jacques, it is I, Brother Cyprien. I am come. All is well. You were dreaming and saying some strange things, my friend.'

'Pardon me, Cyprien. It is that blessed doctor. I don't know what medicament he has pumped into my veins.'

'I gather you have been close to the golden gates – yet again!'

'Which gates? Who is the designer?'

'Monsieur Jacques, you are safe in your bed. Look about you.'

Jacques focuses on the screen. He turns to the monk clutching his hand.

'Cyprien, no last rites... No last rites, you understand.'

'I have just had the pleasure of seeing the Studio again. Jeanne allowed Bonnet to show me round.'

'And...?'

'Putting aside my concerns about your spiritual digressions, it truly is a magical kingdom, Monsieur Magicien!'

'Do you know, Cyprien, something extraordinary has happened? Now that Picasso's fearsome picture has found sanctuary, I have ceased to enquire further, to fret and brood. Something has changed ... I think my ghosts are vanquished.'

Max is astonished.

'... Perhaps I should have just stuck with the world of fashion rather than lose my head in such diversions.'

Lost for words, Max remains still, contemplating the glowing coals in the fire before finding his tongue. 'After all we have been through?'

'I know,' he confesses. 'I'm a blithering old goat! In these times of strange dreams, I keep finding myself a painter. I was to be a painter, once,' he laments soberly. 'I might have been that – The Painter, not The Collector.'

'Seriously? If you had existed simply as a dressmaker, many of us would surely have starved. You are our great defender! ... and a true artist of a kind! Imagine if I had been your patron?' Max jests. 'No, our fates were ordained by The Almighty – just as Picasso's was. He was appointed too. Imagine if his sister had lived? Ha! Our dear Pablo might have stopped painting – and you would never have landed your masterpiece.'

'The burden of which has weighed so heavily, and for so long upon my shoulders.'

'Cubism may never have been invented and the rest...'

Jacques is suddenly alert. 'What's that?' he cuts in.

'I said Cubism might not have been invented.'

'Yes, I heard you. But why so?'

'Before his little sister died, he had vowed to abandon painting – if she could be spared. He even burned his brushes...' Max begins to elucidate, but stops upon seeing that Jacques has slumped down and is drifting away in sleep. As he begins to gently snore, the monk adjusts his robe and prepares to leave.

25

*An artist has no need to express his mind directly in his work
for it to express the quality of that mind; it has indeed been
said that the highest praise of God consists in the denial of
Him by the atheist, who finds creation so perfect that it can
dispense with a creator.* – **Marcel Proust**

MAX JACOB HAS withdrawn and the patient is left alone, heavily medicated. He wanders in and out of consciousness with fleeting thoughts of his last visitor. After falsely believing for a few moments, that he had been released from his obsession, the sensational revelation from Max has engendered a fresh sense of confusion. His unruly mind is provoked into a creeping realisation: he just cannot let go. Obsession bears down with greater intensity. *That damned painting is a blight,* he frets again. He cannot help but try and piece the segments together. Still, something else is awry.

Agonisingly, he climbs out of bed. It is a huge effort. In his attempt to slip his shaking arms into a quilted dressing gown, he can barely manage the task. Taking a sip of water is laborious work. He stuffs a pillbox into his breast pocket.

Jacques drags his decrepit body to a small side door and makes his way along the plain, narrow corridor leading to the Studio vestibule. Reaching the discrete door, adjacent to the Shakyamuni Buddha, he stretches to reach the array of electric light switches.

Arriving in the silent Studio, he is pleasantly overcome with the astonishing scene of exotic colour, dazzlingly illuminated art, fabrics, objects and opulent surfaces. The tattered figure of the man staggers

through the principal salon, to the desk at the rear. He seats himself on Pierre Legrain's lacquered version of the *Throne of King Ghezo,* and with increasingly laboured breathing, and hunches over the ebony bureau. His vision is blurring. He fumbles for an amyl nitrate capsule, snaps it, inhales deeply and recovers, but experiences a chimerical effect.

Gazing across to Rousseau's *Snake Charmer,* the picture appears to interfuse with another painting. *It is surely Le Rêve – the Douanier's dream, in which his naked Yadwigha luxuriates on a crimson velvet sofa in the jungle?* He ponders the illusion.

From Jacques' viewpoint, now hallucinatory, from the sway of the morphine and the capsule, he fleetingly perceives the red sofa below the *Snake Charmer,* occupied by his long-ago muse, *Sonia! What kind of trickery is this?* he whispers. The apparition dances away but then reconfigures. The invalid remains breathless at his desk.

He turns his head, peering towards *The Brothel* in the distance. His experience shifts. The inanimate becomes animated and the conjurer invokes upright figures: his younger self, beside which the raven-haired Sonia, so real in every particular, smiles inscrutably. He watches. The couple are handsomely paired, in twenties lounge attire. They stand together, alongside the Buddha, with only Joseph Csaky's sculptural balustrade shielding them from Picasso's brazen whores.

As Jacques grapples with these strange visual illuminations, he sees himself leaning into her space. The apparition finds its voice: 'Sonia, how I wanted you for mine. The yearning never passed.'

'You wanted a dream we both thought I was a part of,' she tells him gently. 'It was a fine dream, but our love was not like that.'

'No? That is cruel. My life ebbs away now. But you? You were so constrained by a husband ... yet you raised yourself above everything ... You, the *snake charmer...* Did you rise above death...? There was something primitive about you... While I suffocated in all that pulchritudinous couture, and art too, you questioned everything. Then you were gone! You could have made me happy.'

'It is not true. You were made for a different kind of love, Jacques

... like a great classical lover. You have a passion unlike that of a man for a woman. I would never have sufficed.'

'No! No! No!'

'Do you not know who you are?'

'This is not about me! Never me! Do not talk of me,' he pleads.

Sonia remains silent, deftly evading Jacques' outstretched hand. He becomes more forceful. 'Tell me about the painting. It is all I want to know. If Picasso's sister had lived ... little Conchita ... what then?' Sonia, implacable, ghostlike, glances smilingly at Jacques, as they turn, and lean against the stair rail – with *Les Demoiselles,* now a backdrop to the ailing man's vision. The ghostly Jacques changes tack. 'I was traumatised... Did I possess a work so wicked? Little wonder the Louvre was outraged,' he continues softly. 'New art had exploded in their faces ... and I, foolishly expected them to take it to their bosom ... this work, this totem,' gesturing to the picture. 'The detonator that wrought a trail of destruction, attacking all they held dear ... six centuries of Western painting – the destruction of their art.'

'But these demoiselles *will* have a voice for eternity, in some great institution,' Sonia's voice resumes, 'once the bigwigs come round... In the meantime you have it. And why should you not?' She looks around and back towards the great painting with the balustrade and staircase before it.

'They step into our space at the very point where entry into *our* world is anticipated. We have to face them and what they stand for. We cannot know what they mean. Here is a vile portrayal of ugly women, diseased women, giant, deformed, megalithic women, ready to lumber carelessly into life. Woman the predator, loping into the space of men – leering as she offers her cleft, the black hole ... orifice of oblivion... That is obvious. Hatred of women ... yes, no, perhaps?'

'Enough. Enough.'

But she will not stop. 'Perhaps we have an eloquent decree – a defence of womankind?'

357

He holds himself, rigid with shock at her words. The spectre of Sonia waxes on. Her black hair glistens. Picasso's harlots loiter at her fair shoulders, seeming almost to be at her side.

'These demoiselles are not made easy. *Woman* is shown for how she is treated – bought and sold as a chattel. This picture rails against relentless consumption, in an industrialising world. For now everything is to be consumed ... woman ... and all the world's bounty, from empire to emperor. There is no escape from consumption. We are all guilty. The painter points the accusing brush at men, pluckers of pleasure, for holding women up for scorn and woman too for her submission.'

'Enough now. Enough,' he gasps.

Her scarlet mouth opens and closes and yet he is mesmerised by its dance, as well as by the words.

'Here is a painting of geography and of war between the great regions and cultures of Africa and Iberia. The raging artist slices, in an animal attack. Bodies are attacked, in torsion, into components and reassembled. Here is a flashpoint at the bloody boundary – a declaration to the Moors and Iberians – the content is drawn from history's weight bearing down upon the painter. He cannot leave it behind.

Carthage is remembered. The conflict plays out within these strange octoroons. Black faces on white bodies. What does he mean? One side of the canvas is at war with the other. Serene white body parts jostle with black. Black what? Black Madonnas? La Moreneta? Black Mary? In Africa, black virgins ward off disease and disaster. Think of the sketches again ... the medical student, the skull, syphilis, death and the three melon slices – three crescents – mark of the Infidel! The identity of Pablo Ruiz Picasso is here truly, splurged for us all to see, and yet he eludes us... There is too much to unravel.' Jacques the Younger turns to face his muse and approaches her. She is close but unreachable and vaporous.

'Picasso was haunted. Carles was the catalyst. Or was it Conchita, the little sister?' he asks.

The room seems to spin, around and around. He has the sense of being trapped. *Am I inside a drunken cell? Whoah, is it that I am watcher or watched?* Their motion increases to a powerful quick-step. They have a joyous and arresting vigour, until the effect slows. The dancers pivot and halt. The illusion recedes to be gradually eclipsed by another – which expands to fill his full field of vision. The ghostly couple, now quietened, reside at the silvery balustrade. The spry hero advances a friendly arm towards his heroine but she has no solidity.

Conjured before them, there in the picture frame, the thirteen-year-old Pablo Ruiz Blasco sits at the bedside of his younger sister Conchita. The spectres of Sonia and Jacques casually observe, as the old body looks on, Pablo capturing with his pencil the little girl, as she lies dying – the child's face sickly pale in a halo of curls, stricken with diphtheria.

The boy puts down his sketch and kneels. He prays at her bed-side. *Father in heaven ... I worship You... If You save her ... I will sacrifice the only thing I have... I promise, I WILL NEVER PAINT OR DRAW AGAIN. I promise You, I will even do this, if You spare my sister.*

'The bargain is the work of Satan,' remarks the youthful Jacques.

The vision reforms. There is a patch of rough wasteland. Somberly, Pablo makes a fire with kindling. The boy snaps wooden sticks. He is burning paintbrushes. Then he is gone.

Again Pablo prays at Conchita's bedside. A priest enters. They pray together.

'When she dies,' continues the young Jacques, 'Pablo is relieved, at being bound no longer by his promise to abandon painting. *Because* Conchita died ... he believes it is GOD'S WILL – God's Will that he should be a painter... Given his Promise, Conchita had to die. Pablo realises he has been put on this Earth to do God's work – to use his extraordinary divine gifts to create beauty.'

The image is superseded by another – a haberdashery shop. The boy examines a range of horsehair paintbrushes. From a small leather

pouch he picks out pesetas in exchange for all of the brushes. He smiles broadly – his diabolical eyes full of light.

The vestibule and rooms beyond seem to pivot and buckle once more. The ghosts, he and she, resume their dance. Just as the spinning of the Earth is imperceptible to one standing on its surface, he feels as though they are at the still point, in a perfect union – but they move in perfect time. The ethereal couple step and glide with lightness and new liberty. Sonia spins away and young Jacques fades. The old man feels bereft.

Then he hears her voice, and sees Sonia again, ravishing in black, standing beside him: 'Just as Conchita was not spared, God did not save Carles from himself. Demons of guilt depressed and haunted Pablo, as a boy – and Picasso as a man.'

Old Jacques grips the desk, strains to hold on and gasps. He stares at Picasso in the picture frame. The sweating youth is in the basement studio, toiling at the face of the great canvas – naked, except for a swathe of fabric covering his manhood. He balances deftly from a stepladder. His brush darts about. On the adjacent table are two Iberian limestone heads. He tickles the paint onto the canvas in fluid strokes – snatching features from the ancient carvings.

Sonia continues, 'The infusion of vacant, staring eyes – from Iberian stone faces – conjured the flesh-and-blood of his ancestors – *family* – a stricken young sister. But it wasn't sufficient as an exorcism in paint on canvas...'

Picasso turns to the top right figure and paints over the Iberian face, replacing it with an African mask ... he mumbles. 'Might not witch doctor fetishes ward off demons?'

'Was this an act of atonement – FOR CONCHITA AND CARLES?' Jacques shouts.

'No! No!' she demurs. 'It is salving his guilt. The guilt of feeling relieved... The guilt of feeling happy ... of being released from the naïve childish promise he made to God... Every time he picks up a pencil or a brush, he knows he can do so, *because of* the death of his sister ... This burden he shoulders... The burden of feeling that

God took Conchita in order that he, Pablo, would be the supreme artist in His firmament?'

'So Picasso believed that the artist he became was *God's Will?'* says Jacques. That is what he supposed.'

'Isn't everything the *Will of God?'*

'Did you know of this pact?' he demands of Sonia. 'Is it true? Tell me. I must know! ... WAS THIS WANTON REVENGE?' he shouts, gesturing to the picture.

'TO PUNISH GOD, yes!'

'P is punishing K ... Kostro ...' he murmurs... *'with The Brothel...* How K?'

She laughs playfully – *'Picasso punishes K, Kyrios* – written in the Greek – means God!'

He stares aghast. 'So... So Picasso set out to punish *God...?'* The question hangs heavy in *the ether.*

'When he saw El Greco's *Sacred and Profane Love?* Just as he was agonising on how to respond to Matisse's glorious Painting of Modern Life, he perverted a four-centuries-old altarpiece into his own iconic monument, not to celebrate God, but to slap God in the face!

'Picasso had been anointed with a unique genius to create beauty, but he used these gifts as a means to destroy ... *to dismantle beauty* ... unceremoniously rejecting God's Precious Gifts.'

Jacques tries to grasp Sonia but she deftly evades him at each attempt. 'Blasphemy or not,' she continues, 'wittingly or unwittingly, he strangled the Beautiful in art, clearing the way for a different understanding of beauty to emerge in the new age... For better or for ill, the Look of the twentieth-century was cast.'

'And the *meaning* of the painting...?'

'That is the whole point, Jacques. It has no tangible meaning.'

'No meaning!?' he exclaims '... I have searched for years for the meaning.'

'Little wonder you didn't find it. There is no narrative. It is not a window on your wall... It is the *absence* of narrative that gives it its power... There is *no* story here!'

'But there was a sailor and a doctor with a skull,' protests Jacques, 'I saw them in the sketches.'

'Yes, and he removed them in order to kill off any sense of a story ... reshaping it away from horizontal, further rejecting the convention of narrative painting.'

'No narrative? No meaning? What the devil is it for?'

'The flattened, perspectiveless whores have nowhere to go, frozen in the frame, packed like fish in a box of ice, and hence their only place to go is to burst out, towards you. So not a window on the world but an invasion into *your* world...

'Your *Brothel* canvas is a work of Formal Invention in painting ... a *re* - invention of painting ... an experiment ... from Picasso's laboratory ... a new kind of painting in which *form* surpasses *content* ... a freedom devised by a complete rejection of narrative meaning.'

'But I knew it really,' he keeps repeating.

'Now that you have such a powerful work isn't it something to revere?'

The rasping man, clinging to his desk, struggles to remember all he has learned about *Les Demoiselles,* and Picasso's extraordinary words ... *Everything ... all of creation is the enemy.* Picasso sought not to make art, but weapons for combat – against creation, against nature, against GOD and creator of all ... so this is what he meant when he said to me, *Nature HAS to exist, so that we may RAPE it!*

Ah, Picasso, you did fool me, but never in the way that I thought!

'And you, majestic Raven, eliminated from this temporal Earth by Roux, for what he called witchcraft: for communing with a deceased child.' Could this have been Conchita?' he asks, as he assembles the pieces in his fading mind.

'*She* was the innocent victim in God's plan, as the boy Pablo saw it!'

But as he speaks, the enigma of Sonia fades fast and the room reappears in sharp focus.

I see my part in this. I have been locked away – false to my body and inner being. I have failed to answer love's call. I have tried to

rediscover myself, as if time does not exist, touching innumerable objects, and all the while my hand stayed pure.

He turns to the empty space where Sonia had seemed to stand so powerfully.

My Sonia, farewell. You knew. You saw, I have passed a life unlived. This is all for nothing. All I wished for was to look forwards. This is my pain – my Temple de l'art is a Temple to a Life unlived! To all my ravishing artists... He struggles to emit his words. *Ah, at least I have helped them.*

In his moment of realisation Jacques battles to retain his posture at the desk, but his strength has completely dwindled. He leans forward with his breathing laboured.

Picasso hated God. And I, Midas, loved my Young Tigers, but could never reach them. He could paint at least, but I could never be myself, Jacques cries softly in sorrow for himself and also with relief at perceiving the mystery in a fresh light.

Unseen by Jacques, Jeanne arrives in the room from the staircase below *Les Demoiselles,* emerging as though from the painting. She discovers her husband's condition, runs back to the staircase and shrieks, 'DORA, DORA, THE DOCTOR! QUICKLY!' Jeanne rushes to her ailing husband and loosens his collar. His breathing is alarmingly noisy. She strokes the back of his head very tenderly. 'Oh dearest, you are exhausted,' she utters gently with tears forming.

Jeanne holds his hand lovingly, as if knowing he has just moments left. Among a number of items on the desk is the small silver framed photograph of Sonia. Just before losing consciousness, Jacques turns it face down. He meets with Jeanne's eyes for the last time and is able to mouth to her a few sweet words. 'It's all yours now... *You* are my beloved ... my darling dear,' choking out final words of kindness, to she whom he has battled with, but always stood by him, whenever it has mattered most. Jeanne smooths his white hair from his brow and straightens the lie of his beard. Glancing up and around the extraordinary space, her attention is inescapably drawn to *Les Demoiselles d'Avignon* in the distance. Instead of seeing ugliness

and feeling revulsion, she has a sudden recognition of a savage beauty. She is confused by the sensation – a turnabout from all previous reactions. Quickly reverting to Jacques, she discerns that he has quietly expired. Jeanne picks up the framed photograph of Sonia, without noticing the strand of black hair behind the glass, and returns it to the upright position. Her tears fall upon her dead husband's peaceful and contented face.

26

T H E P R E - E M I N E N T art dealer, René Gimpel, who
bought Jacques Doucet's Neoclassical villa in the rue Spontini,
makes an entry in his diary:

October 31 / Jacques Doucet is dead.
*This Couturier was the great gentleman of our time, the
Medici of our circumscribed age. More than fifteen years ago
he was the first to see that our country was going to
revolutionise the world with a new art form and he slammed
the door on the eighteenth-century, which, it is true, we had
brought back into taste, but whose mission was over and
done with. He sold his Fragonards and his Houdons, to buy
Manets and Cézannes. His greatness goes beyond that, to his
having, at sixty, fought on behalf of the artistic youth which
was to lead France towards new honours.*

On a bitter day in November 1929, nine mourners, including
Mme Doucet, huddle around the ashlar stone Doucet family
mausoleum in the small Neuilly-sur-Seine cemetery. The private
burial committal is ending. Jacques Antoine Doucet, who escaped
the barbed clacking tongues of the rue de la Paix had sought his

salvation through his own passions and creativity.

A stark silhouette moves towards the cemetery gates. In the street, a lonely, diminutive, respectable figure, in fine woollen coat and flat cap, walks past. It is Pablo Picasso. He pauses at the gate, to allow the mourners to disperse. 'Whose funeral is this?' he asks.

'Jacques Doucet – the dressmaker,' a neighbour, Mme Jonas replies.

'But there are so few here?' remarks Picasso in surprise.

'He was very old, and scarcely any longer of use to anybody,' replies Mme Jonas.

'You knew him then?' asks Picasso, taken aback.

'After a fashion.'

Picasso watches the veiled Mme Doucet, grieving deeply, in need of bodily support, as the small group of mourners silently and slowly proceed to their funeral cars.

AUTHORS' NOTE

Our story opens in the first decade of the twentieth century when the puzzle of 'modern art' erupted and began its inexorable dominance of the visual arts. In the course of our story we have been able, with the aid of its principal players, to weave a realistic account of how and why this came about.

An historical fiction requires an inevitable compromise in balancing actual truth and imagined fiction. *Picasso's Revenge* involves real people and real events taking place in Paris between 1900 and 1929. In essence, it is a drama intended to capture the truth. On the factual side the novel dramatises the activities of two giants in their respective fields: the couturier-collector Jacques Doucet and the painter-artist Pablo Picasso.

The thrust of our story is told with due regard to biographical facts. The substance of the narrative remains faithful to history, involving an account of how and why Pablo Picasso created a singular, epoch-changing artwork in 1907, and of how Jacques Doucet acquired and deployed it. Nonetheless, a measure of fictional latitude has been assumed where gaping omissions in the historic record persist.

We have endeavored to adhere to Picasso's true history: the tragic losses, beginning with the death of his baby sister Conchita and his abortive 'pact with God' to spare her, and later the suicide of his friend Carles Casagemas; meeting and living with Fernande Olivier at the Bateau-Lavoir and emergence from his Blue Period; the creation of *Les Demoiselles* and the utter disdain with which it was received by almost all of his friends and associates.

The purchase of the painting by Doucet in 1924, engineered by

his art advisor André Breton, is all faithful to history. Unlike the Louvre's acceptance of the Douanier Rousseau's *the Snake Charmer,* the museum refused to accept '*Les Demoiselles*' as a bequest. This led to Picasso feeling that Doucet had let him down.

Doucet's abortive engagement to Jeanne Roger in the early years of the century and their much later marriage in 1917 is also true, as is his affair with a married woman, only identified as 'Madame R', who died in mysterious circumstances on the eve of her asking for a divorce. Doucet's grief, leading to the dismantling and dispersal of his revered antique art collections, were real events, as was the building of the two great libraries. Details of his relationship with Madame R, whom we have called Sonia Roux, are unknown and have been imagined. But aside from Sonia and her husband Serville, all other principal characters are based upon the known lives of real people. All the works of art cited are also real.

A substantial part of the story involves Doucet's friendship with the poet and onetime close confidant of Picasso, Max Jacob. The latter has been our device to explore and depict Doucet's angst, although in real life the two men were associated, but necessarily to an indeterminate extent. Doucet acquired and exotically book-bound the poet's works. The bibliophile also employed the young Surrealists in his library, earning him the recognition that he "financed Surrealism," and they were indeed known as the "Young Tigers."

Finally, the Doucet villa in the rue Saint-James and the unrivalled Studio built above the lodge are every bit as accurate to the collector's realised project as the true historical record could permit. Photographs published posthumously in *L'Illustration* have been relied up for the portrayal of what we consider to be Doucet's finest accomplishment.

RF & CF

AFTERWORD

*In 1971, at the age of ninety, Picasso declares himself '...
ready to kill modern art, and thus art itself, in order to
rediscover painting'.*

I'LLUSTRATION MAGAZINE published its exclusive article
on Jacques Doucet's Studio on 3rd May 1930, written by his friend
André Joubin (sans Vignier's iconographic narrative). In the otherwise
monochrome, 68 page edition, the feature included seven fabulous
colour photographs – the only record known to exist (until 1989) of
Doucet's *Temple de l'Art*. Extraordinarily, as portrayed in this
novel, the magazine did not include Picasso's *principal painting*.

Sadly for posterity, no other publication covered the project. No
photographs were known in which *Les Demoiselles* is shown in situ.
In fact, the subsequent literature surrounding the Studio frequently
cast doubt on the actual location of the major picture – some even
suggesting Doucet had installed it in his bathroom!

During a period of mourning, Mme Doucet maintained the rooms
as a shrine to her husband, although she promptly endowed the *Sui
Dynasty Buddha* to the Musée Cernuschi, the Asian art museum of
Paris. The Studio was closed, and untouched, save for the maid's
occasional forays into the rooms for dusting and cleaning. It was
inevitable, however, that it could not remain in this way in perpetuity,
if only because of Doucet's bequest to the Louvre of Rousseau's *La
Charmeuse de serpents* – quite aside from any pecuniary

considerations Mme Doucet and her family may have entertained.

In 1935 she admitted important visitors from America: art dealer Germain Seligmann, who had previously visited with Anson Conger Goodyear in 1929, shortly before Jacques Doucet's death, and Alfred H Barr Jnr, then director of the embryonic Museum of Modern Art in New York. This visit not only heralded the dismantling of the project, but removal of its principal work. Seligmann negotiated the purchase of *Les Demoiselles* and five other Picassos, including *L'Homme à la guitar.* On 15 September 1937 Mme Doucet signed a receipt for a cheque for 260,000 francs for the paintings, of which 150,000 was in respect of *Les Demoiselles.*

René Seligmann immediately wrote to Picasso offering him the opportunity to come to their gallery in the rue de la Paix to see the picture before its export to the United States. 'Picasso was there almost before it was unloaded from the truck,' said Seligmann. 'He examined *Les Demoiselles* with eagerness, remarking on its perfect condition and how well it had stood the test of time, both technically and as a key to the revolutionary movement it instituted.' The picture sailed on the Normandie from Le Havre on 9 October 1937.

In November there was great excitement at MoMA when Barr informed the trustees that *Les Demoiselles,* 'can be had'. Jacques Seligmann & Co. Inc. mounted a month-long exhibition of their haul at their East 51st Street galleries, along with a further twelve Picasso paintings from elsewhere, entitled *Twenty Years in the Evolution of Picasso, 1903-1923.* The Seligmann catalogue included the statement:

> ... the ... purpose is to exhibit to the American public a
> selected group of paintings from one of the most famous of
> all sources, the distinguished Jacques Doucet Collection.
> These pictures have never before been seen in America and
> have seldom, if ever, been in European exhibitions.

The event generated considerable press coverage, not least of all because of Picasso's highly controversial *Brothel* painting, of which a photograph was invariably included. The *New York Times* said ... *Some of the items on view are pretty sure, even at this late date, to prove caviar (or pickled tripe) to the public at large.*
Henry McBride of the *New York Sun* was a trifle more poetic:

> The Doucet residence ... became a place of pilgrimage but not everyone who wished got inside the gates...
> Here [at the exhibition] for instance is – or possibly one should say are – 'Les Demoiselles d'Avignon', who danced upon the bridge in that celebrated city and got considerably shaken up by their experience, for they seem to be in pieces, and their visages flash at you from different planes, as though you were catching glimpses of them through a rapidly revolving kaleidoscope.

Jerome Klein of the *New York Post* had words to say on the ethnic nature of the principal painting.

> For the centerpiece of the show we have the great canvas which Picasso filled with a jungle of figures (based on African Negro sculpture) in 1907 and slyly titled 'The Young Ladies of Avignon'. Nearly three centuries earlier Nicholas Poussin had remarked the classic beauty in the young girls of Nimes. But Picasso sought another rhythm, more like the wild beat of the tom-tom.

Meanwhile, Royal Cortissoz of the *New York Herald Tribune* did not appear to have joined some of his art critic colleagues in the twentieth-century, and certainly entertained grave doubts about the validity of the art of Picasso, and alluded to the glories of Jacques Doucet of some thirty years earlier.

> [The exhibition is] organized to demonstrate 'an evolution through the Negroid, Cubist, and Classical or Monumental Periods'. I love all this talk about the 'periods' of Picasso, so

comically suggestive of an organic growth that it is impossible to perceive in his art. As a matter of fact, Rothenstein went to the root of the matter when he said of the 'gigolo of geometry' that this 'sad esthetic rake spends each weekend with a different style'. There is no link of evolution that can be detected binding the 'Tete d'Arlequin' at Seligmann's, which represents Picasso in his more conservative vein, to 'Les Demoiselles d'Avignon', with its anatomical distortions and grotesque physiognomies. That picture, I may note in passing, recalls a curious mutation in the taste of a connoisseur. It comes from Jacques Doucet's collection. When I knew Doucet, his house in the rue Spontini was a sanctuary for the dix-huitieme, his pictures, drawings, furniture, statuary, bibelots and the rest making one of the most entrancing interiors that have ever existed in Paris or anywhere else. Then he dispersed it all at a memorable sale and 'went in' for things like 'Les Demoiselles d'Avignon'. I wonder, in heaven's name why? Did he see beauty in this ugliness? Did he see any sequel to the superb craftsmanship of the eighteenth-century in this careless rendition of forms? I can see only a talent pathetically wasting itself on capricious experimentation. The present exhibition may be useful as satisfying curiosity. It can give pleasure only in the few instances of a fitful adherence to the constructive tradition of French art.

At a meeting of MoMA's Advisory Committee on 9 November, just nine days after the exhibition's opening, and despite the media polemic, Alfred Barr's recommendation to purchase *Les Demoiselles* was accepted. The painting was promptly reserved at the Seligmann gallery.

Two days later, the Board of Trustees discussed the proposals from the Advisory Committee and it was agreed, '... If possible *Les Demoiselles d'Avignon* should be acquired for the permanent collection *as an epoch-making work,* a turning point in twentieth-century art.' Funding for the agreed sum of $28,000 (700,000

French franc equivalent – against the 150,000 paid to Mme Doucet just three months earlier!) involved a complicated mechanism. MoMA was still two years away from moving into its permanent 53rd Street home, presently under construction, and had no purchasing fund.

On 17 December the museum's Board of Trustees confirmed that *Les Demoiselles* had been purchased. $10,000 had been donated anonymously and the balance of $18,000 was to be raised through the sale of *At the Race Course* by Edgar Degas, a painting originally given to the museum by the late Lilly P. Bliss. Under the terms of the transaction, Bliss would always be credited for the acquisition of *Les Demoiselles* with the inscription, *Lilly P. Bliss Bequest Fund*.

On 6 December Seligmann wrote to Picasso out of courtesy to inform him MoMA had purchased *Les Demoiselles d'Avignon*. By coincidence the following day the Louvre formally considered the Doucet bequest of Rousseau's *La Charmeuse de serpents*.

Decoupling Picasso from Rousseau was only a temporary separation, for in due course *Les Demoiselles d'Avignon* and the latter's *Le Rêve* would reside side by side in MoMA. For Picasso, however, this final resting place for his magnum opus, rather than his original desired location of the Louvre, may have served him well in posterity. On the one hand, while the prestigious portals of the Louvre might have been the ultimate accolade and legitimisation, on the other, MoMA as the world's most influential institution of *modern* art might have been an altogether superior alternative for the artist's purposes. The centre of gravity of avant-garde art practice was shifting – or would shortly shift – from Paris to New York. Whether because of, or in spite of, the presence of *Les Demoiselles,* large-scale, colour-field canvases of American Abstract Expressionism soon became the Western world's leading *ism* in art. The physical scale of *Les Demoiselles* and recognition of its greatness by a new generation of American practicing artists, together with the arrival of (the very much larger) *Guernica* – on loan to the new MoMA from Picasso, pending the Civil War and

political turmoil in his Spanish homeland – did not escape the attention of Jackson Pollock, Mark Rothko, Barnett Newman, Willem de Kooning, et al.

In 1988 the Musée Picasso, Paris staged a one-man/one-painting exhibition for *Les Demoiselles d'Avignon*. This 'block-buster-style' show commanded a two-volume, seven hundred page catalogue, compiled by curator Hélène Seckel with substantial content from Jacques Doucet's biographer François Chapon, Christian Zervos author of the *catalogue raisonné* of the works of Pablo Picasso, the Alfred Barr papers, MoMA, and the Bibliothèque Littéraire Jacques Doucet. This forensically researched catalogue stands as a major reference work on the painting, but despite the pain-staking scrutiny, its authors and curators could still only speculate as to the definite location of the painting in Doucet's Studio.

The exhibition itself showed many of the 809 preparatory sketches Picasso had made for the painting, along with a number of relevant associated works by the artist and by others – notably El Greco's altarpiece, *Apocalyptic Vision (The Vision of Saint John)*, 1608-14, by then owned by the Metropolitan Museum, New York – a canvas Picasso admired – of similar size and with certain shared features. (At the time *Les Demoiselles* was being created, the El Greco was owned by Picasso's friend, fellow Spanish artist Ignacio Zuloaga, living in the locality of Montmartre).

The main painting was given its appropriate prominence, with just a tiny square plaque alongside:

Cat. 29
Les Demoiselles d'Avignon.
Juin-juilet 1907.
Huile sur toile.
243,9 x 233,7 cm.
New York, The Museum of Modern Art, acquis grâce au legs Lillie P. Bliss, 1939, ancienne collection Jacques Doucet

A year later, in May 1989, a set of eleven black and white photographs emerged, in a Sotheby's, New York, sale of the famous Philip Johnson Manhattan Town House and contents. The photographs included a view of *Les Demoiselles* in its premier location at the head of the sequence in the vestibule of Doucet's Studio (as described in this novel). The source of these photographs is not known for certain, beyond being part of that sale in which furniture and documentation from Doucet's project were included, with the documentation being an archive of Pierre Legrain, and the suggestion that the pictures were taken by or for the designer.

In 1994 MoMA published *Studies in Modern Art, Les Demoiselles d'Avignon,* by Hélène Seckel, William Rubin and Judith Cousins. This work updated further and elucidated the two volume catalogue of the 1988 exhibition. Notably, it includes reproductions of the cache of monochrome photographs unearthed in the Sotheby's sale of 1989, although by then reproductions of these images had become ubiquitous. Many books and other publications have appeared throughout the years and it is true to say, more has been written and published on the analysis of this one painting than any other in the history of modern art and probably in the history of all art - even *Mona Lisa.*

Taking a broad overview of modern art, after more than a century since the great watershed moment that was Picasso painting *Les Demoiselles,* the uniqueness of the occurrence - Apollinaire's *metamorphosis* - can be reduced to one very simple revolutionary idea: from this moment henceforth, painting was liberated from having to be *a window* on the *physical, visual* world. Conventional representation and perspective as *de rigeur* were unceremoniously jettisoned. The floodgates were opened and within a handful of years a cascade of *isms* swamped the art world: Cubism, Futurism, Dada and Surrealism, Abstraction, Constructivism, Expressionism and the rest - all percolating through into the applied arts, graphic design and architecture. Art was emancipated and the look of the twentieth-century cast.

Fictionally attributed to Max Jacob is a theory of the avant-garde:

> *[such artists] exist on a very thin line. Before this line there is no originality – as in, it has been done before, or is mere repetition. Anything beyond the line, however, is too radical, and no longer recognisable as art.*

Les Demoiselles crossed the line, hence Picasso's great struggle to have it accepted. Although the painting was not exhibited for a full decade, it was seen in the artist's studio by key painters working in or visiting Paris at the time. But its chief impact was felt by Picasso himself, manifest in his works that immediately followed, and later notably Braque, with whom he would join forces in further developing Cubism. Their peers quickly joined the revolution with gusto.

While Impressionists had been radical in their means of portraying a scene, a person or an object, and the Fauves even more so with their violent use of colour, such previous movements remained within the six-centuries-old paradigm of Western art, representing that window on the visual world and doing so with visual perspective. Extraordinary as it may seem today, a little more than a hundred years ago this breakthrough was as radical in the arts as was the contemporary revolution in science being wrought by Albert Einstein, whose Theory of Relativity was published in 1905.

As for *why* Picasso made his move in 1906/7, arguably the single most dramatic development in the history of painting, the account of Jacques Doucet's revelation in the penultimate chapter may suffice. The facts as portrayed, concerning Picasso's motivation, are largely in accordance with the published record and words of the artist himself and substantively not indebted to fiction. This, one of the great stories in art, is possibly the first time the various strands have been drawn together to better understand *why* – even if (at least partially) unwittingly at the time – Picasso invented *modern art* and helped determine the *look* of the new century.

Finally, it is worth mentioning, *Les trois danseuses (The Three*

Dancers) was purchased in 1965 by the Tate Gallery, London, in a transaction brokered by Picasso's artist friend, Roland Penrose, a major collector of modern art. The painting bears the label:

> The jagged forms of Three Dancers convey an explosion of
> energy. The image is laden with Picasso's personal
> recollections of a triangular affair, which resulted in the
> heart-broken suicide of his friend Carles Casagemas. Love,
> sex and death are linked in an ecstatic dance. The left-hand
> dancer in particular seems possessed by uncontrolled,
> Dionysian frenzy. Her face relates to a mask from Torres
> Strait, New Guinea, owned by the artist, and points to
> Picasso's association of 'primitive' forms with
> expressiveness and sexuality.

MADAME DOUCET SURVIVED her husband by twenty-nine years, dying in 1958 at the age of 97. The collection of furniture and objets d'art remained largely intact until sometime after her death. The major dispersal took place in 1972 when approximately half the items were donated by Mme Doucet's heirs to the Musée des Arts Décoratifs, Paris.

The remainder was auctioned at a celebrated sale at the Hôtel Drouot on 8 November, 1972, as a result of which Art Deco was instantly catapulted into the high-end, international league as a seriously collectable art form. (Without overstatement, one can say that while Jacques Doucet was responsible for the creation of an important strand of Art Deco, he was also a major contributor to Art Deco's emergence as a valuable collectable in the early 1970s.) Much of the remainder of the collection passed through the hands of a small number of elite collectors and dealers, primarily entering the Robert and Mrs Walker Collection in Paris and later bought by the (much discredited) art and antiquities dealer Robin Symes who also owned the Philip Johnson Town House, referred to above. Sydney and Frances Lewis bought the Rose Adler writing desk and

donated it to the Richmond Museum of Fine Arts, Virginia, to join a collection of some of the finest Art Deco pieces ever realised, of which they were also the generous benefactors.

Sadly for posterity, all Jacques Doucet's personal letters, written records and documents were destroyed as he wished shortly before his death and many aspects of his life remain unexplained.

Today, his name is enshrined in two great libraries of France. Firstly, the Bibliothèque Littéraire Jacques Doucet at the Sorbonne – the foremost library of literature in the country, which also contains more than four hundred volumes in precious bespoke bindings by Pierre Legrain and Rose Adler.

Secondly, the Institut National d'Histoire de l'Art, of which the Bibliothèque d'Art et d'Archéologie, started by Jacques Doucet before the First World War, was its foundation. This became the art library of the University of Paris in 1918. It is effectively the national art library of France and the largest research library in the country for art and the history of art.

So far as *haute couture* is concerned, Doucet led fashion by dressing actresses of the stage, the fashion runway of *la Belle Époque*. He developed his trademark style by using the laces and lingerie of his parents' chemiserie, putting them outside of the dress rather than simply beneath, as well as taking inspiration from eighteenth-century portraiture. For quality and excellence an expression was coined – The Doucet Type.

Paul Poiret, as Doucet's protégé, considered the moment of his dressing leading player Gabrielle Réjane for Zaza in 1898 as the launch of his stellar career: 'I had stormed the ramparts on the shoulders of Réjane.' (Doucet was godfather to her son). As a leading couturier of the 1920s, Poiret revolutionised fashion in the Art Deco period, as well commissioning and producing Art Deco furniture. He always said he modelled himself upon Jacques Doucet.

In a later era, another great fashion pioneer, Yves Saint Laurent, cast himself in the Doucet mould, not only as a couturier but also as a consummate collector – including the acquisition of furniture and

paintings formerly in Doucet's collections. Saint Laurent died in 2008 and in the following year a massive auction sale took place at Christie's, Paris, in which his vast collection, including the Doucet items, was dispersed – an event comparable in celebrity with the great Doucet sale of 1912.

In 2015 Saint Laurent's surviving partner Pierre Bergé staged the prestigious exhibition in Paris, *Jacques Doucet – Yves Saint Laurent: Vivre Pour l'Art*, in which recreations of Jacques Doucet's *secular altars* with original items were recreated. Accompanying this exhibition was a scholarly hardback edition of the same title with numerous colour reproductions (from the aforementioned 1930 *L'Illustration*) and a number of contemporary photographs of individual Doucet paintings, furniture and objects. Bergé wrote a substantial learned text in praise of Jacques Doucet and his rue Saint-James *Studio,* and its indispensable influence upon himself and Yves Saint Laurent in their passion for collecting, *as an art,* describing the Doucet final project as:

A jewel box in which to display harmoniously and to savour the masterpieces of modern art that Doucet assembled.

Furniture, objects, sculptures and paintings were installed in groupings, in layers of colour, texture and form that created and interconnected a succession of secular altars to great artistic sensitivity and creativity ... Jacques Doucet, known as the Le Magicien, had fulfilled a vision to create an exquisite, provocative and stimulating private aesthetic temple, a magical synthesis of media and cultures. The grand salon of Yves Saint Laurent and Pierre Bergé's rue de Babylone apartment pays homage to the inspiration of Jacques Doucet...

Both of these figures in their own time embodied the notion of taste. Warhol referred to Saint Laurent as 'the greatest French artist', and for Proust, in his In Search of Lost Time, Doucet was the epitome of taste: In The Prisoner, it is a 'dressing gown by Doucet' that Albertine longs for.

ACKNOWLEDGEMENTS

Any student of the life and work of Jacques Doucet will be
enormously indebted to his biographer, François Chapon (former
director of the Bibliothèque Littéraire Jacques Doucet, where he
worked for nearly 40 years) for his erudition and encyclopaedic
knowledge of our subject. As far as we know Chapon is the only
individual still living who visited the Doucet Studio at rue Saint-
James, Neuilly-sur-Seine, albeit in 1956, not only after the death of
the couturier, but sometime after the Picasso and Rousseau
paintings had been removed. We were privileged to meet M.
Chapon, first at the Doucet library in 1988, and later at his home in
2010, and received important illumination of the life of Jacques
Doucet, as well as encouragement for our story concerning the
couturier's ownership of *Les Demoiselles d'Avignon.*

The other great authority to whom we are highly indebted is
Philippe Garner, former director and world head of Decorative
Arts and Photography, of Christies, himself a prolific author in
these fields and an expert on Doucet. Phillipe Garner was
appointed external supervisor by the University of Cambridge,
School of Architecture for Ray Foulk's dissertation on the Doucet
Studio, *Jacques Doucet - Cultural Programme or Private Reverie?*
1988. Since then Philippe has contributed to the present project,
initially as a consultant on a film script version of this story, which
preceded the present novel, and then as an insightful reader of the
manuscript. Cambridge University tutor Peter Carl is also
acknowledged for his peerless guidance in preparing the original
dissertation, especially his elucidation of "the Secular Sacred".

Of the key works consulted in the research for this novel we
would single out for special acknowledgement the three volume

biography of Picasso by the late Sir John Richardson and his collaborator Marilyn McCully. Their supreme scholarship in our subject area has been an invaluable resource, as it would be to any project concerning the principal artist. Marilyn McCully also acted as a consultant on our earlier film script, to whom the authors are extremely grateful.

We also express our appreciation to our consultant, Denny Hemming, for her excellent editorial report on the manuscript and suggestions, corrections and revisions, much to the enhancement of this work. We hasten to add that any remaining errors are strictly our own.

We are grateful for the benefit we have received from manuscript readers over the period of the editorial process. For these efforts and extraordinarily valuable feedback, which have resulted in changes and improvements in every case, our warmest thanks go to: (in alphabetical order) Mark Alexander, Mel Cooper, Fanny Dubes Arbuthnott, Miche Fabre Lewin, Catherine Flutsch, Johnny Hinkes, Jenny Lewis, Cecelia Lloyd, Jo McIlvenna, Claire Palmer, Jacqueline Perrin, Martin Richman, Mark Robertson, David Spencer, Sylvia Vetta and Nedira Yakir.

An indispensable resource has been the *On-line Picasso Project,* managed by Prof. Dr. Enrique Mallen, at Sam Houston State University, to whom we are extremely grateful. Full access to this unrivalled archive has been a constant aid to our task.

We would also like to acknowledge our debt to the following principal works: Charles Baudelaire, *The Painter of Modern Life;* Charlotte Benton, Tim Benton and Ghislaine Wood, *Art Deco 1910-1939;* John Berger, *Success and Failure of Picasso;* Monica Bohm-Duchen, *The Private Life of a Masterpiece* (companion to the eponymous BBC television series); André Breton, *Manifestoes of Surrealism;* Leroy C. Breunig, *Apollinaire on Art: Essays and Reviews: 1902-1918;* Benvenuto Cellini, *The Autobiography of Benvenuto Cellini;* François Chapon, *Mystère et splendeurs de Jacques Doucet;* Douglas Cooper, *The Cubist Epoch;* Elizabeth

Cowling, *Picasso Style and Meaning*, Phaidon, London, 2002; Alex Danchev, *Cézanne: A life;* Jacques Doucet & Georges Petit, *Collection Jacques Doucet, 1912 catalogue, Vols I-III;* Dan Franck, *Bohemian Paris;* Philippe Garner, *Important 20th Century Furniture, A Philip Johnson Townhouse, Sotheby's, New York; Twentieth-Century Furniture; Eileen Gray;* Chantal Georgel & others, *Jacques Doucet – Collectionneur et Mécène;* Charlotte Gere, *Marie Laurencin;* René Gimpel, *Diary of an Art Dealer;* Christopher Green (editor), Picasso's *Les Demoiselles d'Avignon;* Joris-Karl Huysmans, *À rebours (Against Nature);* André Joubin, *Le Studio de Jacques Doucet, L'Illustration* magazine 3rd May 1930; Philippe Jullian, *Montmartre; Prince of Aesthetes: Count Robert de Montesquiou, 1855-1921;* Gerald Kamber, *Max Jacob and the Poetics of Cubism;* Jérôme Neutres & Pierre Bergé, *Jacques Doucet, Yves Saint Laurent, Vivre Pour L'Art;* Patrick O'Brian, *Picasso, a Biography;* Fernande Olivier, *Loving Picasso, The Private Journal of Fernande Olivier;* Roland Penrose, *Picasso, His Life and Work;* Yves Peyré & George Fletcher, *Art Deco Bookbindings;* Paul Poiret, *My First Fifty years; King of Fashion: The Autobiography of Paul Poiret;* Évelyne Possémé, *Le Mobilier Français, 1910-1930, Les Années 25;* Hélène Seckel, *Les Demoiselles d'Avignon, Vols 1 & 2* (catalogue to the eponymous exhibition, *Musée Picasso,* Paris,1988); John Richardson and Marilyn McCully, *A Life of Picasso, Vols I-III;* William Rubin, Hélène Seckel & Judith Cousins, *Les Demoiselles d'Avignon, MoMA Studies in Modern Art 3;* Roger Shattuck, *The Banquet Years;* Roger Shattuck, Henri Béhar, Michel Hoog, Carolyn Lanchner and William Rubin, *Henri Rousseau;* Leo Steinberg, *The Philosophical Brothel, Art News;* Hilary Spurling, *Matisse: The Life;* Natasha Staller, *A Sum of Destructions, Picasso's Cultures and the Creation of Cubism;* Gertrude Stein, *The Autobiography of Alice B. Tolklas;* André Suarès & Jacques Doucet (edited by François Chapon), *Le Condottiere et le Magicien;* Ambroise Vollard, *Recollections of a Picture Dealer.*

Quotation Sources – Chapter heads

Chapter 1. Socrates. Cited, Elaine Fantham, Helene Peet Foley, Natalie Boymel Kampen, Sarah B. Pomeroy, H. Alan Shapiro, *Women in the Classical World,* Oxford University Press, 1994.

Chapter 2. Marcel Proust. Edited F. W. Dupee, *Pleasures and days – and other writings,* translated by Louise Varese, Gerard Hopkins and Barbara Dupee, Doubleday, New York, 1957.

Chapter 3. Pablo Picasso. Cited, *Words of Wisdom: Pablo Picasso,* Lulu Press, North Carolina, 2015.

Chapter 4. Edgar Allan Poe. *The Premature Burial, The Philadelphia Dollar Newspaper,* 1844.

Chapter 5. Leonardo da Vinci. Cited, Betty Conrad Adam, *The Magdalene Mystique: Living the Spirituality of Mary Today,* Church Publishing, New York, 2006.

Chapter 6. Joseph Duveen. Cited, Frederick F. Wherry, Juliet B. Schor, editors, *The Sage Encyclopedia of Economics and Society,* Sage Publications, Thousand Oaks, California, 2015.

Chapter 7. Voltaire. Cited, Richard Alan Krieger, *Civilization's Quotations – Life's Ideal,* Algora Publishing, New York, 2007.

Chapter 8. Victor Hugo. *Les Misérables,* 1862, translated by Charles E. Wilbour, Random House, New York, 1992.

Chapter 9. Guillaume Apollinaire. Cited, Vera Mowry Roberts, *On stage: a History of Theatre,* Harper & Row, San Francisco, 1974.

Chapter 10. Edvard Munch. Cited, Patricia G. Berman, *Edvard Munch – Mirror Reflections,* Norton Gallery of Art, West Palm Beach, Florida, 1986.

Chapter 11. Marcus Cicero. (attrib. Robert Harris in historical fiction) *Imperium, Cicero Trilogy,* Random House, London, 2009.

Chapter 12. Francis Bacon. Blago Kirov, Francis Bacon – *Quotes and Facts,* Create Space, Independent Publishing Platform, 2016.

Chapter 13. Émile-Jacques Ruhlmann. Cited, Raymond Foulk, *Ruhlmann Centenary Exhibition,* The Foulk Lewis Collection, London, 1979.

Chapter 14. Marcel Duchamp. Cited, Rudolf E. Kuenzli, Francis M. Naumann, *Marcel Duchamp: Artist of the Century,* MIT Press, Cambridge, MA and London, 1991.

Chapter 15. Pablo Picasso. Cited, María del Carmen González, Susanna Harwood Rubin, *Looking at Matisse and Picasso,* Museum of Modern Art, New York, 2003.

Chapter 16. Aristotle. Cited, N. B. Sen, *Wit and Wisdom of Socrates, Plato, Aristotle,* New Book Society of India, 1967.

Chapter 17. Vitruvius. *The Architecture of Marcus Vitruvius Pollio – in Ten Books,* Translated by Joseph Gwilt, Lockwood & Co, London, 1874.

Chapter 18. Henri Rousseau. Cited, Cornelia Stabenow, *Rousseau 1844-1910,* Taschen, London, 2001.

Chapter 19. Victor Hugo. *Les Misérables,* 1862, translated by Charles E. Wilbour, Random House, New York, 1992.

Chapter 20. Henri Matisse. Cited, Pierre Schneider, *Matisse,* Rizzoli, New York, 2002.

Chapter 21. Confucius. Cited, Graeme Partington, *Confucius Says: First100 Lessons,* Lulu Press, North Carolina, 2017.

Chapter 22. Alfred Jarry. Cited, David Seed, *Imagining Apocalypse: Studies in Cultural Crisis,* Macmillan, Basingstoke, 2000.

Chapter 23. Man Ray. Cited, Andrea A. L. Scala, *About Photography,* Lulu Press, North Carolina, 2014.

Chapter 24. Friedrich Nietzsche. Cited, David Logan Graham, *The Prophet to Zion: Chronicles of Grey: Book 1,* Xlibris Corporation,

NSW, Australia, 2013.

Chapter 25. Marcel Proust. *In Search of lost Time, vol. III, The Guermantes Way,* Translated by: C.K. Scott Moncrieff & Terence Kilmartin, Chatto & Windus, London, 1992.

Chapter 26. Nostradamus. Cited, A. K. Sharma, *Nostradamus and Prophecies of the Next Millennium,* Diamond Pocket Books, New Delhi, 2001.

JACQUES DOUCET DIES, PARIS ART DEVOTEE

Former Dressmaker Had Notable Collection of French Masters Sold in 1912

Special Cable to The New York Times

PARIS, Oct.31 - Jacques Doucet, who before the World War enjoyed a world-wide reputation as a leading Rue de la Paix dressmaker, is dead at his home in Neuilly.

The Sale of his collection of eighteenth century French masters in 1912 brought the highest prices ever obtained in auction rooms anywhere up to that time. Since then he had collected only modern and ultra-modern art. His great wealth enabled him to acquire many works of Degas, Cezanne, Vangogh and Daumier.

His own fine taste was exemplified in the little palace he built to house Picasso's masterpiece, "The Young Ladies From Avignon." The building was in Arabian Nights style and contained other treasures, including early Chinese and Negro sculptures.

M. Doucet's "Snake Charmer," a masterpiece by Douanier Rousseau, goes to the Louvre under the terms of his will.

The New York Times
Published: November 1, 1929

Jacques Doucet by Man Ray, 1926.

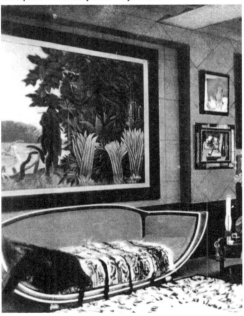

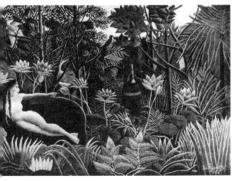

Above: The Snake Charmer, Henri Rousseau, 1907, over *Gondola Sofa,* Marcel Coard, Jacque *Doucet Studio,* Paris ,1929.

Left: *The Dream,* Henri Rousseau, 1912.

Life goes to the Opening

of the new, $2,000,000 glass-front building
of New York's famed Museum of Modern Art

To celebrate its tenth birthday, New York's Museum of Modern Art, which houses a $2,000,000 collection of contemporary paintings, sculpture and old movies, elected a new president and moved into a new home. New president was Nelson Rockefeller, whose mother, Mrs. John D. Rockefeller Jr., sponsors the Museum. The new home was a handsome, six-story example of modern city architecture, designed by Architects Philip L. Goodwin and Edward D. Stone.

Opening of the building was the occasion for the biggest show in the Museum's history—an inclusive, stimulating hodgepodge called "Art In Our Time," which, for the edification of World's Fair Visitors, will last all summer. An equally good show was provided by the audience of top-rank celebrities which the opening drew. The turnout of top-rank celebrities was so impressive that it amazed even the celebrities. To give the occasion national significance, President Roosevelt telephoned a speech hailing the growing importance of art in American life.

New Building of the Modern Museum, on 53rd St. near Manhattan's night-club midway, is less functional than it looks. Glass front let in so much light it had to be boarded up inside.

...emoiselles d'Avignon, being received by the board of the new ...um of Modern Art, New York, 1938. (*Life* magazine).

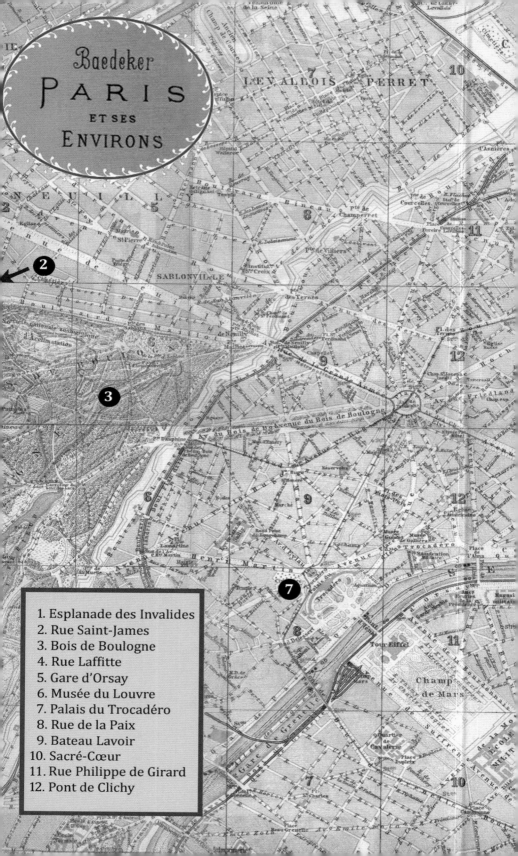

Baedeker

PARIS

ET SES

ENVIRONS

1. Esplanade des Invalides
2. Rue Saint-James
3. Bois de Boulogne
4. Rue Laffitte
5. Gare d'Orsay
6. Musée du Louvre
7. Palais du Trocadéro
8. Rue de la Paix
9. Bateau Lavoir
10. Sacré-Cœur
11. Rue Philippe de Girard
12. Pont de Clichy